D1166023

AT HOME IN THE STUDIO

Laura R. Prieto

At Home in the Studio

The Professionalization of
Women Artists in America

HARVARD UNIVERSITY PRESS

Cambridge, Massachusetts, and London, England 2001

Library of Congress Cataloging-in-Publication Data

Prieto, Laura R., 1968–
 At home in the studio : the professionalization of women artists in America / Laura R.
 Prieto.
 p. cm.
 Includes bibliographical references and index.
 ISBN 0-674-00486-8 (alk. paper)
 1. Women artists—United States—History. 2. Women in the professions—
 United States—History. I. Title.

N8354 .P75 2001
704'.042—dc21 2001039408

For FMIS

Contents

Illustrations

Acknowledgments

It has been a long journey from the Boston Museum of Fine Arts, where I first saw Harriet Hosmer's sculpture of a sleeping faun and got an idea for the seminar paper that grew into this book. Through all the reconfigurations of that paper and the transformations in my life, I was fortunate that I could rely on others to help me navigate my way. I am happy to be able to thank them publicly at last and to offer them a tangible result of all those drafts, questions, and deliberations.

I would like to express my thanks first of all to Mari Jo Buhle and John L. Thomas, who directed my doctoral dissertation and who continue to demonstrate their support for me at every turn. I hope they already know how much their guidance and generosity mean to me. They remain my exemplars of how to be a writer, researcher, teacher, and professional historian.

A wealth of material and valuable assistance from museums, archives, and libraries made this book a pleasure to research. I would particularly like to thank the wonderful archivists, librarians, and other staff at the Archives of American Art; the Boston Museum of Fine Arts; the Fine Arts Room at the Boston Public Library; the John Hay Library at Brown University; the California Historical Society; the Chicago Historical Society; the Cincinnati Historical Society; the National Museum of Women in the Arts; the Arthur and Elizabeth Schlesinger Library on the History of Women in America; the Sophia Smith Collection at Smith College; and the Wellesley College Archives. The Interlibrary Loan staff at Brown, Bridgewater State College, and Simmons College were indispensable. I am equally grateful to the generations of feminist scholars, biographers, and art historians who have (to quote Zora Neale Hurston) "poked and pried with a purpose" before me. Though I am acquainted with most of them only through their words, I know that without them this project would have been impossible.

While writing and rewriting, I benefited greatly from the honest criticism

of both mentors and peers. Ellen Wiley Todd provided vital critical assistance and personal encouragement; her knowledge of cultural history, gender, and of course art was a great resource for me. I would also like to thank Laura Briggs, Susie Castellanos, Carolyn Dean, Kathy Peiss, and Ed Rafferty for reading and critiquing key sections of this book. The New England Board of Higher Education's Compact for Faculty Diversity and my host institution, Bridgewater State College, enabled me to work intensively on the manuscript for a year as a Dissertation Fellow. JoAnn Moody at NEBHE was always enthusiastic about my work and provided good advice when I needed it. Since then, I have depended on my colleagues and students at Simmons College, particularly those in the departments of History and Women's Studies, to help sustain my sense of purpose. I very much appreciate the interest they have consistently shown in my research, and I cherish the feminist environment they have created. I would especially like to thank Carole Biewener for the time and care she has taken to mentor me over the past four years. Marie McHugh cheerfully rendered crucial administrative assistance, often at the last minute, for which I'm sincerely obliged as well.

I am grateful to Peg Fulton at Harvard University Press for welcoming my book proposal with such delight. I also thank Donna Bouvier, who edited the manuscript with the utmost care; her attention to detail saved me from many an embarrassing error, incomplete citation, and ungraceful turn of phrase.

Throughout the process of turning this manuscript into a book, Richard Canedo has leavened my professional life with love and companionship—as well as endless entertainment, befitting a chronicler of vaudeville. He was always ready to comment on a raw draft or perform a heroic research errand to help hasten this project toward publication. Our many conversations have made me a better writer, teacher, and historian, and it is my great joy that the treasured "room of my own," where I wrote and revised so much of this book, is part of the home we share.

My deepest debt for this book lies within my own professional women's network: my graduate student writing group, or as we dubbed ourselves, the Female Mutual Improvement Society. For many years, Chrissy Cortina, Donna DiFabio Curtin, Jane Lancaster, Sarah Leavitt, Marie Myers, and Sarah Purcell have suffused my writing life with their warm friendship, unflagging enthusiasm, and incisive criticisms. Because they continue to inspire me, both as women and as professional historians, I dedicate this work to them.

Introduction

A silly topic . . . Write about women. Or write about artists. I don't see how they're connected.

 Georgia O'Keeffe, 1977

The woman who is known only through a man is known wrong, and excepting one or two like Madame de Sévigné, no woman has pictured herself. The American woman of the nineteenth century will live only as the man saw her.

 Henry Adams, *The Education of Henry Adams*

It rarely happens that two gifted, perceptive individuals as different as Georgia O'Keeffe and Henry Adams are both wrong about the same subject. This book, however, relies on the judgment that O'Keeffe, the celebrated painter, and Adams, the revered autobiographer, are mistaken. Women in the visual arts did picture themselves as women, through self-portraiture as well as through public and private writing. Though the culture in which they lived and worked was not entirely of their own making, women did not simply reflect men's perceptions; rather, they refashioned elements of gender ideology to articulate and legitimate their positions as serious working artists. That is, gender not only shaped how "the man saw her" but how she defined herself. Women chafed against remarks, usually intended as compliments, that they painted or sculpted "like men." Mary Cassatt, for one, wrote, "if I have not been absolutely feminine, then I have failed."[1] Even O'Keeffe, in statements other than the one above, expressed the feeling that gender was part of her identity and thus part of her art after all. "I am trying with all my skill to do painting that is all of a woman, as well as all of me," she wrote in 1930.[2] O'Keeffe's two statements represent two concurrent struggles that other women artists shared: attempting to disman-

1

tle structural exclusions based on sex, and articulating a vision of feminine professionalism that connected or adapted the process of making art to ideologies of womanhood. Though seemingly contradictory, both were pragmatic responses that in tandem enabled women to build networks within and without art institutions, with men as well as with other women.

This connection between "woman" and "artist" was neither biological nor metaphysical, but rather the historical product of how women established a presence in the visual arts in America. Out of necessity, women artists painstakingly developed a distinct identity and a separate route to professionalization in the course of the nineteenth century. Colonial Americans regarded art and artists with a practical eye; as Neil Harris explains, "The portrait was a craft product, not intrinsically different from a chair or a set of candlesticks; only in exceptional cases did the craftsman achieve his immortality."[3] American painters and sculptors began to gain professional status in the late eighteenth century, when society came to regard them as "artists" rather than as mere artisans whose work was not very different (and certainly less practical) than that of silversmiths, coopers, and potters. The new necessities of study and travel (ideally, in Europe) effectively excluded women from participation in this process, however. Initially, art academies did not accept female students. The association of professional status with middle-class status further complicated matters; even the rental of a studio seemed to violate the emerging dictates of domesticity for middle-class women.

In response, women artists hearkened back to the former model of family workshops producing art. They framed their lives and work in terms of their relationship to home and family, and sought legitimacy through an extension of their feminine roles. Across regional and sometimes racial lines, they claimed that art was fully compatible with womanhood, and they minimized the subversive potential of their careers. They were, one might say, at home in the studio—not invading male space but rather claiming it as an extension of their own sphere. Women never lived or worked in a world isolated from men, and women artists always sought to associate with men in the art world as well as with other women. The access that they gradually won to professionalizing institutions like art academies, studios, life classes, galleries, and art clubs, however, often entailed separation from men. In the most cogent example of this process, segregated "ladies' life classes" promised to train women adequately without endangering their respectability by exposing them to undraped bodies in mixed company.

Initially, women artists' own professional enterprises replicated the success of the ladies' life class; separate women's art clubs, exhibitions, networks, and the like provided women artists with professional credentials, albeit on a sexually segregated basis. Though women artists remained underrepresented in some genres (such as landscape painting and monumental sculpture) compared to others that seemed more feminine (such as flower painting), their strategies enabled them to become full-fledged professionals. Separatism, however, became increasingly difficult for women artists to maintain as the gulf widened between professional women artists and the "lady amateurs" whose female culture they had formerly shared. New, modernist reformulations of art in the 1910s and 1920s further induced women to favor individualism over collectivity and self-expression over academic training. Still, because of the persistence of sexism and exclusion in the art world, many women artists continued to find relevance in their identity as female professionals. They maintained women's networks and organizations as strategies for success even as they sought alliances with men. Just as gender proved an inescapable component of their lives and work, so did these artists incorporate gender as part of their identities. Only in such a way could the art they produced be "all of a woman, as well as"—not as opposed to, not instead of—"all of me."[4]

Throughout these developments, a preoccupation with gender also suffused male-dominated institutions as they constructed the ideal artist and the art canon. To stave off the danger that feminization posed to their status, men emphasized the importance of virility, or the masculine aspect of creativity, to making great art. Measured by this standard, the term "woman artist" appeared to be an oxymoron. Women might draw or paint or sculpt, but they could not be Artists. That is, they might be dilettantes and amateurs, but not professionals; they might create decoration, but not Art. They were at best mediocre, conservative technicians with a good sense of color; their sex precluded their achievement of greatness. To cite one notorious expression of this point of view, in 1917 sculptor Edward Simmons announced in a major American art magazine, "No genius is or has been a woman." Another sculptor, Augustus Saint-Gaudens, inspired many women students but believed that "men always seem to compose better than women and are more creative."[5] Such pronouncements implicitly or explicitly invoked "nature" (biological sex, as opposed to gender) in convoluted ways to explain why women could not satisfy the "objective" criteria of greatness.

The resultant trope of the dilettantish "lady artist" proved quite powerful. With the notable exception of two painters, Mary Cassatt and Georgia O'Keeffe, and one sculptor, Louise Nevelson, American women artists remain largely unrecognized. In fact, Cassatt, O'Keeffe, and Nevelson often function as exceptions that prove the rule. If they are "great," their lives and careers must be radically different from those of other women. Their success neither proves nor disproves the capacities of women more generally; if anything, their success is evidence of their own deviance from "normal" womanhood. By this logic, their achievement of becoming an Artist would seem to demand that they sever any connection to an identity as "woman." They would and should be judged only by the professionalized, objective criteria of individual merit—a high standard, which few women could be expected to meet.

Given these assumptions, it becomes something of a shock to learn that their sex did not isolate Cassatt, O'Keeffe, and Nevelson as anomalies. Women comprised the majority of American art students and a large percentage of exhibitors by the end of the nineteenth century. And since the 1960s, artists and writers both inside and outside of academia have rediscovered the rich history of women's work in art. The rise of women's studies, feminist art history, biography, and women's history have all helped make visible what was formerly invisible, by documenting the vibrance of working women artists past and present. Individual and group biographies have identified women within important art movements and gathered women artists' work in exhibitions that highlighted the difference that gender made to their lives and careers.[6]

At the same time, even "great" women are susceptible to trivialization. In popular representations, Cassatt is merely a painter of tender maternal scenes, while O'Keeffe specializes in images of female genitalia masquerading as flowers (an interpretation of her work that O'Keeffe consistently rejected). They appear as artists mired in their social spheres and bounded by their gender, incapable of tackling "larger," more "universal" themes as their male counterparts did. Perhaps worst of all, they seem isolated exceptions, whose individual experiences cannot affirm or deny what "typical" opportunities or systemic obstacles American women artists might experience. For this reason, works of synthesis, bibliographies, and grand narratives have been of crucial importance, not only because they have served to collect information about women artists across nations and historical eras, but also because they have sought common themes and have begun to question the presumption of sisterhood.[7]

Feminist scholars in various fields have also called attention to the gendered bias underlying the very concept of "greatness." Along with postmodernists and social constructivists, they deny the very possibility that a universal aesthetic can exist. Asking the classic question "Why have there been no great women artists?" art historian Linda Nochlin recognizes that "the feminist's reaction is to swallow the bait, hook, line, and sinker, and to attempt to answer the question as it is put: that is, to dig up examples of worthy or insufficiently appreciated women artists throughout history." While these are valuable and necessary efforts, they are by themselves insufficient because they do not challenge the terms of the question. Artists are products of social, not mystical, forces. The social history of art institutions, from life study classes to patronage, explains why women did not achieve greatness: they were systematically excluded from obtaining the credentials and associations that would qualify them for greatness.[8] Knowledge, representation, and power were interrelated; artists themselves constructed ideals of femininity, while gender ideology affected perceptions of the artist (and his or her work).[9]

An overarching image of the woman artist emerges from many of these disparate efforts. Gender, not sex, comprises the woman artist's central problem. It is not her nature or her body that hinders her success as an artist but rather the cultural prescriptions of femininity that make it difficult for her to see and be seen as an artist. She has a double consciousness, an identity divided between "woman" and "artist," since gender ideology will not permit her to be both at once. She lives and works as a neglected, misunderstood being who often comes to a tragic end. The woman artist thus feels isolation and alienation—ironically, characteristics that ideally inform the modern artist's work. Her self-expression in art exposes the gendered aspect of power.[10] Gender and power are, then, the great universal themes of women's art, significant enough to place women on a par with men as artists. Creating representations from the margins rather than the center, women may even provide *more* profound insights into social relationships and cultural politics than men; women's art can give voice and form to the "Other."[11]

Intriguingly, this conception has much in common with fictional depictions of nineteenth-century women artists by contemporary women writers. Elizabeth Stuart Phelps's 1877 novel *The Story of Avis* offers one of the most eloquent narratives of the conflict between womanhood and art. Avis Dobell, the protagonist, resists marriage for fear that domesticity will overwhelm her professional ambitions as a painter:

> "Marriage," said Avis, not assertantly but only sadly, as if she were but rec-
> ognizing some dreary, universal truth, like that of sin, misery, or death, "is a
> profession to a woman. And I have my work; I have my work! . . . For your
> soul's sake and mine, you are the man I *will* not love."[12]

Phelps clearly identifies social pressures and circumstances, not Avis's na-
ture, as the central problem. When Avis relents and succumbs to marriage,
both personal and professional ruin result. The woman artist cannot lead a
life like other women; she is as different from them as Avis is from the do-
mestic virtuoso Aunt Chloe and the fashionable, lovable, unintellectual Coy
Bishop. Womanhood and art are two ideals between which a woman artist
must choose.

To accept womanhood and art as simply oppositional, however, is to miss
the complexity of women artists' own identities, strategies, representations,
and narratives. As Lisa Tickner writes, becoming an artist "was not only a
social matter of training and opportunity, it was also a question of aspiration,
of *imagining* oneself an artist."[13] How, then, did nineteenth-century women
imagine themselves to be artists? Did they accept the ideal artist as a funda-
mentally masculine being? They could not embrace the masculine ideal and
abandon all conventions of femininity. At the very least, in order to be pro-
fessionals they had to sell their work, and even if they could transcend gen-
der in their self-image, their patrons, clients, and critics certainly would not
do likewise. Women artists would be held to a cultural standard of woman-
hood regardless of their individual preference. In the face of such strong op-
position, one is tempted to conclude that they must have conceded the fact
that their womanhood consigned them to eternal mediocrity and amateur-
ishness.

Yet such a position does not explain the professional ambition and suc-
cess of women like Harriet Hosmer, Edmonia Lewis, Cecilia Beaux, Lilian
Westcott Hale, Narcissa Owen, Marie Danforth Page, and Abastenia St.
Leger Eberle, not to mention Mary Cassatt and Georgia O'Keeffe. Examples
of real women like Avis abound: artists whose professional efforts ended
with marriage and motherhood, artists whose early promise went unreal-
ized, artists who chafed against the boundaries of gender. But at the same
time there were nineteenth-century women artists who built successful ca-
reers, won critical acclaim, and continued to work as professionals long after
they became wives and mothers. These women did not simply acquiesce to a
basic conflict between womanhood and art. They sought a place for them-

selves in the intersection of these competing ideals, woman and artist, amateur and professional.

This book analyzes how women artists created a coherent identity, one that used ideas about womanhood to legitimate their position and work as artists. It examines the lives, writings, and art of a diverse group of women, all born or residing in the United States, who worked as visual artists and exhibited or sold their work. It includes painters, sculptors, and illustrators that traverse particularities of medium, genre, ability, training, productivity, region of residence, and critical reception.[14] This permits a wide range of subjects in terms of class and (most elusive for the researcher) race. Such an expansive scope is crucial because ideologies of race and class and definitions of "high" versus "low" art are significant factors in marking the boundaries of both womanhood and art in the nineteenth century. Of course, men also experienced profound changes in the professional, economic, social, and cultural status of art in this period. But this study places women at the center, not the margins, of inquiry.

The central narrative here is the process of professionalization, because it was as professionals that women artists were best able to integrate the ideals of womanhood and art. Despite the rise of social and cultural histories of art, scholars still regard artistic production as a primarily creative, expressive, representative activity, not necessarily as work. In a sense, the labor involved in making art is the very aspect of their careers that mid-nineteenth-century women would have wanted to obscure. Just as household work remained invisible within the cult of domesticity, so did the seemingly spiritual nature of art-making render it all the more possible for women who wished to claim it within their purview. But denying art its nature as work obscures comparisons with other pursuits that shared similar influences and outcomes. Art began to gain social value in the era of the Revolution and achieved legitimacy by the era of the Civil War. By the late nineteenth century, art—like many other fields, from library science to medicine—displayed the familiar aspects of professionalization: it focused on specialized training, professional associations, middle-class status and patronage, concern with authorship, reliable income, and a seriousness of purpose that extended beyond mere money-making.[15]

Gender shaped the process of professionalization in disparate ways. Occupations ran the risk of feminization, which might mean that women dominated the profession numerically or that the type of work evoked feminine associations in the popular imagination—or both. Some professions, nursing

for example, assumed a natural connection with womanhood; according to historian Barbara Melosh, "Women's dominance in nursing nearly equals our monopoly on motherhood: nursing has always been a woman's job." Other types of work that had traditionally been men's jobs came to be performed almost exclusively by women, such as teaching in the early nineteenth century and secretarial positions after the Civil War. Feminization invariably meant lesser status in relation to other professions. Thus, much was at stake in the gendering of occupations, and men tried to use masculinity to mark the boundaries of what was "professional." In some fields, most notably law, women found that gender ideology made it difficult or impossible for them to follow men's path toward professionalism.[16]

Yet gender ideology could also enable women to develop their own route to professionalization, which at times intersected with the institutions and ideals of their male counterparts and at other times developed independently of them. In response to their marginalization within medicine, for instance, women developed their own professional networks and institutions, such as women's medical colleges. In science and literature, as in art, women gradually transmuted ladylike leisure activities into opportunities for serious study and finally some degree of professionalism by the latter half of the nineteenth century. They found success most easily within female enclaves, whether particular genres (like domestic fiction, botany, homeopathy, and flower painting) or institutions (like women's colleges, which employed the majority of women scientists, and hospitals for women and infants). Though this was not the only strategy women employed, the ability to connect an occupation to ideas about "woman's nature" proved crucial to overcoming obstacles erected against women's participation, or conversely to creating alternative "feminine" paths toward the same end. Any field of endeavor could be deemed suitable for women with the right rhetoric—as when a celebrated American art critic declared sculpture of appropriate interest to women because it promised "the quickest returns for the least expenditure of mental capital" when compared to other "fields of Art." Gender conventions might thus lead unintentionally to radical consequences as women claimed an increasing number of genres and subjects to be appropriately feminine.[17]

In that spirit, the first half of *At Home in the Studio* analyzes the origins of women artists' distinct paths toward professionalization. Chapter 1, "Peculiarly Fitted to Art," examines the gendering of the artist's transition in status from artisan to professional. Ironically, the nascent association between

middle-class femininity and artistic accomplishment provided women with their first point of entry into professional art. Certain genres (notably portraiture and still-life) came to be viewed as appropriate fields for feminine endeavor. Middle-class women's need for expertise in the ornamental also led to their inclusion in art education for the first time. Chapter 2, "Domesticating Professional Art," shows how women developed and expanded this strategy through the 1860s. Women artists used ideas about domesticity to create and justify their own empowering peer networks. Domestic spaces and familial metaphors helped legitimate the production of art. The works of genre painter Lilly Martin Spencer and sculptor Harriet Hosmer, among others, stretched domesticity to its limits. Chapter 3, "Figures and Fig Leaves," focuses on the problem of sexuality for women artists in the 1860s and 1870s. Though the nude marked the pinnacle of art, when women artists produced images of undraped figures, both artist and artwork were regarded with suspicion. Knowledge of the human body, and power over representing it, made the woman artist seem impure, racially tainted, and ultimately unworthy of respect. Most formal art institutions restricted women's access to nude models in order to protect them from such a reputation. Starting in 1868 at the Pennsylvania Academy of the Fine Arts, women art students finally gained the opportunity to attend life classes, but only in the context of "ladies' classes," which were segregated by sex. These curricular changes introduced a gap between the serious, professional woman artist who wanted to study the nude and the dilettantish, amateur artistic woman who still preferred to guard her reputation.

The second half of this book studies how a more specific identity for women artists developed, and especially how it gradually shed its associations with a wider women's culture that included amateurs. Chapter 4, "Sculpting Butter: Gender Separatism and the Professional Ideal," explores the transformation of women's culture into a full-fledged "feminine professionalism" between the 1870s and the 1890s. The first professional institutions formed by women artists, from the Ladies' Art Association to the Women's Pavilions at the 1876 and 1893 world's expositions, continued to provide women artists with professional credentials within a sexually segregated framework. This separatist strategy risked linking professionals with increasingly ridiculed "lady amateurs," however, and as a result women artists began to abandon female artistic traditions in favor of a more emphatically professional ideal. Chapter 5, "Portrait of the Artist as a New Woman," analyzes how women artists in the 1890s and early 1900s asserted their pro-

fessional identities more publicly and self-consciously than ever. Some, such as Anna Lea Merritt, began to publish writings and to deliver speeches about the problems that gender roles posed for women artists. They demanded equal treatment as artists and further stretched the boundaries of feminine professionalism by adopting their own brand of bohemianism and embracing urban culture. In addition, many put their artistic skills to practical use, producing works explicitly on behalf of social and political reform and revolutionizing the settlement and suffrage movements in the process. Chapter 6, "Making the Modern Woman Artist," charts the final stage of gendered professionalism as it developed in the 1920s. Suffrage removed the last major formal barrier to women's acceptance in the public sphere, enabling women to adopt professionalism more openly than ever. Meanwhile, modernism's emphasis on individualism threatened any sense of sisterhood among women artists, while the powerful cultural primacy of self-expression undermined the value of the academic training that they had struggled to obtain. Their links with amateur women's culture had dissolved, but women artists still encountered obstacles to success because of their sex. They countered by continuing to employ their own gender-based strategies in response.

Scholars in the past have faulted nineteenth-century women in the professions for their insufficient mentorship of younger women and for their lack of political activism. Robyn Muncy expressed disappointment with the extent to which Progressive era women integrated feminist values with professional culture; Joyce Antler characterized their attempts to create a new feminine identity as "unsuccessful" and charges professional women with "help[ing] to determine the failure of feminism" in the 1920s.[18] Although there was certainly a qualitative change in feminist discourse in the 1920s, historians have begun to question whether feminism truly evaporated with the passage of the Nineteenth Amendment.[19] One should also wonder whether separatism—one of nineteenth-century feminism's most powerful strategies—ever really faded from public view either. Women physicians in the Practitioners' Society, a women's medical society in Rochester, New York, for example, continued to support feminism and social reform alongside professional advancement—and continued to meet as professional women even after other medical institutions, from schools to hospitals, had become sexually integrated.[20] The cultural relevance of women's professional associations for artists even through the 1930s, 1940s, and 1950s is evident from the survival of women's art clubs like the Plastic Club and the

National Association of Women Artists (formerly the National Association of Women Painters and Sculptors) to this day. Many other professional women's organizations, including the American Medical Women's Association (founded as the Medical Women's National Association in 1915), the National Federation of Business and Professional Women's Clubs, and the American Association of University Women, likewise survived the "interwave" period of feminism. Though the push for women's liberation in the 1960s called for fresh alliances among women with explicitly political underpinnings, it is nevertheless worth noting that the persistence of female professionals' identities as women had its own culturally radical potential.

Nineteenth-century women's experience in the professions proved crucial to their assumption of public roles, to shifting definitions of gender, and to the ideological shape of American culture itself. In the visual arts women were both marginal and central, passive and active. Excluded from the paths taken by their male counterparts, women developed their own routes toward professional status, rooted in their purportedly feminine affinity for art. Like contemporary women doctors and lawyers, women artists established their own professional identities that both echoed and reconfigured prevalent ideals of womanhood. Whether with pen, brush, needle, or chisel, women had been redrawing the outlines of gender and professionalism for generations. It is a sign of ultimate success, not failure, that the connections women had laced together so painstakingly seemed by 1977 "silly" and superfluous to Georgia O'Keeffe. In picturing themselves as women as well as artists, her predecessors had helped to transform the conventions both of femininity and of art.

Peculiarly Fitted to Art

When Anna Claypoole Peale set about painting her first self-portrait in 1818 she chose to represent herself in watercolor on a small bit of ivory measuring about three inches by two and a half inches. Her decision to produce a portrait miniature was significant for several reasons. For one, the miniature was, and would continue to be, her specialty in art, the genre in which she felt most proficient and one that drew upon a rich family tradition. As Charles Willson Peale's niece, Anna Peale was part of early America's foremost artistic dynasty; her father, James, three of her five sisters (Maria, Margaretta and Sarah), four male cousins (Raphaelle, Rembrandt, Titian, and Rubens), and at least six other relatives also employed paint and brush.[1] Anna and her sisters began painting as studio assistants to their father, and like their father they specialized in miniatures.

Second, Anna chose an immensely popular form for her self-representation. Portraiture enjoyed singular status as the first type of art accepted and valued by Americans, so portraits comprised the vast majority of early American paintings through the 1820s. Because painting was considered more of a trade than a fine art, however, itinerant portraitists scratched out their living by traveling from city to city seeking sitters who would pay to have their faces "limned" on ivory, wood, or canvas.[2] Though some patrons commissioned more elaborate large oil paintings, many preferred to order miniature portraits that they could carry or even wear as lockets and on bracelets. Unlike the conspicuous grandeur of the portraits on canvas that decorated the walls of gentrified homes, the miniature provided an intimate view of its subject. Even when mid-nineteenth-century art buyers came to prefer a slightly larger "cabinet" size (about three inches square), the small size and focus on the subject's face continued to associate the miniature with preciousness and sentimentality. In producing a miniature of herself, Anna

Peale provided a sample of her artistic skill and thus effectively advertised her virtuosity as a portraitist to potential patrons.

Anna's choice of the miniature was also significant in that it drew upon certain traditions of women's work in art. Both men and women painted miniatures in early America, but the portrait miniature seemed a particularly appropriate field for women artists. This was due at least partly to the miniature's intimacy, sentimentality, and diminutive size—attributes identified with femininity. In addition, portraiture (along with still life, the specialty of Anna's sisters Margaretta and Maria) proved more accessible to women artists than other genres, such as allegorical and history painting, which required keener knowledge of the figure. Women could not gain such knowledge because their sex disqualified them from attending life classes in either Europe or the United States, a pattern unbroken until 1868 when the Pennsylvania Academy of the Fine Arts quietly organized its first Ladies' Life Class. Portraiture, as it was conventionally conceived, allowed the artist to produce the epitome of art—a lifelike image—without requiring the anatomical studies that were unavailable to women.[3] American audiences retained a deep skepticism concerning the propriety of either men or women artists' representing the body in the manner of "decadent" European art. American tastes for portraiture and demands for moral purity thus made art more generally acceptable as a respectable female vocation.[4]

Despite its social acceptance as an appropriate field of endeavor for women, though, the painting of a portrait miniature was not entirely feminized. Men still outnumbered women as artists in every genre, including portraiture. Moreover, miniatures were often included in art exhibitions of the period and could lead to successful public careers for women artists. For example, almost half of the women who exhibited at the Boston Athenaeum during its first thirty years (1827–1857) exclusively showed miniatures there.[5] A number of early American women artists besides the Peales distinguished themselves in miniature painting. By 1817 Ann Hall had exhibited miniatures at the American Academy of the Fine Arts; on the strength of her work in the genre, in 1833 Hall became the first woman named a full member of the National Academy of Design. Painter Sarah Goodridge opened a studio in Boston in 1820. Her portrait miniature of eminent painter Gilbert Stuart elicited widespread admiration. Even Stuart's daughter Jane, a successful painter in her own right, pronounced Goodridge's work "the most lifelike of anything ever painted of him in this country"; her father's very decision to let Goodridge paint him was evidence of

her acknowledged skill, "considering how much he disliked what he called 'having his effigy made.'"[6]

This too, then, was a tradition with which Anna's portrait miniature associated her: a tension between professionalism and femininity. Anna Claypoole Peale incorporates the visual conventions of womanhood that would attract potential future commissions; the self-portrait presents the image of a genteel and feminine young woman, not very different from the class and type of young women that she hoped to paint on commission.[7] Her posture is rigid, but her head is at a slight angle, denoting geniality and ease. Her delicate curls, long elegant neck, sweet face, and lacy ruffled dress all mark her as a genteel subject.[8] Portraying herself as the social equivalent of a patron enabled her to display both her technical virtuosity and her feminine respectability. Because professionalism and middle-class status were so intrinsically linked, a self-portrait as a gentleman would clearly strengthen the male artist's claim to professional status. For women, however, the relationship between gender, class, and professionalism was more complicated. A "lady" might engage in artistic pursuits, but only as an amateur; "ladyhood" connoted leisure rather than work and the incipient cult of true womanhood idealized women as beings who lived above the crass concerns of the market and public life. Thus, assuming the guise of middle-class gentility distanced a working woman artist from claims to professional status. At the same time, however, middle-class respectability was vital for any painter or sculptor—man or woman—who wished to appear professional, that is, as an artist rather than an artisanal "limner." This was a conundrum that would challenge American women artists into the twentieth century.

At first glance, Sarah Miriam Peale's 1818 self-portrait (Figure 1), painted in oil on a 24 foot by 19 foot canvas, seems to evade the gendered cultural tensions surrounding her sister Anna's miniature of the same year. From her choice of medium and composition, one might imagine that Sarah already entertained grander professional ambitions as a figure painter, laying claim to a genre less typically associated with women artists. The flowing dark red drapery around her shoulders, the dark background, and her tousled curly hair suggest a romantic persona rather different from Anna's sentimental, even prim self-depiction. But the image that Sarah produced of herself shares certain characteristics of Anna's miniature. Like Anna, Sarah adopted certain conventions of femininity in her self-portrait. In both paintings, the subject's slight smile, soft look, and tilt of the head suggest an amiable young woman rather than a serious professional.[9] Neither specifically

marks the sitter as an artist or distinguishes the painting as a self-portrait of an artist versus the portrait of a lady patron.

Both Sarah's and Anna's 1818 self-portraits contrast markedly with the iconography of the many contemporary portraits and self-portraits of men artists produced by their brethren in the Peale dynasty. Along with the representation of the artist as a gentleman, two other general conventions emerge in the Peale men's paintings: either they include the trappings of the sitter's trade (palette, brushes, or images of particular works of art that he had produced) or they portray him with a deep gaze suggestive of an intense inner life. Smiles are rare. Another useful comparison may be made between Rembrandt Peale's portrait of his father, Charles Willson (1812), and his double portrait of his daughters Rosalba and Eleanor (1826). In the first, the vertical palette and brushes dominate the bottom half of the canvas, and Charles Willson Peale holds them ready, as if to paint his portraitist in return. In the second, Rosalba Peale's brush droops in her hand; brush and palette are in the bottom left of the canvas, marginal parts of the composi-

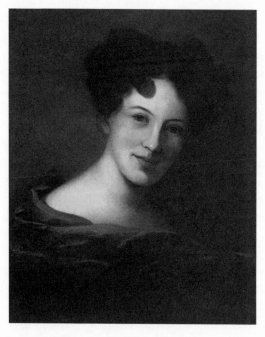

Figure 1. Sarah Miriam Peale, *Self-Portrait* (ca. 1818). Courtesy National Portrait Gallery, Smithsonian Institution.

tion. The pair of women are presented as loving sisters, not painter and sitter, though Rosalba's posture is more erect and it is noteworthy that any reference to her painting was made at all. Considered alongside the work of their male peers, Anna and Sarah Peale's 1818 self-portraits rely more on conventions of portraits of women than on conventions of portraits of professional artists. The two women were certainly aware of these conventions, not only as a result of seeing their peers' paintings but because they themselves used them in other works. For example, Anna's 1823 miniature of Rembrandt Peale portrays her painter cousin with an intense direct gaze and paintbrushes firmly in hand.

This problem of self-representation did not bring women's artistic production to a halt, however. Early nineteenth-century working women artists began to express a new sense of themselves by incorporating both professionalism and womanhood in images of the woman artist. Another pair of the sisters' self-portraits is particularly instructive. Anna's and Sarah's self-portraits of the 1830s, both in oil on canvas, mark a change in their professional identities. They continue to display their femininity and gentility; both wear fine white fabric at the neck, for example, as any genteel woman would in her portrait. Sarah's rich attire was designed to win the admiration of her stylish Baltimore clientele, while Anna allows the dramatic light in her self-portrait to catch the glint of her wedding ring—thus conspicuously identifying her marital status and, by association, her respectability.[10] At the same time, though, each shows less of her neck and shoulders; these are mature women, not young girls aiming to charm and please. Both gaze directly and arrestingly at the viewer. Both exhibit more serious and confident expressions than in the 1818 paintings. Most strikingly, Anna clearly identifies herself as an artist by the painting robe she wears and the frame she holds upright in front of her. Anna and Sarah Peale did not abandon the trappings of femininity, gentility, respectability, or even fashionableness in their quest for a professionalized public image; rather, they adapted the iconography of genteel womanhood in order to accommodate professionalism alongside it. Men, by contrast, often painted themselves simply as gentlemen, with the costume and demeanor of a cultivated man of wealth and distinction.[11] Examples from the National Academy of Design through the nineteenth century suggest that women artists increasingly included brushes and chisels more often than men did in their self-portraits, perhaps to insist upon their professional identities in ways that men did not need to consider.[12]

The 1830s thus marked the advent of a newly visible pattern of professionalism for many American women artists, including Anna and Sarah Peale. In this crucial period, American men succeeded in changing the painter's and sculptor's public image from that of an artisan to that of an artist. The life of sculptor Hiram Powers, for example, enacted a literal transformation from artisan into artist. As a child he was apprenticed to a blacksmith and later worked as a farmer, mechanic, grain merchant, and clock maker before beginning to sculpt. Powers and his contemporary biographers asserted that this background was crucial to his formation as an artist. "The education of young Powers was very limited," but "he could not be content as an artisan; he aspired to something higher," and in the very moment he turned to art his genius was born.[13] As many crafts shifted from workshop production to factory production, workers in the remaining trades—from limning to chiseling—often found it easier to assume the label of "art." Artists founded their own organizations and academies (notably including the Pennsylvania Academy of the Fine Arts) through which they created a new context for the study, practice, display, and sale of art in the United States that differed profoundly from the older system of family workshops and itinerant limners.[14] Painters and sculptors, along with other emerging professionals, played a vital part in creating a new national iconography and in the self-invention of the middle class in Jacksonian America.[15]

The ideal of the genteel professional artist had much in common with general conceptions of the self-made man. "The true artist derives his strength from himself. His genius knows no mutable laws of popular fancy or greedy necessity," wrote George Hillard in 1854 after his grand tour through Italy, during which he observed artists at close range. "There is no surer mark of genius than that calm self-reliance that bides its time, content to work not for a generation but for eternity . . . The only sure source of power for the artist is from within himself."[16]

Self-made men took advantage of the democratization of the Jacksonian era; they had lifted themselves out of the laboring classes to form the foundation of the nation as part of the expanding middle classes. In the model of the self-made man, the newly respectable artist was independent and self-reliant. As Ralph Waldo Emerson, the prophet of self-reliance, explained, the artist must be disinterested in order to serve as a node for the universal mind underlying all art: "a man of no party and no manner, and no age, but one through whom the soul of all men circulates, as the common air

through his lungs."[17] In short, the artist was an ideal—and male—republican citizen. One could even go as far as poet Justin Winsor, who idealistically asserted that:

> The perfect artist is the perfect man,—
> Where each attendant function of the mind,
> in due proportions, and not o'er inclined,
> Acts in a saintly harmony of plan;
> The passions by a sense of right confined,
> Imparting yet an energy to Thought,
> Aided by what experience hath taught;
> The intellect inspires them all, combined
> With garnered knowledge, sharply sought,
> And practise that has trained the eye and hand,
> Working with impulse that produces naught,
> Save what both heart and mind can understand,
> Showing, as such a blending only can,
> The Perfect Artist in the Perfect Man.[18]

The professional artist, as imagined in the early nineteenth century, was thus not only middle-class but specifically and insistently a middle-class *man*. Class and gender ideology worked in tandem to cement men's professionalization in art, thereby continuing to make women artists' professionalization a more complicated, difficult, and ultimately different process. Emerging concepts of middle-class values and behavior were inseparable from new ideals of manhood and womanhood.

Susanna Paine's 1854 memoir, *Roses and Thorns, or Recollections of an Artist*, provides a vivid illustration of the manner in which class and gender ideologies shaped individual women artists' lives, work, and identities. Paine made her living by traveling through New England painting portraits. In many ways, her career typified the itinerant portraitist in the early nineteenth-century United States. Her anxiety over commissions, the constant threat of poverty and corresponding need for mobility in search of work, would have been familiar to contemporary American painters both male and female. Paine's personal ties to the laboring classes remain evident in her use of sailors' slang and printers' jargon throughout her memoir. Like other portraitists, however, she expended effort and resources to establish the respectable middle-class polish that would attract patrons. Another artist advised Paine to steer toward the more genteel (and costlier) boarding houses as she

roamed from city to city.[19] This quickly became part of her strategy for self-promotion, and she expressed disappointment when the tactic did not lead to any commissions in Hartford (though it did work in Boston, Lowell, Portland, and Providence). Both specific training and general cultural knowledge were necessary to a genteel artist. Paine improved her credentials by studying at the Boston Athenaeum. As a result of such efforts, Paine felt accepted by her respectable neighbors: "I was care-worn, and made a shabby appearance among those highly accomplished, elegantly attired ladies and gentlemen, but they attributed that to my artistic habits; said that all artists were privileged to look and act as they pleased, and be admired none the less."[20]

Susanna Paine's most powerful claim to middle-class status was her published narrative, which appropriated the tropes of sentimental fiction in order to tell her own life story. When Paine was a young girl at the turn of the nineteenth century, she recounted in the memoir, her father died and the family's financial situation became precarious. Illness, death, and poverty hounded Paine for many years afterward. Following her religious conversion, her family pressured her to enter a disastrous marriage with a fellow churchgoer. Her husband quickly revealed himself to be "a devoted *gambler*" and tyrant who abused her, burned her Bibles, and after their divorce tricked her out of legal guardianship of their son.[21] Before the father could claim him, however, the child contracted a fever from Paine and died, leaving Paine "*Childless*, and a widow [*sic*], in its most *forlorn sense*." Many elements of this tale would have seemed familiar to Paine's readers: the victimized protagonist is an orphan in reduced financial circumstances who is deserted by an immoral brute, suffers numerous trials and challenges to her womanhood, and yet in the end prevails.[22]

The inventiveness of Paine's memoir lies in the way she prevailed, not through love or remarriage but through her acquisition of a profession. In her "extremity" of grief and destitution, Paine turned to a new field of labor: art. Her lack of formal instruction did not dissuade her. She contracted lodgings and a painting room and advertised herself as "S. Paine—Portrait Painter." Her memoirs recorded the particular moment when her new occupation began:

I was very diligent; toiling incessantly at my easel, until the picture was finished; when I viewed it with great complacency, (artist like) and called Mrs. R., my patron and landlady, to look at it for the first time. She entered with

an anxious, doubting look—but at the first glance she started back, in sur-
prise—then fell into perfect raptures, declaring it was "*most excellent!*" . . .
The next day, the house was "inundated" with callers. They entered my
"sanctum" with eager looks, to see whither [*sic*]—"a *woman could* paint a
likeness?" When lo, they all applauded, beyond my most sanguine hopes—
or expectations.[23]

Commissions followed this surprise approbation, resulting in a winter's
worth of work. Though according to her memoir she remained teetering on
the brink of destitution for some time, by the end of her life Susanna Paine
was proud to be able to provide material comfort for her aged mother and
stepfather. In Paine's narrative, her artistic skills elevate her from the low
position of orphan and childless "widow" to the admiration and social ac-
ceptance of her "betters." Her success as a painter enabled her to rise in class
status and become a respectable (as well as professional) woman.

Women artists, then, became professionals in the mid-nineteenth century
as men did: by identifying themselves as members of the middle class rather
than artisans and tradespeople. However, the process was necessarily differ-
ent for women than for men because middle-class ideology defined ideal
womanhood so distinctly from ideal manhood. Despite the flattery of gen-
teel fellow boarders like Paine's, women artists did not fully share the liberty
of artists "to look and act as they pleased."

Definitions of respectable womanhood complicated the most rudimentary
aspects of Paine's career as an artist. The very lease of a studio, for example,
jeopardized her propriety:

No pecuniary straits had ever yet induced me to take any situation, how-
ever profitable—involving the least impropriety . . . [or] to take [a] step that
prudence and delicacy would not approve. This building, though occupied
by very respectable gentelman [*sic*], had no *lady* occupants—not one . . . I
thought if not *censurable*, it would be very unpleasant and *unfeminine* to oc-
cupy such a situation; and gave up all thoughts of it . . . [24]

But Paine could find nothing else suitable. She leased rooms in that building
for the next three years, each time seeking other, more appropriate quarters
and failing to find them. It would seem that no respectable studio space ex-
isted for women.

The act of renting a studio would appear to be a fairly simple part of an
artist's quest for professionalism. But in violating codes of womanly behav-

ior Paine risked her respectable (middle-class) status—thereby risking her professional status as well, for no artist could distinguish himself or herself from the "mere" artisan without fulfilling middle-class definitions of respectability. The same difficulty persisted into the mid-nineteenth century. Sculptor Anne Whitney wrote that her erstwhile instructor, Dr. William Rimmer, "hoped I would not take a room in the Studio Building but would be independent, saying I should work at present to more advantage in retirement and free from notoriety. Why I should be worse off in the Studio Building than other modest ladies, I did not ask."[25]

Even after she established herself as an artist, Paine's middle-class status remained tenuous. She cited the urge "to do away [with] some *wrong impressions*"[26] of her character and behavior as a principal motive for writing and publishing her memoirs. During the course of her narrative, she clarified the nature of these wrong impressions. Paine's "uncertain marital status" as a divorced woman made her morally suspect and threatened her prosperity as well. "A rumor had risen, and spread in every direction, before coming to my knowledge,—that I had *absconded* from my native place—leaving behind me a *husband, (nearly distracted)* and several young helpless *children!*" She continued, "I had perceived a change of manner in many of my acquaintances—and quite a falling off of professions of regard," not to mention a sharp decline in orders for portraits.[27] Upon the advice of her landlady, Paine published a fictionalized story of her life in response. "Business revived," she reported, "and the affair seemed gradually to be forgotten . . . But with *me*—the wound left a scar, that never healed, during my residence among them."[28] As a woman alone, Paine was vulnerable to accusations of sexual impropriety, and the rumor of domestic scandal was enough to threaten her respectability—and employability. This episode clearly shows the limits of the strategies at Paine's disposal when she needed to defend her character against gossip.

As Susanna Paine's memoir aptly shows, early nineteenth-century ideologies of gender complicated and compromised women artists' struggles to professionalize alongside their male counterparts. At the same time, however, those same ideologies opened an alternative path for women to become artists. If the middle-class man was a self-made, professional, business-oriented individual inhabiting the public sphere, his role and status depended on the existence of a female counterpart: the pure, pious, obedient, domestic individual who maintained a corresponding "private sphere" as a haven from the pecuniary ravages of the Jacksonian market. The domestic

ideal and the invention of the "true woman" were crucial to the formation of the middle class and given cultural force by profound economic changes in industrializing America.[29] In order for women to fulfill their "proper" roles in society, they needed to develop a certain degree of artistic accomplishment that would enable them to build and maintain beautiful, cultivated homes. Along with skills in "domestic arts" such as lacemaking and embroidery, women were expected to possess an educated taste in art and some knowledge of drawing.

Women were increasingly able to take their "feminine" roles as teachers and decorators and use those positions to claim art as part of their proper province. For example, in an 1829 treatise "A Mother" argued that art was a suitable pursuit for children of both sexes, albeit with different ends in mind. "For boys, some knowledge of drawing is useful in many professions and situations besides that of an artist, as soldiers, sailors, and manufacturers. To girls, this charming art is an accomplishment highly desirable, as being quiet, a domestic, and an elegant amusement."[30] Likewise, the fictional and nonfictional artists found in the pages of *Godey's Lady's Book* in this period were predominantly male, with two notable exceptions. In 1845, the magazine published "A Hard Subject to Paint," an engraving of children at play. The editors lauded "the conscious importance of the boy" in the illustration and "the earnest enthusiasm of his sister, who is making her first effort as an artist [to] the evident admiration of the younger girl." They felt that such a scene exhibited the all-important "moral power . . . to induce this sweet spirit of domestic love and social peace and happiness." The depiction of the imperious boy assured the viewer that the usual gender divisions were left intact, despite the girl's drawing.[31] In a later, bolder example, a poem by Mary Arthur titled "The Young Artist" described a girl's compelling and confident vision of herself as an artist.

> I will win a radiant future!
> It shall glow with colors rare,
> And the great and noble of the earth
> Shall pour their tributes there.
> Oh, is it not a glorious gift,
> This living, proud desire,
> That gladdens me with its brilliancy,
> And warms me with its fire.
> No wavering doubt shall hold me

From the point I need to win;
Nor will I heed the world's applause
When satisfied within.[32]

The magazine also regularly published instructions in decorative and domestic arts, such as painting on glass.[33] Widely recognized as the arbiter and definer of womanhood, *Godey's* pronouncement in favor of artistic girlhood presented a powerful image of approval for would-be women artists.

Other writers were more cautious about recommending artistic pursuits to adult women. "Painting in water colors is the kind of painting most convenient for ladies," Mrs. A. H. L. Phelps asserted. "It can be performed with neatness, and without the disagreeable smell which attends oil painting."[34] Catharine Beecher remained skeptical of women who wielded messy art implements, even crayons. "To draw a large landscape, in colored crayons, would be deemed very lady-like," she wrote in her classic *Treatise on Domestic Economy*, "but the writer can testify from sad experience, that no cooking, washing, sweeping, or any other domestic duty, ever left such deplorable traces on hands, face, and dress, as this same lady-like pursuit." However, "In the early years of female life, reading, writing, needlework, drawing, and music, should alternate with domestic duties."[35] As Phelps's and Beecher's concerns attested, the distance between "elegant amusement" and professional situation was shorter than "A Mother" might have imagined for her girl; though artistic skill was commendable in a girl, perhaps they sensed a danger that artwork by an adult woman might transform itself into something ungenteel.

Using the ideology of separate spheres, women could view art as an expression of their "natural" artistic affinities and argue that work in art, even professional work in art, was perfectly compatible with the domestic ideal for women. Ann Hall eloquently makes the analogy between woman's sphere and women's art in her *Self-Portrait with the Ward Family* (1834). Hall painted this work in oil at the summit of her career, the year after she attained full membership in the National Academy of Design, the first woman to be so honored. Like many other women artists, she chose to depict herself at work in her *Self-Portrait*, an artist arrested in the act of painting her clients' likenesses. Unlike other self-portraits, this one expansively included the environment in which the artist worked—the Wards' parlor, a space that Hall clearly identifies as genteel, respectable, domestic, and ultimately middle-class. The family patriarch is completely at ease; this ideal home is his refuge

from the world of public affairs. Meanwhile, the women of his family are busy, but none actually looks at the work in which she is engaged; theirs is effortless, intuitive work, perfectly corresponding to their feminine nature. Hall's own activity is fully integrated into this scene. Her figure is balanced compositionally by other women involved in artistic, feminine tasks, namely embroidery and musicianship. Hall and the young pianist exchange an intimate look, as if asserting their common devotion to the arts. Moreover, these sitters are not patrons but Hall's actual family: her sister Eliza; her brother-in-law, Henry Ward; and their children. In sharp contrast to Susanna Paine's travails over renting studio space, Hall defines her workspace as a living ideal of the middle-class home where each member of the household fulfills the proper gender role.

Ann Hall was not the only individual to associate art with music and needlework as appropriately feminine activities. When women's education first expanded during the early republic, a large proportion of the new female academies offered instruction in the so-called ornamental branches, from embroidery to painting. By the 1830s, "ornamental" arts formed a significant part of the curriculum at schools for girls from New England to South Carolina to towns on the western frontier.[36] In fact, visual art (in the form of drawing and painting) was the only "ornamental branch" that remained part of the preferred curriculum for girls through the remarkable educational reforms effected in the United States between 1790 and 1850.[37] While needlework became less popular and gradually faded from course offerings, art and music continued to attract students through the 1860s. "Painting and music" were the first subjects indicted in the acidly satirical poem "Placing a Daughter at School," which appeared in *Godey's Lady's Book* in 1853.[38] Even the more innovative girls' schools that aimed to replicate the traditional liberal curriculum at boys' academies, such as Emma Willard's Troy Female Seminary and the ladies' preparatory program at Oberlin College, offered drawing and painting. Parents typically paid extra fees to enroll their daughters in these classes.

Art instruction was intended to train girls in a genteel accomplishment, not to prepare them to become professionals. The girls usually learned drawing "from the flat," that is, by copying engravings rather than sketching from life as in European ateliers and newly founded American art academies of the early nineteenth century. Some girls advanced further and learned to grind and mix colors, but overall lessons remained at a basic level.[39] Students at ladies' seminaries acquired far less technical knowledge and experi-

ence than members of an artist family, like Anna or Sarah Peale, might have attained. Separate drawing schools also existed (in Philadelphia, for example) that catered to "lady amateurs" as well as "gentlemen" who needed proficiency in drawing for engineering work or architectural design.[40] Instructors at these schools concerned themselves with feminine propriety rather than professional prestige. For one Georgia girl, lessons in art seemed intimately connected to lessons in feminine deportment:

> I have been a great deal this summer, with Mrs. Huger . . . She has inspired me with some ambition to excel in drawing and painting—lectures me on my want of carefulness, and tells me when my collar is wrong side outwards; so that I have drawn and painted more than usual, have my drawers in order, and now and then dress decently. I go over to her every day and paint on my first attempt in ivory . . . [41]

Despite the intentions of educators, however, the acceptance of amateur art as a desirable feminine pursuit enabled American women artists to separate themselves from the family-trained, itinerant patterns of the past and to reinvent themselves as middle-class professionals—*feminine* professionals whose status as artists did not endanger either their womanhood or their class status. Drawing classes at ladies' seminaries provided a context in which the more professionally minded woman art student could be understood, tolerated, and even encouraged.

In addition, the attainment of one's first drawing lessons as "ornamental" study did not preclude more rigorous training in art later. In the case of painter May Alcott, the usual program of music, French, and drawing eventually led to lessons with renowned Boston sculptor Dr. William Rimmer.[42] Another, more celebrated painter, Elizabeth Gardner Bouguereau, first studied art at the Lasell Female Seminary. Late in life, she described those early art classes to an interviewer as "drawing from outline cards and dabbing water colors or slavishly copying, where copies could be had, Old World models."[43] Yet as poor as this training might seem, it proved enough to secure her a teaching position at the Worcester School of Design and Fine Arts in Massachusetts in 1856. Eight years later, she and Imogene Robinson, her former Lasell art teacher, embarked together for Paris to study art.[44]

The links between women's education and women's professional work in art remained strong, as evidenced by women who combined art with teaching. Susanna Paine "commenced the labors of an artist" as a teacher in Rhode Island "and painting in the recesses of school hours."[45] Several

other professional women artists, including painters Catherine Drinker and Mary Williams, also had teaching careers and, like Bouguereau and Robinson, used their earnings from teaching to finance their art study abroad. Women's ostensibly amateur and merely "ornamental" training increased their opportunities for establishing careers in visual art, as teachers, painters, sculptors, illustrators, and writers on fine-art subjects.[46]

Meanwhile, a growing number of art schools were forming across the United States. Institutions such as the Pennsylvania Academy of the Fine Arts (est. 1805) and the Cincinnati Academy of Drawing and Painting (est. 1812) provided American students with training in the French academic model; New York's National Academy of Design (est. 1825 as the Society for Improvement of Drawing) was modeled after Britain's Royal Academy. American schools carefully kept pace with European innovations; for example, the Pennsylvania Academy of the Fine Arts instituted the study of painting (as an addendum to life, antique, and anatomy studies) in 1869, just six years after the École des Beaux Arts adopted its first painting course.[47] The movement towards art education included less formal organizations as well, such as "art unions," which collected art works, and "art clubs" in urban centers, which gathered amateurs and professionals together for sessions in which they sketched or painted from casts, copies, or sometimes models. Art clubs in smaller cities, such as the Association for Mutual Improvement in Cincinnati and the Rhode Island Art Association in Providence, helped foster nascent communities of local artists. Art schools, art unions, and art clubs also sought to educate the American public about the visual arts. They held regular art exhibitions, exposing Americans to an ever widening variety of loaned and locally produced art, as well as dramatically increasing the space available for American artists to show and sell their work and compete for prizes.

Stereotypes of the dabbling lady amateur and the genteel true woman helped to explain why women might want (and benefit from) instruction in fine art, even at more professionally oriented institutions. The comparatively late beginning of widespread art education in the United States proved an advantage for women by providing a more level field of endeavor than existed in Europe. In addition, because they were private institutions—not state-affiliated ones like the École des Beaux Arts in France and England's Royal Academy—American art schools simply could not afford to bar women students from attending classes.[48] The venerable Pennsylvania Academy of the Fine Arts began to admit women students in 1844; this sig-

naled the beginning of women artists' access to indispensable professional credentials.[49]

Moreover, without the inclusion of women (including mothers and future mothers) the art schools' lofty goals of educating the general American public would have been doomed. As painter Asher B. Durand stated upon the admittance of women to the National Academy of Design in 1846, "if the potent influence of mothers has developed and directed the impulse of the statesman and the Hero, what may not result from its exercise in our more genial cause?" Artistically trained mothers would "doubtless eventuate in no small advantage to the cause of Art."[50] Some of the less prestigious art schools—for example, the Corcoran School of Art in Washington, D.C.—had a student population that was almost entirely female. The ideology of republican motherhood thus indirectly led art schools in the United States to welcome women in greater numbers than did contemporary European institutions.

Most powerfully in terms of a specifically feminine professionalism, the first separate women's art school was founded in 1844. The Philadelphia School of Design for Women fittingly began in a room in its founder's home, "a charming abode of good taste and refinement," according to a later account.[51] Sarah Worthington King Peter, a social leader and wife of the British consul, hired a teacher to provide instruction in drawing. Her goal was not to tutor girls in "accomplishments" and "ornaments" but to train professionals who could maintain their status as respectable women but gain enough skills to earn their living independently of men and the vagaries of the market.

Peter spoke and wrote passionately about the poverty and deprivation suffered by "deserving women" that inspired her to do something to foster the possibility of a "more independent life" for women through the school of design. Her sex was "confined to the narrowest range of employment," she complained. "We have a constantly increasing number of young women who are chiefly or entirely dependent upon their own resources, possessing respectable acquirements, good abilities, sometimes even fine talents, yet who are shut out from every means of exercising them profitably for themselves or others. To such as these the establishment of a school of design opens at once the prospect of a comfortable livelihood, with the assurance of a useful and not ignoble career."[52] The school won the early approval of woman's rights activist Frederika Bremer, who visited it during her travels in the United States. "Here genius and the impulse for cultivation in young

women may receive nourishment and development, and patient industry and the power of labor have occupation and pecuniary profit in the most agreeable way," she applauded.[53]

As passionately as Sarah Peter believed in a "more independent life" for "deserving women," less radical ideals of womanhood and domesticity determined the particular shape of her charitable endeavor. Peter wrote that she chose to concentrate her efforts on design, "not only because it presents a wide field, as yet unoccupied by our countrymen, but also because these arts can be practised *at home*, without materially interfering with the routine of domestic duty, which is the peculiar province of women."[54] The board of managers of the Franklin Institute agreed enthusiastically: "Now one of the distinguishing peculiarities of the female sex . . . is the very general possession by them of a more refined and correct taste, and a power of delicate discrimination, especially in regard to the effects of form and color . . . few, except women, are able to analyze and produce it at will." The establishment of a school of design would equip women for "a heretofore unoccupied branch of industry, for which, by their very natures, they are peculiarly fitted" and which "could be exercised at their own homes, or at least without crowding them together in workshops, and especially without forcing them into contact with the opposite sex."[55]

Thus professional work in art—as in Ann Hall's *Self-Portrait with the Ward Family*—could be contained within the home and enclosed within the parameters of women's proper roles. Notably, the School of Design referred to its students as "ladies" and "young ladies" in the minutes, despite the fact that its official name identified them as "women."[56] It is also significant that the school trained its pupils in the design of objects that also belonged in the home: textiles, wallpaper, wood engravings, and lithographs. Just as the establishment of the Philadelphia School of Design fulfilled Peter's own duties as a social leader and moral guardian, the course of instruction promised to enable her "ladies" to remain respectable and womanly. Women could gain employment in art without disrupting the equilibrium between class status and gender role upon which their professional status and "true womanhood" rested.

The Philadelphia School of Design for Women provided an important model for the ethos of feminine professionalism that would shape women artists' institutions throughout the nineteenth century. Peter herself later helped establish a women's art school in Cincinnati and in 1854 the Cooper Institute of Design for Women was founded in New York. In 1866, the La-

dies' Art Association became the first of many clubs to gather women artists together in a separate professional network of their own. In addition, the model of separatist art education would help women to carve out a place at nominally coeducational art schools. This proved crucial when artists and educators came to deal with the controversial subject of study from the nude. Women students gained the right to attend segregated "Ladies' Life Classes" long before art academies granted them access to sketch or model the nude in coeducational spaces.

Even before such institutional privileges were won, though, the language and tactics of feminine professionalism began to help more and more women artists establish successful careers. In the 1830s, the young Lilly Martin (later Mrs. Benjamin Rush Spencer) began to produce art "at home" as would any "deserving woman" or "lady." In fact, Spencer turned the house itself into her studio, decorating the walls with full-length charcoal drawings of family members, friends, and fanciful ladies and gentlemen of fashion. The house eventually became a local tourist attraction, and the fame of the murals paved the way for Spencer's career as a genre artist. The narratives surrounding the murals' creation measured Spencer in terms of ideal domesticity at least as much as they discussed her as an artist. The catalogue of her first exhibition, held in 1841 in the rectory of St. Luke's Church, Marietta, Ohio, explained how, "in the fall of '38, she began, in her leisure moments, to draw on a larger scale . . . the rough plaister of her sleeping room constituted her *canvass* and *easel*."[57] Created in "her leisure moments" (not during time that should have been spent on domestic duties), the murals represent the conversion of the physical house ("rough plaister") into the material of art ("*canvass* and *easel*").

By 1850, reform-minded Ohio author Frances Dana Gage was writing a much more elaborate story of the murals, one that pointedly represented Spencer as a woman artist. According to Gage, Spencer's mother would not allow her to wear a dress with a tight-fitting bodice because Spencer was too sexually mature ("too en bon point") for the style; Spencer then retired to the parlor, where she painted a self-portrait on the wall. "The likeness was so strong that the mother's reproof turned to praise as it fell from her lips." Spencer's art, it would seem, justified her womanhood, even her sexuality. Gage recounted a similar but far more detailed narrative about the artist's delinquency in making bread: "Mrs. Martin sought for the loitering bread maker; and when she found her, she was astonished to know she had a duplicate of help. The flour, the yeast, the warm water, were untouched, but

on the wall behind the table glared out an exquisite picture of the whole . . . [these images] and the mixer herself, were left on the wall so life-like, that for years the room was sought as a wonder . . ."[58] In both of these incidents, the young artist's talent overcame her mother's anger—and conventional expectations. Moreover, in the more widely circulated bread-making story, Spencer's artistic labor actually *substituted* for domestic labor. Rather than a simple violation of domestic ideology, her transgressive drawing wins maternal approbation. Her *decoration* of the home fulfilled a cultural function that was more important and useful—even within the cult of domesticity—than the merely physical labor of bread-making.

The spontaneous, as well as domestic, nature of Spencer's murals marked her as a feminine prodigy, perhaps even genius. In fact, during an era that witnessed the rapid expansion of American art education for both men and women, it was Lilly Martin Spencer's *lack* of formal training that became a vital part of her public persona and actually contributed to her popularity as an artist. "The occupation of LILLY has been, exclusively and emphatically, that of a *farm-girl*," insisted the 1841 catalogue.[59] Lauded in an article on "The Arts in the West" and an encouraging editorial by prominent Ohio journalist E. D. Mansfield, Spencer left Marietta for Cincinnati.[60] Her father accompanied her in order to provide initial financial support, and probably chaperonage as well, but left before his daughter married Benjamin Spencer around 1844. Lilly Martin Spencer was not searching for art lessons, however, but for paid work, and consequently devoted herself to commissioned portraits.[61] As she slowly made her reputation in art circles, the "naturalness" of her skill stirred special interest in her paintings.

Benjamin M. McConkey expressed a typical response to Spencer in his 1847 letter to fellow painter Asher B. Durand: "The history of this woman and her attainments in art are inexplicable to me. Without instruction or example, in the midst of squalor and poverty, obstructions of many kinds, herself seeming to you at first sight like an ignorant savage, she has here produced a work which if it did not add to certainly would not diminish the reputation of any artist of our land."[62] Of course, as a woman Spencer faced a paucity of opportunities for "instruction and example" that were available to McConkey and Durand in 1847. Spencer and her publicizers attempted to use her lack of formal training to augment her reputation as an artist. She could lay claim to being a truly American, Western, and even "savage" artist—the native genius Americans always seemed to be seeking. As art education became increasingly available to American men—and thus expected of

them—perhaps only a woman could fill this role of "homegrown artist." A woman could be excused from leaving the hearth to seek art lessons; moreover, a woman's genius in overcoming a lack of training could be more easily attributed to her Americanness than to innate personal genius, which was not commonly believed to exist in women.

Given Spencer's initial success at marketing herself as an autodidactic wonder, her reaction to the very concept of art study becomes less surprising. Cincinnati philanthropist and art patron Nicholas Longworth proposed to finance study in Europe for Spencer and, failing that, study in New England with John Trumbull and Washington Allston. But Spencer, it seems, wanted no painting master.[63] She refused Longworth's offers of patronage and continued to represent herself as a self-taught, popular, and eminently domestic artist. The option Spencer chose was also one of independence and immediate income for her artwork. Spencer's labor in the studio, assisted by her husband, differed in almost every sense from what her life and status would have been as a female art student abroad asking her wealthy patron for spending money. She moved East, to New York, in 1849, when she pragmatically sought an established art community that would make art sales easier. However, she undertook this uprooting under her own auspices and her own responsibility.

As Spencer's experience shows, the relationship between prestigious art education and professional success was not a completely straightforward one, especially for women artists in the early nineteenth century. However, in the period after 1840, it became increasingly unwise for any artist to forgo formal training. In the wake of the success of the Philadelphia School of Design for Women, opportunities increased for women to study art in a more formal, consciously professional manner. In the postbellum period, new institutions for art education, such as New York's Art Students League (est. 1875) and the Art Institute of Chicago (est. 1879), admitted women students from their inception. Even in Spencer's case, the glow of native Western genius could not provide a bright professional career in the long term. She earned her livelihood through quantity rather than quality; that is, she sold her paintings for chromolithographic reproduction only to find that such wide duplication cheapened demand for the originals and forced her to produce oils at an even more rapid rate or else suffer a decline in income. "Private orders, or purchasers, are not to be had for fancy pieces, when once publishers have got what they want," Spencer quickly discovered.[64] Her decision to focus on popular art (in both senses: of fame and of wide availabil-

ity among "common" people) led to a difficult and sometimes precarious livelihood. Despite the length and celebrity of her career, Spencer may have been left with a desire for greater—or simply different—achievement: "my fame does me a great deal of good, but . . . fame is as holow [sic] and brilliant as a soap bubble, it is all colors outside, and nothing worth kicking at inside," she wrote.[65]

The strategy of feminine professionalism did not immediately win equal status for women painters and sculptors in the nascent art-historical scholarship of the early nineteenth century. William Dunlap included just three women artists—Ann Hall, Anne Leslie, and Jane Stuart—in his landmark three-volume *History of the Rise and Progress of the Arts of Design* (1834), and among them only Ann Hall garnered his admiration. He described Anne Leslie as a mere copyist and painter of "portraits of her friends" while chiding Jane Stuart as an imitator of Gilbert Stuart's work who suffered for lack of instruction from her eccentric father. Hall, by contrast, produced work "of the first order." Dunlap was quick to attribute her talent to the nurturance by a network of men (her father, brother, painting instructors, and old masters). Despite her patriarchal training, though, Hall's sex influenced her work. She produced portraits of children not only "composed with the taste and skill of a master" but also exhibiting "the delicacy which the female character can infuse into works of beauty beyond the reach of man—except it might be such a man as Malbone, who delighted in female society, and caught its purity." Elsewhere, Dunlap identified James Sharples and his two sons as artists, without mentioning that James's wife and daughter, Ellen and Rolinda, were also painters; he wrote about a few men of the Peale family but not about their female relatives who were also artists. Dunlap referred to Stuart, Leslie, and Hall as "ladies."[66] The qualities that made them "ladies" apparently were not enough to class them with their brother artists. Along with training and independence, a spark of "genius" was wanted. At the same time, a rejection of gentility would have marked these women as working class, that is, as artisans rather than artists, and thus of still lesser status than their male counterparts.

One nineteenth-century writer did champion woman artists. Among her contemporaries, historian Elizabeth Ellet set forth the argument for the affinity between true womanhood and art most insistently, eloquently, and radically. Throughout examples provided in her *Women Artists in All Ages and Countries* (1859) Ellet explicitly united her subjects by using the category of womanhood—certainly a surprising choice when narrating the history of a

profession. While Ellet relied on the research of other "authorities" for her basic facts, her biographical compendium was the first to treat women in the visual arts as a discrete group. Moreover, she included her contemporaries in the final chapters.[67]

Though not expressly political, *Women Artists in All Ages and Countries* belonged to the same cultural climate as Margaret Fuller's *Woman in the Nineteenth Century* (1845), the speeches of such activists as Susan B. Anthony and Lucretia Mott, and the publication of the first woman's rights periodicals, such as *The Lily*. In all her work, from that on women artists to the notable *Women of the American Revolution* (1848–50) and *Pioneer Women of the West* (1852), Ellet insistently revealed women's presence and active participation within an arena usually regarded as masculine. Women played a direct and vital role in history, Ellet implicitly argued in these works; public events—whether war, settlement, or painting and sculpting—represented an opportunity for women to make a special, markedly feminine contribution, a contribution that merited recording. With the expansion of education for American women in the early republic, women authors such as Ellet emerged to tell this "domestic history"; an increasing female literacy rate ensured an eager readership, and a burgeoning woman's rights movement enabled those readers to recognize Ellet's basic premise. Elizabeth Barrett Browning's highly popular poem "Aurora Leigh" (1857) further prepared the seedbed of American culture for reception of Ellet's work. Women artists themselves read "Aurora Leigh" and identified with its creative, intelligent artist protagonist.[68]

By pulling biographies of women artists out of Vasari's, Descamps', and other traditional histories of art, Ellet subverted the conventional male artist narrative. She appropriated many conventions from Vasari's history, such as the trope of the childhood prodigy, which had become the fundamental proof of the true artist, according to nineteenth-century scholarship.[69] Ellet's narratives of the lives of women artists evoked familiar elements that would clearly identify those women as something more than ladies with artistic tastes and ornamental accomplishments.

But placed in a historical narrative of her own, Ellet's woman artist was no longer an exception to the male norm, as she was in Vasari's narrative. Ellet used another familiar framework along with Vasari's tropes: the domestic ideal, which she implicitly argued did not disqualify women from art careers. Ellet skirted essentialist explanations for women's tendency to paint portraits, flowers, and animals rather than grand historical or allegorical

scenes. "Such occupations might be pursued in the strict seclusion of home, to which *custom and public sentiment consigned* [my emphasis] the fair student. Nor were they inharmonious with the ties of love and friendship to which her tender nature clung."[70] This was the language of feminine professionalism: using conventional definitions of womanhood to legitimate work that would otherwise appear deviant, improper, and even "unsexing."

Ellet expected that the revelation of women's lives and work in art would both inspire more women to take up such careers and convince others to recognize their talent. Her self-declared aim in this history of women artists was "simply to show what woman has done" and to give the reader an idea of each woman artist's "character." Ellet wrote of her hopes that the information would "inspire with courage and resolution any woman who aspires to overcome difficulties in the achievement of honorable independence, or . . . lead to a higher general respect for the powers of women and their destined position in the realm of Art."[71] Presuming that other artists, like painter Mary Weston, "loved to read books relating to artists better than any thing else,"[72] a book such as Ellet's could potentially influence the way in which professional women artists viewed themselves.

However, Ellet's second goal—the increase of "general respect for the powers of women"—complicated her project. If women's "honorable independence" were to garner "general respect," the narratives of model women artists would need to conform to certain cultural expectations, in particular to certain gender ideologies. Indeed, for a woman's independence to be honorable in the first place, it would have to harmonize with the attributes of a so-called True Woman. Yet deviance from the male narrative of artistic progress, in the tradition of Vasari, risked her subjects' credibility as true artists. Ellet's intellectual challenge, then, was to frame women artists' quest for "honorable independence" in terms that did not call their womanhood into question at the same time that she asserted their rank as artists.

As Ellet realized, ideas about domesticity posed the main potential, and sometimes actual, threat to women artists' "honorable independence" and professional identity in the mid-nineteenth century. The cult of domesticity embraced a set of naturalized ideals and cultural dictates that came to the forefront of American culture in the 1840s, 1850s, and 1860s.[73] It was intimately connected to the concept of separate spheres as well as the mid-nineteenth-century sacralization of motherhood and the home. It expressly confined women's appropriate "sphere" to the home, imbuing their place there

with an almost mystical significance.[74] How, given this ideal, could one legitimate a woman who earned her own income, created things that "claimed the public eye," and, most importantly, left home and hearth to study and/or produce art?

Ellet repeatedly emphasized the compatibility of women's artwork and family life in her exemplary biographies. Anna, Sarah, and Margaretta Peale developed their feminine artistic talent within the context of a family. Though Anna Peale "in time became able to command an independence," Ellet explained Peale's motives as unselfish: "her father had a large family to support by his profession of portrait and miniature painting, and his daughter looked forward with pleasure to the thought of being a help instead of a burden to him." In Ellet's version of her life story, Anna Peale also exhibited appropriate submissiveness, specializing in ivory miniatures because her father, James Peale, thought it "the most suitable employment for a lady"; and she learned how to go about it "by standing behind his chair, hours and hours at a time, and watching his progress." Anna Peale gave up her career during her married years, "though her love for art [could] never be lost." Both of her roles, as artist and as wife, seemed perfectly natural and feminine, as she proudly remembered "the days when she toiled to woo the Muse of Painting."[75]

In the case of women who continued their art career after marriage, Ellet carefully pointed out, their children and husband suffered no neglect. Rather, family members often served as models for the woman artist, thus fitting her work snugly within the family circle. Louisa Lander's first sculpture was "a bas-relief portrait of her father" and her second "a bust of her brother." Mary Weston taught herself to draw by sketching her younger sister every day. Mrs. Wilson, a "devoted mother," reportedly used her husband and son as her first subjects. Mrs. Cornelius Dubois also produced "with but little labor, a bust of her husband," and an "eminently successful" one at that, despite its being her very first attempt at modeling. It was followed by sculptures of her children and later still of a Madonna—completing a veritable pantheon of domesticity.[76] In many cases, a woman's work in art supported her family.

Ellet asserted that art was a normal interest for girls and that families should encourage it in their daughters. Painter Ann Hall's father and brother both encouraged her early interest in art. So did the mother of landscapist Mary Swinton Legaré, "being herself accomplished in no ordinary degree in both these lady-like pursuits" that interested her daughter, namely music

and painting.[77] Sculptor Louisa Lander's mother and grandmother were artistic too. Julia du Pré Bonnetheau's mother not only supported her daughter's interest in painting but saw to her education and later opened a school for young ladies with her. In Ellet's presentation, all of these girlhoods represented appropriate, feminine upbringings.

Even those women who had experienced a less conventional childhood of boyish independence and freedom did so only with the approval of their parents, and often out of necessity. Two particularly successful artists, sculptor Harriet Hosmer and painter Lilly Martin Spencer, enjoyed unfettered childhoods as a countermand to delicate health. The Martins moved from New York to Ohio on behalf of their daughter, and there she "was enchanted with the change from a city life, and with the liberty she enjoyed of roaming at will through woods and fields, for, her health being the paramount object, no restraint was placed on the child . . . Thus constantly, like Rosa Bonheur, in the open air, she rapidly regained strength and health."[78]

Art itself was, after all, a "lady-like pursuit," evidence of a woman's cultivation and gracefulness. Ellet quoted an admirer of Mrs. Cornelius Dubois, who wrote, "While all who know her admire the artist for her talents, her unceasing energy, and philanthropic exertions, they behold in her the good wife, mother, and friend, and the elegant and accomplished woman, presiding over the social circle."[79] The same might be said of any of the women Ellet catalogued. By Ellet's definition, the woman artist was the consummate woman as well as a professional whose inborn talent would have won Vasari's approval.

Ellet thus managed to make a nearly flawless case for the femininity, domesticity, and "honorable independence" of women artists. Her argument faltered only when she attempted to explain the woman artist's physical departure from home. It was not simply her family's economic need but her desire to "work out *her own ideas*" which propelled painter Mary Weston out of domestic space.[80] Another painter, Mary Swinton Legaré, struggled over the need to leave home. She was supposedly "retarded by the want of models or scenes in nature that might take her fancy," since the beauty of South Carolina was "not of the kind available for the artist," Ellet explained; it lacked mountains and a variegated landscape.[81] Given these conditions, "how was she to produce an original picture? How to do justice in any way to the powers of which she felt conscious? It was not so easy for a lady to travel."[82] Legaré's patience was rewarded, for she traveled with her mother

to the Hudson Valley and then the Blue Ridge Mountains. In the summer of 1833, Legaré finally found the artistic landscape she needed in North Carolina. Ellet quoted "an artist" (i.e., an expert) who dismissed Legaré's lack of European training as unimportant: "if she go to Italy, or study the old landscape painters, she may give a finer finish, but it will be artificial."[83] Legaré's feminine professionalism appeared to survive the test intact: she could be an artist and a lady by painting the proper American landscape.

Legaré's particular career remained a problematic one for Ellet to recount, however. Legaré moved to Iowa in 1849, soon married a Mr. Bullen, and "found, in the new cares that surrounded her, and the habits of life so different from those to which she had been accustomed, such a pressure of occupation that her beloved art was for a time abandoned."[84] Despite Ellet's assurance to her readers that this state would be only "for a time," she ended the biography on an ominous note. Legaré's entry into actual, as opposed to metaphorical, domesticity interrupted her work as an artist and risked ending it entirely. The demands of domesticity overrode the possibilities for Legaré's continued artistic production.

The success of feminine professionalism may be measured by the enthusiasm of social commentators and art writers who began to recommend art training for women in the mid-nineteenth century. As late as 1843, the *Charleston Courier* painted a satirical portrait of women artists: "a manoeuvering and *art-ful* race, and some bolder than the rest have gone so far as to insinuate that they used the article of—*paint* to improve upon the defective colorings of Nature!"[85] But by the 1850s, eminent American art periodicals such as *The Crayon* accepted women artists without serious objections. Like Sarah Peter, they considered painting and sculpture appropriate for women precisely because they appeared less "public" than other "artistic" pursuits; a visual artist could remain within the domestic sphere in ways that an actor or musician could not. The editors of *The Crayon* reasoned that in the case of the woman who was a "Painter, Engraver, or Sculptor,"

> it is her works alone that claim the public eye. Her person is sacred; no one dares to lift the veil that conceals her countenance; no one presumes to call upon her to courtsey to feeble applause . . . the female painter or engraver may follow her profession in the shadow of retirement, overlooked, never publicly advertised, and never summoned to appear before the curious and heartless world; in the occupation which art affords her, she finds ample re-

sources for maintaining the honor of life, whatever may be her grade in so-
ciety . . . Is it not too much to ask of the modesty of woman not only a public
exhibition of her talents, but also to demand her presence?[86]

According to this formula, women's work as artists did not necessarily vio-
late the tenets of true womanhood. Because art could be created within do-
mestic spaces, a woman artist remained womanly despite her profession,
still "veiled" and "shadowed," with her modesty intact and her identity con-
cealed.[87] Rather than endangering her womanhood, earnings from artwork
might even enable a woman to preserve her honor and respectability.

Thus, like Elizabeth Ellet, *The Crayon* began to emphasize women artists as
domestic beings. For example, the magazine described colonial sculptor Pa-
tience Wright as "a lady of uncommon talent" who "must have made her
earliest attempts before she had seen any works of Art, in modelling or oth-
erwise. From childhood the dough intended for the oven, or the clay found
near the house, assumed in her hands somewhat of the semblance of a man;
and soon, the likeness of the individuals she associated with."[88] If Wright's
praiseworthy skills resulted from her untutored experiments with dough or
"clay found *near the house*," one would reason that there must be a special
affinity between womanhood and art.

The Crayon urged the acceptance of women's professional involvement in
particular artistic fields suited to them, such as wood engraving. "There is no
reason why females should not find in the profession of wood-engraving
constant and lucrative employment," the editors insisted to their readers. "It
is adapted to their powers, physical especially, and it is a medium for the dis-
play of much skill and taste."[89] Teaching offered another fertile field for
women's useful and respectable employment. "There are a great many la-
dies in this community whose situations would be vastly improved by mak-
ing themselves good teachers of drawing . . . The profession is very pleasant
and uncommonly remunerative." The "easiness" of art instruction made it
only the more appropriate for women. "It is an art easily attained . . . How
many poor girls are suffering even for the necessaries of life, who might,
with a tenth part of the time they have wasted on the piano, become well
fitted for such a position?"[90]

The association between womanhood and professional art eventually re-
sounded among advisers concerned with women's options for employment.
Virginia Penny, for example, recommended the teaching of art for women,
because such work could be done in the home. Likewise she suggested that

smaller-sized works, especially miniatures and portraits of mothers and children, which could be painted at home, might be the most potentially successful—and profitable—options for professional women artists.[91] Penny's conclusions signaled the level of acceptance that feminine professionalism could garner, both in an ideological and in a pragmatic sense. Women's "domestic" artwork could be both genteel and lucrative. In a way, critics and commentators were too successful in linking art with proper womanhood; over the course of the nineteenth century, art became so identified with femininity that the masculinity of male artists came into question. This was especially true within particular genres: portraiture, still life, wood carving, and other decorative arts.[92] As increasing numbers of women studied and produced art, men rallied to protect their professional institutions from female invasion. Women continued to encounter blatant, sex-based exclusion from important art associations, life classes, and the more informal, bohemian aspects of "art life" through the 1860s. In many ways, the insistent virility of the male artist developed as a defensive reaction to women's gains in establishing themselves as professionals.

American women artists in the early nineteenth century self-consciously began to explore their identity as professionals. Conventions and ideologies of gender prevented them from simply following men's route to professional, and by association middle-class, status. As self-portraits like Anna and Sarah Peale's show, middle-class definitions of gender presented women artists with a cultural problem: How could they represent themselves as professionals without violating the middle-class ideals upon which professionalism was predicated? Diverse texts like Susanna Paine's memoir, Ann Hall's self-portrait, and Lilly Martin Spencer's self-promotion ingeniously looked to those same exclusionary gender ideologies to legitimate women's work in art. Needlework and other domestic arts provided women with a feminine context, a cultural tradition, that helped legitimate their own work in art as a proper expression of womanhood. The inclusion of drawing and painting in antebellum women's education fortified this connection. Women began to create their own institutions, such as the Philadelphia School of Design for Women, with the explicit goal of training women for lifelong employment in art.

By midcentury, a discernible group identity emerged that bound women artists together within a shared women's culture. Elizabeth Ellet's authoritative 1859 study of women artists codified this emerging identity and publi-

cized the strategy of feminine professionalism that women artists had begun to invent for themselves. Women artists' identity connoted a shared gender, class, and implicitly race. "All countries," in Ellet's and many of her contemporaries' usage, meant only Europe and the United States, and even then excluded the arts of Native American and African American women. As the artisanal roots of painting and sculpting faded from memory and the middle-class status of the artist became the norm, this presumption of whiteness served to join artists together as a cohesive community. Racial exclusivity helped render feminine professionalism intelligible and acceptable to mainstream cultural institutions in the United States. In the 1850s and 1860s, women artists would gain a measure of tolerance from critics and writers. As a result, they were able to gain greater access to art training, including study abroad, and to build professional networks of their own. The concept of feminine professionalism would shape women artists' lives, work, and institutions throughout the next generation—not only subverting the icon of the artist as masculine, but also stretching ideals of womanhood to their limits.

Domesticating Professional Art

Through the 1850s and 1860s, domesticity became the most powerful strategy available for women to establish their identities as "feminine" professional artists. After all, women were not merely passive recipients of prescriptions to be domestic; some women were important theorists of domesticity as well. Catharine Beecher, Sarah Josepha Hale, and their counterparts asserted that women could find a measure of social authority through an adherence to "separate spheres." No longer would the patriarch have absolute dominion over his family; now a wife and mother could claim ascendancy over matters that fell in her "natural" province, namely the care of house and children. Although feminine power was nominally limited to women's proper sphere, the boundaries of that sphere proved to be extremely elastic. Both as a cultural ideal and as a metaphor, domesticity expanded well beyond the literal limits of household management and child rearing. Ultimately the greatest value of "home" for the woman artist was as an analogy for a kind of professional work that was concomitant with feminine, domestic spaces.

Like women who argued for the importance of girls' education and who became active in benevolent societies and the temperance movement, women artists used their position of authority in the domestic sphere in order to justify less obviously domestic activities. As they claimed more and more ground for their proper province, women artists would stretch the ideological boundaries and meanings of womanhood. Their group identity as women enabled them to form valuable peer networks with other women artists. They used gendered language and ideology to enter less traditionally feminine fields of endeavor, including landscape and public sculpture. Some, such as genre painter Lilly Martin Spencer, found themselves circumscribed by middle-class definitions of respectable womanhood. But others,

including sculptors Harriet Hosmer and Anne Whitney, used gender ideology to position themselves as professionals who could fulfill the ideal purpose of art: to uplift and morally transform the viewer, a task for which it was thought their "moral" female natures gave them an affinity. Women artists reinterpreted the contexts in which art was produced and viewed in order to claim them that their work in art was acceptably domestic as well as professional.

Ideas about "woman's sphere" and "woman's place" served to keep women and men separate even in cases where they might have shared interests—for instance, in the navigation of the art market. Male painters and sculptors built networks with each other, with patrons, and with writers, their figurative brothers in the arts. These friendships and alliances often became the power base on which a range of art institutions, from museums to art clubs, were built. Male artists studied and traveled together; their "bohemian" studios served the function of salons where they met with fellow artists, critics, and patrons. Women, idealized as domestic producers of art, clearly did not belong in the public, often rambunctious, spaces associated with antebellum masculinity where men made art and did business.[1] Though the Pennsylvania Academy of the Fine Arts began admitting women in 1844 and the National Academy of Design in 1846, gender barriers persisted in various forms. Would-be art students like Sarah Ellen Blackwell learned to ask whether particular teachers "took lady pupils" and were often disappointed at the irregularity with which women's classes began and disbanded. One instructor explained that he found teaching the ladies' class "so pleasant that he devoted more time to it than he ought" and therefore would not offer one at all that year. Presumably, less enjoyable male students were not a distraction from his professional life.[2]

Women were also excluded from most male artists' formal organizations. The Rhode Island Art Association, for example, founded in 1854 for "the improvement of Art" and "the elevation of popular taste," did not formally forbid women, but it had no women members and its constitution used masculine pronouns to describe associates. The Century Association, whose members included Asher Durand and Henry Tuckerman, allowed women only at their semiannual fairs and special dinners, and then "grudgingly," fearing that a feminine presence would spoil the atmosphere of camaraderie.[3] Though women increasingly studied art at the same schools as men, apparently the only women welcome in men's studios and clubs were models.[4] Most men and women artists knew one another, and a few even devel-

oped close friendships and working relationships. It was her future husband, Henry Merritt, who became Anna Lea's mentor, giving her casts, engravings, draperies, and frank criticism that by her own admission contributed immensely to her development as an artist. Sarah Ellen Blackwell engaged in a collaborative effort on a canvas with a male friend. But men did not typically regard women as their real peers in art, and the sexes did not forge a common work culture.

Excluded from these relationships and the advantages they represented, women artists formed their own parallel networks in order to further themselves in the profession. Ironically, the ideology of domesticity and separate spheres worked as rallying points around which women artists, or at least middle-class women artists, could find a common professional identity. Women shared certain challenges in reconciling social and professional expectations, as the Peale women, Susanna Paine, and others had before them. Women hoped that their friendships and alliances could compensate for their exclusion from professional, male-dominated networks and associations. In some cases they were very successful. The most productive and clearly professional group of midcentury women artists was the one that formed around retired actress Charlotte Cushman in Rome. Harriet Hosmer and Emma Stebbins, both successful sculptors, lived with Cushman. Other members of Cushman's salon included sculptors Margaret Foley, Edmonia Lewis, and Anne Whitney as well as writers Kate Field, Constance Fenimore Woolson, and Sara Jane Clarke (who published as Grace Greenwood).[5]

For women artists, peer networks followed the development of women's organizations and a "women's culture" within the American middle class. As the idea of separate spheres shaped Americans' lives in both ideological and practical ways, women often found that they shared more values, experiences, and responsibilities—in short, affinities—with other women than they shared with men. The "bonds of womanhood," as contemporary writers often referred to them, functioned as links between, as well as limits around, women.[6] Such associations among women simultaneously challenged and accepted conventional notions of the family, and of woman's place in it. Just as woman's domestic role as an ostensibly private moral guardian paved the way for her entry into more public moral reform societies in the early nineteenth century, her responsibilities as a preserver and teacher of culture permitted her to enter increasingly professionalized areas within the arts. Though based on woman's position in the home, however, such commercial activities threatened to undermine the dichotomy

between public and private on which separate-spheres ideology rested. Groups of women might veer toward social and political reform, as female antislavery societies did, or toward intellectual pursuits, as did the women who attended Margaret Fuller's "Conversations."

Many women artists' peer networks had their practical origins in burgeoning art classes, both formal and informal. In 1853, for example, Mary Elizabeth Williams reported that "a 'Drawing Club' . . . meets in my room on Monday and Thursday forenoon and is composed of Mr. Conner's scholars who were considerably advanced when he left . . . they arrange their own drawings, and enjoy it very much."[7] Williams drew upon her network of artistic friends when she made long-distance arrangements for companionship to Europe for more advanced study. "Anna Page, one of my old scholars from Danvers whom you may remember still says she will go with me whenever I go. She has relatives now living in Rome. Will you join us?" she asked her other "old scholar" and friend, Mary Ann Bell.[8] Similarly, Elizabeth Gardner's connection with her former art teacher, Imogene Robinson Morrell, led to a professional venture together: the two women ran a School of Design together in Worcester, Massachusetts. They then used their earnings to go to France to study in 1864.[9]

Of course, every personal relationship between women artists did not result in two brilliant careers; each woman had her own dreams, plans, and limitations, and no amount of loving support could force a less committed artist to become a professional. Anne Whitney's circle of friends and acquaintances shows the range of intensity—and efficacy—that can be found in one woman artist's networks. Whitney repeatedly urged her beloved younger friend Adeline Manning to adopt a more serious attitude toward art and commissions. "But Addy does she know that you are a professional worker and charge fifty cents a head?" Whitney asked anxiously when she feared Manning did not conduct herself assertively with a patron. By this point in their relationship, however, Whitney realized that Manning did not want career advice: "I know you thought my remarks in some previous missive just a little impertinent; thought perhaps I had better look after my own gains instead of your's [sic]. Well, well—I will remember."[10] Over time Manning let her career fade in order to devote herself to Whitney as a domestic partner and companion. Fidelia Bridges, however, thrived as a professional under Whitney's encouragement. Whitney's consultations with her regarding the design of a statue must have made the younger woman feel valued and respected as an artist. Bridges decided to leave her position

as a governess and join Whitney in Philadelphia, where they drew at the Pennsylvania Academy during the day and attended William Trost Richards's lectures in the evening.[11]

In subsequent years Whitney and Manning helped each other track Bridges's and their other friends' progress in the art market. "The Artists Fund Exhibition is excellent," Manning wrote from New York in 1865, "and the first thing that attracted me was a lovely crayon head, by Miss Cheney. Fidelia has three pictures there . . . Miss Muncy has a picture there, 'The Eleventh Hour,' that I dont like at all."[12] Whether or not she approved of specific women's work, Manning noted their participation; she recorded no descriptions of paintings by men at the exhibition, and Whitney did not ask for any in her response. Such rapt, even single-minded, support for other women artists was not always freely given, however; sometimes the manifestation of female "love and ritual" required solicitation. Emma Stebbins sent Whitney a pack of favorable notices of Stebbins's recent work, hoping to revive "the interest you used to feel in me" when they knew one another in Rome.[13]

After the Civil War, women artists began to convert informal peer networks into more formal associations, like those that male artists had founded since the 1820s. The Ladies' Art Association, founded in New York in 1867, marked the beginning of a trend that would continue through the turn of the century.[14] Such new institutions, which combined female networks and metaphorical domesticity, eventually established a path along which women could think of themselves as professional artists.

At midcentury, though, the most significant step an artist could take in her professional development was not merely to associate with other American painters and sculptors but to seek training and experience in Europe. Since Lilly Martin Spencer's refusal of Nicholas Longworth's patronage in the 1840s, European study had only become more indispensable to serious American artists. Consequently, more and more women decided that they needed not only to study art but to study it abroad in order to win professional status. They saw that almost every successful male artist traveled to Europe at some point in his career, and that this experience formed the basis of an artist's reputation at home as well as abroad.[15] It is no wonder, then, that in 1855 Mary Elizabeth Williams considered a "sojourn in Italy" to be the "height of my worldly ambition"—a pinnacle that she "truly expect[ed] to" reach.[16] The wide availability of art education for women in the United States made European study an even clearer way for professionally minded

artists to differentiate themselves from lady amateurs who had learned to draw and paint as schoolgirls.

Along with France and Germany, Italy was an especially popular destination for mid-nineteenth-century artists. Most did not take formal classes there, but rather took advantage of free admission to rich galleries and magnificent churches in order to study paintings and sculptures unlike any (in quality or quantity) available in the United States. Copying great works was, after all, considered an indispensable part of art training in this period; art students usually learned to copy well before they attempted to draw from nature. Painters relished "the scenery, the light, the climate, the local color," while sculptors prized the availability—and relatively cheap prices—of Carrara marble, as well as the presence of experienced stonecutters to aid them in their studios. Living costs were low, and models readily available; for those who desired instruction, eminent colleagues of all nationalities abounded. Moreover, the Italian people, from dukes to contadinas, reputedly possessed an understanding and appreciation of fine art, which gave artists a feeling of importance (when they did not find such expertise in the lower classes disconcerting). By the 1840s, vibrant communities of expatriate American artists and writers had established themselves in both Rome and Florence. Americans and Britons on the Grand Tour would often stop at their compatriots' studios and sometimes place orders for art to bring home. It was, all in all, an extremely supportive climate for developing an artistic career.[17]

Despite the many obvious advantages, however, it was not easy for women to confront the idea of uprooting themselves, perhaps for many years, from home and loved ones, in order to pursue art abroad. Socialized as domestic beings who found their deepest fulfillment in their relationships to their families, women were more troubled than men by such separations. "I am thinking how hard it will be to put so many leagues of sea between me & those . . . who try to make me better by their love," wrote Anne Whitney anxiously as she contemplated the thought of study in Europe.[18] "Don't think of going there to *live*," her beloved friend Adeline Manning begged her. "Will you? What does Rome mean?"[19] By the 1860s, as Whitney and Manning both knew, Rome supplied an artist with credentials that were unobtainable elsewhere. If she were going to succeed as a sculptor, a Roman sojourn had become a necessity. The most Whitney could offer was a fatalistic promise: "Addy, if I can help going to Rome I shall—but if I must there is no resisting one's fate."[20] Years later, as Whitney finally began to make con-

crete plans for the trip—significantly, in company with Manning and other friends—her anxiety started to sound more like excitement. "Will our hearts not quake a little as we put the liquid barrier between us & old habitats & we sail into the new epoch?" she asked Manning.[21] Once in Europe, she reassured herself and "My dear Home" (as she addressed her first letters) by maintaining a regular correspondence with her family and noting that she was still well aware of being under her family's gaze.[22]

In addition to the emotional difficulty of undertaking such a journey, the idea of professional training in Europe seemed distinctly undomestic. This was the one professional activity that Elizabeth Ellet had found the most difficult to justify for women artists. Rome's "large, dreary," and solitary studios seemed almost as inappropriate for the woman art student as the "life-schools of Paris [where] a crowd of young men . . . whistle, and smoke, and sing, and argue, sometimes blaspheme."[23] It was the American world of men's studios, salons, and clubs writ large. Harriet Hosmer even wrote an irreverent comic poem about a group of sculptors, plotting against their "sister artists" while puffing on their cheroots at the Caffe Greco in Rome.[24] The camaraderie of male artists was a higher-status version of masculine saloon culture; and, like the saloon, the studio threatened to tarnish the reputation of women who dared to invade its confines.

Many women artists in the mid-nineteenth century also found it strategically difficult to leave home for the sake of art training. Their primary practical concerns were financial: how to afford art study (sometimes in the face of their family's disapproval) and how to support themselves while living apart from their families.[25] For the majority of women artists, who were middle class, a privileged background and material comforts afforded a great advantage. Sculptor Anne Whitney was fortunate that her brother Edward passed part of his inheritance to her, providing her with a regular income.[26] Sculptor Emma Stebbins of New York, graphic artist Francesca Alexander of Boston, and painter Julia du Pré Bonnetheau of Charleston also came from socially elite and moneyed families that supported their careers.[27]

While women painters seem to have had fewer opportunities to attract benefactors from outside the family, a very small number of women sculptors found (and accepted) patrons before they had really established themselves as artists. Edmonia Lewis, for example, tapped into Boston's abolitionist network in order to finance her passage to Rome; both her African American heritage and her favorite themes (portrait busts and medallions of Robert Gould Shaw, who had been recently killed in battle while leading the

African American 54th Massachusetts regiment) appealed to antislavery advocates. Vinnie Ream was only eighteen years old and had never before executed a public sculpture when she won a federal commission to sculpt a memorial to Abraham Lincoln in 1865. Harriet Hosmer won the support of Wayman Crow while she was still a schoolgirl and classmate of Crow's daughter, Cornelia. Notably, she addressed Crow as "father," invoking a personal, familial relationship to explain a professional connection, as contemporary women writers often did.[28]

Lacking family fortunes or powerful patrons, other women artists managed to finance their own training, often through the properly domestic work of caring for and teaching children. Nature painter Fidelia Bridges worked as a nursemaid to a Salem family while she attended drawing lessons in the 1850s.[29] Several teachers saved their salaries for many years in order to finance study in Europe. The ambitious Mary Elizabeth Williams of Salem, Massachusetts, was always looking for a way to increase her earnings. An "increased purse" signified independence; that is, money meant "that we need not be compelled to be tossed at the mercy of everyone."[30] It took six years for her to realize her plan to study in Italy, but the investment paid royally; Williams resided in Europe with her sister for eighteen years, developed a reputation as an art expert, and when she finally returned to the United States, established a successful gallery in her home. Similar examples abound. The widowed Eliza Pratt Greatorex made a gradual transition from amateur to professional artist, teaching drawing at Miss Haines School for Girls in New York before she could sail to Europe to study art herself. Imogene Robinson Morrell of Massachusetts taught at Lasell Seminary before her first trip abroad, to Dusseldorf. In 1864, she and Elizabeth Gardner used their earnings from teaching at the School of Design to study in France. After unsuccessfully attempting to establish her own studio in Boston, Eliza Allen Starr worked as a governess in Natchez, Mississippi, from 1851–1853, and later taught drawing in various cities. It was not until 1875 that she was able to afford study in Rome.[31]

For many other women, teaching art became an end unto itself—a state of affairs that the expanding American art world encouraged, since teaching art seemed a more unquestionably feminine field of labor than making and selling art.[32] Sarah Ellen Blackwell left her family for New York and Philadelphia, where she studied painting (often teaching herself because art classes for ladies were not always available) and waited to see "what course in life it will be wisest for me to pursue," as she wrote in her diary in 1851.

"My life is dedicated to one great purpose, and surely the hand of an infinite father will guide me."[33] Blackwell worked diligently but soon felt frustrated; she "doubt[ed] of the wisdom and usefulness of the aims I was pursuing, yet could see nothing better to do."[34] Her painting instructor "thought it very doubtful if the Antique school will open this winter for ladies . . . he said I was a very fair artist, capable of teaching etc. I made up my mind that minute to go to Boston; walked home, feeling sad at the thought of leaving friends, but confided that it was best."[35] Blackwell later regretted the decision; despite her credentials and skill, she struggled to find employment upon her return home: "I spent two months at home very much dissatisfied because I could get no teaching, and could not progress in drawing."[36] In 1855 she managed to travel to Europe, studying in the Paris School of Design for Women and a London art school, but in 1859 she was again teaching art. Her credentials, however hard-won, did not grant her full recognition—and employment—as an artist. On the other hand, Blackwell's educational attainments helped her to establish herself as an independent professional and eventually to buy her own house.

The female companionship inherent in art study and travel often continued in the form of female households among women artists, both abroad and at home. Sculptor Anne Whitney, for example, sailed to Europe in 1867 in the company of painter Fidelia Bridges and artist Adeline Manning, with whom Whitney lived (both in Italy and in the United States) until Manning's death. Sculptors Harriet Hosmer and Emma Stebbins lived with Charlotte Cushman in Rome. These types of arrangements continued into the twentieth century as a feature of women's lives in various professions. Some female households grew out of sheer convenience and camaraderie; others formalized romantic and sexual relationships.[37] Such living arrangements excited such little commentary at the time that it is very difficult (and probably unnecessary) to distinguish between the platonic and the passionate. Besides the likelihood that women artists simply enjoyed living in these arrangements, the establishment of female households preserved the appearance of propriety despite the unconventionality of women living on their own far from fathers, brothers, or husbands. The definition of family was flexible enough to include relationships quite unlike the nuclear family. Literary scholars have charted the subversive potential of domesticity; while woman was vital to the creation of "home," man was superfluous to it. This is apparent in domestic fiction of the period, where male characters are often invisible and ancillary to the plot. Women artists' households exemplify

how a home without a masculine presence could still be respectable, and appropriately domestic, in the mid-nineteenth century.

These female networks and households fostered a sense of community and shared identity among women artists. By studying, keeping house, and working in groups that were segregated by sex—thus obeying the strictures of separate-spheres ideology—women developed a group identity that eventually challenged some assumptions of that ideology. Women artists' networks could unite in self-defense of their sex against charges that they did not, or could not, be real artists. For example, in the early 1860s rumors circulated that Harriet Hosmer's male stonecutters were the real sculptors of her works. In response, Hosmer published an authoritative explanation of "the process of sculpture" in the *Atlantic Monthly*.[38] "I am always ready to defend my sex," Hosmer declared after the experience. "Whenever I hear such things said about any woman, you may be sure I will always write immediately to something or somebody."[39] Her resolution passed the test in 1871, when Hosmer defended Vinnie Ream against similar accusations that Ream had not really sculpted the statue of Abraham Lincoln for the Capitol as she had been commissioned to do. Hosmer and Ream were able to garner popular support through their association with female networks.

Just as women artists relied on the credo of domesticity in shaping their households, they also ingeniously employed familial metaphors to describe and to justify their commitment to art careers. For example, in *The Crayon* French painter Rosa Bonheur used marital claims to explain her unusual profession (and her unusual success in it): "I wed art. It is my husband—my world—my life-dream—the air I breathe . . . What could I do with any other husband? I am not fit to be a wife in the common acceptation of that term. Men must marry women who have no absorbent, no idol. The subject is painful, give me some other topic."[40] Young American women artists of the period, such as Anna Klumpke, who idolized Bonheur and eventually became her domestic partner, conceived of their choice in similar terms. Such language rested on the sense that dedication to art was a substitute for marriage. As Harriet Hosmer put it, this generation generally believed that, "even if so inclined, an artist has no business to marry. For a man it may be well enough, but for a woman, on whom matrimonial duties and cares weigh more heavily, it is a moral wrong, I think, for she must neglect her profession or her family, becoming neither a good wife nor a good artist. My ambition is to become the latter, so I wage eternal feud with the consolidating knot."[41] The metaphor was so powerful that married artists might think

of their spouses in terms other than that of husband. Painter Anna Lea Merritt remembered her husband, Henry Merritt, as her "master" in her 1879 memoir; Henry Merritt called her "Little Pupil" in return.[42]

In employing domestic metaphors, however, women artists did not always choose the role of wife. Harriet Hosmer, in fact, cultivated the persona of the "child-woman," as Grace Greenwood called her, or "boy-woman"; Nathaniel Hawthorne, Henry James, Lydia Maria Child, Maria Mitchell, and numerous other commentators repeatedly described the boyishness of Hosmer's manner and appearance.[43] Her most recent biographer writes that Hosmer's statue *Puck* could be a sort of self-portrait: "the little figure is more nearly the image of a puckish Hosmer than the tragic marble maidens ever were."[44] It was an effective strategy; Elizabeth Barrett Browning thought that Hosmer "emancipates the eccentric life of a perfectly 'emancipated female' from all shadow of blame by the purity of hers."[45] Hosmer did not just act the part of a child in a general sense, but specifically identified herself as the child of her "father" patron and appealed to him for paternal advice (especially in financial matters).

Extending the family metaphor even further, Hosmer's *Atlantic Monthly* article referred to her detractor as her "brother-sculptor"; not that they shared patron Wayman Crow as their father, but rather evoking the impression of squabbling siblings. Women artists could even play the role of husband within this figurative family. Hosmer announced to Crow: "I have taken onto myself a wife in the form of Miss Stebbins, another *scultrice,* and we are very happy together." The bounds of gender were thus very fluid; Hosmer wrote of herself simultaneously as a husband (taking a wife) and as an insistently feminine "scultrice." Already experienced at managing the tensions between the supposedly "feminine" and "masculine" attributes of an artist, Hosmer apparently saw no contradiction in filling both roles at once; perhaps this is why she considered herself a woman capable of producing "a *manly* work."[46] Similarly, Hosmer and Mary Crow referred to each other as husband and wife, while in a later relationship Hosmer referred to herself as alternately "hubbie" and "wedded wife" of Louisa Lady Ashburton. Hosmer may have meant these terms to describe her emotional (rather than metaphorical) relationships with other women. But she eagerly adopted the role of mother as well; her sculpture *Will o' the Wisp* was "my young son" and one of Crow's "grandchildren." She explained her need for a larger studio because "the members of my family are crying for more space." Hosmer appreciated the difference between her style of motherhood and conventional

maternity, and clearly liked her version better than the "real" thing: "Well I must confess I like marble babies best," she wrote. "Instead of boxing their 'jaws' only, you can hose the whole of 'em and send them out of the way."[47]

While Hosmer provides particularly flamboyant examples, she was far from alone in utilizing the rhetorical convention of referring to the artworks she produced as her offspring. Anne Whitney referred to a pair of her statues as "my girl" *(Lady Godiva)* and "my boy" *(The Lotus Eater)* and wrote worriedly of statues sent to exhibitions as if they were her children growing up and leaving home: "about the exhibition—My baby I am told has gone, or was to go—Did they put her under a perpendicular light so that all the shadows of her figure were distorted? I have no doubt of it." Whitney explicitly compares the production of sculpture to the experience of childbirth, complete with emotion, danger, and a male physician attending: "My little bust as well as the alto relief came near ruin in the casting at which Mr. Mundy presided . . . I think I felt some of the agonies of child-loss when I thought I should never be able to bring the smiling little head to the light again—whereat who gazed settled into a permanent expression of joy and good will—such as it was a pleasure to mother-me to behold."[48] Painter Cecilia Beaux "justified her own career by equating her portrait work to motherhood and particularly to the raising of boys."[49]

Metaphors of the family legitimated the lives and work of women artists in several important ways. References to artworks as "children" (that is, not commodities, but the result of love and marriage with art) helped erase the taint of the market and the public from the woman artist's lifestyle. The familial metaphor also accorded women artists a recognizable and even praiseworthy social role. The analogy between cultural and biological reproduction conferred value on women's artwork at the same time that it folded them into the category of True Woman. The device must have been especially poignant during the era of the Civil War, when the family evoked so much emotion as political metaphor.

American women artists at midcentury largely succeeded in using domestic ideals and images to justify their choice of lifestyle and career to themselves and their public. However, domesticity was not equally accessible to all women who might want to become artists. The True Woman might or might not be artistic, but she was certainly white and middle class. Art, as a profession, had risen in terms of social status; if she worked in the more prestigious genres of art, any woman could consider herself middle class.

Many of their male peers, such as Hiram Powers, had risen from the ranks of the laboring classes in this manner. But an artist's race could not be so easily overwritten. Thus the domestic model's success for women artists was contingent on their homogeneity, particularly on their racial homogeneity. The very few women artists who had no claim to whiteness used other strategies and metaphors to explain themselves as professionals.

Sculptor Edmonia Lewis, perhaps the only example of a nonwhite professional woman artist in the United States in the mid-nineteenth century, capitalized on reform impulses and cultural tropes of the noble savage. She kept many details of her early life obscure, but spoke openly about her parentage, an African American father and Chippewa mother. Supposedly, upon her arrival in Boston from Oberlin College in 1862, Lewis noticed a statue and though "she did not know by what name to call 'the stone image' . . . she felt within her the stir of new powers."[50] Though it is highly unlikely (to say the least) that by this point in her life Lewis had never heard the word "statue," this story may have served as proof of a natural, even divinely ordained, affinity between women and art. Lewis took advantage of racial stereotypes in other ways as well. When she repeatedly approached her patrons to pay bills for freight and marble, they simply assumed that Lewis could not manage her money. "How could it be otherwise, when her childhood was spent with poor negroes, and her youth with wild Indians?" wrote an exasperated but sympathetic Lydia Maria Child.[51] These patrons clearly considered Lewis a worthy recipient of charity rather than a professional artist worthy of commissions; they did not censure her penchant for sculpture, but neither did they commend it. Their very puzzlement over Lewis's impatience to earn money rather than merely study art for a period of years reveals their blindness to Lewis's real socioeconomic situation. When Lewis asked Child for information on Pocahontas, for a possible statue:

> I complied with her request, and told her it would be a good subject for her, because she had been used to seeing young Indian girls, and could work from memory, and with her heart in it, for her mother's sake; but I recommended it as a practice in clay merely, and that only a portion of her time should be given to it. But if marble and freight are obtained by whistling "to raise the wind," she will probably send over a marble Pocahontas, to be presented to the Chief of the Chippeways; the tribe to which her mother belonged. I think she would make a statue of an Indian better than anything

else; but neither her mind nor her hands are yet educated enough to work in marble. She should wait until her models are good enough to be ordered in marble.[52]

Professional art critics frequently commented on the personal ethnic origins of Lewis's artistic themes (emancipation, Native American life), but ignored their challenges to gender roles. In assessments of both her life and her work, Lewis's sex was almost entirely obscured by her race. The great majority of African American, Native American, Latina, and Asian American women would have found no access to high art, either as students or as professional artists or even as important audiences.[53]

Women artists who could do so thus employed domesticity and the family as legitimating metaphors, a sort of language with which they could comprehend and represent themselves as both women and artists. The ideology of domesticity also shaped the particular works of art that these women produced. Ideals and definitions of womanhood determined which genres of art were acceptable for women artists. But gender ideology could be quite malleable in this regard as well. Women claimed their place as professionals within a wide range of artistic genres, from the traditionally feminine, such as still life and flower painting, to the less conventional, that is, genre painting, lithographic landscapes, and neoclassical sculpture. Even when they appeared to be engaged in appropriate fields of art, the particular paintings and sculptures which women created often were not so conventional. While certain genres of art attracted few women, the works of painter Lilly Martin Spencer and lithographer Fanny Bond Palmer show how far domesticity would (or would not) stretch to enable the production and reception of artwork by women. The remarkable success of several women sculptors in the mid-nineteenth century also merits close analysis in this context. Harriet Hosmer, Emma Stebbins, Anne Whitney, and others used the moral imperative of neoclassical sculpture to justify a surprising array of subjects and themes, including images of women who were ambivalently domestic at best. Through their work, these women artists tested the boundaries of domesticity.

At first glance, genre painting would seem to furnish a perfect field of endeavor for professional women artists. It depicted everyday life; both its frequent domestic themes and its production therefore appeared to be seamlessly integrated with the household's daily routines and experiences. It

ranked below history, allegorical, and landscape painting—that is, relatively low in the hierarchy of painting genres; yet it was clearly classified as "fine art" when compared to etching and china painting. Moreover, genre painting achieved its greatest popularity and prominence in the United States during the period between 1830 and the Civil War.[54] One might therefore expect a large number of women to take up such an eminently respectable, approachably middlebrow, and potentially profitable artistic tradition. But in fact, only one American woman, Lilly Martin Spencer, achieved a degree of national success as a genre painter. The less apparent cultural role of genre painting—namely, to identify social types, delineate their relationships, and anchor a social hierarchy—made it potentially dangerous ground for women to explore, since it could evolve into a critique of the domestic realm. Even when a woman produced domestic imagery, it did not always satisfy the cultural expectations of critics and audiences; it was not only the genre in which women worked but the specific iconography they produced that determined the extent to which they could challenge mainstream definitions of femininity.

Spencer began her career as an artist by producing a wide range of subjects, including literary and allegorical sketches. Her earliest exhibited work was largely inspired by poetry; the catalog to her 1841 exhibit in Marietta, Ohio, printed excerpts of verse identified with Spencer's paintings, including one titled "The Artist": "Thy picture, sweet lady! Ah, little she dreameth / That already it grows in the artist's fond breast; / And ever the light of its loveliness beameth, / In those exquisite tintings which cannot depart."[55]

Spencer recognized her own romanticism; it is not clear whether she perceived it as particularly feminine, but she certainly believed in the importance of idealism for art and artists. She also stressed the didactic and moral potential inherent in art, thus making it an appropriate field of endeavor for any woman. "I mean to try to become a Michel Angello if I posibly can," she wrote to her parents from Cincinnati, "and I mean to try to make my painting have a tendency toward Morall improvment at least as far as it is in the power of painting, and oh! a fine painting has a beautiful power over the human pasion's, and oh! mankind need's all that the more powerful mind's can do, in the way of writting of painting—speaking from those who are good and virtuous, to counter the what I call the over whelming effort's of evil . . ."[56]

Spencer's domestic scenes became popular with the American Art-Union, but her work in other genres did not win commissions even though Sully,

Leslie, and other male artists were able to sell literary subjects.[57] A male friend explained Spencer's problems to her in terms of the acceptability of her themes: "The plain truth is that pictures remarkable for Maternal, infantine & feminine, expressions, in which little else is seen but flesh, white drapery, and fruits, constitute your triumphs, according to popular estimations."[58] Such were the images that the public expected a woman painter to produce. For most of her career, Spencer acquiesced to these limits and concentrated on genre painting out of a pragmatic desire for critical and commercial success.

At the same time, however, the domestic content of Spencer's genre paintings—albeit "maternal, infantine, and feminine"—was not necessarily conventional. Her work, whether for art unions, raffles, or private patrons, was more than a lightning rod for popular culture. Spencer explored the boundaries of genre painting by combining it with still life painting (her other specialty) and even self-portraiture. Beyond writing and thinking of her paintings as her "children," as many women artists did, Spencer used her real children, her husband—and, significantly, herself—as models for many of the approximately five hundred paintings she produced. Many contemporary male artists included themselves, their wives or lovers, and their children in their art. But in her canvases, and in her genre painting as a whole, Spencer occupied a rare and often critical place: an artist not only *in* the domestic sphere but *of* it. Her most imaginative work may be *The Artist and Her Family at a Fourth of July Picnic* (ca. 1864), in which the figures of the members of her "family" allude to her other paintings—for example, the baby and the nursemaid from *Dixieland*. This seems an especially appropriate visual joke for a painter whose professional and domestic selves so overlapped.

Even Spencer's sweetest scenes of mothers and children served to promote the sentimental family over patriarchal supremacy.[59] Her domestic settings enabled her to depict both women and children as sexual beings to some extent, through coquettish glances, bared shoulders, and other coy signifiers of sexuality.[60] Spencer's particular vantage point enabled her to bend the framework of domesticity in other ways as well. In *Fi Fo Fum* (1858), Spencer portrays herself as the mother hovering behind the family group, on the periphery of activity; the father (modeled by her husband, Benjamin Spencer), who is actively telling a story, looks rather buffoonish. While the role of observer places this mother in a passive role, it also draws a parallel between her and the ultimate observer of the scene: the artist. This suggests a compatibility, or even equality, between the social roles of mother

and painter, and perhaps between domestic and professional spheres. *Fruit of Temptation* (1857) depicts an observing mother as well. But in this case Spencer's double stands aghast in the doorway, having just come upon a roomful of domestic chaos. Silverware is overturned, a cat laps at milk from a pitcher, and a dog closes his jaws upon a piece of food from a chair. A little girl reaches into the spilled sugarbowl; her older brother sits on the floor eating melon with both hands. Meanwhile, the young aproned servant admires her collar in the mirror, her back turned to her young charges. The painting hardly depicts the idyllic refuge that "home" purported to be.[61]

Spencer's sometimes pointed use of humor was unsettling to critics, and nowhere more so than in her references to relations between the sexes. A popular series of kitchen scenes portrayed female subjects addressing the purportedly male viewer on disturbingly egalitarian terms. When Spencer's first effort in this vein, *The Jolly Washerwoman* (1851), met with success, she produced another, *Shake Hands?* (1854). The subject of *Shake Hands?* (Figure 2) is clearly more genteel than a washerwoman, but like her predecessor she is engaged in household labor, the very type of grubby work that the typical Victorian household struggled to render invisible to visitors and men. Even more defiantly, the merry cook extends a hand full of dough, offering to "shake hands" with the viewer. The supremely egalitarian gesture is both an invitation and a joke: the cook knows that her visitor will never shake hands with her, for her hands are always metaphorically covered with dough, the stuff of domesticity.

Spencer's kitchen paintings were popular. *Shake Hands?* appeared in several exhibits and two lithographs, the second distributed to subscribers by the Cosmopolitan Art Association in 1857. But Spencer reached the limit of this satire of gender conventions in the companion piece to *Young Wife: First Stew* (1854). *The Young Husband: First Marketing* (1854), again modeled by Spencer's husband, even more clearly than *Fi Fo Fum* pokes fun at the male head of household. A critic's review of the painting reveals the central source of his anxiety: not really Spencer's technical flaws, but the lack of propriety and womanliness in the particular types of images she produced. Moreover, the critic's grievances against this particular painting reminded him of similar ideological problems with the rest of Spencer's irreverent work, including *Shake Hands?*

> Mrs. Spencer has a truly remarkable ability to paint, but unfortunately ruins all her pictures by some vulgarism of hopeless attempt at expression. She paints still life with unsurpassed delicacy and force, with exquisite color

both in tint and quality, and above all, works with entire freedom from artistic conventionalism . . . [but] the subjects she chooses are frivolous and whimsical, things to be laughed at for a moment, and then passed by, even if ever so successful . . . Is there in her woman's soul no serene gay thought, no quiet happiness, no tearful aspiration, to the expression of which she may give her pencil? Being a woman, she should have some deeper, tenderer conceptions of humanity than her brother artists, something, at all events, better worth her painting, and our seeing, than grinning house-

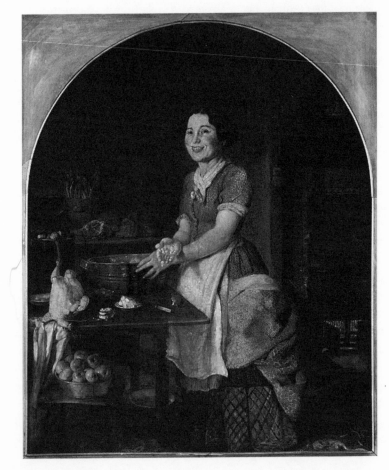

Figure 2. Lilly Martin Spencer, *Shake Hands?* (1854). Courtesy Ohio Historical Society, Columbus.

maids or perplexed young wives. We should hope for much from her, if she could see that it was her duty to be serious sometimes.[62]

Spencer's adoption of genre painting and domestic subjects thus enabled her to produce successful works of art, but only up to a point. Her iconography was still subject to criticism because of its alleged lack of femininity and respectability, even though no one expressly objected on principle to a woman's painting genre scenes. Because Spencer was a woman, her paintings should exhibit sincerity, seriousness, and tenderness; frivolity, whimsy, or any "attempt at expression" were vulgar and unfeminine, tainting even the best choice of subject. The boundaries of domesticity could be stretched too far. If a woman artist—and the subjects she chose—did not remain within the limits of the middle class, she risked being labeled as vulgar and unwomanly herself.

Unlike the more checkered reputation of genre painting, with its "grinning housemaids" and "perplexed young wives," landscape painting and neoclassical sculpture were seen as the pinnacles of antebellum American art. Both avowed the transcendent power of beauty to transform (rather than merely inspire) the onlooker in a spiritual sense; in this equation, beauty and goodness were irrevocably connected. Linked to the literature of American Romanticism, landscape oils and neoclassical marbles helped form the core of a native intellectual movement.[63] Of the two genres, however, landscape was more manifestly "American" in the view of most contemporary art connoisseurs. Neoclassicism had to struggle against the legacies and conventions of European art, while the depiction of *American* wilderness marked landscape painting as a truly indigenous project of national importance. In the wake of Washington Allston's romantic scenes and Thomas Cole's "sublime landscapes" of soaring mountain cliffs and turbulent skies, painters such as Fitz Hugh Lane, George Inness, John F. Kensett, and Martin Johnson Heade moved from the grandeur of Hudson River scenes to serene, linear, and tonally subtle luminist canvases.[64] Yet despite these stylistic and conceptual changes, landscape painting remained American history painting.[65] Its political implications were veiled; the capture of wilderness onto canvas was instead regarded as a spiritual performance, what William Cullen Bryant called an "act of religion."[66]

Most women artists seem to have been excluded from this spiritual affirmation of American identity and history portrayed through the American

landscape. Two exceptions were Mary Swinton Legaré Bullen and the self-taught marine and landscape painter Ann Sophia Towne Darrah.[67] Sarah Cole (fl. 1846–1852) was another early woman landscape artist. She sometimes accompanied her brother Thomas on sketching trips; however, she is principally remembered for singing ballads or reading books to him while he painted.[68] Other artists, as well as art critics and connoisseurs, took little notice of these women. Accomplishment in genres such as still life and flower painting, which seemed appropriate subject matter for ladies, were more likely to win praise; but such praise did not necessarily lead to lasting recognition. For example, Evalina Mount, niece of celebrated genre painter William Sidney Mount, could attract critical attention neither with her landscapes nor with her still lifes. Women's work in landscape remained limited to local audiences and faded into obscurity after their death.[69]

Despite the changes that took place from the grand, ordered landscapes of the Hudson River school to scenes emphasizing the effects of "feminine" light and air, the midcentury figure of the landscape artist remained irreproachably masculine, and the great majority of landscape painters continued to be men.[70] The gaze assumed by the painter—and viewer—of the nineteenth-century landscape connoted a position of ownership.[71] Moreover, however spiritual the qualities of American landscape, its ultimate cultural function was more explicitly political than moral. Its referents were specific, physical, and by the 1850s insistently regional.[72]

One small group of women did successfully lay claim to landscape—that is, to a landscape that was domesticated by its production and distribution rather than its aesthetics and atmospherics. In popular prints, engravings, illustrations, and lithographs, women such as Fanny Bond Palmer and Eliza Greatorex depicted American landscapes with a degree of success that contemporary women painters could not equal. Since the 1820s, when the technique of lithography emerged, printing firms welcomed women as delineators. Some came from the dwindling number of printing and engraving families; others had studied at one of the growing number of urban design schools for women. Their success fed the demand for women's education in design as well as for drawing manuals and sketchbooks, including Fanny Bond Palmer's *New York Drawing Book*, which she wrote with her husband, Edmund, in 1844. Lithography was generally a very hospitable field of endeavor for women: it provided women with an alternative to teaching while still enabling them to earn their livelihood through artistic skill.[73]

Of course, prints did not have the prestige of landscapes in oil; they were

"only" graphic art, part of popular culture. While painters and sculptors had wrested a new higher status for themselves in American society, their professionalization depended on the creation of distinctions and hierarchies within the realm of art. Unlike painters and sculptors, visual artists who produced images for the masses rather than for upper-class patrons (and rather than public commissions, which were filtered through a group of elected officials) remained closer to the artisanal class. Their work was seen as more routine and mechanistic than intellectual; no divine fire of genius was necessary because good etchings and illustrations could be produced by anyone with sufficient training. As a result, no art critic of the time would have considered Palmer's work worth comparing to that of Cole, Inness, or Lane.[74] Yet her assignments as a staff member at Currier and Ives filled the same cultural and ideological function as landscapes painted in oil; her works, from *Morning in the Woods* (1852) to *The Rocky Mountains: Emigrants Crossing the Plain* (1866), evoked a shared American spirit embodied in the landscape. Moreover, they evoked that spirit for a greater number of viewers than a typical painting would attract in the same period of time.

None of Fanny Bond Palmer's subjects seems to fit the mold of domesticity and feminine accomplishment. Others at Currier and Ives drew the sentimental ladies and courtship scenes; Palmer, the one woman on the staff, was known as the resident expert in drawing realistic natural scenery.[75] It must have been this recognized proficiency that won her many assignments to portray insistently masculine activities in the great outdoors, such as hunting and fishing in *Partridge Shooting* and *Bass Fishing at Macomb's Dam, Harlem River, New York* (both 1852), and *Trolling for Blue Fish* (1866). In these prints Palmer drew a lush, bounteous nature quite effortlessly harvested by men. She often depicted the change of seasons in rural spaces, as in the series titled *American Farm Scenes* (1853) and *American Country Life* (1855). These sparsely populated scenes emphasized a realm of nature tamed, ordered, and made productive, the mainstay of American economy and society. Palmer's country occupied the same so-called middle landscape or Arcadia that painters returned to again and again to define the American ideal.[76] While contemporary landscape paintings made metaphorical references to land ownership, surveying, and manifest destiny, Palmer made these allusions literal in one of her most popular prints, *The Rocky Mountains: Emigrants Crossing the Plain* (1866). Palmer's *Rocky Mountains* became the icon of westward expansion for the many Americans who hung the picture in their homes.[77] This and her other landscapes were never merely bucolic; they

were also celebrations of American progress. The two scenes printed together in *View of New York* (1849), for example, show a shining city in which Arcadia (rugged, forested banks seen "from Weewauken-North River") and progress (seen "from Brooklyn Heights") coexist in perfect harmony. The two views are not "before" and "after" but simultaneous and equally New York. They are merely recorded from different vantage points; neither space encroaches on the other.[78]

How could Fanny Palmer's artistic subjects extend so far beyond the usual range deemed appropriate for the mid-nineteenth-century woman artist? Beyond any specific talent and personal affinity Palmer might have had for "masculine" iconography that won her such assignments, it was, first of all, the logic of distribution and the means of production of her prints that reclaimed Palmer's landscapes as part of the domestic. In some ways prints seem shockingly public, being distributed so widely and sold so cheaply among the members of the working and the middle class. But whatever their quantity or price, prints were meant for display within the home. Their eventual domestic destination erased the commercial (and public) aspects of the work. Palmer was creating art for other women, families, and members of the lower orders (who were often feminized in public discourse) to enjoy and use for edification within private spaces, not to grace exhibition halls or to decorate monuments.

Second, the purpose of each of Palmer's original drawings or etchings was *to be copied.* For Currier and Ives, the value of the original lay in the number of copies they would make of it; by working for them, Palmer was essentially making copies, and it was acceptably feminine to be a "copyist." In truth many popular prints *were* copies of acclaimed paintings. Palmer's *Mount Washington and the White Mountains* (1860), for example, reproduced the painting of the same name by James Smillie.[79] In other cases, Palmer's work was an original conception, but the finished print was not exclusively her work. Firms such as Currier and Ives operated under a communal mode of production; that is, a print was frequently the work of several artists working together on different parts of the composition. For example, Nathan Currier often drew figures onto Palmer's scenic background, while Palmer did color work for another artist. Neither of these finished products could be claimed, as a painting could, as being "by Fanny Palmer."

Third, because they were "only" popular depictions, etching, illustration, and lithography of the landscape could be performed within domestic spaces. Palmer herself never ventured further west than Hoboken, New Jer-

sey.[80] She was physically limited in her pursuit of an art career both by the demands of earning a livelihood (Palmer was a widow and the mother of a tubercular son) and by the questionable propriety of a woman's embarking on a sketching tour of the West. Such lack of mobility would have almost certainly disqualified her from a career as a landscape painter. In the model of the French academy adopted by most American art schools, students began by copying paintings and studying casts, but progressed to drawing from life. Increasingly, Americans saw the benefits of learning art by drawing directly from nature. Critics of fine art lambasted unrealistic depictions of flora and fauna, as well as human anatomy. However, in the business of prints and lithographs, a lack of realism was no hindrance; the only opinion that mattered was that of the buying public. Louis Maurer of Currier and Ives researched his popular Indian subjects by perusing books and prints at the library, not by traveling west on sketching trips.[81] The limits of domestic space thus did not confine Palmer's career.

Perhaps most important, the low status but genteel nature of the work of etching made it an acceptable means for respectable women in reduced circumstances, like the widowed mother Palmer, to earn their living. Landscape painting (along with history painting, which attracted very few American artists in this period) occupied the highest rung within the hierarchy of painting. The "lower orders" among artists were more likely to be feminized, and thus women artists could find a greater degree of acceptance working among them.

In sharp contrast to the middling lot of the genre painter and the suspicious popularity of the graphic artist, the neoclassical sculptor occupied a very high status among mid-nineteenth-century artists. In many ways, sculpture seemed the most insistently masculine of the fine arts. First of all, the high cost of marble precluded amateurism; even the wealthiest women found it impossible to build a professional career without winning commissions. European study was even more of a necessity for sculptors than for other artists. Not only marble, but mentors, assistants, and experienced models were much more readily available in the vibrant expatriate art communities of Rome and Florence than they were in the United States. In addition, the act of sculpting required no small degree of manual labor, or in its stead the supervision of male stonecutters.[82] Sculptors' studios were open to the public and became increasingly popular stops on the Grand Tour. Visiting tourists were important sources of commissions; but such scenes of staged working

and selling hardly fit the sheltered and private domestic space in which art writers liked to picture women. While typically American landscapes might (at least theoretically) be found near one's home, neoclassical sculpture demanded more removed subjects: classical, historical, and allegorical figures that required some amount of academic knowledge and intense study of the human body. Even the display of sculpture seemed incompatible with domesticity. A contributor to the *Art Journal* argued in 1866 "that sculpture by women belonged in a domestic setting where it was 'destined to refine and embellish many a home.'"[83] But statues bought for private homes were displayed in foyers and parlors, the most public rooms of a house; or in gardens, where guests would likewise be sure to see them. A work of art could hardly attest to the cultural sophistication of its owners if it were never seen. Even sculpture within the home could not help being conspicuous; as Lydia Maria Child stated, "A mediocre statue is worse than a painting of the same degree of merit; for it is so conspicuous, and takes up so much room, that one knows not what to do with it."[84] The home itself might not be private enough to render such a piece suitable work for a True Woman.

Despite its public characteristics, however, mid-nineteenth-century sculpture proved congenial to women artists in its themes. Neoclassicism encompassed many different styles and subjects, but all shared a common purpose: to render a high moral theme that was worthy of being immortalized in stone. Neoclassical sculpture in particular was associated with moral transformation; as in landscape, a view of the sublime truth would have the intrinsic power to uplift. Thus a subjective and emotional audience response was critical for an artwork's success.[85] Unlike landscape, however, neoclassical sculpture represented the ideal in human figures and embedded those figures in particular narratives. The literary, historical, or Biblical context of a sculptural subject was a crucial (albeit invisible) component of the sculpture itself and the impact it was hoped to have.

By embodying moral lessons and truths in this manner, neoclassical sculpture gravitated toward specific characters and stories that embraced Western civilization, as opposed to landscape's coded references to American citizenship and nationalism. Furthermore, such sculpture often meant to present a specific lesson or example of virtue, teaching rather than suffusing the viewer with pride of possession. It was this combined didactic, narrative, and moral imperative, rather than the terms of production, that enabled women sculptors to claim their place in the field. As proper "angels of the house," women had the responsibility of their families' moral guard-

ianship. Through neoclassical sculpture, they extended the realm of their guardianship to a wider audience and a more explicitly public, political subject matter.

Women artists produced a wide range of work within the idiom of neoclassical and ideal sculpture. Several sculpted fountains and garden statuary. These often displayed impressive technical virtuosity, as contemporary critics noted, including the modeling of nude or seminude figures. Though cherubs and fauns seem innocent enough, and though gardens are not entirely public arenas, this type of subject (like sensual children in the paintings of Lilly Martin Spencer) allowed women to suggest sexual themes and depict the nude human body within the confines of propriety. Taking her theme from a poem by Alfred Lord Tennyson, for example, Anne Whitney modeled a male nude, later reworked and named *The Lotus Eater* (1867).[86] In Harriet Hosmer's *Sleeping Faun* (1865), a mischievous infant satyr is tying a knot in the faun's tail. The bare, recumbent body of the young faun recalls a host of vulnerable female figures in art, from the trope of the voluptuous odalisque to Edward A. Brackett's *Shipwrecked Mother and Child* (1850)—except that Hosmer's figure is male. Playful humor remained possible in these works because the subjects seemed so removed from reality; Hosmer's *Puck* and *Sleeping Faun* could hardly be construed as attacks on the gender hierarchy in the way of Spencer's *Young Husband.*

Women artists would make some of their strongest, most direct challenges to conventional definitions of femininity and domesticity while working within the neoclassical idiom. In American neoclassical sculpture, female subjects such as Eve predominated.[87] Thus, though remaining within this traditional range of subjects, women sculptors could reinterpret the female figure through representations of their own. Harriet Hosmer's earliest professional efforts featured a series of classical heroines: busts *Hesper, the Evening Star* (1852), *Daphne* (1854), and *Medusa* (1853), followed by *Oenone* (1855), her first full-length sculpture. Other artists had depicted these same figures, but Hosmer's particular representations show her fascination with women who are oppressed and powerful at the same time. Like Bernini, she sculpted *Daphne* at the moment of her transformation into laurel leaves, the same moment of her escape from Apollo's unwelcome lust. Medusa, her hair in the midst of its metamorphosis into snakes, was beautiful. "I never saw her so represented before . . . It strikes you with no feeling of revulsion," an approving viewer wrote. Yet Medusa's sad beauty could be as powerful as her monstrousness in other depictions: "It was hard for me to look

away from this statue," the viewer continued; "if long gazing could have turned one to stone, the old tradition would have been fulfilled."[88] Oenone, abandoned by her husband, Paris, emerges most clearly as a victim, but it was a type of victimhood Hosmer saw as a possible danger for all married women.[89]

The narrative context of Hosmer's next major work, *Beatrice Cenci* (1856), illuminates it as a complicated and critical commentary on domesticity itself. Hosmer took the theme from sixteenth-century Roman history. The historical Beatrice Cenci was condemned to death for planning the murder of her abusive father. Her tale, kept visible by Guido Reni's famous painting of her at the Palazzo Barberini in Rome, fascinated Victorian audiences, including eminent writers Percy Bysshe Shelley, Robert Browning, and Nathaniel Hawthorne. Hosmer cited the Reni portrait as a source, but her representation of Cenci is more markedly feminine. Unlike Reni's enigmatic figure, Hosmer's Cenci clearly exhibits the attributes of the idyllic True Woman. She has fallen asleep while praying the rosary and dreams innocently in her cell on the night before her execution. The rosary, still in her hand, marks her as both blameless and religious—the pure, pious ideal of the cult of true womanhood. In this depiction, her violent act against family and home is understandable and excusable.

Hosmer's *Zenobia, Queen of Palmyra*, or *Zenobia in Chains* (1859), contrasts even more sharply with the neoclassical ideal of woman as passive, vulnerable, and resigned (see Figure 3). A historical subject, Zenobia, the warrior queen of Palmyra, was taken prisoner in battle by the emperor Aurelian in 272 A.D. The theme of the enslaved woman was a popular one among neoclassical sculptors; Hiram Powers's *The Greek Slave* (1841) caused a sensation, becoming the century's most popular statue in the United States and inspiring similar representations of innocent female slaves by Erastus Dow Palmer and others. The image evoked a wide range of different cultural meanings. The woman's rights movement used the trope of the slave woman as a powerful analogy for all women's oppression. Though captive, Hosmer's Zenobia is recognizably regal and proud, and pulls at her chains as she steps forward. Though her circumstances make her sexually vulnerable, Hosmer largely obscures that aspect of the narrative by presenting Zenobia as a political prisoner, richly arrayed in a long robe, cloak, crown, and jewels to designate her royal status—not, like *The Greek Slave*, a nude commodity on the market. Hosmer's *Zenobia* is a woman worthy of freedom, not titillating the viewer into dreams of possession. Despite its challenge to gender ideology, Hosmer's

Zenobia earned wide acceptance and appreciation among American audiences on its nationwide exhibition tour; even Nathaniel Hawthorne admired it, calling it "a very noble and remarkable statue indeed, full of dignity and beauty."[90] Yet many reviewers described the statue in terms that emphasized Zenobia's "true womanhood," easily slipping her narrative into the

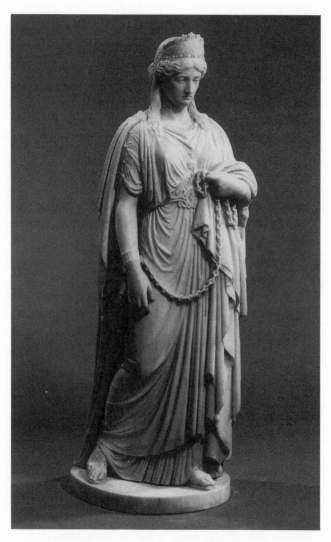

Figure 3. Harriet Hosmer, *Zenobia in Chains* (1859). Courtesy Wadsworth Atheneum, Hartford; gift of Mrs. Josephine M. J. Dodge (Arthur E.).

tropes of domesticity: "The same struggle of sorrow that is almost pride, and a gentleness that is almost tenderness, are legible upon her lips. But the heart warms to the woman rather than to the queen; we regret the fallen state, but we welcome her who has descended."[91] Despite the strength of Hosmer's challenges to traditional models of domestic womanhood, many contemporaries insisted on *Zenobia*'s vulnerability and weakness—in other words, her ideal femininity.[92]

Thanks to their success as neoclassicists, women sculptors were able to cross over into nationalistic and political subjects that were unavailable to women painters. Women sculptors won public commissions for explicitly political subjects, which meant portrayals of men. Statues of great men by women artists include Harriet Hosmer's *Senator Thomas Hart Benton* (ca. 1861). Edmonia Lewis sculpted Charles Sumner, William Lloyd Garrison, Wendell Phillips, and Robert Gould Shaw, all abolitionist icons, during 1864 and 1865. Vinnie Ream began sculpting her statue of Lincoln in 1866. Emma Stebbins sculpted several male figures: *Horace Mann* (1865); *Columbus* (1867); the allegorical male figures of *Industry*, a miner, and *Commerce*, a sailor, both commissioned in 1860; and even a historical scene, *The Treaty of Henry Hudson* (1860). Through works depicting political figures and events, women directly interpreted history and politics and participated in the creation of a national iconography, a pantheon of heroic men. Because sculpture was expected to elicit a response from its viewers, these women artists were not only creating static figures but also engaging in political discourse through their work. Anne Whitney's most successful political commentary of the period assumed female form: *Lady Godiva* (1861), an image of a woman engaged in political protest. The legendary Lady Godiva rode naked through the streets of Coventry in order to protest the excessive taxation of her people. Whitney depicted Godiva in the act of removing her belt, that is, at the moment in which she decided to protest.

Using not only her body but also her sexuality and womanhood as a point of entry into politics, the image of Godiva undressing emblemizes women's lives and work as professional artists at the middle of the nineteenth century. The cultural definitions of domesticity and femininity governed the boundaries within which women could perform and yet remain respectable. However, women were able to stretch those boundaries to legitimate their own networks and lifestyles. Many women quietly pursued successful careers in watercolor, still life, portraiture, flower painting, and decorative art.

A notable group pressed further, using gender ideologies to justify their work in less conventional genres. A few decided to remove their belts—to challenge domesticity by traversing its limits, to extrapolate their traditional gender roles to the point of contradiction. If every metaphor and scene of home life and family, every duty to preserve culture and to educate others in morality, might be labeled appropriately domestic, women's exclusion from the ranks of fully professional artists would require a different configuration. Their true femininity must hinge on something else, something more tangible. It was the body, revealed by the protests of Godivas, that became the critical focus in subsequent decades. The lady might choose to remove her subject's belt, but depicting the result would incite another set of conflicts.

Figures and Fig Leaves

American women artists used domestic ideology to claim art as an appropriate field and even profession for their sex, creating the model of a feminine artist whose profession was a natural expression of her womanhood. But domesticity was not the only attribute required of a nineteenth-century True Woman. Purity—particularly female sexual purity—functioned as an important marker of respectability, connoting both middle-class status and whiteness. Both sexes were measured against a standard of sexual behavior. Middle-class white men were expected to exercise self-restraint, curbing their virility and imposing a control over their bodies and behavior that working-class and nonwhite men were believed incapable of achieving. Respectable women did not merely achieve purity; they embodied it. The ideal woman, again coded as white and middle-class, was pure to begin with, possessed of a natural passionlessness. Feminine purity required constant vigilance, however. Once lost, it could not be regained; a fallen woman had denatured and unsexed herself. By the late nineteenth century, "falling" began to be regarded as a danger for any woman, reinforcing the need for women to treasure and cultivate their "natural" modesty and purity.[1]

As more and more women artists gained access to art training and established art careers, they began to find that ideals of feminine purity barred their progress toward full professionalization on a par with men. Purity became an especially important issue as women began to extend their artistic repertoires beyond flower painting and formal portraits to sculpt and paint representations of the human figure such as Harriet Hosmer's *Zenobia* and Anne Whitney's *Lady Godiva*. Prestigious genres, such as history painting and ideal sculpture, required the artist to study from life and often to use undraped models. But the myth that surrounded the relationship between

artist and model sexualized both the act of depicting the nude and the art-
work resulting from that act.[2] As a result, the public scrutinized women
artists' lives and work for evidence of impurity. As sculptors Louisa Lander
and Vinnie Ream discovered, rumors of private indiscretions could not only
damage a woman's reputation but also could have devastating effects on her
professional work and its reception. Both life and work needed to embody
the passionlessness of a True Woman.

Women artists struggled within this confining ideology in attempts to
avoid the vaguely sexual taint of publicity to which their professional ca-
reers exposed them, to gain equal access to life studies at art schools, and to
depict sexualized figures—including African American and Native American
figures—in their art. Throughout these challenges, they continued to build
upon a shared women's culture as the basis for their *feminine* professional
identities.

The problem of sexuality had long been a central concern in American art.
In the early nineteenth century, paintings such as John Vanderlyn's volup-
tuous nude *Ariadne at Naxos* and sculptures such as Horatio Greenough's
bare-chested, toga-clad *George Washington* had kindled a large number of
American invectives against the corruption and sensuality of European ar-
tistic traditions. The very first U.S. law against obscenity, passed in 1842, was
directed against imported pictures—a vain effort to preserve American pu-
rity against European pollution.[3] Gradually American critics came to accept
a certain amount of nudity in art, as long as it appeared in the proper con-
text. Neoclassical nudes gained the greatest acceptance because the idiom
drew on explanatory narratives exterior to the artwork itself; a neoclassical
work's context was not limited to its subject and composition, but necessar-
ily included the subject's history or legend, which often illustrated a didactic
moral lesson. For example, Hiram Powers's *The Greek Slave* provided visual
clues to its subject's story: a cross, Greek hat, and locket dangling on the post
beside her marked her as Christian, Greek, and someone's beloved; and her
chains convey that she is about to be sold as a slave. The message is one of
resigned Christian womanhood and of antislavery sentiment, a moral lesson
profitable for both victims and oppressors.

Nineteenth-century art critics interpreted works like these and tried to in-
struct the public's gaze by emphasizing the moral qualities of the artworks.
When viewing *The Greek Slave,* for example, writers directed the audience to
see the figure's "maidenly modesty and innocence" and Christian resigna-

tion instead of her nudity; her saintliness, her pure and lofty sentiments "clothed" her, they insisted. Some even suggested that one could see the sculpture in a strictly spiritual way and be unconscious of the slave's body. In this manner, gazing upon *The Greek Slave* could be both a transformative experience and a moral one. Viewers wholeheartedly adopted the art critics' recommended perspective; upon entering the exhibit, sponsored by the Cosmopolitan Art Association in New York, "Men take off their hats, ladies seat themselves silently, and almost unconsciously; and usually it is minutes before a word is uttered." Some viewers reportedly wept. Without the initial direction of art experts, the masses might interpret such sensational subjects wrongly. With guidance, however, neoclassical nudes such as *The Greek Slave* might be safely included in the pantheon of great American art.[4] Interpreted by experts, the pure (in this case, subtly abolitionist) intent of the pure-minded artist would sanctify an otherwise titillating work of art. The romanticist ethos of Transcendentalism called on the viewer to transcend the perceptions of the senses and "see" with the mind instead of the eye.

Just as male artists, like all middle-class men, were admonished to exercise self-restraint in their professional and personal relationships, women artists were measured against the same standard of purity as other middle-class women. That is, the ideal woman artist was as pure as the ideal woman. In fact, her womanly purity should not simply survive the rigors and traps of professional art, but transform her life and work into something transcendently feminine, and ultimately different from art produced by men. This cultural expectation set boundaries around women's participation as professionals. They no longer had to justify their careers in terms of domesticity per se, but they still had to ensure that art did not betray their modest, passionless nature as women.

The requirements of feminine purity for a woman artist, as distinguished from those of masculine self-control for men, emerge clearly in the terms used to praise individual women artists. Margaret Foley, for example, won the effusive admiration of art critics and other writers throughout her career. Her "genius with no adventitious aids has already won her an enviable position . . . winning peculiar honors from Italian and English critics as well as her own countrymen," *Harper's* declared as early as 1866. "She has been forced to confine herself too closely to portrait medallions to allow the freest development of her genius . . . And yet her portraits are true creations of art."[5] The London *Art-Journal* echoed this assessment, commending Foley for her "great taste, purity, and tenderness" in particular, and pronouncing

her "one of the many sculptors of whom the New World may be justly proud," with a "large and merited celebrity" in both Italy and the United States.[6]

After her death in 1877, Foley's admirers emphasized her character instead of her talent, and memorialized her as a womanly icon of purity rather than as a sculptor of genius. In his poem "In Loving Memoriam of Margaret F. Foley," Charles Timothy Brooks likened his subject not to Michelangelo but to a bird; he associated Foley not with chisel and clay but with light and whiteness. The versified Foley is a devout Christian who "hadst chosen the better part" and a "Pure priestess at the shrine of Art!" This image combines qualities of piety and submissiveness with woman's role as a cultural guardian, serving "at the shrine of Art." At the same time, Foley appears not as creator (or creative artist) but as a priestess, and emphatically, as a "Pure priestess." Foley is a "goodly pearl" born as a "prize" by "The heavenly merchantman . . . rejoicing, homeward to the skies"—an object, not a subject. In the poem, Foley's purity manifests itself physically: Foley has a "sweet and pure and kindling face" and "The very light of Heaven shone through / Those eyes, so tender and so true, / With radiance caught from heaven's own blue."[7] Brooks was not alone in finding physical evidence of Foley's purity. Foley's friend Harriet Robinson described the artist as if she were an ideal sculpture of womanhood, with "a head as classic and a skin as white as her own beautiful marbles."[8] Granted, poetic conventions influenced the way in which Brooks and Robinson chose to commemorate Foley; but those poetic conventions echoed more general cultural ideals of femininity. As a woman, Foley won admiration because of her "purity of heart"; her profession was incidental to her fame.

Foley's case, however, was even more complicated than that of other women artists because her status as an ideal of purity *resulted* from her work as an artist. Foley was a schoolteacher and mill worker in the 1840s; her origins might be identified as working class, where the demands of daily life made the True Woman an unattainable ideal. As with Susanna Paine, Foley's artistic talent elevated her class status as long as she remained a pure Christian woman. Observers and critics often portrayed Foley as a worker; that is, they emphasized her work ethic and her actual labor in producing sculptures. She had "worked her way bravely up to fame and success" and "among the American artists now in Rome no one is working harder than Miss Foley," various newspapers reported. British writer Mary Howitt later called Foley "a born carpenter and practical inventor."[9] These authors never

questioned Foley's place as an exemplary woman. Foley's past as a manual laborer, rather than a leisured lady, may have even made it easier for her to take up sculpture, a physically demanding field of art, for she would not have grown up hearing the same assumptions of woman's natural delicacy and fragility.[10]

Of course, many other mill girls besides Foley exhibited a middle-class sensibility. Like Foley, they wrote sentimental poetry and domestic fiction for magazines like the *Lowell Offering* and the *New England Offering*. By becoming a professional sculptor, however, Foley outpaced them in the shared pursuit of refinement. She left the mills after several months to pursue the study and teaching of art; mill worker Lucy Larcom was one of her students. Larcom and her sister Emilie dreamed of being artists, but writing—a sufficiently lofty profession—seemed a more reasonable goal.[11] Foley inspired Lucy Larcom's earliest published works, "a story about Margaret, a sculptor, who learned her art through love" and a poem titled "The Weeping Prophet," which was based on one of Foley's bas reliefs; it is not difficult to imagine Foley inspiring other young women at the mills as well.[12] Foley's work as an artist made her more "womanly" than the average female operative; she became a symbol of a pure, ideal womanhood that could be attained even by women who performed physical labor. In this way, Foley epitomized what the mills promised to all young female operatives: the chance to acquire the dowry, education, clothing, and genteel manners that would transform their social status.[13]

Women artists understood that these middle-class expectations of female purity connoted sexual purity in particular. They identified themselves as innately pure, yet remained keenly aware that this "innate" purity required constant vigilance to maintain. Purity seemed to be an especially acute problem for women artists while they resided in the corrupt, sensual world of Europe. "At first it is awful for a pure woman to walk the streets and be looked at by beastly men as if she were a cow, to feel a man's insolent stare measuring her as he would any animal," painter Mary Wheeler wrote from Paris to her artist friend Mary Noble in 1878. "She can never *get used* to this, but one can be so engrossed in and occupied with one's pursuit as not to *notice* much. I walk the streets with my eyes fixed in the distance. It has grown to be a habit. There's no *danger*, a man waits to be approached, the talk of its being unsafe to go out alone is absurd."[14] Wheeler assumed that a superior purity could offer protection to a woman, in a manner like that of the subject of *The Greek Slave*. Months later, by her own report, Wheeler's tactics

were still working marvelously well: "I go by the vile men and disgusting women and take no heed of them because my mind is so much on the city itself with its mysterious river, its soft sky and soothing atmosphere, its interesting streets and its multitudes of romantic buildings."[15] As in Foley's case, Wheeler's artistic sensibilities augmented, rather than detracted from, her feminine modesty and purity.

The typical threats to a woman artist's purity often resulted from her engagement in what were routine public activities for her male peers. Even the most commonplace social interactions could endanger a woman's reputation (and thus her effectiveness as an artist) if she did not conform to gendered codes of behavior. Women artists seemed to be held to especially high standards while studying or working in Europe. In addition to the distances and the length of time involved in study abroad, American intellectual tradition regarded the Old World as a decadent, sensual, sophisticated society that threatened to corrupt young Americans, particularly young American girls. Many novels by contemporary American writers took this loss of innocence abroad as their principal theme. Nathaniel Hawthorne's *The Marble Faun* (1862) and Henry James's *Roderick Hudson* (1875) specifically chose artists' communities as the setting for this cultural battle between European worldliness and American purity. In literature, the Europeans almost always won that contest.

For these and more pragmatic reasons, May Alcott Nieriker included specific, practical advice on selecting lodgings, art classes, and wardrobes in her book *Studying Art Abroad, and How to Do It Cheaply* (1879). Her manual was aimed primarily at women, most often using feminine pronouns to describe the projected progress of "our artist" from steamer across the Atlantic to an appropriate boarding house and studio.[16] Cecilia Beaux recalled the experience of an artist friend, Lucy Taggart, who "did a good deal of sketching in the streets, and one hot morning started out in a gingham dress, cut square in the neck. As she was going out, Soeur Denyse called her back, very sweetly smiling, and made her pin a handkerchief across the space, which was a very modest one, saying that it was not *convenable* [appropriate] for a *pensionnaire* at a convent"—and, one suspects, for any woman.[17] Already having felt the barbs of slander, young sculptor Vinnie Ream took her parents with her as chaperones when she went to Italy to put her *Lincoln* in marble.

Scholars of impressionism have noted the importance of a masculine culture of urban streets, cafés, and brothels both to the production of particular

images of modernity and to the construction of the artist as *flâneur,* the idle gentleman who prowled the city streets observing urban life. The proscriptions on women's involvement in public culture limited the subjects they could represent in their artwork and the cultural authority they could muster as artists.[18] When young painters Mary Cassatt and Emily Sartain went to Parma, Italy, in 1872 they made a special effort to fit into the local culture and "behaved with scrupulous respectability." They even declined invitations when they could not find appropriate chaperonage. Their vigilance was rewarded by their acceptance by local artists, including circles of intellectual women in Parma.[19] Later, Cassatt's sister Lydia acted as her companion and chaperone, traveling between the United States and France every year. When Lydia became too ill to make the annual journey, the sisters' parents came to live with them in Paris. Mary Cassatt seemed quite aware that her association with the impressionists only increased her need for immaculate respectability.[20] For the sake of her career she needed to be as public as possible, but without damaging her reputation.

Gender norms also affected women artists' participation in more expressly professional activities. As Susanna Paine had found a generation before, studios were essential not only for artists to work in, but as exhibition sites to meet prospective patrons, woo potential buyers, and win future commissions. "A studio, even a poor one, is indispensable for *recueillement,* even if little gets done in it," noted Cecilia Beaux, the most successful woman portraitist of her generation.[21] Yet the studio exposed the woman artist as well as her work to public scrutiny and to the marketplace. In addition, every art student in Europe was expected to copy examples of great paintings from the rich art collections there. Both men and women engaged in copying paintings at the Louvre in Paris, Florence's Palazzo Pitti, London's National Gallery, and other renowned museums. But among the ranks of students with easels in the museum halls, women seemed decidedly more conspicuous. They were subjected to the gaze of tourists and themselves became a visual attraction of the museum. Contemporary writers, such as Nathaniel Hawthorne and Henry James, recognized the professionally and sexually ambiguous position of the female copyist. "Sometimes a young artist, instead of going on with a copy of the picture before which he had placed his easel, would enrich his canvas with an original portrait of Hilda at her work," Hawthorne wrote in his novel *The Marble Faun,* depicting a scene in which the woman artist becomes the art-object, the thing on display. In *The American,* Henry James described a transaction between copyist and patron

in sharply sexual metaphors, eliding the question of whether the object for sale was the copied canvas or the woman herself or both.[22]

Copying in American museums, such as the Pennsylvania Academy, may have been a more solitary occupation, but even on their native turf women artists attracted disproportionate attention when they painted or sculpted in public. Naval officers "flocked" around Vinnie Ream, for example, as she worked on a commissioned sculpture of Admiral Farragut.[23] Women attracted less attention when merely sketching; sketching did not challenge gender boundaries as obviously as sculpting, with its more intense physical effort. But even the more "ladylike" forms of art production attracted the notice of strangers.

While many women artists successfully managed their careers within the limits of pure womanhood, others found the cultural dictates of femininity to be harsh and ultimately unreconcilable with their ambitions as artists. Louisa Lander began sculpting cameos and family portraits in Salem and Danvers, Massachusetts, then launched a professional career in Washington, D.C. At age nineteen, she sailed to Europe in the company of her father. In Rome, noted American sculptor Thomas Crawford accepted her as his student, and Lander opened her own studio, where she sculpted two major figures, *Virginia Dare* and *Evangeline*. She called on Nathaniel Hawthorne, a fellow native of Salem, who was in Rome with his wife and children. A few days later, Nathaniel and his wife, Sophia, visited Lander's studio. Impressed by Lander's *Virginia Dare*, Hawthorne agreed to let Lander sculpt his bust in marble, and soon began giving Lander regular sittings.[24]

Theirs became more than a strictly professional relationship; Lander joined the Hawthorne family on many excursions in the following months, to the Colosseum and other artists' studios. While the young woman sculpted his portrait, Hawthorne took Lander's "moral likeness" in his notebook. He seemed proud of her as a fellow townswoman. Not only did Lander "appear to have genuine talent," he wrote; she also possessed "spirit and independence enough to give it fair play . . . Miss Lander has become strongly attached to Rome, and says that, when she dreams of home, it is merely of paying a short visit, and coming back before her trunk is unpacked." She enjoyed a "delightful freedom" by "living . . . thousands of miles from her New England home, going fearlessly about these mysterious streets, by night as well as by day, with no household ties, no rule or law but that within her, yet acting with quietness and simplicity, and keeping, after all, within a homely line of right." Furthermore, she shared the "strange fascination that

Rome exercises upon artists," which was rooted in "the peculiar mode of life, and its freedom from the enthralments of society" rather than in any "artistic advantages which Rome offers."[25]

Though Hawthorne's initial notes attributed a protective, innate purity to his portraitist, his description of Lander hints at the dangers inherent in her chosen lifestyle. Lander's "delightful freedom," fascination with artist life, and disregard for social codes, "household ties," and "rule or law" all threatened to place her outside genteel society. Other women artists, like Emily Sartain and Mary Cassatt, conscious of the extent to which both peer acceptance and commissioned work shaped their careers, guarded their reputations more zealously. As it turned out, Lander's fall from grace occurred with astonishing speed. Her dinner with the Hawthornes on April 15, 1858, a farewell party before her departure for America, marked the last time she would be admitted into Hawthorne's presence. He sent her off with a letter to influential Boston publisher William Ticknor, reporting everyone's praise for the portrait bust and asking Ticknor to "do what may be in your power to bring Miss Lander's name favorably before the public . . . She is a very nice person, and I like her exceedingly."[26] When Lander returned to Rome and, with her sister Elizabeth, called on Hawthorne on November 9, the women were turned away at the door; the next day, Lander called again but was "not seen." No particular disagreement between sitter and artist had occurred; in fact, the affair is strangely void of direct confrontation. Its apparent cause was that during Lander's sojourn in the United States, Hawthorne had heard something shocking about her from painter Cephas Thompson. "What a pity!" he exclaimed in his pocket diary.[27]

Though Hawthorne never spoke specifically about the matter, sculptor John Rogers did. "I don't know the whole story but there have been stories in circulation affecting Louisa's moral character . . . She has the reputation of having lived on uncommonly good terms with some man here. She is very vain of her figure and a number of respectable people affirm that she has exposed herself as a model before them in a way that would astonish all modest yankees—I suppose there is not much doubt of that part of the story and it probably forms the foundation of all the rest."[28] Nude modeling and improper relations with men: these stories provided evidence of Lander's lack of womanly purity, remarkably similar to the accusations that would be made against Vinnie Ream a decade later.

Rome's reaction to the rumors was swift and vicious. "Some of her friends have turned the cold shoulder to her and cut her in the street, whilst a few

have formed themselves into a committee to try and unravel the story," Rogers reported. "It will make Rome a disagreeable place for her even if the committee are satisfied . . . If I had been in her place such a loss of reputation would have killed me I believe but she snaps her fingers at all Rome and has not the least desire to leave."[29] Other women artists, including Harriet Hosmer and Emma Stebbins, may have intervened on Lander's behalf. But Lander herself did not seem to comprehend her compromised position in its full horror. If she thought the letters in her care, from the Hawthornes' correspondents in the United States, would gain her admittance to the household, they did not. On December 5, Hawthorne received "A note from Miss Lander in the evening. Wrote an answer by bearer." He finally responded with a letter of his own. He wrote in the third person, divorcing himself further from the affair:

> Mr. Hawthorne is glad to be informed that some (he hopes many) of Miss Louisa Lander's friends are convinced of the purity of her life and character. He is himself open to conviction on that subject; but as guardian of the sanctity of his domestic circle, he is compelled to be more cautious than if he were acting merely for himself. Before calling at Mr. Hawthorne's residence, Miss Louisa Lander had been made fully aware that reports were in circulation, most detrimental to her character; and he cannot but think that any attempt at social intercourse with her former friends, (especially where young people and children are included in the number) should have been preceded by a full explanation and refutation of those reports. As far as her own conscience is concerned, Miss Lander's life (as she truly observes) lies between her Maker and herself, but in her relations with society, the treatment she receives must depend upon her ability to make a good and reasonable defence against the charges imputed to her. If Mr. Hawthorne were one of those friends who have faith in Miss Lander's innocence, his first and last advice to her would be to sift through those charges thoroughly, to meet them fully, and to throw her life open to the world. This should be done at once, and nothing short of this will enable Miss Lander to retain her position.[30]

Lander did not "throw her life open to the world," and she did not "retain her position," either in Hawthorne's friendship or in professional circles. The end of the two artists' friendship was impersonal and absolute. Hawthorne paid for his bust and used the scandal as inspiration for his novel of art life in

Rome, *The Marble Faun* (1864). Lander tried to salvage the wreck of her career without pawning her pride in the bargain.

The episode was not simply a personal contest between Louisa Lander and Nathaniel Hawthorne but a conflict between ideologies of womanhood. As long as Lander was pure, Hawthorne's relations with her were above suspicion. When she "fell," Hawthorne felt himself at risk. The relation of model to artist especially carried a discomforting taint of sensuality, and perhaps Lander's own inappropriate sessions as model would have carried implications for Hawthorne as model of the bust. Hawthorne, however, explained to Lander that it was concern for his children that forced him to bar her from his house until she cleared her reputation; he was probably thinking of his daughter Una in particular, who may have regarded Lander as an alternative model of womanhood.[31] It was not Nathaniel but his wife, Sophia, who expunged Lander's name from Hawthorne's notebooks when she edited them for publication. Sophia, who had begun a career in painting and abandoned it for marriage and motherhood, had even more reason to reject Lander than her husband did. Lander represented the independence that Sophia had renounced when she married. If Nathaniel Hawthorne could admire and have an intimate relationship with a woman like Louisa Lander, then Sophia's "feminine" qualities of domesticity, purity, privacy, and sacrifice were all rendered of questionable value. Doubt would be cast on Hawthorne's success in achieving the masculine ideal of self-control as well.[32]

Lander found it especially difficult to rebuild her career because her remaining reputation rested on a sculpture of dubious respectability: the semi-nude *Virginia Dare* (Figure 4).[33] The tension between purity and sexuality was particularly intense within the idioms of ideal and literary sculpture. Neoclassicism claimed the highest moral ground and didactic purpose, but individual statues could be problematic. Emulation of the classical ideal inspired a preference for nude subjects, especially female ones. At the same time, the goal of high art—to uplift and transform the viewer—remained paramount. The greatest failure of a neoclassical statue was to be "vulgar"—that is, too obviously sexual. Purity and nudity achieved a precarious balance at best in sculptures such as Hiram Powers's *The Greek Slave* and Erastus Dow Palmer's *White Captive*.[34] Even as American sculptors left strict neoclassicism behind, they still had to confront this danger, the threat of sexuality.

Lander's *Virginia Dare* was a popular success; it was exhibited in Salem for the benefit of wounded soldiers during the Civil War and after its Boston ex-

hibition was labeled "the National Statue."[35] Lander herself promoted the work as a model for American art. "This design," she claimed in an interview, "shows that we have in our own country, rich subjects of sculpture without resorting to the old heathen mythology for them"—or, she might have added, without resorting to the ideal of female submission and passivity.[36] Yet Lander encountered many difficulties in selling the piece. Neither its technical virtuosity (with contrasting textures for fishnet, feathers, skin, and hair, for example) nor its American subject attracted enough commis-

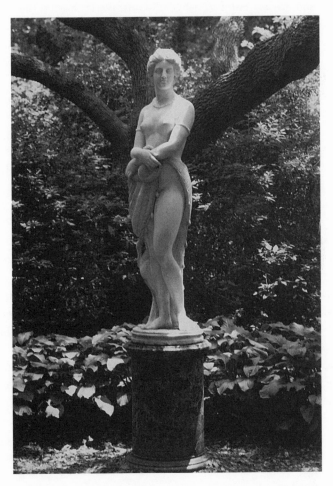

Figure 4. Louisa Lander, *Virginia Dare* (1859). Courtesy The Elizabethan Gardens, Inc., Manteo, N.C.

sions and sales to allow Lander to resume her career. Lander imagined Dare as an adult who had been raised by Native Americans and thus wears Native American dress, but she is looking wistfully out to sea, remembering her English heritage. The figure's nudity and self-assured pose, lacking the shame and resignation of the popular *Greek Slave,* seemed too analogous with Lander's own sexuality and refusal to capitulate to the rules of propriety. Unable to sell *Virginia Dare,* Lander kept the statue with her until her death, bequeathing it to the state of North Carolina, where Dare was born.

Roughly a decade after Lander's fall from grace, Vinnie Ream likewise found herself at the center of a heated controversy, but by the 1870s the terms of debate had changed enough to allow room for a defense of Ream's purity, whereas Lander, once fallen, had no recourse. At the age of eighteen, Ream won a $10,000 commission from Congress to sculpt the portrait of martyred president Abraham Lincoln. Loud protests erupted as soon as the commission was announced. Ream, a native of Wisconsin, had been working in Washington, D.C., for three years as a postal clerk while studying with sculptor Clark Mills; she had not gained the commission after years of acknowledged, professional work in art but rather by the patronage of certain congressmen who had befriended her through Mills and through the Ream family's boardinghouse, where Senator Edmund G. Ross of Kansas resided. The senators and representatives relished the idea of a child of the West becoming a famous sculptor, and several of them posed for her. She even gained sittings from Lincoln shortly before his assassination.

However, others could not overlook Ream's gender and inexperience, and immediately suspected feminine wiles at work. How else could a lovely young girl have won such a prestigious and lucrative public commission? Ream was attacked both by rumor and in print, including a piece by journalist Jane Grey Swisshelm. Swisshelm described Ream as "a young girl of about twenty who has been studying her art for a few months, never made a statue, has some plaster busts on exhibition, including her own, minus clothing to the waist, has a pretty face, long dark curls and plenty of them." To make the innuendo even clearer, she added that Ream "sees members [of Congress] at their lodgings or at the reception room at the Capitol . . . sits in the galleries in a conspicuous position and in her most bewitching dress, while those claims are being discussed on the floor, and nods and smiles as a member rises."[37]

Like the women copying paintings at the Louvre, Ream looked too public to be pure. Her own body became conflated with the figures she sculpted, so

that the "plaster busts on exhibition, including her own, minus clothing to the waist" seem a display of her seductiveness, her overt sexuality, and even her bare breasts. Sitting in the congressional galleries, Ream reminds one of prostitutes sitting in a theater's third tier, wearing a "bewitching dress" and nodding and smiling at former or prospective clients. Woman's rights advocate Swisshelm did not doubt Ream's ability because of Ream's sex; in fact, Swisshelm herself was an amateur painter, and meant to champion a different woman artist, Harriet Hosmer, for the Lincoln commission. The attacks on Ream also resulted from a regional rivalry between the Midwest and established art centers in the East, such as New York and Boston. But all of the protests over Ream, including Swisshelm's, assumed pointedly gendered terms, and employed charges against Ream's sexual innocence in order to discredit her artistic ability. The terms of the debate would have been far different over an inexperienced male sculptor.

Ream's champions defended her within the same context and set of cultural expectations as her accusers. Accepting the paradigm of pure womanhood, they too focused on her youth—not as beauty and seductiveness, but as girlhood and maidenhood that connoted purity. A typical article about the official inspection of the statue in January 1871 described Ream as "fragile, youthful . . . pale and anxious, and rendered more child-like in appearance by her petite form and wealth of Dora-like curls." When the assembled dignitaries enthusiastically applauded her work, "glad tears" welled up in her eyes. This seemed innocence and modesty incarnate; the "little sculptor-girl" did not even share center stage with her statue, but rather "stood a little in the rear" of the room.[38] The public unveiling of the Lincoln statue occasioned more of the same. During the requisite speeches, Senator Morrill portrayed Ream as "a little girl from Wisconsin [who] occupied a little place at the Post Office Department, at $600 a year" but "had faith that she could do something better." Morrill posited an affinity between Ream and Lincoln as self-made Westerners, "architects of their own fortune," which might help explain Ream's selection and ultimate success as Lincoln's portraitist. Ream "was fortunate," he added, "in selecting a block of marble of pure white, and without a stain, a Fitting Symbol of the pure character and spotless life of him it was intended to represent." Presumably the "pure white" marble also represented "the pure character and spotless life" of the much-maligned woman who had sculpted it.

Instead of evaluating the statue as art, Ream's defenders praised its faithfulness to the original. Over and over, senators and speakers were reluctant

to evaluate the artistry of the statue but vouched for its resemblance to the real Lincoln: "Others will judge of its artistic execution," Senator Morrill declared; "as I gaze upon the statue I am ready to exclaim 'That is Mr. Lincoln.'" Senator Carpenter of Wisconsin agreed: "Of this statue, as a mere work of art, I am no judge," he admitted. But "the people . . . did wish for an exact likeness of Abraham Lincoln," and that is exactly what Ream had delivered. Her status and experience as an artist did not matter; what really counted were her technical skill and her powers of perception, her ability to recognize and copy Lincoln's physiognomy rather than her genius at producing a great work of art. In the ceremony's crowning moment, the artist herself was presented. Her appearance directly countered the image of Ream as seductress. Ream's attractions were only the inner beauty of a modest, pure woman:

> There was a general movement to catch a look at one who has been painted in popular romance as a smiling beauty, winning her way as much by her fascination of manner as by her genius. But it was no doll-like, dimpled face of seductive grace that met the view, but one which told in its paleness, and in the sad, earnest eyes, of overwork, broken health, and a burden of cares and responsibilities beyond her years. It was a face of unmistakable beauty, but it was the beauty of intelligence and genius shining through dark, lustrous eyes, and the lineaments of a mobile countenance. She paused but a moment in answer to the warm applause of sympathy and admiration that greeted her and shrunk back modestly to her inconspicuous seat.[39]

The sculpture itself conformed to popular expectations of purity and modesty. Unlike Greenough's bare-chested *George Washington* and the scandalous busts at her own studio, Ream's *Abraham Lincoln* wore contemporary dress, hiding the precise musculature of his body.

Despite the campaign of slander against her, Ream had managed not only to keep the Lincoln commission, but to sculpt a statue that elicited admiration from the public, an accomplishment on which she could build a career in art. This was an outcome that had proved impossible for Louisa Lander. Unlike Lander, Ream had been able to muster defenders to bear witness to her respectability. By the 1870s, the development of public leisure activities for both sexes, urban growth, and the expansion of the woman's rights movement, among other factors, were gradually easing strictures on women's behavior and presence in public.[40] In addition, the controversies involving Ream unfolded in the United States, far from the suspiciously sen-

sual overtones of Europe, where a different cultural climate had seemed to infect Lander.

Even in this less rigid domestic environment, however, rumors continued to shadow Ream's career. Harriet Hosmer intervened on Ream's behalf, writing a letter to the *New York Tribune*. Hosmer was only too conscious of her own battle in 1863–64 against detractors who charged that Hosmer's workmen did the actual sculpting of her pieces; now similar accusations circulated about Ream, who reportedly spent her time "flitting about" with dignitaries while stonecutters did her work. When Ream won her next major commission, for a statue of Admiral Farragut, she began carefully collecting written affidavits from such notable individuals as Samuel Wetmore, who willingly bore "testimony to the fidelity of [the] bust."[41] Virginia L. Farragut, the admiral's widow, also sent Ream comforting words, assuring her that she had made an "excellent likeness" of the famous man: "Don't be in the least discouraged by adverse criticism, for it is impossible for any one to achieve greatness in any way without being a target to be shot at from the quiver of envy."[42] Emily Edson Briggs described Ream at work on the statue not just as a "brave little pioneer who has undertaken and achieved so much for women" but the antithesis of vanity, dressed in coarse gray woolens and covered with dust and plaster, her magnificent curls tied back "and a gray veil wound round her head with no more attempt at display than if she were a Carmelite nun."[43] Despite (or because of) this sartorial severity, Ream attracted a group of naval admirers, including Lieutenant Richard Hoxie. It took Ream's marriage to Hoxie in 1878—and subsequent retirement from professional sculpture until 1906—to quell doubts concerning her reputation.

Overall, the public perceived the activities of women artists in the studio as reflections of their activities outside it. Women artists had been able to claim the studio as domestic space. However, now they found that the codes of home life and woman's sphere were being applied to women's professional space. Women's studios were expected to be as void of sexual imagery and energy as the parlor and nursery—a passionless ideal very different from the prototype of the male artist's "virile" genius, and from the practical requirements of professional art. As in Swisshelm's attack on Vinnie Ream, objections raised about women artists often involved a dual disapproval of personal and professional choices. The ideal woman artist not only lived a pure life but depicted pure subjects, such as the fountain *Angel of the Waters*, in which four ideal figures—Health, Temperance, Peace, and (of course) Pu-

rity—stood on a pedestal. Its sculptor, Emma Stebbins, claimed it was in-spired by a Biblical verse.[44] Women sculptors with more earthbound inter-ests incited the aspersions of male fellow artists as well as their patrons and audiences. "Miss Hosmer's want of modesty is enough to disgust a dog. She has had casts for the *entire* model made and exhibited them in a shocking in-decent manner to all the young artists who called upon her. This is going at it *rather strong*," sculptor Thomas Crawford wrote to his wife, Louisa.[45] Mea-suring Hosmer against his own wife, Crawford found Hosmer lacking in femininity and fashion sense; furthermore, he criticized Hosmer by associat-ing the artist's character with the type of work she did. Hosmer "made" *and* "exhibited" her casts "in a shocking indecent manner"—that is, she made nude figures and placed them on public display. One wonders how she could have exhibited the casts in a conventional, decent manner, or how she could have produced casts for a partial model.

But ambitious women artists could not avoid controversial subjects any more than they could reject the aspects of art life and training (like copying at the Louvre) that placed them in questionably public roles. Artists aspiring to professional status, or even to the lofty realm of greatness, had to meet specific expectations and satisfy distinct criteria. The nude in particular was an extremely important part of art traditions in both sculpture and painting; historical and figure subjects represented the apex of the art hierarchy. Any artist who categorically avoided the nude would occupy a diminished posi-tion as a professional. At the same time, as the experiences of Louisa Lander, Vinnie Ream, Harriet Hosmer, and others like them made apparent, it re-mained necessary for a woman to maintain a pure reputation if the critics and the public were to accept her as an artist. A blameless reputation might enable a woman artist to take some professional risks; a fallen innocence rendered her unfit for any type of art career at all.

Sculptor Anne Whitney consciously weighed those two sets of demands—demands on the artist versus demands on the woman—while deciding how to represent Lady Godiva. *Lady Godiva* (1862) was Whitney's first full-size sculpture. According to English legend, Godiva, a noblewoman, had ridden naked through the streets of Coventry in protest of an unfair tax. Whitney, a woman's rights activist, felt that the image of a woman involved in political protest could be particularly powerful. The question was how to represent the figure. Whitney conferred with other artists in deciding whether to make her Lady Godiva a nude. Her friend, painter William Trost Richards, advised her not to. He could not envision Whitney succeeding when, in his

opinion, other sculptors had failed to avoid sensationalism and immorality in depictions of the nude; in Richards's eyes, Erastus Dow Palmer's *White Captive*, depicting the nude figure of a girl captured by Indians, was nothing more than "a wickedness." "Godiva is certainly an embodiment of the essential purity of woman which cannot in itself be unconscious, and so her act of piety is a sacrifice of greater force," he wrote. "From this standpoint Godiva is too sacred to be put up in the market place."[46] He was alluding to the auction block, on which Hiram Powers's *Greek Slave* and other neoclassical images of captive women stood, as well as to the marketplace of art, in which Whitney ultimately agreed that her message would be better communicated by a clothed Godiva. She elected to show her subject in the act of removing her belt, her moment of defiance against social convention. The subject, Godiva, defied; Whitney, in portraying her clothed, did not.

Woman's rights champion Caroline Healy Dall wrote to Whitney approvingly. "I am glad it is not nude, for I don't think nude figures fair in this century. There is not any common knowledge of the nude form as in ancient times, and so there is no criterion of judgment. There is something to get over, and so the beauty does not touch as it should." Whitney's response to Dall reveals her own greater sophistication on the subject. "About the nude in Art—you are in outer darkness where are wailing and gnashing of teeth. I shall let you go this time, but when I catch you, look to be dealt with."[47] Part of Whitney's artistic decision to portray Godiva clothed was based on an anticipated audience response; she knew that although there was still a place for "the nude in Art," the public would associate an unclothed figure with those sculpted by Powers and Palmer. She wanted to create an alternative image to the modest, resigned womanhood idealized by *The Greek Slave* or *The White Captive*, and offer a different model of femininity: a woman who was willing to break rules in order to achieve social change on behalf of others. The subliminal sexuality of the neoclassical nude would have undermined Whitney's moral purpose.

Other women artists also admired and defended the nude in principle as a legitimate subject for women, but avoided or rejected it in their own work, knowing it could not be rendered acceptable. "When Mr. P. found out that I admired Rubens, his face fell, much as if I had confessed to being the Scarlet Woman," Cecilia Beaux recalled when she wrote a memoir of her successful career as a painter. "His aesthetic sensitiveness was extreme; my appetite was voracious"—a voraciousness that did not, as it turned out, extend to the inclusion of nude subjects (Rubenesque or otherwise) in her own oeuvre.[48]

Mary Cassatt had to be particularly vigilant of her reputation while part of impressionist circles because of the movement's radicalism; its supposed "brutality" and "sensuality" were so jarring to Victorian sensibilities that impressionist art was often labeled pornographic. As a serious artist, Cassatt was fascinated by the major themes of modern art: realism and sexuality. Her admiration for Edgar Degas extended to his paintings of dancers and bathers, with their veiled references to prostitution; in fact, Cassatt did not shrink even from Degas' more frankly sexual drawings of brothel scenes.[49]

Driven to incorporate sensuality and realism into her own work, but aware that male impressionists' subject matter was largely inaccessible to her, Cassatt turned her focus to a different sort of public woman: the woman in the theater audience. Nineteenth-century Europeans and Americans viewed female stage performers, including ballet dancers and actresses, as gender transgressors because their professions were so public. They not only displayed their bodies in a very public setting, but also in a sense sold their bodies (or, more specifically, the view of their bodies) to ticket holders. It was a small step to associate these public women, often of working-class origin, with actual prostitutes. Theater audiences, however, grew increasingly genteel. Cassatt herself went to the theater "once or twice a week" with her parents and sister Lydia; what could be more respectable? This was a satisfyingly modern subject: the woman at the theater, who—unlike the woman *of* the theater—could evade sexual connotations.[50]

In this way, Cassatt's "young women watching and being watched" at the theater, a theme she worked between 1879 and 1882, had much in common with the subjects of other impressionists, like Renoir, though women in Cassatt's theater scenes are of a higher social class.[51] She exhibited a painting of her sister, *Lydia in a Loge*, at her first showing with the impressionists in 1879. A series of others followed, including *Young Lady in a Loge Holding a Wide-Open Fan* (1879), *Young Lady in a Loge Gazing to the Right* (ca. 1880), and *Two Young Ladies in a Loge* (1882). The dominant image in these paintings is the fashionable young girl in the theater audience. Cassatt often juxtaposed the image of the girl against the girl's reflection in a curved mirror behind her: a visual metaphor for society, vanity, consciousness of one's self on display. Cassatt's young ladies are pure and virginal, not sexual; innocent, demure, and—crucially—upper class, and therefore not viewed as sexually corruptible like the lower-class women, from dancers to laundresses, often depicted in impressionist iconography. Her frequent use of her own sister as the model for these paintings reinforced the respectability of the subject.[52]

The most intriguing theater-audience painting by Cassatt depicted a completely different type of woman, however. The subject of *In the Loge* (1879, Figure 5) is also pure, but she is not a debutante. She is a more mature woman, both physically and intellectually. She is not dressed in pale décolletage but in sober black, relieved only by touches of lace and pearl stud earrings. Her fan is folded, and instead of flowers she holds opera glasses. While Renoir and Degas both portrayed women in theater boxes, they never showed their subjects using glasses. Cassatt's *In the Loge* does not simply carry glasses, she *uses* them, with confidence and concentration.[53] The woman is gazed upon as she gazes; she has the power to look and as-

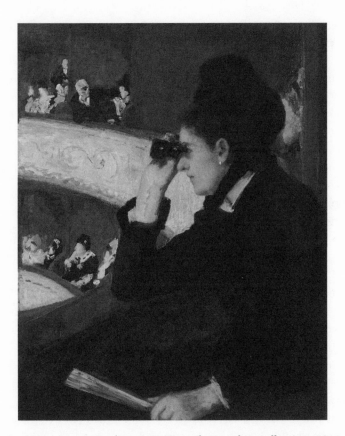

Figure 5. Mary Cassatt, *In the Loge* (1879). The Hayden Collection, 1910. Courtesy Museum of Fine Arts, Boston. Reproduced with permission. © 2000 Museum of Fine Arts, Boston. All rights reserved.

sess for herself, but she is also subjected to the inspection of a man across the theater. Ingenue or intellectual, the woman at the theater is a public woman, a woman who may be sexualized despite her sobriety and modesty. In this way, her image functions as a subtle analogy to the woman artist's similarly sexualized status as a public woman. Though the woman in black carries none of the painter's tools, Cassatt's painting is essentially a portrait of herself as an artist, doing the artist's most crucial task: looking critically. One of Cassatt's biographers has noted the woman's striking resemblance to Cassatt herself.[54] Most of all, the painting is remarkable for its ingenious ability to engage the theme of sexuality and to place an autobiographical woman subject at its center in a position of power—the power to see (and be seen) for herself.

For most women artists, though, the tension between purity and passion-lessness in their art began long before any mature work; it started with their instruction in life drawing. Without offering a full curriculum, including life classes, to their female students, art schools would not be fully preparing them for professional careers. Besides the fact that the nude represented the epitome of high art, any work of art that rendered the human form re-quired some knowledge of the body in order to seem realistic. In order to provide training in rendering the figure, art schools since the Renaissance had been organized around three main subjects: the antique, the life class, and the study of anatomy.[55] Yet how could women art students look at na-ked human models without endangering their innocence, their modesty, their "feminine delicacy"?

At first, American art academies simply did not allow women to take cer-tain classes. The Pennsylvania Academy of the Fine Arts (PAFA) in Philadel-phia did not even permit women students to enroll in the Antique Class, which focused on the drawing of antique casts and statuary, or to copy works from the Academy's gallery because they would be sketching nude figures while in sexually mixed company. In 1844, the PAFA began to set aside one hour three days a week for female copyists. In 1856, "a close fitting, but, inconspicuous fig leaf" was attached to certain statues "in need of it" (all these statues depicted male figures). This action not only freed women to join the Antique Class but would encourage other modest Phila-delphia ladies to visit the PAFA gallery.[56] Some nineteenth-century Ameri-can art schools did allow women to draw from draped or partially draped models, but only under terms that would preserve their students' delicacy and respectability: they established separate female and male life drawing

classes. Excluded from the Pennsylvania Academy life class, a group of women students including Eliza Haldeman organized their own, "although not from the nude."[57] The PAFA quietly began a Ladies' Life Class in 1868, the direct result of a petition from women students. Within a month, more women than men were attending life classes at the academy.[58] In this and subsequent petitions, women at the Pennsylvania Academy explicitly connected access to life studies to their aspirations toward professional status. "We are earnest," wrote Susan Macdowell in representing the Ladies' Life Class, "and without any desire of dictating ask only that whatever may be done by the Academy for the Students will be in the direction of the life classes, which means of study we understand to be the most important to those who wish to make painting a profession."[59]

Other American art schools soon followed suit. New York's National Academy of Design started offering its own ladies' life class in 1871. The Corcoran School of Art in Washington, D.C., offered two life classes: one during the day for women and a separate one at night for men. Twenty out of the fifty-one founding members of the radical Art Students' League in New York were women; by 1879, a mere four years later, the League provided "more hours of life study than any other school in the world," but there too men and women attended separate life classes. The Art Students' League continued the practice of gender-segregated life classes until World War I, as did the National Academy of Design until the early 1930s. The men's and women's classes at the Art Students' League did not join to draw undraped models of both sexes until the 1960s.

Though women art students were receiving a rigorous education by the 1880s, this training was granted only on a strictly segregated basis. Even so, life classes for women remained controversial. The ultimate reason behind the life class—preparation for professional status as an artist—might seem as improper as the activities in which it engaged women students. Perhaps that is why Cecilia Beaux attributed her uncle's opposition to her enrollment at the Pennsylvania Academy to his "chivalry" as much as to his "Quaker soul."[60]

The innovation of sex-segregated life classes seemed the ideal compromise for two significant reasons. First of all, it allowed different models for each group, thus making it possible to protect women art students from exposure to nude male models. The Pennsylvania Academy of the Fine Arts did not allow any male models to pose for its ladies' life class until 1877. The National Academy of Design's School Committee clearly stipulated "that the *Male*

model in the Life School for women shall in no case stand *entirely nude* and also that *no woman* shall be admitted to the life school *under 21 years of age*."[61] At the Art Students' League, "Men's classes worked from completely nude male models; women worked from either nude female models or from male models in loin clothes."[62] (Interestingly, men would also be held to a standard of purity at the Art Students' League: they were kept from unclothed female bodies.) Second, these arrangements ensured that men and women would not be simultaneously looking at a naked body.

Moreover, in both popular and artistic circles, the pairing of artist and model overwhelmingly connoted a male artist and a female model, a relationship reinforced by the professional attire of the former and the nudity or costume of the latter. In fact, around the late eighteenth century, unclothed female models largely replaced unclothed male models in life classes at both academies and studios.[63] It would have been embarrassing both for the men and the women sketching or sculpting to view the model in the others' presence. But for the women students especially, the presence of a nude female body would have seemed both a revelation and an exaggeration of their common position: as women, both students and model were on public display. The nude model exposed women artists' sex and sexuality. One is reminded of the ambiguous position of the copyists at the Louvre and the bare-breasted sculptures in Vinnie Ream's studio. When both artist and art subject were female, the lines between them seemed more blurred than ever. Ensconced in their own environment, however, free from masculine eyes, women artists could restore the normative relationship between artist and model. In the absence of men, women could take up their full-fledged roles as artists. The segregated life class did not count as a public space any more than the parlor did; by definition, the public sphere denoted the space in which there were only men. Notably, life-class instructors—most of whom were male—did not appear to figure into this equation, first because their position was so clearly authoritative, and second because they were not in constant attendance in the classroom anyway.[64]

Women artists were conscious of the importance of life studies to their careers, of its danger to their reputation, and in particular of the risk that in sketching or sculpting nudes they themselves would be sexualized. When Janet Scudder first met her employer, Lorado Taft, he was in the act of "modeling from life the figure of a nude girl." Scudder felt no discomfort— quite the opposite: "The whole scene was filled with enthusiasm and energy and concentration. I felt I had suddenly stepped into Paradise." She recog-

nized that the act of modeling a nude figure defined professional art—her personal Paradise. She described another model as "handsome, sedate, dignified," kind, a good friend, and a lover of art. Having grown up in a poor family, perhaps Scudder had not internalized the middle-class ideal of pure womanhood in its entirety. Anne Whitney, certainly well inured to the demands of "true womanhood," experimented with a different strategy: desexualizing the model. *Le Modèle* (1875) is not only advanced in years, but exhausted from her labor; Whitney depicts her asleep in her chair. As in her previous work, *Roma* (1869), Whitney pushed against the boundaries of allegory, proposing that an aged, working-class woman could signify the corruption of Roman politics, or the spirit of France.[65]

Art schools largely ignored the danger that interactions between women artists and women models might erode the passionless feminine ideal. Serious women students learned to ignore it as well because, increasingly, a refusal to study the nude became an impediment to professional status in the fine arts. In the traditional rhetoric of art, at least, the relationship between artist and model might be sensual, but it was not really sexual; the model, whether a human being or a bowl of fruit, merely acted as a vehicle for the artist.[66] Furthermore, nineteenth-century Americans had an enormous capacity for dismissing the possibility of homoeroticism between women. The same dearth of suspicion that led to tolerance of female households also extended to the studio and classroom, where the absence of men seemed to guarantee safety from sexual passion.

Thus, administrators and students alike felt secure that the segregated life class would enable both men and women to gain professional training and credentials without entering the muddy waters of sexuality. Proud of their innovative course of study, and perhaps eager to advertise among prospective women students, the Pennsylvania Academy commissioned Alice Barber to paint *The Women's Life Class* (1879, Figure 6); Barber herself engraved the painting for *Scribner's Monthly* that same year, to illustrate an article about Philadelphia art schools.

Another illustration for the article shows women and men sketching together in an antique class, and a drawing by Susan Macdowell of a lesson in "Differentiating the Muscles of the Face by Electricity" seems to include women as well as men in the shadowed, indistinct audience in the foreground. However, etchings of *The Men's Modeling Class* (originally drawn by James P. Kelly) and Walter M. Davis's *The Male Life Class* (the companion piece to Barber's) illustrate how men and women would be carefully

separated when nudity was involved. Kelly, Davis, and Barber documented models of the same sex as the students sketching, and in each case with back turned to the viewer. The students' work in *The Men's Modeling Class* is on clear view; in fact one of the sculptures in progress is turned so that the viewer can see the front of the nude figure. All of the men in both the modeling class and the life class are portrayed in deep concentration. In Barber's *Women's Life Class,* however, the women artists assume a more ambivalent role. Some are loitering at the periphery of the group, and they lack easels and brushes, so that it is not clear whether they are painters or models waiting to pose next. Only four canvases appear among twelve students. Compared to the sharp profiles of several students in *The Male Life Class,* only

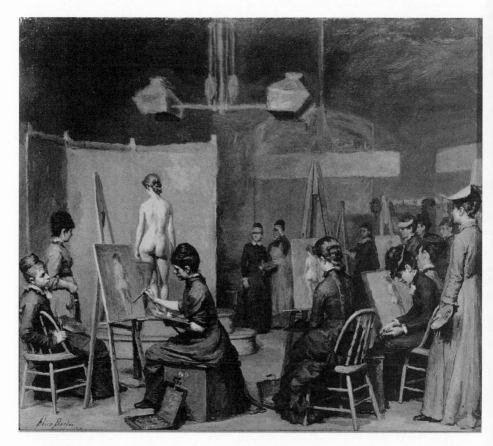

Figure 6. Alice Barber (Stephens), *The Women's Life Class* (1879). Courtesy The Pennsylvania Academy of the Fine Arts, Philadelphia. Gift of the artist.

two of the women's faces emerge clearly; the rest are shadowed, hidden by hats, or turned to their work. Like the model, their identities are obscured out of modesty, but in the case of the women art students, it is either their work or the model herself that draws their heads away from the viewer. The text of the *Scribner's* article mentions raw numbers of women students at the Pennsylvania Academy and points out the existence of men's and women's life classes (held at different times in the same room, "probably the largest room in the country that is devoted to such a purpose"), but otherwise renders the women students invisible. It is in Barber's image of the female life class alone that women appear prominently as Philadelphia art students. But the image is there, for all its evasions an insistent reminder of women's arrival as professionals in training, portrayed in the act of painting the most revered subject in nineteenth-century art: the female nude.[67]

The readers of mainstream magazines like *Scribner's Monthly* may have approved of the idea of a separate female life class, but its respectability remained contingent on the observance of certain unwritten rules. The Pennsylvania Academy hired painter Thomas Eakins in 1876 to assist Christian Schussele; Eakins became the school's director in 1882 when Schussele died, but was forced to resign only four years later. An ardent advocate of anatomy and life drawing for all students, Eakins proved to be too radical for the Academy, and for the postbellum Philadelphia art community in general. In an infamous example of Victorian morality, an anonymous woman, R. S., attacked his ideas in a letter to the Academy's president:

> Would you be willing to take a young daughter of your own into the Academy Life Class, to the study of the nude figure of a woman, whom you would shudder to have sit in your parlor and converse with your daughter? Would you be willing to sit there with your daughter, or know she was sitting there with a dozen others, studying a nude figure, while the professor walked around criticizing that nudity, as to her roundness in this part, and swell of the muscles in another? That daughter at home had been shielded from every thought that might lead her young mind from the most rigid chastity. Her mother had never allowed her to see her young naked brothers, hardly her sisters after their babyhood, and yet at the age of eighteen or nineteen, for the culture of high Art, she entered a class where both male and female figures stood before her in their horrid nakedness.[68]

Dissent grew, scandal loomed, and the PAFA administration became skeptical. Eakins insisted that students, both male and female, work from nude male models, some of whom were also students at the Academy. The partic-

ular practice of using male students as models drew the criticism of another student, Diana Franklin.[69] Probably fearful of losing female students, in February 1886 the board of directors finally asked Eakins to resign his position.[70] Though a group of his students (both male and female) sent a letter of protest, the dismissal stood. The Philadelphia press immediately attributed the dismissal to Eakins's life-class policies. The controversy repeated itself in 1888, when Eakins delivered a series of anatomy lectures to the Art Students' League. "I am sure that the study of anatomy is not going to benefit any grown person who is not willing to see or be seen seeing the naked figure, and my lectures are only for serious students wishing to become painters or sculptors. Adverse criticism could be avoided by announcement of when I should use the naked model," Eakins advised. "Kindly console the jock-strap people with my conviction that missing a few lectures will have no effect upon their careers." But forewarnings and precautions were not enough to avoid complaints, such as that of Mrs. M. W. Tyndale, who wrote that "the feelings of both students and model were needlessly outraged" by the lecture.[71] When the Art Students' League instituted a mixed modeling class, taught by Augustus Saint-Gaudens, in 1890, many women protested. Such incidents show the limits of women's participation in art training and art life—limits imposed by themselves as well as by others, for even within a professionalized context, some women artists felt their sensibilities threatened by the nudity of a male model. New lines were being drawn between women who wanted full inclusion among the ranks of professional artists and women who felt that the loss of their modesty or purity was too high a price to pay.[72]

American women who studied in Europe in the 1870s and 1880s encountered curricula that were at least as conservative as those of United States art schools with regard to life studies. Many prestigious schools, including the Académie des Beaux Arts in Paris, still refused to accept women students. The schools and studios where women might enroll offered sex-segregated life classes just as in the United States. May Alcott recommended that young women artists band together to hire their own studio and teacher "and get on with the business of learning to draw the male and female figure" when they found they could not join sexually mixed life-drawing classes.[73] Elizabeth Jane Gardner tried another strategy, disguising herself in masculine clothes in order to enter the life-study classes at the government-subsidized Gobelins tapestry school in January 1873. Other women chose the simpler option of attending the popular Académie Julien in Paris, which was open to

both women and men since its foundation in 1868.[74] But mixed classes ended in 1876–1877, when the school initiated a separate women's class, which was "notoriously overcrowded, airless, overheated, and incredibly noisy," at double the tuition men paid.[75] In a letter to her family back in Concord, Massachusetts, May Alcott commented on this change:

> I believe the lower school as it is called, or the male class, no longer opens its doors to women, for the price being but one half of the upper school, attracted too many. Also, with better models, and a higher standard of work, it was found impossible that women should paint from the living nude models of both sexes, side by side with the Frenchmen. This is a sad conclusion to arrive at, when one remembers the brave efforts made by a band of American ladies some years ago, who supported one another with such dignity and modesty, in a steadfast purpose under this ordeal, that even Parisians, to whom such a type of womanly character was unknown and incomprehensible, were forced into respect and admiration of the simple earnestness and purity which proved a sufficient protection from even their evil tongues; M. Julien himself confessing that if all ladies exercised the beneficial influence of a certain Madonna-faced Miss N. among them, anything would be possible. Something besides courage was needed for such a triumph, and women of no other nationality could have accomplished it; though it must be acknowledged, a like clique will not easily be met with again. So, let those who commonly represent the indiscreet, husband-hunting butterfly, as the typical American girl abroad, at least do her the justice to put this fact on record, to her credit.[76]

Alcott's account illuminates the way in which women artists themselves understood the interrelation of art, sex, femininity, and purity. First, she contended, it was because of the "better models" and the "higher standard of work" that "it was found impossible that women should paint from the living nude models of both sexes, side by side with the Frenchmen." That is, no one bothered about what dilettantish ladies did, but when the motivation was Art and professionalism, men could not afford to work alongside women; the very presence of women adulterated the professionalism of the enterprise. Second, Alcott considered the best argument against this "sad conclusion" to have been "the brave efforts" of a group of American women (presumably led by Jane Gardner) who had earned their place in the class by their "simple earnestness and purity," approaching that of the Madonna in looks as well as actions. It is also worth noting that Alcott traced this coura-

geous purity to the women artists' Americanness, silently but powerfully measured against the implied impurity of Parisian women artists. It is because "such a type of womanly character was unknown and incomprehensible" to Frenchmen—having no counterparts to pure American women among them—that all women were shut out of the class. Indeed, "if all ladies exercised the beneficial influence of a certain Madonna-faced Miss N. among them, anything would be possible."

In Europe as in the United States, women students pressed for equal access to studio resources and equal treatment as professionals. Painter Anna Klumpke remembered that at the Académie Julien "the nude model posed all day in the men's class . . . In the women's class the draped model posed in the morning and the nude in the afternoon. The women's class had its talent, not to say its ambitions, and Marie Bashkirtseff circulated a petition demanding that they too should be permitted to work all day after the nude model. Julien granted the request, and moved the men students to another place."[77] In this story, as well as Alcott's, it is the woman artist who stands up as the hero and demands her right to work and study like her male counterparts. But she apparently did not protest her isolation from her brother artists as long as she could follow an equivalent course of study. Women art students seemed conscious that the institution of a women's class, a feminine space within the masculine system, offered them a sort of protection. Integrating the life classes, like removing a male model's loincloth, would expose them to public disapproval and perhaps to the real loss of their maidenly modesty as well—in both cases jeopardizing their status as professionals and as proper women.

Many women painters expressed distaste for or uninterest in nude subjects. "I had no wish to paint the nude," Anna Lea Merritt declared. She expressed doubt over the necessity of life studies to the production of great art: "the many years of training in life classes may be rather unnecessary if the people who go for study are artists at heart, truly called to be artists." Yet her first nude study, done without ever having taken a life class, won an honorable mention at the Paris International Exhibition in 1889, and she allowed herself to be "persuaded" to exhibit a nude subject at the Royal Academy even though "at that time a nude was hardly ever exhibited, and I had not intended it for that purpose."[78] Other women artists emphatically denied feeling any sensual connection between artist and model. "I look upon a model as I would a statue and wish it were as easy to draw," Mary Wheeler wrote to her friend and fellow painter, Mary Noble.

As to the argument of its corrupting models to pose, I do not believe it a consequence, for I find the line carefully drawn between those who are *convenable*, the girls speak with contempt of those who are *not*. One of the best models, we have had, came regularly with her husband, 'tis chosen by these girls as much as any other vocation. I think it unkind to criticise the way in which a pure-minded woman goes about her work and I felt more grieved by Mrs. L. as I hope confidently to teach this way in America, for in London the women draw from the nude and already in New York, I am told . . . I've been now so long in Paris that I've learned to avoid the disturbing nude monstrosities at the Salon that glared so upon me at first. I can pass by and enjoy what is pure and breathes of country and real poetry and sentiment.[79]

In another letter to her friend, Wheeler wrote, "When Mrs. L. talks to you of Paris, please don't accept her facts, for her statements are not reliable. We've a little better chance to know than she. In Monsieur Jacquesson's studio for one, there has scarcely ever been a nude female model." This was not a complaint, but a statement in defense of the propriety of her life abroad.[80]

For the most ambitious women painters and sculptors, life studies offered more than the opportunity to learn the technical aspects of depicting the human body. Life studies also represented the chance for a woman artist to occupy the position of true artist, to adopt the "male gaze" of desire and possession.[81] May Alcott viewed male models with a sensual eye. She described one as "a perfectly superb model, an Italian of fine rich color, grand physique and the head of a god, with great soft eyes, proud dilating nostrils, and dark moustache, while his black hair curls all over his finely shaped head . . . you can't wonder we admire the beautiful creature."[82] When Cecilia Beaux attempted to describe why she wished to paint a particular model in Brittany, she cited the woman's physical beauty, "a face that halts the passing stranger, by its pure cool reflection of line and proportion, its color and texture like the inward slope of a seashell." Beaux saw evidence of "high race" in the "paysanne" woman's physiognomy. Her "purity" is further "purified" by the headdress that covers her hair. The other elements of her costume sensualize her with a curious androgyny: "a high, black bodice, tightly binding in her form, as she goes in her heavy skirt and sabots, with her long boyish stride." It is little wonder that Beaux decided she "wanted a better chance to enjoy her beauty and know it better.[83] She began by trying to intellectualize her attraction to the model by citing her beauty in terms of

"line and proportion," but soon slipped into more subjective language. It was the Breton woman's combination of feminine and masculine qualities that won Beaux's notice. Beaux's descriptions of other models and sitters, such as Louise Kinsella, have a similarly sensual tone.[84]

For women with the highest aspirations toward serious professional careers and even greatness in art, life study was not just a right to be won but an experience to be enjoyed. Women artists such as May Alcott and Janet Scudder wanted full access to life classes not only in order to be able to study the figure, but in order to be artists. At the same time, it was not Alcott's nudes or even her figure paintings but a still life, *Fruit and Bottles*, that won a place in the Paris Salon of 1877 and thus signified Alcott's arrival as a serious, professional artist. As acceptable as women's nudes became in the classroom or studio, the limits around their production prevailed. The general public was of course not sexually segregated; thus an exhibition would result in the same sexual danger evoked by men and women looking at nude models together. The public's perception of nudes produced by men, such as the quintessential *Greek Slave*, could be managed by art critics and experts. But because they exposed the artist's sexuality, not just the viewer's, nudes by women proved more unruly; either the woman artist risked being over-identified with her nude female subject or she displayed her transgression of having looked at and interpreted a nude male body.

The ultimate boundary separating pure women artists from the sexualizing nude, however, was linked to race as well as gender. The complicated power dynamics between a woman artist and her male model differed considerably with the artist's and model's race. A white woman artist might even find the balance of power in her favor when an African American man posed for her. May Alcott described one of her Parisian models, a man of African descent, as "such a splendid specimen of a man that he looks very princely" and "the most gentlemanly, polite, and delicate model that we have had." The instructor praised her drawing: "Muller said, 'With what passion and enthusiasm you draw this ensemble; it is very vigorous and shows your interest and not scorn of the race.'"[85] The event brought Alcott no negative consequences: Muller praised his student, Alcott felt proud enough to report the incident to her family (though she couched it in terms of her abolitionist proselytizing among other students), and editor Caroline Ticknor thought it flattering enough to include an account of it in her memoir of Alcott.

At the same time, the sexuality of racial "others" was considered to be so

strong and vulgar that it might contaminate the woman artist. One should remember that Alcott's experience was a rarity, and that it occurred in France, not the United States. By her own account, her fellow American women in the studio could not set aside their prejudice sufficiently to draw the African model successfully; unlike Alcott, with her unusually strong abolitionist upbringing, they must have felt quite uncomfortable sketching this particular subject, even though he was draped. It is worth noting that Muller specifically lauded Alcott's "passion"—that the African model had elicited a passionate response in the woman artist. Outside of the classroom, and often within it as well, the awakening of passion in an ideally passionless woman would have been seen as inappropriate, dangerous, or even indicative of Alcott's innate impurity.

Racial difference seemed such dangerous ground in the postbellum period precisely because sexual anxieties played themselves out in the intertwined terms of race and gender. Traditionally, the lack of sexual control supposedly exhibited by African Americans, Native Americans, and Asian Americans was cited as grounds for their political exclusion. Images of nonwhite Americans in both high art and the popular press made clear that these groups were vulgar figures, objects of mockery, or, at best, foils for white figures. Emancipation threatened to introduce disorder and "animal" appetites into polite society and politics. In postbellum America, sexuality continued to be what John D'Emilio and Estelle B. Freedman call a "'weapon of terror' with which to intimidate blacks and keep them from assuming social equality with whites," as it had been under slavery. Sexual attacks of African American women by white men and lynchings of African American men for alleged attacks on white women ripped the South asunder with physical violence and the North with fierce verbal battles.[86] Only oppression could contain the extreme sexual danger posed by "Negroes," Southern apologists argued; only slavery had kept this threat from erupting earlier. The characterization of African Americans and other nonwhite groups as lascivious, sexually voracious, and potentially violent proved potent and effective in marginalizing them from mainstream American culture. Certainly nothing seemed further from the ideal of pure womanhood.[87]

Some women artists protested this sexualization of race and the white-supremacist political agenda that went along with it. Anne Whitney's antislavery statue *Africa* (1864), a plaster cast of which was exhibited in conjunction with *Lady Godiva*, had an innovative design: *Africa* was not a woman on the auction block, like *The Greek Slave*, but waking to a destiny of

freedom. *Africa* "was a masterly design, wrought out in a most triumphant manner. It imitates no model, followed no tradition, copied no antique, but was a fresh, original masterpiece of genius, contributed to the art and history of the time," wrote woman's rights and temperance leader Mary Livermore.[88] Of all the neoclassical sculptors, only William Wetmore Story had ever used a black woman to emblemize emancipation, and his treatment was very different, his *African Sibyl* foreseeing the future of her race as enslavement, not freedom. Though *Africa*'s almost complete nudity could be interpreted as vulnerability, Whitney's scenario gives no hint of lurking danger. As Mary Livermore described the statue, *Africa* "is depicted just rising from sleep, awakened by the activities of the Civil War and the sound of dropping shackles. She shades her eyes from the glow of her people's growing knowledge, shining bright as they emerge from slavery to a new enlightenment."[89] The Biblical inscription on the statue's base read "And Ethiopia shall soon stretch out her hands unto God." This is a story of triumph, a prophesy of the end of slavery itself; no threat of rape or humiliation figures in *Africa*'s narrative as it does in *The Greek Slave*'s, *The White Captive*'s, and even *Zenobia*'s. Also, *Africa*'s scale was colossal, larger than life-size, reducing the likelihood that *Africa* would be seen as an eroticized odalisque—it was a monument in spirit, though no one had commissioned it.

Whitney thought a great deal about how she should represent her subject. Female models were hard to come by in Boston; women artists usually ended up modeling for each other. So it is no surprise that Whitney's model for *Africa* was another white woman artist, Elizabeth Howard Bartol, or that Whitney returned the favor by sitting for Bartol a number of times in 1865. But when it came to *Africa*'s head and face, Whitney aspired to greater realism than Bartol could provide. She wanted a physiognomy that was clearly black but not stereotyped; she decided to create a three-dimensional composite sketch of real African American features. She visited Harriet Tubman and carefully observed the "noble dusky faces" of the 54th Massachusetts regiment as it marched through Boston, adding to her friend Adeline Manning, "I must tell you, when you come back, of the good time I had calling round on the black people two or three weeks since," presumably to sketch them. "I learned by the means a good deal of the variety of treatment of which the subject is capable, and have felt ever since much more confidence in proceeding with my work."[90]

Whitney was undoubtedly a perfectionist in her work but the problems she would have with *Africa* were not simply technical ones. She had com-

pleted studies in anatomy and had already cast two well-received full-length statues as well as numerous busts and medallions. Her difficulties can be traced to the reactions of her audience to *Africa*. None of the objections raised about the prospect of a nude *Lady Godiva* were brought up in relation to *Africa*. It was not considered unnatural to portray a black woman un-clothed. What art critics objected to in *Africa* was the notion that a female figure with "negroid features" could represent an ideal type. "Neither the colour nor the features of the negro race can be associated with European notions of aesthetic beauty," one contemporary critic wrote.[91] The *Boston Journal* used the same logic in deciding that in Whitney's *Africa* "the African and Egyptian type of feature are most wonderfully fused, the former suf-ficiently prominent to indicate its meaning, without bordering on the more vulgar and broader development of the African peculiarity."[92] The image of a black woman was so inherently and overtly erotic in the public's eyes that it was "vulgar," the furthest possible remove from true womanhood. Whit-ney's dilemma became clear: if she made *Africa* look black enough to exem-plify her race, the subject would be eroticized by her viewers. Though Whit-ney was a devout abolitionist, it is also likely that she could not escape her own culturally constructed conception of slavery.[93] In nineteenth-century European art, which she would have studied in depth by this point in her career, the slave market, whether in New Orleans or Turkey, belonged to the genre of exoticism. The iconography of the "tragic octoroon" was inter-changeable with that of the fair-skinned, voluptuous odalisque of Orientalist harem scenes.[94]

Simultaneously, Whitney began to receive criticisms that *Africa* was not black *enough*. Colonel Thomas Wentworth Higginson, whom she respected both as a friend and as a celebrated abolitionist, suggested gently but firmly that she remodel the statue's head:

I have never seen more noble or impressive heads than some in my regi-ment, which yet would have conveyed fully, even without color, the Afri-can type. And I believe that, had you seen them, they would as inevitably have modified the features of your statue as did your interview with Harriet Tubman the hair. The aesthetic effect of your statue would thus not be marred, and its moral symbolism greatly enhanced—because precisely that which has held Africa down has been the prejudice of the nations against this physical type. It is nothing for her to rise and abnegate her own features in rising; she must rise as God made her or not at all. To my eyes, all that

your statue asserts, the features of the face deny; and I believe that every one, in proportion as he appreciates the spirit of the whole, would appreciate the added triumph of Africanized features.[95]

The *Boatswain's Whistle*, the promotional paper of the Sailor's Fair in Boston where *Africa* first met public eyes, defended Whitney as well as it could. "Standing by this statue yesterday, we heard much fault found with the delicate outline of the features; the childish expression of the whole face," it reported, continuing, "Those who best know all the varieties of the African race, before the Saxon blood has mixed with it, will understand that this criticism is wholly undeserved." But Whitney's exhibition moved on to New York, where art reviewers echoed Higginson's objections. The *New Path*, after praising *Africa* as "the only work in the room that looks as if it had been done by a man," charged that "the face is not the negro face nor any variety of it, nor is the head the negro head. Miss Whitney has only half dared, and between realism and idealism has made a woeful fall . . . she has succeeded in making only a debased type of the Caucasian breed."[96]

Whitney agreed with Higginson that an ideal sculpture should be able to have pure African features and decided to remodel *Africa* before casting it in marble or bronze. She said she had been wrong in handling her theme so broadly, trying to sculpt a black woman as a composite of different types. Whitney collected photos of Sojourner Truth, and began by reworking *Africa*'s nose; soon she was modifying all of the face. She wrote to Manning in despair, "I am not satisfied with the face of the woman. What it has gained in strength of feature, it has lost in feeling and expression, and I will not have done with it until I am better satisfied," and, days later, "Yes, the feet and now the left hand and arm are subjects of revision." She mocked those "foolish little Doctors of opinions with their prescriptions!—The thing that is rightly done justifies aim and method."[97] But she could not forget that the Academy of Design report, the *Leader*, had already claimed that *Africa* "positively offends by a voluptuousness amounting almost to coarseness."[98] What would her audience think if she made the woman look even more stereotypically African? Whitney probably also worried that she might turn her icon into a caricature—her message of hope would definitely be "abnegated" then.

By March 1866, *Africa* had become a "monster" to her sculptor. The plaster cast was at Whitney's studio a month later, presumably still undergoing modifications; but Whitney eventually gave up and destroyed the mold,

an action she regretted in later life. After this failure, Whitney attempted to model a portrait bust based on the exact measurements of her subject (twelve-year-old Nelly May). If she had been pleased with the results, she would probably have tried to use the same methods to remodel *Africa;* but Whitney remained as frustrated as before. "I began, and have continued, with measuring," she wrote, "and I can't get anything out of it but a dull, mechanical thing. I have never done this before. I think I shall never do it again. You cannot make a copy of a live thing, live . . . Art is simply a rendering of *effects* because the nature of things themselves is perpetually elusive."[99] Whitney's next attempt at an abolitionist message featured a historical male black subject: Pierre Dominique Toussaint L'Ouverture, who had expelled the British and Spanish from Haiti in 1798. By 1873, when Whitney completed the statue, the image of a black man (once rarer than the image of the slave woman) was accepted by the art public.[100] Her *Toussaint L'Ouverture* attests to the powerful cultural anxieties surrounding race in the postbellum United States. White women artists had to use iconography carefully in order to evade the dangerous eroticism of African American subjects; judging from Whitney's experience, they could not challenge the association of blackness with corruption and sexuality.

Among women artists in the 1860s and 1870s, it was only Edmonia Lewis—herself half African American and half Chippewa—who was able to produce successful representations of nonwhite women in her art. As a nonwhite (and thus sexualized) woman herself, who exploited rather than denied her racial identity for her own advancement, perhaps Lewis was not in danger of being made any more vulgar by a "vulgar" subject. Even before she became a professional artist, Lewis had experienced firsthand the association of African American women and sexual impurity. While a student at Oberlin in 1862, two white female classmates had accused her of poisoning them with an aphrodisiac before the pair went sleigh riding with their gentlemen friends. The community responded to the accusations with violence: Lewis was severely beaten and left for dead in the woods. Defended by John Mercer Langston, she was cleared of all wrongdoing by the court, but her attackers were never apprehended.[101] In February of the following year, Lewis was accused of stealing art supplies. She would always, it seems, be a transgressor at Oberlin. Consequently, she decided to leave the college and settle in Boston. This time she took advantage of general stereotypes and appealed to abolitionist patrons in the guise of a childlike savage who had never seen a "stone image" (statue) but wanted to make one. Her tactic proved fruitful;

through sales and commissions for future work, she soon financed passage to Rome, where she lived and worked, relatively free from racism, for the rest of her life.

Lewis used nonwhite subjects before other women artists could. She did not derive her Native American subjects from her personal experiences as a Chippewa woman who had by her own account "lived among her mother's people." Instead, she used Henry Wadsworth Longfellow's *Song of Hiawatha* as her point of reference—a source with which her potential audience would have been very familiar. Sculptures such as *Min-ne-ha-ha, Wooing of Hiawatha, Marriage of Hiawatha*, and *Min-ne-ha-ha's Father*, all exhibited at the National Academy of Design in 1868, illustrated scenes from Longfellow's poem. Lewis's identity sanctioned her interest in (and sexual safety among) nonwhite subjects, while the specific subjects she chose did not stray from the conventions of high art. In a way, they are more conservative than other sculptures of Native Americans, such as Hiram Powers's *The Last of the Tribes* (1873), which make no particular literary references.

Like her Native American subjects, Lewis's African American themes drew on romanticized images easily recognized by her white, abolitionist public. For example, Lewis chose an inventive and difficult composition in *Forever Free* (1867), a celebration of the Emancipation Proclamation: two full-length figures, a man and a woman, visually balance and define one another. The straight-haired woman is kneeling with her hands extended, while the man, clearly African American, exultantly lifts his left arm, showing the viewer a manacle and broken chain, while his right hand rests on the woman's shoulder. The composition provides visual evidence of the subjects' propriety and purity—despite their race. The woman is seen as either the wife or, less frequently, the mother of the freedman standing beside her. In either case, she appears to be a worthy woman with a place in the traditional family structure, though she might just as easily be an allegory of Woman, replicating the abolitionist image of the supplicant slave—the woman who, though her race has been freed, is still a slave of her gender.

The inclusion of both male and female figures in *Forever Free* helped Lewis overcome the kind of difficulties Whitney encountered in her allegory *Africa*. As a woman with a specific relationship to a man, the potentially explosive sexuality of the female figure in *Forever Free* is safely contained. Her purity, like that of any True Woman, reflected in her physical appearance: in this case, straight hair, which brings her closer to the neoclassical ideal of beauty (and thus purity) than Whitney's *Africa* ever could.[102] Lewis's use of

mainstream (white) imagery enabled her to represent racial "others" in ways that her audience could recognize as pure, and thus appropriate for a woman artist's work.

In the wake of their success at domesticating art, women artists tried to legitimate their lives and work by redrawing the conventions surrounding women's sexuality. The invention of the sexually segregated life class provided a space in which women artists could sketch, paint, and sculpt the nude, a genre that was otherwise inaccessible to them. But the boundaries around female purity proved less malleable than definitions of domesticity; despite the efforts of less conventional women artists, the ethos of passionlessness remained in place. Even in the role of professional artists, women and men were not supposed to gaze upon unclothed bodies at the same time, and women could not study the male nude. Thus women won the right to *study* the nude, but actual serious artworks by women depicting the nude were only marginally accepted. The original tensions surrounding women's sexuality were covered over again rather than resolved or even challenged on their own terms.

Within these limits, women artists continued to turn gender restrictions to their advantage, using them as the basis for a feminine process of professionalization that paralleled the art classes, clubs, and other institutions that excluded them. Women learned to guard their reputation against charges of immodesty or impurity. They often policed these boundaries themselves, as in the case of some women's response to Thomas Eakins's life classes and anatomy lectures. Access to full professionalism was won only gradually and painfully, and at the cost of widening the divide between the serious woman artist who was willing to risk her reputation for her career and the dilettantish amateur artistic woman who considered her purity more important than her training. This trend would intensify in subsequent decades and fracture women artists' group identity by the 1920s. In the meantime, however, artistic traditions within women's culture and the innovation of the sex-segregated life class worked together to establish a pattern for women's professionalization in art. In the decades to come, women would develop their own institutions and networks to help them lay claim to an identity that was both feminine and professional.

Sculpting Butter:
Gender Separatism and
the Professional Ideal

By the 1870s and 1880s women had succeeded in gaining access to artistic training that was roughly comparable to what men could receive, but women's presence at art schools did not change art education. Segregated in ladies' life classes at school, formally and informally excluded from many artists' associations, and generally perceived as different from their male counterparts, women artists still could not escape their categorization by sex. The specific conditions of their inclusion in the ranks of students and professionals had largely preserved rather than eliminated their status as "women artists." Women artists clearly recognized and worked within the boundaries that gender ideology placed on their development as professionals. As a result, an increasing emphasis on professionalism and the development of the innovative image of an androgynous artist did not lead women artists to abandon a gendered identity. Even as they left behind their increasingly uncomfortable association with domesticity, these artists developed their own "feminine professionalism" to parallel but exist independently of men's.[1]

Even if women artists had wanted to cling to their former image and justify their work as appropriately ladylike and compatible with family responsibilities, by the late nineteenth century the pressures of modern life were blurring the ideological boundaries between public and private, thus effectively fragmenting domesticity. Women had to adapt to the new concepts of gender that they had helped make. At the same time, they had to face their persistent exclusion from men's professionalizing institutions. No longer ideally confined to the physical space of the home and dependent on metaphors to it, women had to develop their own spaces in the larger world. Moreover, they had to reconfigure their identities so that they made sense alongside cultural shifts. The concept of a distinct "feminine professional-

ism" enabled women artists to accommodate ideologies of gender difference that they did not have the luxury of being able to ignore, even as they embraced the principles of professionalism. They both embraced a beneficent separatism and fought for greater inclusivity in mixed-sex institutions. Feminine professionalism represented an additional strategy from which women could draw cultural authority and personal identity.

To cite one important example, professional art associations had become increasingly important in the American art world, and women's explicit exclusion from, or implicit marginalization within, these clubs provided the impetus for them to form their own organizations. In the last decades of the nineteenth century, women transformed their informal female networks into professional women's associations. They also drew on the rich American tradition of female voluntary societies and the expanding club movement. Since the Revolutionary War, women in the United States had learned to raise funds, speak publicly, conduct business, demand rights, build community institutions, and educate themselves through their experience in voluntary associations. Associations, embracing causes from temperance to socialism, comprised women's most acceptable path toward full participation in public and civic life, and thus held great appeal for women professionals of all sorts, including artists. As Estelle Freedman notes, the period from the 1870s to the 1920s was "an era of separate female organization and institution building, the result on the one hand, of the negative push of discrimination in the public, male sphere, and on the other hand, of the positive attraction of the female world of close, personal relationships and domestic institutional structures." Women artists were redefining womanhood through their institutions in a way that paralleled the founding of women's colleges (including women's medical colleges), the club movement, and the settlement movement.[2]

The world's fairs of 1876 and 1893 were pivotal moments, the crowning achievements of female institution building. At the same time, however, the Women's Buildings at the Centennial Exposition in Philadelphia and the World's Columbian Exposition in Chicago revealed tensions and contradictions within separatist ideals. First of all, women's culture emphasized the commonalities shared by all women's art, from china painting to oil painting, embroidery to sculpture, regardless of its public prestige. Professional women artists trying to promote their work found these associations with domestic art increasingly difficult to sustain in the art market. In addition, many believed in formalistic distinctions between "high" and "low" art and

began to resent having their work associated with "lower" kinds of domestic art. Second, analysis of the fair exhibitions reveals that women's culture—and, by association, the ethos of feminine professionalism—was implicitly white women's culture and white feminine professionalism. White women used race to mend the fractures between "high" and "low" art within women's culture. That is, belief in a racial hierarchy still promised to unite all white women's art, and all white women's work, insofar as it was supposedly superior to the "handicrafts" of nonwhite women. African American and Native American women artists in the late nineteenth century found that the strategies of female institution building and feminine professionalism were unavailable to them; while their white "sisters" struggled to preserve their shared culture, women of color drew on other sources to develop their professional identity as artists.

In the abstract, many women envisioned an ideal artist who was independent of either the male or the female sex; however, this androgynous artist was imagined most often by women (including art critics, painters, and sculptors), not men, and was almost always invoked when assessing a woman's work, not a man's. Mariana Van Rensselaer, the renowned critic, articulated this view in 1891 when she told Sara Hallowell that "she would be eager, glad to criticize a woman's work, but with regard to the work and not *because* it is by a woman . . . The fact that it *is by a woman must speak for itself*, but must not intrude itself, any more than a man's sex should be emphasized in speaking of his achievements in art."[3] "One would not need to ask of these drawings whether they were done by a man or woman, or care to know," a typical review claimed, "because the artist is uppermost in the expression, and the execution is so broad and skillful that there is no need for excuse. This is the plane that our women artists must attain."[4] The rebuke that "one would not need to ask" was necessary exactly because viewers asked—or rather, already knew, in attending this particular exhibit, that the charcoal drawings were the work of Sarah J. F. Johnston. While some women began to use initials to hide their gender, exhibits and reviewers often foiled them by revealing them as a Miss or Mrs. Furthermore, the assertion "This is the plane that our women artists must attain" implied that women artists (apart from Johnston) had not yet attained it, and men artists had—that women were, after all, distinguishably inferior; that their sex intruded upon their art; and that as a group women needed to work toward the androgynous ideal where "the artist is uppermost in expression." Less talented men did not provoke the same reproof; a male artist failed as an in-

dividual, not as the representative of a group that had to labor harder and better in order to win a modicum of respect.

While many women would have preferred to strive toward an androgynous ideal, they recognized the very real limits that gender ideology placed on them as professional artists. Painter Elizabeth Bartol summarized the situation in the simplest terms: "We have more to contend with than men," she wrote.[5] As a consequence, they set aside evanescent ideals in practice and pragmatically chose to develop a group identity on their own terms. The most successful late-nineteenth-century women artists, such as Mary Cassatt, Cecilia Beaux, and Anna Lea Merritt, managed to live and work within the ideological boundaries of gender and attained professional status without giving up their publicly perceived femininity.

Indeed, one can argue that women artists pursued a parallel professionalization of their own between 1870 and 1900. Professionalization, as it is generally understood, entails the formalization of credentials, the regularization of training, and the creation of professional associations and clubs.[6] Women artists had won access to art schools and gained permission to study from the nude. But the ladies' life class was kept carefully separate from the men's, and women art students do not seem to have protested the segregation as long as they received equal studio time and instruction. This pattern continued as women artists formed their own professional associations and organized separate women's art exhibitions. They accepted their status as a distinct class of artist, preserved their separate networks, and asserted their identities as professionals who had progressed far beyond the dilettantism of the genteel lady artist. Separate women's associations and exhibitions could have the same functions as general, dominantly male associations and exhibitions, while at the same time creating a protective female space. That is, separatism could dramatically increase women's opportunities for professional development while shielding them from notoriety, in the manner of the ladies' life class, as long as strict standards of excellence were maintained.

An increasing number of women's self-portraits attests to this double consciousness of the woman artist as both feminine and professional. Some identified themselves explicitly as artists by depicting themselves holding brushes or chisels, in the act of making art. They also relied on the convention of the direct gaze, traditionally seen much more frequently in portraits of men than of women, to imply a sitter's depth and intellect. The direct gaze was particularly important in self-portraiture, partly due to the practical ne-

cessity of looking at oneself in order to depict oneself. It also acted as a marker, however, of the artist's self-transformation from object to subject. Women artists could use this convention in their self-portraits to suggest their own keen powers of observation and analysis, their artistic skill—in effect, their professionalism. The artist who sat for a portrait and turned her gaze back out to the viewer transformed herself from an object to a subject. Her image was not merely the object of the viewer's gaze, but asserted its own gaze upon the viewer; her métier was to paint, not to be painted. Elizabeth Nourse, for example, depicts herself arrested in the act of painting in her *Self-Portrait* (1892). Her searing, intellectual gaze leaves no doubt that she is engaged in a serious analytical enterprise. To complete the impression, though it may have been herself she was studying so intently to produce her image, it is the viewer who is under scrutiny as the artist peers from the canvas.

Not all paintings exposed the sitter's profession so explicitly, but other self-portraits are not so easily categorized as feminine versus professional. As had been true for generations, the self-portrait explored a complex sense of self that might or might not have included the props and paraphernalia of art. Cecilia Beaux presented herself differently in each of her self-portraits, painted in 1872–1873, 1880–1885, and 1894; none expressly referenced the tools of her profession. In the earliest, she is obviously very young, her hair tied with ribbon and her gaze averted. In the 1880–1885 painting, all of Beaux's interest is concentrated on the face; the body is conveyed through very loose brushwork. Her head is in the same position as before, but now she gazes penetratingly at the viewer. Beaux's 1894 self-portrait returned to the image of conventional prettiness, a feminine self, with averted eyes, sweet expression, and bright-striped shirtwaist (unlike the typically dark costume of the serious Gilded Age woman professional). In 1902, Beaux submitted this last self-portrait (along with *The Dancing Lesson*) in applying for membership in the prestigious National Academy of Design; that is, she used the 1894 self-portrait to claim her place as an artist. This suggests that Beaux did not consider feminine identity to be a detriment to her public persona as a professional painter. Alice Pike Barney likewise painted many different versions of herself, including *Self-Portrait Reflected in a Mirror* (1896), which shows a smiling, rosy-cheeked belle, and *Self-Portrait in Painting Robe* (1896), where she is shown in the role of artist, staring ahead at the viewer with a serious expression and daubing her brush with paint from her enormous palette. Ellen Day Hale's gaze at the viewer in her 1885 *Self-Portrait*

(Figure 7) rivals that of Nourse in its intensity and acute intelligence. Though there is no brush in sight, the painting's patterned background and Hale's attire mark her as a modern, even a bohemian—not only (or even primarily) by trade but by sensibility. No dreamy feminine figure ornamenting decorative backdrops, Hale is a keen observer, in command of her stylish environment.

The variety and virtuosity of these paintings point to women artists' complex sense of identity. These new images were divorced from the home and family—including the idea these artists had developed in the 1850s and 1860s, that their status as wives, mothers, sisters, and daughters qualified them for art in some special way. Now that they had access to the same (or, in the case of life studies, parallel) routes toward professional status as artists, women no longer had to claim that their place as domestic guardians es-

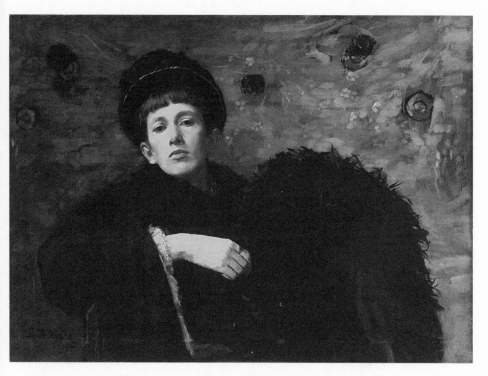

Figure 7. Ellen Day Hale, *Self-Portrait* (1885). Gift of Nancy Hale Bowers, 1986. Courtesy Museum of Fine Arts, Boston. Reproduced with permission. © 2000 Museum of Fine Arts, Boston. All rights reserved.

pecially fitted them for work in art. In fact, allusions to domestic art were often counterproductive to the professionally minded woman artist because of the strong association between domestic femininity and artistic dilettantism. Beginning in the late nineteenth century, most American women artists preferred to point to their individual talents and their rigorous study of art in order to legitimate their pursuit of art careers. Their identity as artists was increasingly less dependent on their familial relationships or their literal position in the home.

Women's new emphasis on art and training, instead of art and domesticity, made marriage seem increasingly incompatible with an artistic career. Women had first gained entry into professional art by arguing that their roles in the home and the studio were complementary. Now they began to regard the demands of career and family as pragmatically and ideologically conflictual. This shift made the woman painter a particularly powerful symbol for many contemporary women writers. Elizabeth Stuart Phelps, Louisa May Alcott, and Constance Fenimore Woolson, for example, wanted to expose the social and emotional costs women paid for public success; their novels drew attention to the many ways in which society constrained female creativity.[7]

Women artists' personal experience as wives and mothers reinforced their sense that professional life interfered with domestic life and vice versa. There was no longer an expectation that a wife would halt her career, as Vinnie Ream had done when she wed Richard Hoxie. But even under the best of circumstances—a supportive husband, ample household income, and servants to help with child rearing—marriage and family placed an increased burden of social expectations on the woman artist. "There *is* no *art* for a woman who marries," illustrator Mary Hallock Foote wrote bitterly to her friend, painter Helena de Kay Gilder. "She may use her gift if she has one, as a drudge uses her needle, or her broom,—but she must be content to see the soul of it wither and the light of it go out."[8] Charlotte Perkins's marriage to one of Providence's most famous artists, Charles Walter Stetson, brought her to a crisis point; her physical and mental health broke down under the pressure of social expectations. "I could not write nor paint nor sew nor talk nor listen to talking nor anything," she recalled in her autobiography. She eventually gave up her art career in favor of writing and lecturing.[9]

Many women artists still chose to marry and attempted to create a balance between family and professional demands within marriage.[10] May Alcott imagined an ideal creative partnership when she married Ernest Nieriker, a

fellow boarder, in Paris in March 1878. For a time, the Nierikers' plan seemed to work: "It is the perfection of living; the wife so free from household cares, so busy, and so happy," May Nieriker reported to her family.[11] "I paint and walk and write all day . . . I mean to combine painting and family, and show that it is a possibility if *let alone*."[12] In autumn she reported an admirable productivity, "oils and water colors, fourteen sketches."[13] But this brilliant promise was cut short. May Alcott Nieriker died in December 1879 from complications following the birth of her daughter, Louisa.

Marriage to one's art teacher or fellow artist seemed to promise a woman the greatest chance for the successful and productive continuation of her career. An artist husband would already be acculturated to the artist's life and thus perhaps be more understanding of a wife's professionalism in the same field; a professional partnership might even evolve, as in the case of California-based painters Alberta and William McClosky. After their marriage in 1883, William and Alberta collaborated on, and actually cosigned, many of their portraits and publicized this unusual working arrangement to attract commissions. Their individual still lifes and genre paintings often featured similar subjects, such as the tissue-wrapped oranges for which they became most famous. The couple separated in 1898, after which Alberta continued to paint.[14] Artists Lilian Westcott and Philip Hale both continued to paint after their marriage; Lilian was widely regarded as the more talented artist of the pair. Philip's sister, Ellen Day Hale, was also a painter, and with Gabrielle de Veaux Clements formed a female network of professional artists who were also literally family for Lilian.

However, most women artists found that the family claim impeded their self-promotion and influenced their professional choices, particularly regarding the genres or styles in which they specialized. In addition to their many sources of encouragement, compromise with convention in other areas of their lives may have contributed to the Hales' success at both marriage and art. Certainly Lilian's soft interiors and frequent mother-and-child subjects invited little apparent disturbance to traditional gender roles.[15] Maria Richards Oakey Dewing, a friend of Helena de Kay Gilder, gave up figure compositions in favor of nature and flower paintings when she wed fellow painter Thomas Wilmer Dewing in 1881. This shift served two purposes: it enabled Dewing to fulfill her duties as a mother, and it took her out of direct competition with her husband. She even collaborated with him on some figure paintings. Though she was able to rescue her art career, however, Dewing gave up writing entirely.

The experience of domesticity and professionalism as conflicting spheres ultimately undermined women artists' sense of themselves as professionals. Susan Macdowell buried her professional ambitions when she married Thomas Eakins, a former teacher from the Pennsylvania Academy, in 1884. Thomas Eakins was widely recognized as a supporter of women artists; he was one of the few American art instructors who treated male and female students equally, and as a result a great number of women who studied with him went on to successful careers. This attitude predisposed him to encourage his wife's continued work in art. Susan maintained her own studio in their home and exhibited a handful of paintings and photographs during her married years. However, the erratic fortunes of Thomas's controversial career seemed to require a wife's constant ministry. Susan chose the role of wife and muse, rather than the role of artist, as her primary one. She was the soother and inspirer who wrote in her diary, "I try on rich stuffs to tempt Tom to paint."[16] She remained an artist but not a fully professional one. That is, regardless of how much she painted in private, Susan's professional activity as an artist was decidedly curtailed during the marriage, while Thomas's was not. She had exhibited at least twenty paintings as a single woman between 1876 and 1884, had another two engraved for *Scribner's Magazine,* and won two prestigious awards (the Mary Smith Prize and the Toppan) from the Pennsylvania Academy. Though she won two medals at the 1893 Columbian Exposition, during her thirty-two-year marriage to Thomas, she exhibited only two paintings and a photograph. After his death, she returned to public work, culminating in nineteen paintings for a group show at the Philadelphia Art Club in 1936.[17]

When analyzing their lives and work side by side, though, the Eakinses' relationship as artists seems more complicated than many scholars have realized. Susan's *Portrait of Thomas Eakins* provides lustrous evidence both of Susan's painting skills and of her image of the ideal artist.[18] Thomas grips his head in intense concentration as he leans against his easel, holding his brush ready. The composition of the painting represents Thomas as painter rather than painted, subject rather than object. Susan depicts him in the midst of painting the viewer; the colors he will use to paint us are already mixed on his palette.[19] Through the figure of her famous husband, Susan defines painting as a fiercely intellectual act, but she does not explicitly include herself in the ideal. If she appears at all, it is only as a hazy reflection on the wall behind him. Susan did not incorporate her self-portrait into her husband's portrait (as Marie Danforth Page did in her 1909 portrait *Calvin Gates Page*).

In art as in life, Thomas served as the reflection of Susan's artist self. In some ways, even after her widowhood and reemergence as a painter, her identity as a professional remained precarious. Her letters referred to her work as "little paintings" and expressed discomfort in dealing with monetary remuneration.[20]

The professed incompatibility of marriage and career, as late-nineteenth-century women artists perceived and experienced it, helped to legitimate women artists' cohabitation and even intimate relationships with each other in a time of increasing hostility toward homosociality. Many decided to forgo marriage in favor of pursuing their art career—a decision their families might find perfectly acceptable. Eliza Haldeman joked easily about the subject with her mother: "Do not trouble about me disappearing in Paris. I know it thoroughly and I think [it] likely the lady you read of ran off with some good looking Frenchman. As I am to be an old maid there is no danger for me in that quarter."[21] Status as a single woman could even imply a consecration to art. "I preferred to keep my own name. I believe I have been able to give it some renown," illustrious painter Rosa Bonheur reportedly told her artist companion Anna Klumpke. "And then, as in religion, art also has its vestals."[22]

Women artists' cohabitation, in rejection of marriage, ranged from the sharing of studios and apartments, as fictionalized in *Three Girls in a Flat*, to committed, romantic, and probably lesbian relationships, as in the case of Bonheur and Klumpke.[23] It is often difficult to define these relationships as primarily professional, intimate, or sexual; Helena de Kay Gilder and Mary Hallock Foote have been cited as a quintessential "romantic friendship," yet both were also part of a larger network of women artists that included painters Maria Oakey and Kate Bronson. The boundaries between the professional and the social often blurred in these female networks; besides sharing sketching sessions and art talk, Hallock, Oakey, and Bronson all gave baby shower gifts to Gilder.[24] Charlotte Perkins enjoyed many friendships with other local women artists, including Kate Bucklin (a particularly close friend), Jennie Bucklin, Annie Morse, Helen Potter, Abbie Cooke, and Harriet Chace. She visited with illustrious women painters of the previous generation, Mary C. Wheeler and Sarah Eddy, who might have acted as her mentors.

Women's relationships with other women were not automatically more egalitarian than their relationships with men. Many lesbian couples resembled heterosexual couples in terms of their gender roles. As recounted in

Chapter 2, Adeline Manning was an art student when she met her future partner, Anne Whitney; but when she came to live with Whitney she gave up any professional ambitions she may have had. Even in a marriage between women there was often only room for one professional artist. But the absence of external cultural expectations for a same-sex couple made for less deterministic dynamics of gender and power; that is, without sex as a basis for apportioning gender roles, it was left for Manning and Whitney themselves to determine who would sculpt and who would keep house. In this sense, female relationships could insulate at least *some* women from social pressures. Like women's culture and institutions more generally, these relationships helped women artists to develop a distinct identity as women professionals.

Even women who managed to accommodate their ambitions within their private lives and social relationships found additional obstacles to professional status. "General" professional art associations greeted women with varying degrees of hostility, and sometimes explicit exclusion. The Boston Art Club entirely barred women from membership through the nomination and election process. The 1883 Rules of the Board of Management eliminated any doubt that the absence of women from club rolls was a mistake; "The rooms of the Club-house shall not be open to ladies except on occasions when they are invited by the Board of Management, and during the evening receptions at the opening of exhibitions," the bylaws stated.[25] In Cincinnati, a city roughly the same size as Providence, with an increasingly prestigious art school and rising art community, the Cincinnati Art Club completely excluded women from membership; women artists finally formed their own art club in Cincinnati in 1892.

Of course, many art associations did admit women and some even had women founders, but even in heterosocial art clubs, the pattern of women's participation was one of meager influence or of power that decreased over time. At first, women dominated the leadership of the Art Students' League, but their role in guiding the organization declined over the years. No other woman succeeded Helena de Kay Gilder when she gave up her post on the Board of Control because of family pressures.[26] Similarly, the Providence Art Club (PAC) was founded by women and men as equal partners in 1880; one of the women founders, Rosa Peckham Danielson, even served as the club's secretary and vice president. Almost half of the club's original members were women, including established local painters Emma Swan, Eleanor Talbot, and Emily McGary.[27] Women members apparently enjoyed the full

breadth of the PAC's activities, from social occasions (including "Paint and Clay Parties," evening lectures, and musicales) to the more professionally minded sketch class begun in 1883, which hired draped models three times per week to give members valuable experience in life drawing.[28] When the club's first exhibition opened on 11 May 1880, almost half of the 68 artists represented were women; of the 162 individual works displayed, 58 had been painted by women. Women played significant roles as club leaders as well as exhibitors and participating members. Rosa Peckham Danielson served as the club's secretary before her marriage in 1882, and afterward as vice president (1883–1885). Mrs. N. W. DeMunn and M. Louise Torrey held seats on the club's Board of Managers, and along with Sarah J. Eddy sat on the Executive Committee and Jury of Admission. Other women, such as Selma Borg, gave public lectures under club auspices. The club attracted a soaring membership among both sexes, numbering 252 men and women by 1885.

The Providence Art Club's initial inclusivity proved unsustainable, however, and before long the protocol and the conventions of members' involvement began to change. Some men in the club became uncomfortable with the level of female participation in the PAC, even though by 1887 the percentage of women exhibitors in the annual shows had fallen to half of what it had been in 1880.[29] Several PAC men held simultaneous memberships in a parallel art club, the Ann Eliza Club (est. 1885), which completely excluded women from membership. Presumably, the absence of women permitted a different atmosphere to prevail—perhaps greater seriousness, professionalism, and intellectualism. (The name "Ann Eliza" was a play on the word "analyze.") Changes began to take place within the PAC as well. By 1886 the Providence Art Club constitution was much longer than the original, reflecting its larger membership and more complicated organizational structure. In the process of its emendation, the new constitution also replaced or inadvertently abandoned the 1880 original's gender-neutral language, which used frequent plurals and referred to a member's payment of "his or her dues."[30] Like Helena de Kay Gilder at the Art Students' League, Rosa Peckham Danielson had no female successors among the highest-ranking officers. The number of women on the Board of Managers remained constant even though the total number of women club members increased throughout the 1880s. With the growth of a bureaucracy, women were relegated to a relatively less powerful place in the club's official structure. The changes were reflected less formally as well. In 1887 Friday night gatherings

began, bringing predominantly (if not exclusively) male artists and their guests together for conversation, beer drinking, and general merrymaking.

In 1889 the PAC women responded to this altered climate with a change of their own. At the women's request, the club abolished the Entertainment Committee, headed by M. Louise Torrey and Mary C. Wheeler, and a Ladies' Advisory Board was formed in its stead, with the same two women in charge. At the same time the women members initiated "a commendable series of weekly meetings for 'talks' on art subjects, followed by afternoon tea." The women's reasons for this maneuver have not survived in the club's records, but President John C. Peagram mentioned the Friday nights as an influential, if indirect, cause: "The forerunner (it would be presumptuous to say the prototype) of these meetings of the gentler sex—I mean the Friday evening gatherings of the ruder members of the Club, which began nearly three years ago."[31]

The Ladies' Advisory Board chose to go further than their Friday night forerunners by specifically excluding the opposite sex from attending their events. Yet the club expressed official approval of this policy, finding the talks "well attended and much enjoyed by the participants, and, so far as one disqualified by sex from observation of these mysteries may judge, a great help to the general objects of the Club. A number of very creditable lectures have been given, all, I am proud to say, by lady members of the Club, and the attendance and evident interest have been very gratifying and encouraging."[32] That is, such meetings, lectures, and teas were commendable but nevertheless the proper province of "the lady members of the Club," not designed for all of the PAC's artist members or even judged to be of interest to the amateur men who belonged to the club. Perhaps by 1890 PAC membership had grown enough in size to accommodate different constituencies with different needs and preferences. In any case, Peagram did not see such divisions as dangerous to the PAC's integrity; on the contrary, they provided "a great help to the general objects of the Club." Presumably, male and female roles could be both different and complementary within the PAC, as they were in the culture at large.

In view of their experience with other professional art clubs, women artists clearly needed to create their own professional opportunities. European women artists' associations were developing during this period, and American women may have come into contact with them while studying art abroad.[33] The first major American women's art club, the Woman's National Art Association (WNAA), was formed in Philadelphia in 1866 with the spe-

cific object of organizing a national women's art exhibition and auction. The formation of separate associations offered many advantages to women artists, but also entailed certain risks. The WNAA won praise "as a step in the right direction," but that direction meant "elevating the mental and moral influence of womanhood" rather than establishing women among the ranks of professionals.[34] The Ladies' Art Association (LAA) was founded in New York in 1867 along similar lines. When soliciting donations or government appropriations, the LAA could cast itself in the role of a social service agency, "aiding women strangers in the city to earn an honorable livelihood without decreasing the wages given to men." The organization's publicity flyers emphasized that "the efforts of the Association have been, and are still, directed toward opening avenues for employment of women at home."[35] This language echoed the rhetoric used by the Philadelphia School of Design for Women in the 1840s; in both instances, women promoted their professionalism by claiming that their work could be performed in the home and that it posed no economic threat to men because the employment in art was rapidly expanding.

In a gesture toward a cohesive women's art, early women artists' associations highlighted commonalities among female creators of both "high" and "low" art, and celebrated traditions of women's art across the boundaries of genre. In the WNAA's 1866 exhibit, the inclusion of industrial art designs by women as well as paintings, sculpture, engravings, photographs, sketches, and studies would help fulfill the organization's goals not only "to stimulate and encourage women to greater energy and perseverance in the pursuit of art" but even "to elevate the standards of women's work and to make her aspirations higher, whilst securing to her an honest independence." WNAA organizers recognized the potential danger of mixing fine art with industrial and decorative art, and announced that "in future years this list may be curtailed." But a wide-ranging exhibition would best represent "the capacity of American women for the highest and most difficult pursuits."[36] The Ladies' Art Association originally established different levels of membership (fellows, juniors, and associates) in order to maintain professional standards without sacrificing inclusivity. Any member could rent the LAA's studio space, but only fellows voted in elections and attended monthly meetings (to each of which they were required to bring "an original work of some kind"). Moreover, the association recognized two distinct routes toward professional status as Fellows; the LAA constitution made provision for either "juniors" (i.e., art students) or "associates" ("amateurs or connois-

seurs") of the LAA to become fellows ("professional artists, or considered by the Executive Committee capable of being such," based on an evaluation of their original work).[37] They showed only paintings at their first exhibition in 1867, but by 1877 included decorated furniture, fabric designs, lace, porcelains, and "fancy articles"; in 1880 they organized an exhibition of American pottery.[38] The LAA offered both "high" and "low" art classes, including a Life School for Women (instituted in 1869) as well as "technical classes for women in carpet designing and reproductive pen and ink drawing."[39]

In a sense, it had become more difficult for professional women artists to differentiate themselves from lady amateurs because of the general public's increasing acceptance of not just embroidery, drawing, and watercolor as suitable feminine endeavors, but even oil painting as a mainstream occupation for ladies. By 1886 the masthead of the *Ladies' Home Journal,* for example, depicted a woman painting in oils at home; on either side of her, other women cared for infants and watered the garden.[40] How could serious women artists maintain a feminine identity without having their work confused with domestic labor?

Yet women painters and sculptors chose not to divorce themselves entirely and absolutely from "low art" in the way that men and the American art world in general, under the leadership of art critics, did in this period. Gilded Age cultural mavens infused certain kinds of art with a quality of sacredness. This art had not only to be interpreted for common folk, as was the case in the mid-nineteenth century; it now also had to be protected from the vulgarizing and corrupting influence of the masses. Newly professionalizing art critics and museum collectors cemented the traditional hierarchy of art, with allegory and history painting at its apex and decorative art, "crafts," and design at its bottom.[41] Women may not have been able to afford a divorce from the expanding market for illustration and the growing admiration for ceramics, especially given the consensus that these were suitable arenas for women to exercise their artistic talents.

Like the PAC's Ladies' Advisory Board, some women carved out their own spaces within larger organizations. In December 1885, for example, the San Francisco Art Association (SFAA) sponsored the First Annual Exhibition of the Lady Artists of San Francisco—simultaneously celebrating the work of its female members and marking women artists as a distinct group. The show's organizers selected their exhibits a bit more carefully than did the Ladies' Art Association. Out of 265 individual works at the exhibit, 210 were paintings, drawings, and sketches—primarily featuring flower and nature

studies, but also including a large number of landscapes as well as a few fig-
ure paintings and urban scenes.[42] The organizers of the exhibit maintained
women's traditional boundary crossing of both high and low art by includ-
ing six decorated panels, four decorated mirrors, three decorated screens, a
set of tiles, and six cases of decorated porcelain among the loftier paintings
on display.[43]

Thus, rather than marking a time when women artists abandoned gender
identity for professionalism, the late nineteenth century witnessed the cre-
ation of separate women's institutions that attempted to bridge the gap be-
tween domestic art and male professionalism. Women increasingly formed
organizations on their own terms; through the 1880s and 1890s, women's
art associations appeared across the United States. The Sketch Club, the
first women's art club in California, was established in the summer of 1887
with a simple goal: "to foster and support sketching tours and related activi-
ties."[44] The club welcomed both amateurs and professionals—a common
policy among women's art clubs—and by 1897 the Sketch Club had a mem-
bership of over 200, including most of the city's most prominent women art-
ists. With respect to exhibitions and entertainments, the club modeled itself
after the all-male Bohemian Club; the elaborate costume parties and exotic
banquets created a bohemian milieu that was a significant part of contem-
porary male artists' culture but unavailable to most women.[45] In Denver in
the 1890s, women modeled the Le Brun Art Club (named after Elisabeth
Vigée-Le Brun) after Chicago's Palette Club. Again, both professional and
amateurs were welcome.[46] Caroline A. Lord commemorated the tenth anni-
versary of the Woman's Art Club of Cincinnati with a humorous poem. No-
tably, the verses do not point to the club members' gender in any way; Lord
suggests that the trials and travails of which she writes are common to all
artistic "geniuses." Only one line—"the old masters pale when we come
within hail"—hinted at the club members' sex.[47]

Women in the nation's largest art centers—New York, Philadelphia, and
Chicago—organized themselves in gender-segregated professional associa-
tions as well. The longest surviving association of women artists would
emerge in Philadelphia when Emily Sartain and Alice Barber Stephens
founded the Plastic Club in the spring of 1897. Illustrators, etchers, and pho-
tographers were included in its membership along with painters and sculp-
tors. Stephens's solo show at the Plastic Club in February 1898 exemplifies
the range of work a single artist could produce: ten landscapes in oil, pastel
studies, mixed media illustrations, four photographic "repros," pen and ink

drawings, and two photographs. The Plastic Club held two annual shows of members' work as well as loan exhibitions, several small group shows, and individual exhibitions.[48] Stephens, the club's vice president almost every year from 1897 to 1912, recognized "the belittling prejudices against women's art clubs" that the Plastic Club had to overcome. Women had to remain conscious of their public image, to the point where "there is no portion of the Club work which requires more sagacity and tact than the compiling of the Club catalogues . . . [they] are our introduction to the public, and by their character and style we have come to be known as a society wherein good taste prevails."[49] Many of the women who belonged to these localized clubs were also members of a national counterpart, the National Association of Women Painters and Sculptors, which held its first exhibition in 1891.

New York's Pen and Brush Club, founded in 1893 by painters Janet and Mary Lewis, turned to a new set of allies in the struggle toward professional ideals: women writers. Only professionals, defined as "women who are engaged in literary or artistic pursuits and who have monetary remuneration for their work," could become members; illustrators as well as painters numbered among the "brushes." The Lewis sisters sought to create "a medium of contact for women of similar interests" and a more "fraternal feeling" among women artists and writers; the problem of gender and professionalism cut across barriers of medium and genre.[50] The result was clearly modeled after contemporary men's clubs; the Pen and Brush kept club rooms where members could relax or entertain, as well as library and studio space where guests could work; and it held annual art exhibitions, displaying art from paintings to bookplates.

Plastic Club cofounder Alice Barber Stephens was not alone in recognizing that women artists had to counter "the belittling prejudices against women's art clubs" through hard work and diligent publicity. Critics of women's art clubs charged that women banded together and held separate art exhibitions because their inferior work could not stand the test of general exhibitions; thus, the only women who would stoop to identify themselves as women artists were those who could not compete successfully against men as (simply) "artists." Such dismissals ignored the practical barriers to women's full and equal participation as professional artists and ascribed the low percentage of women's work in mixed-sex exhibits to be the result of inferior skill. But art critics' assessments of quality and aesthetics were (and are) subjective, inextricable from cultural values, ideologies, and construc-

tions of gender. The mere claim of universalism could not assuage the basic assumption that the greatest artists were men. Moreover, as we have seen, the typical women artists' club did not completely conform to new ideals of professionalism. In its insistence on a female tradition in art, it traversed categories of amateurism and professionalism and refused to separate "high art" entirely from decorative and industrial art. Contrasted with the implicit masculinity of the ideal professional artist, the self-identified woman artist still seemed too—female. In this formulation, women artists were inferior either because they showed their work as women artists or because they failed to achieve renown as simply "artists." Faced with this conundrum, many chose to show their work as women artists rather than be unable to build a career at all. They identified as women artists out of both necessity and affinity.

The World's Fairs of 1876 and 1893 provided the ultimate public space in which women artists contended with the ideological tensions and contradictions of gender separatism and professionalism. The women's separate exhibits at these expositions were the most publicized exhibitions of women's art in the nineteenth century and the most widely visited. Scholars estimate that 10 million people attended the Centennial Exposition in Philadelphia in 1876 and over 27 million visited the World's Columbian Exposition in Chicago in 1893. Many of these visitors entered the Woman's Buildings, which were among the most popular (and most controversial) exhibition spaces at each fair.[51] Most significantly, in terms of repercussions for women artists' lives and work, the women's Centennial exhibit revealed the central problem of their gender-separatist strategies: the difficulty of connecting women's achievements in fine and decorative art without conflating both as inferior, amateur art. The organizers of the Columbian Exposition attempted to resolve this problem by emphasizing racial hierarchies in the place of aesthetic ones. The result, however, left women artists even more sharply divided than before.

Various notable women sculptors and painters garnered enthusiastic support for the Woman's Pavilion at the 1876 Centennial Exhibition, even though it was women who were wealthy social leaders—not, for the most part, professionals—who took charge of the fundamental planning. Harriet Hosmer not only sent her own work to the Pavilion, but also helped establish the Women's Centennial Committee in Rome to oversee other women artists' contributions to the exhibit. Hosmer expressed a firm commitment to

the Woman's Pavilion as a separate women's exhibit that would address women's particular concerns. "We had a terrible fright here that there was not to be a Woman's Department, which disappointed us all, me in particular, because I don't think I should trouble myself to send anything to a *General* exhibition, whereas for the women I shall send everything I can rake and scrape together," she wrote to the president of all the women's committees, Elizabeth Duane Gillespie, adding, "I must try and find a good woman-subject."[52] Like earlier exhibits of women's art, the Woman's Pavilion traversed the lines of "high" and "low" art. Industrial and mechanical devices were segregated in another part of the building, but neoclassical sculptures by Hosmer, Florence Freeman, and Blanche Nevins went on display alongside students' lithographs, etchings, engravings, watercolors, carved bedsteads, and an ornate rosewood piano case.[53]

Despite the contributions of respected artists like Hosmer, Ellen Day Hale, Fidelia Bridges, and Anna Lea Merritt, and even the praise given to particular works such as the Rookwood ceramics and Blanche Nevins's *Cinderella* and *Eve*, champions of the Woman's Pavilion had to put up a spirited defense against charges of mediocrity and amateurism. "H. C.," a writer for the *New York Times*, complained that:

> A number of influential and widely circulated newspapers in the East and West . . . have more or less severely criticised the display made in the Woman's Pavilion, and in that lofty and stilted style which some men assume when writing of women and her [*sic*] works the public has been informed that "the exhibit of feminine handiwork is bad in nearly every particular," that "the woman's building contains nothing but old bed-quilts," or, as a paper now before me says, that "the Woman's Executive Committee should have hired a few men or boys to help them out." Criticisms and statements of this kind are not only unjust and ungenerous; they are maliciously false and wholly unworthy of credit. It is true to some extent that the display in the woman's department proper, although a creditable one, is not everything that could have been reasonably expected. The defects in the exhibit, however, were caused not by any inability or lack of skill and taste among women, but by a natural desire on the part of many exhibitors to have their work placed side by side and in direct competition with the results of masculine labor or artistic skill.[54]

In the end, though, this type of defense played into the hands of the pavilion's critics by claiming decorative art as the summit of women's achieve-

ments. H. C. directed the reader's eye *outside* the Woman's Pavilion to find women's work in pottery, lacework, and textiles—the conventional areas in which women's artistic talent was recognized. In a moment of zeal, H. C. defended the domestic tradition of women's art and condemned women who rejected the strategy of separatism to the charge of mediocrity. "The ungenerous women artists" who refused to show in the Woman's Pavilion "have done themselves a great injury, for in the great mass of noteworthy pictures that grace the walls of Memorial Hall their efforts are covered up and lost sight of."[55] Another writer similarly commented that in the Woman's Pavilion "the pen, the pencil, the chisel, display no mean genius and may dare to rival the best work of men, and in the thousand beautiful fancies wrought with the needle—in laces, embroideries and silken flosses they exhibit superlative excellencies."[56] Kind reviews of the pavilion invariably mentioned the exhibits of lace and needlework as well as the extremely popular and culturally significant ceramics display.

Because they were decorative art, the masterpieces produced by Rookwood Pottery could not approach the lofty status of oil paintings and marble sculpture. At the same time, because of their lesser prestige within the fine arts, ceramics and other decorative arts became fertile ground for women to establish art careers—and to enjoy the patronage of other women. Mary Louise McLoughlin, Maria Longworth Nichols, and other women gained reputations for innovation, creativity, and technical expertise and assumed the front line of the Arts and Crafts movement. It was in these fields that women's artistic talents would shine, while genius in high art was implicitly surrendered to men. In reviewers' eyes, even sculptures in the Woman's Pavilion, such as Florence Freeman's *St. Christopher,* seemed to attract the public's attention "because of [their] conspicuous position, more perhaps than any merit they possess."[57] "Any quantity of nobodies had been allotted space and would exhibit their daubs," an anonymous leader of the "artistic sisterhood" reportedly explained.[58] Only Blanche Nevins's *Cinderella* was singled out for its creator's skill.[59]

Well aware of these general attitudes, the best "high" artists represented in the Woman's Pavilion were careful to display their work in the main exhibition halls as well as in the Woman's Pavilion. That way they could both preserve their professional reputation and express their commitment to women's cause and women's culture. Lilly Martin Spencer's monumental *Truth Unveiling Falsehood,* exhibited in the Woman's Pavilion, enshrined women's role as a moral guardian. Critics and fairgoers alike applauded it;

the prize committee awarded it a medal, while photographs of the canvas sold swiftly as souvenirs of the Centennial. But Spencer also sent work to the general art exhibit. Other women artists showed their less prestigious or ambitious work in the Woman's Pavilion and sent the rest to Memorial Hall. Emily Sartain exhibited steel engravings and a portrait of a young girl sewing in the Woman's Pavilion, while her painting *The Reproof,* which had already won a medal at the Paris Salon, hung in the general exhibit. Margaret Foley sent small bas-reliefs to the women's exhibition and her fountain to Horticultural Hall.[60]

A few women artists, notably sculptors Edmonia Lewis, Vinnie Ream, and Anne Whitney, decided not to show works in the Centennial Woman's Pavilion at all. Because of her race (she was of African American and Chippewa ancestry), sculptor Edmonia Lewis had to guard her professional status even more carefully than the other women. Her grand, dramatic *Death of Cleopatra* was one of only two works by African American artists represented at the exhibition. The sculpture would have been rendered even more marginal if it had appeared in the Woman's Pavilion, among lacework, vases, and carved pianos. As it was, it won a medal and mixed praise from critics.[61]

The piece of art in the Woman's Pavilion that attracted the most attention was *Iolanthe,* a life-sized figure sculpted in butter by Caroline S. Brooks. In one sense, *Iolanthe* was pure spectacle; crowds pressed close to examine the "Butter Lady," which lay in a tin box packed with ice and remained frozen through the six months of the fair. "Thousands wondered 'how she did it,'" one writer reported. "The 'lovelies' and 'oh mys' were scattered promiscuously around the building. 'Did she churn it?' 'Was it Butter?'"[62] Brooks added to the spectacle by printing an explanatory booklet and by performing as a living exhibit herself, demonstrating the process to fairgoers and creating another butter sculpture in an hour and a half.[63] Her work was often considered (and ridiculed) as simultaneously a curiosity and a technological feat.

But *Iolanthe* also provided a witty commentary on the meaning of "domestic art" and the role of the woman artist. Sculpture was a public-minded, masculine enterprise; butter-making was a domestic, feminine activity (though an increasingly commodified one, which men supposedly produced better—that is, in more scientific ways—than women could).[64] Brooks, an Arkansas farmer with her own butter business, used a historically feminine, domestic medium in order to make the highest art: ideal, neoclassical sculp-

ture. She employed the masculine field of science to achieve the desired re-
sult, won a patent for her technique, and actually intended the method to be
only the first stage toward creating plaster casts, which would later be copied
in marble.[65] Ironically, the crowds around *Iolanthe* eventually convinced
Centennial officials to move the sculpture to Memorial Hall. Though one
commentator pronounced it "undoubtedly the cream of both buildings," it
was not artistic merit but sensationalism that graduated *Iolanthe* from the
Woman's Pavilion to the fair's main building. Descriptions of Brooks pre-
sented her as neither a sculptor nor even an innovator, but rather a lady am-
ateur, an "unconscious artist of the West," possessor of only "native talent,
as the lady had no regular instruction in art."[66] In later years, Brooks's pat-
ented invention was overshadowed by a more conventional story that she
had spontaneously carved a portrait of an invalid in a pat of butter, and the
invalid's husband (a respected local judge) had convinced her to send it to
the fair.[67]

Beyond its sheer kitsch, the butter sculpture challenged strict definitions
of what the boundaries were between high art and low art, masculine and
feminine. Like separate women's art clubs and exhibits more generally, it
referenced a tradition of women's art that traversed those lines. To art crit-
ics, however, *Iolanthe* (again like separate women's art clubs and exhibits)
seemed only proof of the ridiculousness of such transgressions.[68] Caroline
Brooks may have seen a clear methodological trajectory from butter mold-
ing to marble sculpture, but the similarities evaded her public and thus
proved problematic for women artists too.

As personally advantageous and publicly fascinating as women's separate
exhibits and clubs were, women painters and sculptors like Brooks could
not ignore the opinions of the fine art experts who exerted increasing influ-
ence on the art market. Art critics looked dubiously on women's brand of
separatism and the conflation of high and low art on which it seemed to de-
pend. Discussions among the Board of Lady Managers for the World's Co-
lumbian Exposition in Chicago illustrate the tensions between separatism
and inclusion, womanhood and professionalism, that made women artists'
choices so difficult in a time of transition. The Board had initially planned to
oversee women's contributions to gender-integrated exhibits and devise an
ambitious system of labels identifying the percentage of women's labor that
went into making each object on display at the fair. However, this arrange-
ment collapsed under a lack of cooperation from exhibitors in providing
statistics, coupled with the Lady Managers' dearth of capital and the domi-

nation of experts and large corporations in the fair planning overall.[69] President Bertha Honoré Palmer and her colleagues decided to expand their idea of a small exhibit of women's progress and construct a Woman's Building even grander than the pavilion at the Centennial Exhibition. The theme of women's progress was an auspicious choice, since the "progress of civilization" was a preoccupation of the fair as a whole. In the narrative of the Woman's Building, art played a pivotal role in offering the fairgoing public proof of women's progress. "Progress" proved to be an ingenious theme that allowed room for both "high" and "low" examples of the feminine artistic tradition by arranging these examples in a cultural hierarchy, with painting and sculpture by white women at the apex. Thus, ideologies of race and progress permitted the (white) woman artist to present herself as professional even while she claimed connections to feminine traditions of craft and decorative art.

Sara Hallowell, assistant to the fair's fine arts director and Bertha Palmer's close confidante, expressed her doubts about the Woman's Building early in the planning stages. She worried that there existed "too few fine women artists to warrant their making a COLLECTIVE exhibition worthy to compete with their brothers" and that "no woman artist of ABILITY would I believe be willing to have her work separated from the men's." The Board of Lady Managers discussed the matter at their very first meeting and decided that "a competition among women only would result in the award of premiums to articles which would not necessarily have been successful if entered in a general competition." According to the rules of the Columbian Exposition, all medals were to be awarded by building, with a separate awards committee for each building. The Lady Managers could not imagine how to attract talented women exhibitors when the placement of any work in a Woman's Building would disqualify it from winning any general prize or distinction in competition with men. "It was thus found that not only would the best of women's work be withheld from a 'Woman's Department,' but the loss in amount would be equally disastrous," the Board's report read; that is, any woman who would exhibit without the chance of winning renown must be an artist who could not win anything anyway, inferior to male artists and an embarrassing example of women's *lack* of talent. There would be no separate exhibit of women's work at the 1893 fair.[70]

By the second Board meeting, though, many Lady Managers had changed their minds. A Woman's Building with no exhibits inside would prove "uninteresting" to visitors, some argued; and, besides, a special women's ex-

hibit would present "a fine opportunity of emphasizing the most creditable achievements of women . . . it is therefore proposed, where there is anything of such extreme excellence that we, as a sex, feel proud of it, that we have a duplicate of it, or another piece of work from the same hand in the Woman's Building, in order to call attention to the fact that it is the work of woman. But we want to keep this exhibit very choice," the Board cautioned. "We must keep the standard up to the highest point. No sentimental sympathy for women should cause us to admit second-rate things into this gallery."[71]

Clearly, the key to a successful women's art exhibit lay in convincing the most respected women painters and sculptors to send their work to the Woman's Building. If, as Sara Hallowell feared, the Board of Lady Managers received no "first-rate" contributions, they would be forced "to admit second-rate things" or leave the gallery empty and admit defeat. At one point Hallowell suggested that the women's exhibit be confined to decorative arts, where presumably a greater number of women were sufficiently accomplished. But this would have seemed too much like an acknowledgment of women's inadequacy; the ambitious Lady Managers and their driven president, Bertha Palmer, wanted to assert a place for women within the grand ideal of the White City. Even if many Americans still did not believe women could become great artists, art was a profession in which women *had* clearly advanced. How could an exhibit glorifying Woman leave out women's contributions to the progress of civilization? The themes the Lady Managers ultimately set forth for the Woman's Building—the themes of women's work and women's progress—masterfully allowed woman as mother and domestic being to be conflated with woman as artist: both were advancing culture; both were true to women's feminine nature.

Bertha Palmer, a leader in Chicago's high society and not herself a "working woman," held fast to the older model of the woman artist as the basically conventional, feminine counterpart to the male Artist—a woman who would limit herself to "her highest and truest function" as mistress of "a happy home" if she only could. This was a publicity problem that President Palmer learned to manage with great intellectual ingenuity (and perhaps disingenuousness as well), arguing that all women worked out of economic necessity, not ambition. "Men of the finest and most chivalric type . . . have asked many times whether the Board of Lady Managers thinks it well to promote a sentiment which may tend to destroy the home by encouraging occupations for women which take them out of it," Palmer said in her open-

ing day speech. "We feel, therefore, obliged to state in our opinion every woman who is presiding over a happy home is fulfilling her highest and truest function, and could not be lured from it by temptations offered by factories or studios . . . [but] the conditions under which the vast majority of the 'gentler sex' are living are not so ideal as [these men] might assume . . . [Many women] must work or they must starve . . . We advocate, therefore, the thorough education and training of woman to fit her to meet whatever fate life may bring, not only to prepare her for the factory and workshop, for the professions and arts, but, more important than all else, to prepare her for presiding over the home."[72] Palmer's rhetoric, like that of the other socially prominent women who helped organize the fair, echoed notions of the domestic woman artist.

For women artists themselves, however, domesticity seemed an increasingly outdated touchstone with which to justify and explain their ambitions. Other speeches given at the Woman's Building by professional women artists espoused an image of the artist that was less markedly gendered. This perspective held particular sway among the younger generation of women artists, who had always had access to art education and who had embarked on their careers in a cultural climate where ideas about domesticity and true womanhood had already begun to fragment. A new assumption of inclusion marked the attitudes of these women. Philadelphia sculptor Katherine M. Cohen carefully mentioned both male and female artists in every section of her talk, "Life of Artists." She presented neither gender as normative; in fact, she made no distinctions at all between the experiences of men and women who made art. She described artists of both sexes following the same daily routine. She then spoke of "Douglas Tilden, the deaf and dumb sculptor from California," and another sculptor, "Miss Matthews, who has only one arm, and yet, who has managed to do better work than some of the fraternity who have all their members." These testimonials, she hoped, would prove that "artists, if they be truly such, may be bereft of almost anything except their heads and yet succeed in their work, for the spirit of a true artist can never be wholly suppressed." Presumably, for an artist to be great, sex was even less of a factor than limbs; "talent knows no sex," she asserted. Even in discussing the impediments to artistic development, Cohen cautiously avoided speaking of gender differences. American art would become "better than anything we can get in Europe," she contended, but only "if we encourage our boys and girls to cultivate their artistic tastes instead of scoffing at them as impractical and never likely to make them rich." In this

formulation, both boys and girls who would be artists faced the same obstacle: the scoffing of others. No other barriers were mentioned.[73] This new authority, of women dispensing advice on becoming artists, extended beyond the Woman's Building. Though writing for *Woman's Progress* magazine, for example, Alice Barber Stephens gladly shared her wisdom to "either the young girl or young man directly aiming to be an illustrator."[74]

The vision of the Woman's Building could not be fulfilled until the best American women artists, both the established and those rising in reputation, were convinced that they should participate in it. The Board of Lady Managers therefore worked to understand, accommodate, and overcome the reluctance of some women artists to participate in a segregated display of women's work. The underlying problem was not that these artists objected to gender separatism per se; some of them belonged to women's art organizations and showed their work in women's exhibitions. Rather, they were concerned with guarding their professional status within such a venue.

Anne Whitney's reservations, for example, grew out of her belief in the sanctity of art and a real distinction she perceived between divine art and everyday craft. "Let the thought be so worthy that it shall seek and find the divinest form as the only expression commensurate. Here all might finally meet and agree," she wrote in a typical passage explaining her theory of art.[75] Probably as a consequence of these views, Whitney had not shown any work in the Woman's Pavilion at the Centennial Exposition; but now the Board of Lady Managers worked hard to convince her to exhibit in the Woman's Building in 1893. "I think I understood the position as regards Miss W——, it being an exceptional case in every way," C. Emily Frost reported to the Board in April 1892.

She is eminent, and has a very *strong* and *unique* personality. I told her I was only the ambassador, but I *hoped* Mrs. Palmer would write her . . . and explain to her how fully Mrs. P[almer] appreciated the higher Art and its presence in the Woman's Building as women's mastery, etc., and, *above all,* that it should have its own *special* recognition, and above all, its own special position by itself. This was Miss W's. prelude—"I do not believe in a Woman's Building, and for people, and women especially, who are forever preaching co-education and all those things, to have women alone by themselves to show alone their achievements, is very inconsistent and directly opposite from former practice and positions they have heretofore taken. I feel there is no use for such an exhibit because it is a woman's, or women's. That is

why the newspapers have quoted *me* as well as *Harriet Hosmer* taking the position we have." She was evidently on the skirmish line, but I "stooped to conquer" and staked every trump card I had. She became a little more plastic, and Mrs. Palmer, I am sure, could *woo* and *win* her. She finally *tumbled* enough to say her "marbles should not be in the same room as bed-quilts, needle-work and other *rubbish.*" I did not offer her the whole building or promise a *gallery* for *her,* but modestly and in humility, still swinging the censer, I assured her that with Mrs. Palmer "all things were possible and probable"; so, with an exalted opinion of Art and Mrs. Palmer, "what is to hinder?" . . . I feel it a greater triumph if Miss W—— will exhibit after her pronounced opposition and position. I enjoyed the interview, and the fact that her ideas were equally radical and ultra with my own, was none the less interesting.[76]

Apparently, Frost's assurances did soften Whitney considerably; just a few days later, Mary Crease Sears reported:

I called on Miss Whitney yesterday and extended the invitation to her to send some of her work to the Fair . . . she said she was ready and willing, but would first question about its going into the Woman's Building. She wished to know if a space would be set apart for sculpture, art, etc.—not have a bit of drapery and a bed-spread in the same room. She wished a good light, plenty of room and appropriate surroundings. If those were allowed her, she was ready and willing to send to the Woman's Building; other than that, she would send to the general exhibit where she was sure of all, and, at the same time, be placed on [sic] competition with the men.[77]

Whitney, an ardent supporter of woman's rights, was also probably persuaded by the Lady Managers' visible commitment to that cause. In the Woman's Building, Anne Whitney's busts of Lucy Stone and Harriet Beecher Stowe joined Adelaide Johnson's busts of woman's rights activists Susan B. Anthony, Elizabeth Cady Stanton, Lucy Mott, and Dr. Caroline Winslow. This seemed like a proper use for a Woman's Building: the commemoration of women leaders and reformers.

Despite the promises made to Anne Whitney regarding the conditions under which her work would be displayed, cases of embroidery did surround her fountain and bronze *Leif Ericson* in the Hall of Honor. Rather than having to face a half-empty building and little evidence of women's achievements, the Lady Managers found themselves overwhelmed with contribu-

tions from the state commissions they had organized. In all the confusion and clutter, their nightmares seemed to be coming true; it was difficult to decide what was not "first rate," and some work went on display that had not seemed good enough to compete with the men—Vinnie Ream's *The West*, for example, had already been refused by the Department of Fine Arts when the Woman's Building accepted it. Under pressure, the Lady Managers and women's state committees reverted to regional stereotypes and labeled the work of Southern and Western women as the least deserving. Palmer wrote to Western state commissions to discourage them from sending: "It seems to me a mistake for our western sisters to attempt to make a showing in art, embroidery, etc., as they cannot hope to compete with the older sections of the country."[78] In the end, the crush for display space forced the Lady Managers to resolve the tensions inherent in their project: how could the gender-separatist strategies of the Woman's Building avoid confirming that women's art could not compare or compete with men's?

In order to protect women painters and sculptors from the trivialization and feminization that would likely result from their presence "in the same room as bed-quilts, needle-work and other *rubbish*," the organizers of the Woman's Building resorted to a racial model of progress that enshrined white women's artistic production as "civilization," while the simpler work of other women represented the "savage" or "primitive" state from which white women had risen. This was an important emendation of the overall theme of the Columbian Exposition: the progress of civilization. "Progress" found its metaphor in the spatial organization of the fair. The White City, with its Court of Honor clustered around the main lagoon, celebrated the artistic and technological achievements of white men in an atmosphere of neoclassical reverence. By sharp contrast, the carnivalesque Midway featured commercial amusements; it invited the fairgoer "to descend the spiral of evolution" as one walked past recreated villages of Germans and Irish, Turks and Chinese, and finally Native Americans and Dahomans, in that order. The Woman's Building stood sentinel between the White City and the only entrance to the Midway. Woman, it would seem, marked the border between civilized and uncivilized, and remained literally and figuratively marginal to both categories.[79]

The Woman's Building organizers and contributors embraced the idea of woman as civilizer and beautifier in order to assert that women's contributions were vital for human progress. "The footsteps of women will be traced from prehistoric times to the present and their intimate connection shown

with all that has tended to promote the development of the race," the Preliminary Prospectus for the Woman's Building had stated. The concept of the white race elided with the idea of a single human race. This racialized, evolutionary history of women framed the contributions of nonwhite, "primitive" women as artifacts rather than art. In a living exhibit (reminiscent of the Dahomey villages on the Midway), two Navajo women wove blankets in the Colorado booth.[80] Nonwhite women were the artists of the past, not the present or future. Bertha Palmer even tried to exclude the work of contemporary Native American women, claiming that such work was inauthentic; "contact with civilization" had irreparably "spoiled" Native American women's artistic "instincts."[81] The white lenders of Native American beadwork, Punjab silks, and African baskets were celebrated on the labels and in the exposition's publicity, while the women who made the items remained anonymous.

So, amid its displays of lacework and paintings, embroidery and sculptures, the Woman's Building conceptualized the "advance of women" in the same terms that the fair at large conceptualized the "progress of mankind": that is, a progress from "savagery" to "civilization." This model of progress and woman's advance—from primitive to modern—informed the way in which all women artists' contributions were organized, as well as visualized, in the Woman's Building. It marked not only the way the fair was planned, but also the way the fair was *understood* by its organizers, exhibitors, and visitors. Most of all, it assumed the same racial categorization and hierarchy that appeared on the Midway. Though none of the murals depicted an explicitly nonwhite subject, American culture, the fair as a whole, and the hierarchy of art objects in the Woman's Building all served to associate the "primitive" indelibly with Native Americans, Asians, Africans, and Latin Americans, cultures in which Woman had not yet advanced to the freedom and civilization of white American and European women.[82] Candace Wheeler, director of the planning committee's Bureau of Applied Arts, visualized a "sisterhood of effort"—or, more specifically, a "reaching out of hands to clasp other invisible hands," those of others "who had no share in the past, and are only beginning to live in the present." The white middle-class woman continued to be the ideal woman, she "who stands for all that belongs to the best estate of woman" and beckoned her "savage" sisters from Africa and Asia "out into the sunlight."[83]

White American women's work in the finer arts was thus seen as proof of their superior civilization, and of their whiteness itself. Meanwhile, the ar-

tistic contributions of nonwhite women were limited to anonymous basketry, textiles, and other examples of domestic, useful arts. This effectively asserted woman's "natural" affinity for art while composing a counterpoint against which white women's "advances" could be measured. The association of "low art" with "primitive" women helps explain Bertha Palmer's resistance to recommendations that the Woman's Building limit itself to exhibits of applied art by women. An exhibition of decorative art, or of "the *primitive* feminine industries," would not, as Sara Hallowell contended, represent "a glory to the sex" or prove that "woman possesses creative powers."[84] A woman's exhibition that lacked high art would lack evidence of white women's superiority.

The idea of progress suffused women artists' work on exhibit at the Woman's Building. Blanche Nevins, for one, entered a series of sculptural models "designed to illustrate woman evolving from ancient bondage to the advanced ideas of the nineteenth century" for the sculpture contest. Jean Loughborough interpreted sculptor Bessie Potter's submission of an angel blowing a trumpet as "proclaiming woman's freedom to all nations of the world."[85] Most impressively, in the Gallery of Honor, the main rotunda of the Woman's Building, various large murals provided powerful images of the connection between women's work and women's progress through civilization. Women in the remotest past lived in romanticized idleness and paganism, as in Amanda Brewster Sewell's *Women in Arcadia*. Mary Fairchild MacMonnies' widely admired *Primitive Woman* and Lucia Fuller Fairchild's *The Women of Plymouth* depicted the next stage of women's history: domestic labor. MacMonnies' "allegorical-symbolical-representation" (in her own words) depicts primitive women carrying water, plowing, and caring for children. Fairchild's women are also extremely busy, cleaning, spinning, sewing, teaching, and cradling infants. They are productive and useful, and thus more advanced than the women of antiquity, though their work threatens to become drudgery. The official guidebook made sure to praise the figurative women's toil, adding that "unless the higher education now open to our sex makes women better and wiser wives and mothers it is a failure."[86] Rosina Emmet Sherwood's panel, *The Republic's Welcome to Her Daughters*, depicted women in the roles of musician, sculptor, painter, weaver, and college graduate (in cap and gown). Lydia Emmet's *Art, Science, and Literature* also depicted artistic and professional women with the trappings of their individual specialties: a woman musician (playing the guitar), a woman graduate (holding a diploma), and a woman artist in her apron,

holding a small statue in the crook of her arm, about to be crowned with a laurel wreath. To these, Emmet added the conciliatory figure of a mother with a child on her lap. Woman's progression into higher education and professional work would not violate her basic femininity, these paintings assured the viewer; but at the same time they claimed education and professionalism as the appropriate realms of the modern woman's activities. Of all the murals in the Woman's Building, Mary Cassatt's *Modern Woman* was singled out for the most bitter—and incoherent—criticism.[87] Yet even Cassatt's subversive vision of "modern woman" imagined a sisterhood of women helping and teaching each other in the pursuit of knowledge. Cassatt herself said of the mural that "if I have not been absolutely feminine, then I have failed."[88] Through these commissioned murals, women artists and the Board of Lady Managers associated women's professionalism with women's progress, women's role in the "advance of civilization," and thus ultimately with women's whiteness.

However abstractly and allegorically it was imagined, the racial model of woman's progress had a real effect on the art that women produced. Women artists adopted a "white gaze"—that is, a perspective that constructs racial "others" as its object, and the spectator as white.[89] This enabled them to adopt a position of authority and portray other races in their art. Grace Carpenter Hudson produced her first paintings of Native Americans in the 1890s. While women's oil paintings in the 1893 fair's Gallery of Art depicted nothing more exotic than scenes from Brittany and Italy, the California state building at the 1893 fair displayed Hudson's paintings of Pomo Indian children, *Little Mendocino* and *The Interrupted Bath*, in the building's woman's department. Native American subjects would come to dominate Hudson's professional career and win her critical acclaim. In this period, Native American themes were considered to provide interesting and popular material, as is evident from a women's sculpture class at the Art Institute of Chicago (Figure 8). Other women artists, such as San Francisco etcher Helen Hyde and painter Lilla Cabot Perry, also began to turn to "exotic" subjects in the 1890s. Hyde favored Asian American and Mexican scenes, both of which sold well; Lilla Cabot Perry painted over eighty canvases of Japanese subjects while she lived in Tokyo between 1893 and 1901.

At the same time, the racialization of the artist limited the options of non-white American women artists of the period. If African Americans, Native Americans, Latinas, Asian Americans, and other racialized immigrant groups comprised the "primitive" against which most women profession-

als defined themselves, women who were members of those nonwhite groups could not very well identify themselves as "women artists."[90] Marginalization and informal exclusion by mainstream American culture, the American art world, and women artists' organizations also make the identification of women artists of color a difficult task, and there is a great need for more recovery work, especially since for obvious reasons these artists may not have readily identified themselves as anything but white. Apparently,

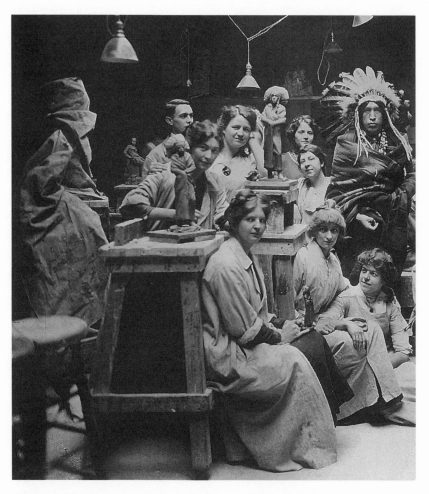

Figure 8. Sculpture class at the Art Institute of Chicago, ca. 1890. Courtesy of The Art Institute of Chicago.

there were simply not enough Latina and Asian American women artists to create their own group identity (whether that be race within gender, or gender within race) until later in the twentieth century.[91]

Several late-nineteenth-century African American and Native American women artists worked in relative isolation from the mainstream art world. Again, it would require a larger, more geographically concentrated number of women (as later during the Native American crafts revival and the Harlem Renaissance) for them to develop their own identity and challenge the definition of the woman artist as white. Certainly no nineteenth-century woman of color before or after neoclassical sculptor Edmonia Lewis gained recognition in the upper strata of painting or sculpture. Lewis fell into obscurity after the Centennial Exposition, as the popularity of neoclassicism waned and she continued to live in Rome. Thus, despite her success in a prestigious medium, Lewis was not named as a foremother or inspiration to other women artists. Women of "lower race" who managed to establish careers as artists kept to the lower echelons of the art hierarchy. For example, Pauline Powell (1872–1912), an African American, was known as a still life and landscape painter in Oakland, California; she exhibited *Champagne and Oysters* at the Mechanics' Institute in 1890.[92] Susette LaFlesche Tibbles (1854–1903), an Omaha, created the illustrations for *Oo-mah-ha Ta-wa-tha (Omaha City)*, published during the 1898 Trans-Mississippi and International Exposition in Nebraska. The frontispiece declared that this represented "the first artistic work by an American Indian ever published." But Tibbles' work as a reformer overshadowed her art career, and represented her deeper commitment.[93]

The association between "low race" and "low art" was enforced as well as assumed, with significant repercussions for women artists. Industrial schools for African Americans and Native Americans, such as Tuskegee and the Hampton Institute, often included instruction in art, but only in the form of mechanical drawing or "native Indian crafts." Thus, even if these students gained proficiency, they would remain esconced in the minor, usually commercial, arts.[94] Unlike Susette LaFlesche Tibbles, Angel DeCora (1871–1919), a Winnebago, felt that art was her true vocation. A graduate of Smith College and the School of the Museum of Fine Arts in Boston, and a friend of Cecilia Beaux, DeCora belonged to the most conventionally professional art circles. One of her teachers, however, noted illustrator Howard Pyle (who also taught Alice Barber Stephens), may have regarded DeCora as the ideal example of a great artist thwarted by social and cultural barriers. When

asked if he had ever had a student he considered a genius, he purportedly replied, "Yes, once, but unfortunately she was a woman, and still more unfortunately, an American Indian." DeCora exhibited two paintings at the 1910 Paris Salon, but most of her work in art was limited to illustration and teaching. She could not separate the cultural strands that made design work both earn her more money and make her feel more authentic as an artist. "Although at times I yearn to express myself in landscape art, I feel that designing is the best channel in which to convey the native qualities of the Indian's decorative talent," she wrote in a brief autobiography for the magazine of the Carlisle Institute, a school that specialized in vocational education for Native Americans. "Perhaps it was well that I had not over studied the prescribed methods of European decoration, for then my aboriginal qualities could never have asserted themselves." Resigned to this limited and racialized version of the artist, DeCora still claimed a place for her people in the annals of high art: "There is no doubt that the young Indian has a talent for the pictorial art, and the Indian's artistic conception is well worth recognition, and the school-trained Indians of Carlisle are developing it into possible use that it may become his contribution to American Art." Notably, DeCora had internalized racialized rather than gendered explanations of her talent.[95]

The most successful nonwhite woman painter of the period was probably Narcissa Chisholm Owen (1831–1911), a Cherokee. Like Tibbles and DeCora, Owen felt that her most pressing duty was to elevate the image of the Native American. Unlike other Native American artists, however, she refused to accept the racialized hierarchy of art that many artists (increasingly including women artists) touted. She considered neither embroidery—"quite like painting with the needle"—nor landscape painting to lie outside her sphere as an artist. Neither her womanhood nor her Native American ancestry limited her art. Owen's memoir, published in 1907, claimed art as part of Native American history and legend, noting that one of the seven founders of the Cherokee Nation was Arni Waut, "the painter." Indeed, she claimed that depictions of Nature came easily, almost instinctually, to her, no violation of her "native qualities" (as Angel DeCora called them) at all. In her first attempt at oils,

After a cessation of thirty years from any effort at watercolors or even a pencil sketch, I went to work and spent two weeks down in the corner of the parade grounds of the fort, where the children of the post gave anima-

tion to the view, and I carefully studied Nature's grand pictures—rivers, mountains, and palisades. That was eighteen or twenty years ago. Since that time I have found art my greatest resource and general pleasure and pastime, having painted many pictures, tapestries, and portraits.[96]

Owen claimed landscape painting as her natural province while blurring any distinctions between high and low art (mentioning "pictures, tapestries, and portraits" in the same breath).

Owen's 1896 self-portrait (Figure 9) presents the image of a woman with a strong sense of herself. Dressed in dark colors with sparse jewelry (small

Figure 9. Narcissa Chisholm Owen, *Self-Portrait* (1896). Courtesy Oklahoma Historical Society.

earrings, a wedding ring, and a locket), she appears serious, even somber, refined, and eminently respectable—the equal of any middle-class white woman. The jet beads and black lace adorning her shirtwaist attest to her wealth, while the spectacles in her right hand evoke intellectual pursuits (and perhaps refer to the sitter's visual profession). Reinforcing the decorum of the image, Owen paints herself looking straight ahead, but not facing front, toward the viewer. There is none of the woman artist's intense gaze at the viewer here. Aside from the spectacles, there is no hint that this woman might be an artist. In print, Owen could depict art as an almost unremarkable part of her life and legacy, but in this self-presentation dignity and refinement embodied professionalism in a way that differed from contemporary white women's works. Owen's self-portrait is also the antithesis of Grace Carpenter Hudson's contemporary paintings featuring costumed, feathered Pomo Indian children and women posing with baskets. That was the exoticized image and "savage" association with which every one of Owen's (or any nonwhite woman's) paintings would inherently find itself in dialogue.

As the merging of high art and low art continued to provoke disfavor, women's world's fair exhibits faded away, but separate women's art clubs continued to form and women artists continued to organize their own exhibitions into the early twentieth century.[97] As long as women artists could guard their professionalism, separatist strategies thrived. In California, for example, the San Francisco's Sketch Club in 1906 held a Women Artists' Exhibition featuring sixty-five works, the Women Painters of California (the first women's art club in southern California) held its first exhibition in the winter of 1909, and the Oakland Art Museum organized a women's exhibition in the summer of 1916.[98] Clubs like the Plastic Club and the Pen and Brush forged onward with strong memberships. The only major transformation in women artists' associations came in 1909, when the National Association of Women Painters and Sculptors and the Plastic Club joined seven other art associations (including mixed-gender and all-male clubs) to form the Washington, D.C.–based American Federation of the Arts (AFA). Men dominated the AFA leadership, but women made up the majority of its membership and were able to gain much valuable information and direction from the umbrella organization. Women's art clubs generally managed to keep their autonomy alongside AFA affiliation, but the AFA required some amount of conformity. Notably, ad illustrators—whose commercial work did not qualify as "high" art—were excluded from membership.[99]

* * *

Figuratively, late-nineteenth-century women artists were all, like Caroline Brooks, sculpting butter—drawing upon their experience and identity as women to try to gain a foothold as professionals. Segregated women's art clubs and exhibits formalized the networks that women artists had formed since the mid-nineteenth century. These clubs significantly expanded women's opportunities to display and sell their work, to develop professional credentials and contacts, and to maintain an identity as artists that did not necessarily conflict with their identity as women. To counterbalance the very real limits that family obligations (especially marriage and motherhood) could place on their careers, professional women artists sought to turn their gender to their advantage. Even as they began to espouse a professional ideal that did not specifically reference gender, they allowed themselves to see cooperation and continuity with the feminine domestic artist of the past. They still largely regarded their identities as women and as professional artists as complementary.

Women's rejection of an artistic hierarchy created a serious problem in maintaining their status as professionals, however, and as the nineteenth century ended, more and more women left behind their assertion of a special feminine artistic sense and female tradition in art. Not only did the overtones of domesticity and amateurism grow more pejorative, but the association between low art and feminized "low" (that is, nonwhite) race became increasingly inescapable. The Woman's Building at the World's Columbian Exposition had attempted to resolve the problem of women artists' double consciousness, using racist ideologies to explain what bound women's high and low art together as examples of progress in civilization and to argue for woman's significant role in that progress. But this rationale made it difficult to continue to claim decorative art as part of a feminine professional tradition. Professional women artists of all races would have to lay claim to the "high art" that discomfited DeCora and distinguish themselves from designers and decorators—or else redraw the boundaries of art once more to bring full professional status, concomitant with their womanhood, within reach.

Portrait of the Artist
as a New Woman

In the course of the nineteenth century, women painters, sculptors, and illustrators largely transformed the idea of woman as domestic artist into a more self-consciously professionalized figure. Taking advantage of the expansion of art education for women, they had developed an ethos of professionalism that nevertheless maintained a strong gendered dimension. This brand of specifically feminine professionalism continued to thrive among women artists into the twentieth century. The development of separate institutions persisted; women founded more professional art associations of their own including Denver's Le Brun Art Club (founded in the early 1890s), the Woman's Art Club of Cincinnati (est. 1892), and perhaps the most successful of all, Philadelphia's Plastic Club (est. 1897). Membership in other women's art clubs, such as the Women's Art Club (est. 1889; later the National Association of Women Painters and Sculptors) and the Sketch Club in California, soared. Artists like painter Theresa Bernstein appreciated women's art clubs as places "where women could make inroads in the more inventive presentations" and for providing "a place for connoisseurs to wander toward" and buy art.[1] In the face of anxieties that art itself was becoming more "feminine" and therefore eroding in quality, these societies grew increasingly vocal and confident. More and more women studied art, produced art, and gained publicity as artists. The publication of Clara Erskine Clement Waters's biographical study *Women in the Fine Arts* in 1904 cemented the public sense that "woman artist" was a discrete identity, and that these artists made up a group with its own history.[2]

The development of feminine professionalism among artists and other groups of women before the turn of the twentieth century laid the groundwork for the emergence of the New Woman, an image that in turn won increasing acceptance for women in the public sphere. Historians have

pointed to a range of men, from illustrator Charles Dana Gibson to painter John Sloan, as the inventors of the New Woman as cultural icon. The image simultaneously soothed anxieties over social changes and signified modernity. In this sense, the New Woman was the ultimate commodity and symbol of commodity, whose independence made her more physically attractive and more companionable to men, and whose freer sexuality only equipped her better to be the subject of the male gaze.

But the trope of the New Woman was also the product of women professionals for whom it had a different significance and a different potential. Her appearance on the American scene is often explained as being the result of a combination of social and cultural factors: an expansion of opportunities for women in education and wage labor; technological changes and increasing affluence, which freed women from many household chores; urbanization and the rise of consumer culture; the disintegration of a homosocial culture; and a media explosion capable of producing and disseminating specific images of social expectations. As historian Nancy Cott describes, the nineteenth-century movement for woman's rights had succeeded in transforming many of the social, political, and economic power structures from which women had formerly felt excluded. A modern definition of womanhood emerged, infused with feminist values.[3]

The New Woman thus promised to be a vital symbol and model of independence, professionalism, and public visibility around which women artists could rally. Professional women artists contributed in two vital ways to the creation of this new ideal of womanhood: they acted as flesh-and-blood models of the New Woman, who had already embraced education, wage-earning, urban living, and professionalism; and they participated in the production of images that established the New Woman's ideal attributes.[4] They laid claim to the New Woman as their own self-image, developing a powerful iconography for womanhood and professionalism that ranged far beyond the sweet, high-spirited Gibson girl.[5] In addition, the free lifestyle of a New Woman, rejecting the confinement of the Victorian lady, could approach the bohemianism that male artists had cultivated since the mid-nineteenth century. These artists exhibited an exuberant sense of themselves as public actors as well as professionals. Their self-confidence propelled them from demanding equal treatment as artists to making innovations in portraiture, embracing bohemianism and urban culture, and using their art to strive for social and political change. Earlier women's life and work as artists may have been subversive or radical, but at the turn of the twentieth cen-

tury women artists explicitly intended and labeled their work as such for the first time. They produced art explicitly for the sake of reform, revolutionizing the settlement and suffrage movements in the process.

The New Woman proved such a powerful model because, unlike the domestic lady artist, it could preserve the woman artist's gender identification without threatening her professional status. The New Woman's intrinsic seriousness and sense of purpose mitigated the rift that had grown between professional and nonprofessional women in the late nineteenth century. Women used their status and skills as artists to lend weight to public, even political, movements that invoked their identity as women, from the settlement house to the suffrage parade. They occupied the public stage with the confidence and expectation that they would make significant contributions to American society and culture—and they could do so without unsexing themselves.

But the icon of the New Woman had its limits. Its class and racial boundaries made it as homogenous as the earlier, more conventional image of the True Woman and the shared domestic culture that had first made women's work in art possible. Within their own communities, working-class, immigrant, and even nonwhite women adopted (or, rather, adapted) the New Woman as a model of feminine assertiveness, a figure that provided an acceptable context for public life and action.[6] But in the popular press, the New Woman was definitely a middle-class white woman, a figure that reinscribed the barriers of race and class in important ways. In this sense, the New Woman represented a continuation of the Columbian Exposition strategy: using race (and racial hierarchy) as well as gender to unite women artists across the many different genres and styles, media and messages, "high" and "low" art in which they worked.

The New Woman's call for equality led to the first pervasive public attack against "sex in art" by women art critics and feminists. "Art is art, and should speak for itself, and the pictures themselves should be placed in competition, not the sex of the painter," the editors of the *Woman's Journal* wrote in 1896. "Sex in art is a fact, and it should be written against by all journals that wish to encourage true art." Even when writing specifically about women artists some writers, like art critic Lida Rose McCabe, carefully pointed out that their subjects merely "happen[ed] to be women," not artists whose sex mattered.[7] In this way, they evaded the charge that women's professional equality would mean competition between men and women.

This was no battle of the sexes, or even a contest among artists—the pictures themselves, not their makers, were the competitors. These critics argued that they were only holding art to its own ideals of universalism, and consequently androgyny. Some male reviewers obliged and began to perceive a new type of woman artist at work: "The prettiness and amateurishness, once so generally considered the inevitable attribute of womens' [sic] work, is usually foreign to the methods of the modern young female enthusiast, who works side-by-side with her fellow student, with the same aims and the same methods," the New York Independent noted approvingly.[8] It seemed that the woman artist's association with "the modern"—that is, with the New Woman—would serve her well in her quest for an egalitarian, androgynous professionalism.

Women artists themselves, however, were more conflicted regarding "sex in art." Circumstances forced them to recognize how profoundly gender ideologies affected the way they were perceived. In practice, "sexless" meant "masculine"; no truly androgynous art ideal or criteria existed. To paint well meant to paint "like a man." Some women artists had turned feminine stereotypes and domestic ideology to their advantage and risked losing much if their "feminine" qualities were effaced. Other women internalized the belief that manly art was better art or pragmatically accepted that "masculine" genres or styles usually translated into higher status. Thus Elizabeth Nourse, who specialized in domestic genre painting, angrily protested when her work was described in masculine terms, while elite portraitist Cecilia Beaux considered the same treatment high praise.[9] Alice Barber Stephens does not appear to have objected to her repeated identification as one of very few women to exhibit talent at illustration.

It soon became all too apparent that neither femininity nor sexlessness could be easily reconciled with women's professional identities. In the 1890s, American women artists began to deliver speeches and publish writings that addressed the problem of gender in their lives and work. Aspiring to a sexless standard, they confronted the conditions that made women's careers as artists different, through professional exclusions, social expectations, and maternal duties. Women had repeatedly grappled with the issue in private, but now they addressed it in public discourse. For example, in a 1909 speech to the International Council of Women, sculptor Vinnie Ream Hoxie insisted on an equal place for women as artists. "Sculpture . . . is eminently a field for women; no one has ever questioned that the eyes are as true, the thoughts as noble, the touch as delicate as with men." Her lan-

guage ("*as* true," "*as* noble") was egalitarian, claiming no peculiarly feminine affinity for art. Like Katherine Cohen's address at the Columbian Exposition, the much older Hoxie held up a universal ideal of art that remained untouched by the artist's sex.

Yet these same women could not ignore that the surrounding culture constructed the artist in gendered terms. "I have sometimes wished to be a man," Ream admitted, "and have some loving, clinging soul leaning upon me—depending on me."[10] If women did have special characteristics—to love, to cling, to depend upon men—these did not ultimately seem appealing. Masculine independent strength, on the other hand, felt more becoming to a true artist. Why not wish to be a man? Ream's vision of the artist in this speech could not account for the feminine professionalism that she herself practiced. Cecilia Beaux also implicitly recognized the masculinity of the professional artist as popularly perceived. "I very earnestly believe in the text which is that there should be no sex in Art," Beaux said in an address to Barnard College in 1915. "I am pointing, I know, to a millennium at least in the woman's view if I predict an hour when the term 'Women in Art' will be as strange sounding a topic as the title 'Men in Art' would be now."[11]

In other words, the end to "sex in art" entailed the erasure of women artists' sex, not a recognition of gender differences that would allow women artists to preserve a distinct feminine professional identity. In her open "Letter to Artists, Especially Women Artists," painter Anna Lea Merritt spoke plainly about the obstacles to segregated women's exhibitions. She even claimed that "women artists have been fairly treated in the [integrated] exhibitions; there was never any exclusion." Meanwhile, "recent attempts to make separate exhibitions of women's work were in opposition to the views of the artists concerned, who knew that it would lower their standard and risk the place they already occupied. What we so strongly desire is a place in the large field: the kind ladies who wish to distinguish us as women would unthinkingly work us harm." Merritt argued that gendered distinctions would result in inequality; real professionals aspired to an androgynous view of art.[12]

In the very next paragraph, however, Merritt acknowledged a gendered difference in women's art. "The inequality observed in women's [art] work is more probably the result of untoward domestic accidents," she wrote; that is, the problem for women artists lay in the conflict between their work as women and their work as artists. As a working painter herself, Merritt understood the benefits and liabilities that gender posed for the woman artist.

All women needed to be feminine; but a woman's femininity depended on her acceptance of her domestic role, which simultaneously interfered with her work as an artist. "Women who work must harden their hearts, and not be at the beck and call of affections or duties or trivial domestic cares. And if they can make themselves so far unfeminine, their work will lose that charm which belongs to their nature, and which ought to be its distinction," she warned.[13] While Merritt opposed separate exhibits of women's work because there was no difference in men's and women's theoretical *capability* for producing great art, she still insisted that women's art ought to be "distinct," that women artists should carefully guard their femininity because that femininity should ideally mark their art. "The great strength of their work will be its feminine quality," she predicted.[14] This was the central contradiction with which all American women artists had to contend in order to be successful artists. Merritt was radical enough to call for an end to gendered art institutions; but, like Ream and most other women artists, she could not imagine an androgynous artist or an androgynous art. Her ideal of the woman artist more closely resembled the nascent New Woman: someone who occupied the public (that is, professional) sphere comfortably alongside men and deserved equal consideration, but at the same time somehow maintained her femininity.

Painter Margaret Lesley Head Bush-Brown also invoked an egalitarian but gendered ideal in depth in her 1901 speech "The Relations of Women to the Artistic Professions." Bush-Brown claimed to have little interest in measuring women's art against men's, preferring to hold both sexes to the same standard: a "strong bent" for art. Unlike Anna Lea Merritt, she recognized that "judging by history" the woman artist remained "unlikely to reap fame, or satisfy her own ambitions." But the true artist of either sex, she argued, would not concern herself or himself with "sex in art" because fame and status are superfluous to one's real vocation.[15] Like women art critics in the previous decade, she contended that the artworks, not the sexes, were competing for professional laurels.

But gender remained a problem, for Bush-Brown was emphatically unwilling to exempt women artists from the demands of femininity and motherhood. As she explained in a short autobiographical essay, Bush-Brown firmly "believe[d] that most women are intended to be wives and mothers," and that all women, including "the most intelligent class," led the happiest lives when they abjured professional careers in favor of "the men who need them, and the future of the race which calls them."[16] Other women art-

ists, such as Alice Barber Stephens, reflected this sentiment; despite her extremely successful career in illustration, Stephens insisted to interviewers "that the big things of her life were, first, her marriage to the fellow-student and illustrator who is her companion in work as in all other affairs of life, and then the coming of her son." Bush-Brown went further than Stephens in reconciling her ideas about womanhood and work in art by declaring that mothers should consider art to be an avocation, as she did, instead of a profession. Whatever her primary role, Stephens spent "the whole day in the studio as a general thing" and struggled to maintain an identity outside the domestic sphere. "My life is still a professional one, and I am glad to keep it so," she stated. "But I have allowed the home life to involve me more and more. I find it indeed hard to regulate and balance this since home seems always a compelling interest."[17] In contrast, Bush-Brown avowed that her responsibilities as a woman did and should supersede the demands of art. "If interruptions come the woman of faith and courage abandons her easel almost without regret," she declared, "and does not bemoan her fate or compare her lot to that of her husband whom household contingencies do not draw from his work."[18] Yet "Mrs. Bush-Brown knew that the time would come when, if she held onto her painting it would make her latter years happy and full of interest, and that time has now come . . . [her work] assumed once more that importance of a profession."[19]

How, then, could a woman become a professional artist without violating her womanhood? By suggesting that gender roles, not sex itself, were the impediment, Bush-Brown offered an ingenious solution. Her ideal femininity accorded space before and after child rearing for a woman to devote her energies to her career. Even more significantly, Bush-Brown asserted that work and interest in nondomestic matters actually enriched a woman's contribution to her family: "She knows that her life is richer for her work, while that of her dear ones is also enriched by it, and she knows too that she can afford to wait."[20] Elsewhere, Bush-Brown elaborated: "If the children had no slave in their busy mother, and had to learn early to do for themselves, they certainly had intimate companions in both parents, seeing far more of their Father than do most American children."[21]

A woman's work and identity as woman and as artist could thus have fluid boundaries, and even be mutually reinforcing. In practice Bush-Brown's vision of art as mothers' "avocation" was remarkably similar to many women's earlier ideals of feminine professionalism. Her diaries, kept intermittently from 1872 to 1903, attest to her steady work as an artist both

before and during motherhood. For example, in 1894, when her eldest child was only eight years old, Bush-Brown reported regular, often daily, work on paintings, especially portrait commissions; in fact, most of the entries concern her artwork, not her family life.[22] A certain hierarchy remained in which "homemaking must stand first in the woman's own mind and that if she has not the strength for both, the other work, whatever it is, should be sacrificed."[23] Bush-Brown did not consider that a woman might take up artwork out of economic necessity; she could only imagine the woman artist as a middle-class woman like herself. A woman's professionalism was a self-indulgence, permissible only if other hands (most likely paid ones) took over her true duties: the work of domesticity.

Within this tangle of gender expectations and class obligations, however, Bush-Brown saw a place for the extraordinary woman in professional art. "To the woman of exceptional gifts or peculiar circumstances a course is right which would be wrong to a less well endowed sister," she explained. Bush-Brown's sentiments resembled the more radical views of contemporary feminists: a small group of overqualified women would be allowed to step beyond their sphere, while gender roles themselves remained intact. "Let no woman with a family become or continue to be an artist, if her chief ambition be to compete with men. Only if she care single-mindedly for the work for its own sake can she hope to be happy in it."[24] Only talent and androgynous ideals—"work for its own sake" rather than mere "compet[ition] with men"—could qualify a woman for a profession in art.[25]

Margaret Bush-Brown, Anna Lea Merritt, and Vinnie Ream sought to theorize very real anxieties and contradictions in the identity of the professional woman artist. Their public writings and speeches echoed the more private anguish of Jessie Hamilton, who wrote to her cousin Agnes (also an artist) of the painful sense that an artist's life and a woman's life could not cohere.

> I really ought not to paint. If I paint I can do nothing else—I can not live—I cannot keep my clothes tidy, my room in order, write letters, buy Christmas presents, wash my hair, put things away, do things in the house, go to missionary societies, take walks, teach Sunday School lessons . . . or do anything—I must do one or the other. I have not the physical strength for both, or else I imagine I have not. It is a pity to be forty-three and not to have decided the trend of one's life and I shall go to the other world still between the two, with neither done—[26]

Hamilton's catalog of domestic failings had led her to conclude that she "really ought not to paint"; she was not one of Bush-Brown's brand of superwomen, possessed of vitality enough to conquer both home and world. She inhabited a borderland, "between the two, with neither done"—but neither renounced. How could Hamilton—and Ream and Merritt, Bush-Brown and Beaux—flourish as professional artists when they lived in stasis? Or were their identities, as artists and as women, more coherent than the gendered language of professionalism and art criticism could express?

It was not, ultimately, through words that women artists reconfigured their professional identities at the beginning of the twentieth century, but rather, as in the past, through their skill as visual artists. Through their work they found a more positive and coherent resolution to the persistent tensions between gender identity and professional identity. In the tradition of Elizabeth Nourse's and Ellen Day Hale's self-portraits discussed in the previous chapter, women artists' portraits of themselves and each other embraced an overt but feminine professionalism. In sharp contrast to her professed views on maternal duty, there is nothing in Margaret Lesley Bush-Brown's *Self-Portrait* (1914) to identify her as a wife and mother; yet the combination of painting robe and lace collar, intense gaze and slight smile, meld the identities of artist and woman in ways that Bush-Brown's writing never conveyed. The well-appointed interior testifies to the artist's professional success; in fact, the palette in the crook of her arm and the poised brush in her other hand suggest that all of the artistic decoration in the room might be her handiwork. Likewise, in her *Portrait of Anna Vaughan Hyatt* (1915), Marion Boyd Allen presented Hyatt as a serious and confident artist, intently modeling an equestrian figure. Hyatt is much taller and larger than the maquette, inviting the viewer to conclude that as the artist she is much more important than her subject. She appears strong and muscular, denoting her physical ability to work in monumental sculpture. At the same time, her body is lean and elegant, with the neck, spine, elbow, wrist, and bent knee composing an arabesque of gently curved forms. But her body is turned to her work rather than to the viewer. Hyatt is graceful and feminine, but not on display.

Through an expansion of this iconography, women artists successfully used the figure of the New Woman to mediate cultural anxieties over womanhood, sexuality, public space, and women's careers. Margaret Foster Richardson's *A Motion Picture* (1912, Figure 10) and Gertrude Vanderbilt Whitney's *Self-Portrait* (1913) represent two very different, even oppositional,

Figure 10. Margaret Foster Richardson, *A Motion Picture* (1912). Courtesy The Pennsylvania Academy of the Fine Arts, Philadelphia. Henry D. Gilpin Fund.

visions of the artist as New Woman; as such, they mark the wide range of images that could deploy the New Woman as a model for the woman artist.

Like the portraits of Margaret Bush-Brown and Anna Vaughan Hyatt, the self-portrait of Margaret Foster Richardson presents a working artist, dressed in her painting smock, with both hands firmly gripping her brushes. There is, however, no evidence of her labor, no fresh canvas or just-completed masterpiece in view. All attention is focused on Richardson herself, an arrested glimpse as she strides across our field of vision. Her gentle smile and beaming face, turned to the viewer, draw the viewer into her state of busy, happy satisfaction. The painting's titular pun connects Richardson's mobile persona to the epitome of modern life, the union of art and technology: the movies. Yet she is not a film star, with her androgynous smock, white collar and tie, eyeglasses, and simple pulled-back hair. She has all of the New Woman's wholesomeness and sense of purpose with none of the Gibson girl's coquettishness.[27]

In sharp contrast, Gertrude Vanderbilt Whitney's *Self-Portrait* is a gilt bronze statue of a long, elegant, stylized female figure. This subject is decorative rather than professional, idealized and exoticized not realistic, static instead of dynamic. The figure's pervading sense of stillness and calm seems the antithesis of Richardson's rush and enthusiasm. Yet this choice of self-representation connected Whitney to new womanhood in a different way. Through the figure's slippers, the symbolism of the lotus blossom from which the figure has emerged, and the Buddhist gesture, Whitney marked herself as a member of the artistic avant-garde which was looking to Asia (Japan especially) for a new aesthetic. She is not only a professional artist but a cutting-edge one, the sculpture announces. In comparison with Richardson's androgynous appearance, Whitney chose to display the contours of her own body through the draped garment. This, too, was the hallmark of the New Woman: a more open sexuality. Whitney played with the identities of artist and model in a way that few women self-portraitists dared to emulate.

Women artists sought a new imagery with which to represent themselves and their professional identities outside formal portraiture as well. For example, the Plastic Club, a large women's art club in Philadelphia founded in 1897, featured a series of woman artist icons in its early exhibition catalogs. One of the earliest images, drawn by "Kay" ca. 1897, offers the intriguing figure of a short-haired woman in professional attire, carrying her easel, canvas, and brushes, and surveying a landscape of rolling hills and rooftops.

She is, like Richardson's self-portrait, arrested in motion, an active woman with a sense of purpose, self-reliant and strong. Other images of 1897 and 1898 represented much younger women—girl artists, or (by implication) art students, much like the figure in the advertisement for William Chase's classes as it appeared in the back pages of an 1899 Plastic Club exhibition catalog.[28]

After the turn of the century, these woman artist icons became increasingly divorced from professionalism and realism. An allegorical goddess of painting from 1901, daubing at her palette though wearing fantastic drapery, paved the way for an emblematic winged figure, whose long hair seems to twine around her body and oversized palette to bind the tips of her wings together. This curious figure graced several catalogs between 1902 and 1911. By 1912, the Plastic Club logo had lost all connection to the professional woman artist: two classically garbed, female Art Nouveau figures hold up the stylized name of the club. There are no art-making paraphernalia in sight.[29] Yet such images could also represent variations of the New Woman; like Gertrude Vanderbilt Whitney's exoticized self-portrait, the Plastic Club emblem asserted women's identification with the modern in art.[30]

The image of the New Woman managed to project a relatively liberated, youthful persona without seeming to challenge convention too profoundly. It created new possibilities for women to represent their identities as still feminine but also increasingly professional. Though women artists had forgone matrimony and disguised their sex for professional reasons long before the turn of the twentieth century, a new context for such behavior emerged from the paradigm of new womanhood and the novelty of bohemianism for women.[31]

Bohemianism implied a poverty-stricken embrace of art and a carefree morality. As such, it required a type of social rebellion, including a rejection of sexual norms, which excluded all but the most notorious women.[32] Women recognized bohemianism as a pose that men assumed to win attention and differentiate themselves from the masses. While studying at the Art Students' League in New York, Norah Hamilton commented to her cousin, "The men students are the most tiresome things—they try so desperately hard to be Bohemian and artistic—and in the life class always shout and sing and blow crazy musical instruments."[33] Men certainly used gender to police the boundaries of bohemianism; but by the 1890s women artists had begun to infiltrate bohemian life.[34] Just as Henri Murger's wildly popular *Scènes de*

la vie de bohème (1847–1849) inspired the first real surge of bohemianism in the United States, George du Maurier's equally celebrated *Trilby* (1894) provided a model for female bohemianism in its beautiful heroine, an artist's model of the Latin Quarter in Paris.[35] Long gone were Susanna Paine's travails in seeking a studio where she could still seem respectable enough to attract art buyers. By the turn of the century, a woman's studio was regarded simultaneously as a romantic, bohemian space and a professional one. For example, "Eleanore," a Greenwich Village artist, is marked as a bohemian by her acceptance of a male acquaintance sleeping off his drunken state on her studio couch. At the same time, she holds herself aloof from his behavior. "She is in no sense disconcerted by the occasional snore that wakes the midnight echoes," a contemporary observer commented. "She works peacefully on at the black-and-white poster which she is going to submit tomorrow. She does not resent Dickey at all. Neither does she watch his slumbers tenderly nor hover over him in the approved manner. Eleanore is not the least bit sentimental,—few Villagers are."[36]

Women also recognized the inherent dangers of bohemian life: not just poverty and hunger, but the loss of sexual innocence. Emilie Ruck de Schell readily posed nude for her roommate, Agnes, a painter. But when a male artist friend "who had spent many a jolly evening in our den" saw the nude sketches and offered to pay her for the same type of modeling, she declined his proposition with "just a shade of indignation." De Schell's 1898 article in *The Arena* warned innocent country girls (who she thought would not have the experience to make such fine distinctions in comportment) against blindly embracing "Bohemian ways."[37] The greater sexual freedom that female bohemianism implied did not necessarily enhance a woman's professional status. On the contrary, the complete loss of respectability could still be quite costly for a woman's career.

As a result of these tensions, women's bohemianism became most effective and productive for them as an innovation within their own separate art communities and networks. It became a way for women artists to differentiate themselves from the stereotypical lady dabbler without giving up their strong gender identification. In delightful detail, Marietta Minnegerode Andrews described the process by which proper Victorian ladies became bohemian women artists at the Shinnecock art colony in Long Island:

> When Miss Alice Tinkham, from Boston, arrived for a few weeks' stay and surveyed the outfit with stern disapprobation, it was [Della] Milhau who

decided that we must break her in or be ruined . . . When Miss Tinkham's sister joined her we agreed that . . . we would conquer the refinement of the second sister all at once. The night of her first appearance in the dining room, pandemonium broke loose. We came in every possible disguise. Some pretended they were drunk, and hiccoughed in the most perfect way. Then came Milhau, in her riding togs, coat-tails over her arm, hat on one side, spurs, whip, everything one could think of, and the brush of a fox she had killed the day before, in her hand. This she extended suddenly before the Tinkham sisters—"Don't it stink?" We danced around them like young Hottentots; some were in evening dress and painted up like Jezebels—others were in painting aprons, most disreputable. Some had used paint brushes instead of hairpins, some were smeared with emerald green across the forehead; and the two sweet little ladies from Boston were filled with consternation of the sincerest sort. Within three days their ruin had been accomplished . . . and they were volunteering to jump through burning hoops at the circus we were planning.[38]

Like the radical women of Greenwich Village who formed the Heterodoxy Club, women painters, illustrators, and sculptors reacted to their continued exclusion from the masculine avant-garde by creating their own spaces for bohemianism. As with the venerable ladies' life class, the absence of men freed women to engage in activities, from "disreputable" high jinks to cross-dressing to nude modeling, that would in a different context cast a shadow on their reputation. In addition, the modern ideal of the New Woman made such antics acceptable enough for women to imagine and for men to tolerate.

The height of female bohemianism at the beginning of the twentieth century could be found at the Rabbit, the annual New Year's revel of the Plastic Club in Philadelphia. "This will go down in the Annals of Bright Bohemian Art, our Annual Rabbit," club president Sara Patterson Snowden Mitchell declared in 1910.[39] The festivities involved fanciful settings and complicated costumes as pretexts for merriment: a Mexican Pinata party complete with bullfight (1900), Alice in Wonderland (1907), the Houseboat on the Styx (1909; for this occasion the Plastic Club has preserved a special album of members in costume as Confucius, Romeo and Juliet, and so on). In general, the Plastic Club did not emphasize the gender exclusivity of its membership, and the outside press did not display signs of discomfort with the club's professional activities. The Rabbit, however, was another matter—"the nearest

approximation to the masculine lodge goat that present-day chivalry will allow," in the words of one newspaper.[40] "Just to prove to the men that they are not indispensable, and what a jolly good time women can have without them, members of the Plastic Club last night held their annual 'Rabbit' in an Adamless Eden," another noted.[41] For their part, the Plastic Club women turned the publicity to advantage. They dressed up as "famous Old Masters" to promote an auction of their work; it was, Philadelphia's *Public Ledger* headlines proclaimed, "rare fun" and a "great financial success"—presumably more so than the usual sales of such "dainty" paintings.[42] The Plastic Club had rehearsed this type of role-playing many times; now they performed a Rabbit of sorts for the public, to make a profit. The event doubled as a chance to experiment with their identities as artists when they donned drag to impersonate Rembrandt, Michelangelo, and other old masters. Connecting themselves professionally to this lineage of canonized "Great Artists" would have boosted the women's claims to fame and the marketability of their work. Club members also asserted women's historical place among venerable painters and educated the public about "Mme. Ronner, the celebrated painter of cats," and Rosa Bonheur.

By adopting bohemianism within a female environment, women artists approached the masculine culture of the professional art world more closely than they ever had before. Women in the United States had made much deeper inroads into the "public" sphere at the turn of the century than French (or American) women had in the 1870s and 1880s.[43] But women still found it difficult to join circles of urban, professional men on an equal basis. As before, they tended to achieve much greater success when, like Cecilia Beaux for example, they worked in more conventional or traditional genres.[44] But despite the pervasive masculine culture surrounding the avant-garde generally, women did make inroads into the social and art life of the most avant-garde circle of all, the Ashcan school. This group of painters and sculptors were based in New York City and specialized in realistic, urban subjects that were markedly different from those of mannered, traditionalist Victorian art.[45] Women connected to the Ashcan school included the male painters' wives, such as Florence Scovel Shinn; students, such as Margery Austin Ryerson; and friends, such as Janet Scudder—all artists in their own right. Though only men exhibited in the landmark New York show of The Eight in 1908, some women participated actively in the lively café debates, beaux-arts balls, and amateur theatricals that formed the core of Ashcan society. In the early 1900s, May Wilson Preston, Edith Dimock,

and Lou Seyme hosted their own convivial gatherings of artists and friends every week at their apartments in the Sherwood Studios.[46] An *Art News* critic wrote that painter Theresa Bernstein might as well be "elected as the ninth member of the Eight"; Bernstein won the moniker of "Henrietta," that is, a feminine counterpart to Robert Henri.[47]

These women shared the men's fascination with depicting urban spaces and subjects—including the New Woman icon, which was widely identified as an urban type. The feminist socialist magazine *The Masses* presented the work of women illustrators Cornelia Barns, Elizabeth Grieg, and Alice Beach Winter alongside that of George Bellows, John Sloan, and other Ashcan men.[48] Illustrations such as Alice Beach Winter's *Discrimination* (depicting a thin young woman standing beside the sign "BOY WANTED" in a butcher-shop window) revealed the connection between economic necessity and the New Woman's demands for gender equity in work. In the 1910s, Ethel Klinck Myers sculpted a satirical series of the urban woman in her many guises. Devoting special attention to her subjects' (often misplaced and ex-aggerated) sense of fashion, Myers consistently portrayed them as examples of the New Woman, self-consciously on display, in public, in motion, with one foot stepping forward as they parade before the viewer. A contemporary reviewer presciently commented that "it may be in time, when future histo-rians seek to discover what manner of women existed in the twentieth cen-tury and sought votes the while, they will turn to these statuettes and find in them a great deal more truth than in a lot of work done in dead serious-ness."[49] By creating a new iconography in this way, women artists helped shape the public perception and popular image of the New Woman, and the New Woman in turn provided a context for accepting the woman artist's in-dependent, public, professional self.

Women who illustrated for the mainstream press also played crucial roles in representing the New Woman, both by drawing images of the icon and in exemplifying this emerging type through their own lives. Women's posi-tion as consumers of popular culture had gradually expanded opportunities for them to be its creators. About 11,000 periodicals and magazines were published in the United States between 1885 and 1905, and the great major-ity (88 percent) of magazine subscribers were women. It is no coincidence, then, that illustration became widely touted as a career for women in the 1890s. Illustration was seen as a commercial, practical art (not a fine art) re-quiring training and skill (rather than genius), circumstances that certainly made it seem a reasonable field of endeavor for women. But more than this,

publishers called on women artists to draw for women readers, assuming that the two would inherently share a particularly feminine point of view of the world.[50] The strategy proved successful, given the popularity of illustrators such as Rose O'Neill, Violet Oakley, Jessie Wilcox Smith, Elizabeth Shippen Green, and Jennie Augusta Brownscombe. Brownscombe's paintings, for instance, began to be engraved and reproduced in magazines and calendars in 1892. Paintings such as *Love's Young Dream* (1887) clearly express a sentimental view, but a "feminine" perspective is evident even in the colonial and Revolutionary subjects to which Brownscombe turned in the same decade. The composition of her *First Thanksgiving at Plymouth* (1912–13), for example, emphasized women's presence at this historic moment. The standing figure of a man leading prayer is balanced by the even more prominent grouping of a mother with two children. She holds her little daughter by the elbow while she rocks her infant in the cradle. This woman may not be seated at the Thanksgiving table, but her maternalism is clearly coded as significant to the meaning of the event portrayed. In this way, Brownscombe was able to use the success of her commercial illustrations in order to become a history painter, a rare specialty among women artists. Brownscombe's work might even be claimed as an early part of the feminist project of writing women into history. Yet her self-conscious identity as a woman remained central to her professional success.[51]

As a result of these factors, the print revolution expanded opportunities for women of varied class backgrounds to establish careers in the arts. According to an 1899 study, *What Women Can Earn*, "comparatively few artists, men or women, realize large sums from the sale of easel pictures. There is always a demand for good portraits. Illustrating for magazines and advertisements pays well. Teaching pays best of all."[52] An art career promised women upward mobility, not only in terms of social status but in a financial sense as well. Women artists and art students clearly understood the implications of the hierarchy. Lilian Westcott confided to Elizabeth Stevens, her instructor at the Hartford Art School, "my highest ambition [is] to be a portrait painter and next to that an illustrator." Her decision was not based simply on the prestige of painting. "Portrait painting is of course a much higher plane . . . higher art and everything . . . [and] there is more money in portrait painting when it is once conquered than in anything else."[53] Westcott's concern with the financial aspects of art-making explains why illustration seemed almost as promising a specialty as portraiture for her.

At the same time, the revival of illustration led to the reclaiming of these

fields as fine art, at least to a certain extent. At the turn of the century Mary Cassatt turned her attention to traditions of avant-garde (not commercial) printmaking; she was able to experiment with aquatint and dry-point etching without damaging her painting career (or her future reputation as a great artist). Painter Alice Kellogg took a philosophical approach in her advice to her younger sister, Mabbie, who was just entering art school. "In whatever class you enter (and why not take the Design along with the other?) . . . I remember how I used to feel about doing any bit of decoration work—(ask my snubbed family!)—but Mabel dearie—now the study of design—as you might take it up would be most interesting to me. All forms of Beauty—are divine."[54] Such attitudes created new links between "high" and "low" art by appealing to aesthetics instead of women's culture, thus tipping the balance of women's identity toward professionalism and individualism.

Women's self-conscious exodus from the crumbling domestic sphere had extremely wide repercussions. The line from social consciousness to reform impulse to political involvement was a direct progression for many women at the turn of the twentieth century, and women artists were no exception.[55] Women's work as Ashcan artists, as popular illustrators, and as exemplars of the New Woman propelled them into public life, including into the beginnings of Progressive reform. Of course, women could cite a legacy of producing art for reform, from mid-nineteenth-century abolitionist sculptors Edmonia Lewis and Anne Whitney to Angel DeCora and Susette LaFlesche Tibbles, who illustrated Native American reformist literature. But at the turn of the century, women's reformist art (like women's reform activity overall) became more explicitly public and political. The icon of the New Woman had helped to change the rules of involvement. The visibility of women professionalizing social work, the increasing momentum of women's rights, and the Women's Christian Temperance Union's political involvement still cited a moral platform as a rationale for such causes being appropriate for women, but at the same time Americans began to accept women's public involvement for its own sake.[56] Within this context, a much greater number of women than ever before used art to agitate for political and social change. Inspired by novels such as Mrs. Humphrey Ward's *Robert Elsmere* and Edward Bellamy's *Looking Backward*, many women hoped to produce art that would likewise reshape political debate and effect social change.[57] Of course, individual women artists' involvement in reform encompassed a wide range of activities and addressed numerous reformist themes, from poverty to

prostitution. But their role and work *as artists* contributed to two reform movements in particular: settlements and suffrage, both of which created women's physical and psychic spaces in the public sphere.

Personal and professional networks were often instrumental in helping women artists find practical applications for their reform impulse. Illustrator Norah Hamilton, for instance, specialized like the Ashcan artists in working-class and urban subjects. Introduced to Hull House in 1900 by her older sister Alice, Norah Hamilton quickly placed her artistic talents at the service of the settlement movement. Not only did she illustrate various books on settlements, including Jane Addams's highly influential *Twenty Years at Hull House*, but she also founded the Hull House Art School.[58] Ellen Gates Starr, "tired to death of art for art's sake," had first put art to social reformist purposes at Hull House, beginning with a class in the "history of art," which Jane Addams credited with "chang[ing] the tone" of the students' minds.[59] Art thus formed a central part of the settlement ethos, and consequently the settlement house could provide a stage for the woman artist to put her talents and professionalism to use in various ways.

Settlements varied greatly in the extent to which they incorporated art into their philosophy and programs. Many held art exhibits and adorned their walls with edifying prints, as at Hull House. But they usually limited their art instruction to history and handicrafts, the "primitive" activities that reformers associated most closely with preindustrial traditions: textile- and metal-working, wood carving, bookbinding. Furthermore, among these they favored the "feminine" textile arts (spinning, weaving, lacemaking, embroidery, dressmaking).[60] Hull House deviated from this model by offering classes in drawing and clay modeling, taught by highly respected artists such as Lorado Taft.[61]

Settlement work was particularly appealing to women artists because of its close association with another reform movement: Arts and Crafts. Arts and Crafts was primarily an aesthetic reform movement, rather than a social or political one, but its English originators, John Ruskin and William Morris, emphasized philosophy rather than mere style and explicitly connected the aesthetic with class relations. The complex system of societies and individuals that associated themselves with the Arts and Crafts movement can hardly be reduced to one brief definition. But in general the movement stressed simplicity, craftsmanship, and functionalism, constantly referencing an idealized, preindustrial past.

The Arts and Crafts movement became an important part of art instruc-

tion and appreciation throughout the United States in the early twentieth century. Thousands of arts and crafts groups were founded between 1896 and 1915, some remaining independent and local, others organizing into networks such as the National League of Handicraft.[62] These groups were often grounded in the women artists' clubs and networks that had developed since the 1860s. As a result, women artists (both professional and amateur) played significant roles in the Arts and Crafts movement in the United States. For example, women were active leaders from the beginning in the Boston Society of Arts and Crafts (est. 1897), which served as a model for many other arts and crafts clubs. Decorative artist and designer Sarah Wyman Whitman served as the organization's vice president, and leathermaker Mary Ware Dennett worked as the artistic director of its highly successful Handicraft Shop, a cooperative workshop. Dennett became active in several reform groups, beginning with suffrage in 1908, and eventually abandoned art for these other causes, perhaps because she was "unsure of her artistic talent."[63] Women also founded the Blue and White Society of Deerfield, Massachusetts. Such groups validated the art activities of amateur and professional middle-class women as significant aesthetic contributions.

Although the Arts and Crafts movement accorded a new philosophical significance to the "lesser" arts of decorative art and industrial design, it did not challenge the basic hierarchy of high versus low art, and it left divisions of class, gender, ethnicity, and race untouched. Arts and Crafts primarily aimed to transform working-class homes and lives, supposedly contaminated by cheap, ugly, machine-made goods; this was the idea that connected it to the settlement house. Yet this rationale left women as the only objects for conversion among the privileged classes—women "who occupy the debatable land between housework and teaching," women "who pined for independence."[64] "There is perhaps no truer form of art than the work that awaits women . . . where the artistic becomes the practical and everyday life is gladdened by some manifestations of the art crafts," wrote Katherine Louise Smith. But if "the distance between art and artisan is surely becoming less," even Smith had to admit that the particular arts deemed most suitable and practicable for women represented "less ambitious forms" than the others. Women's importance as founders, teachers, supporters, and practitioners of arts and crafts in the United States still could not prevent a certain sexual division of art labor. Within arts and crafts shops and studios, men typically did the printing, metal-, and woodwork, while women specialized in china painting, textile, and jewelry design—objects with connections to

domestic production.[65] Even at Newcomb College, art teachers considered embroidery "peculiarly a woman's craft."[66] These gendered divisions implied that the hierarchy of high and low art remained in place. Perhaps arts and crafts seemed so suitable for women, children, immigrants, and the "feeble-minded" *because* these were supposedly "lesser" arts. Meanwhile, the lower echelons of painting, like "flower pieces," remained as feminized and low in status as ever.

Many settlement workers used arts and crafts philosophy to argue for the value of Old World culture; Jane Addams in particular hoped to encourage Americanized daughters to respect their skillful immigrant mothers. Yet the romanticization of preindustrial "peasant" and "folk" cultures as the antithesis of mechanized mass culture continued to regard the immigrant and (notably) the Native American as exotics. In addition, the network of women's art clubs on which the Arts and Crafts movement drew was almost ubiquitously white. Through the early 1900s, art for Native American and African American reformers (including settlement workers) continued to imply industrial art, or crafts such as basketry. African American women included art in their burgeoning club movement at the turn of the century; and Fannie Barrier Williams, who had studied at the School of Fine Arts in Washington, D.C., urged the expansion of industrial education to include art along with more "practical" subjects. But except for the most "minor" crafts, such as basketry, art does not seem to have been part of the African American settlement experience. Within the African American community artistic accomplishments and appreciation seem to have functioned as markers of class status rather than evidence of women's professionalism.[67] Narcissa Owen's self-portrait (1896; see Chapter 4, Figure 8) and published memoirs (1907) suggest that the same held true for Native American women.[68] Art's significance for African American and Native American women at the turn of the century resembled its role for white women in the mid-nineteenth century: even professional art was masked as middle-class feminine accomplishment.

Despite shortcomings, the settlement environment maintained a connection between fine art and decorative art by women. Settlements also encouraged connections among women that crossed class boundaries and led artists to produce socially conscious work. The effects of settlement philosophy are evident in the career of sculptor Abastenia St. Leger Eberle, who specialized in immigrant and working-class subjects. After fielding complaints that her Puerto Rican figures, such as her first nonclassical work,

Puerto Rican Mother and Child (1901), "were not American," Eberle gradually shifted to Jewish and Italian immigrant subjects, which seemed more acceptable to her art dealers.[69] At the same time, Eberle became friends with Lillian Wald, founder of the Henry Street settlement in New York City, and Frances Perkins, then Executive Director of the Consumers League. Deeply influenced by these women reformers as well as by the writings of Jane Addams, in 1907 Eberle arrived at the Music School Settlement on the lower East Side, where she planned to live and work. Of her neighbors on the lower East Side she wrote, "I did not enter their neighborhood as a disturber, but to study them and the conditions under which they live, to be near them and to learn from them, to give help when I could and where I felt the need."[70]

Eberle did not aim to be merely one of the urban poor; she still believed in a powerful role for the artist. "The artist should be the 'socialist,'" she declared in an interview, perhaps purposefully toying with an incendiary label. "He has no right to work as an individualist without responsibility to others. He is the specialized eye of society, just as the artisan is the hand and the thinker the brain. More than almost any other sort of work is art dependent on society for inspiration, material, life itself; and in that same measure does it owe society a debt. The artist must see for people—reveal them to themselves and to each other."[71] Along with Eberle's use of the masculine pronoun as generic, her description suggests that the artist's very public role as "socialist" and "specialized eye" still seemed more masculine than feminine to her. Yet her own commitments as reformer and artist attest to how she appropriated these roles for herself. Some of Eberle's favorite models were neighborhood children; later in her career, she established her own mini-settlement, a playroom for street children, precisely in order to observe them at play. In *Roller Skater* (1906) she depicted the New Woman as a joyful girl, her wide gestures occupying urban spaces, moving in and across the urban landscape, dancing, roller skating. In this light, it is no coincidence that Eberle's buoyant *On Avenue A*, a similar lower East Side scene of two girls dancing in the street, was exhibited as part of a woman suffrage exhibit. Eberle did not merely engage feminist issues and images through her art; she was also a member of the activist Women's Political Union. Her social consciousness as an artist-reformer thus extended to suffragism as well as the settlement movement—both eminently appropriate concerns for a real New Woman.

One might easily agree with Theresa Bernstein's observation that, like

herself, "Most of the people who worked for social reform were also interested in gaining the vote for women."[72] It would be an exaggeration to claim that all professional women artists were suffragists or even feminists, but, like other groups of New Women, professional women artists' political sentiments tended toward suffragism.[73] American women artists never developed a level of suffrage activism equivalent to that of British women artists, who directly supported the National Union of Women's Suffrage Societies through the Women Artists' Suffrage League (est. January 1907) and the Suffrage Atelier (est. 1909). But British and American reformers shared close connections throughout the late nineteenth and early twentieth centuries; several influential suffrage leaders worked in both nations. American women artists, in particular, may have studied in England or met English women artists in continental art academies and salons.[74] Women artists' contribution to the suffrage movement serves as a powerful example of women's using their cultural influence to change social and political status. Other women professionals in the arts, from modern dancers to actresses, also employed their artistic skills in feminist activism. For these women, politics, culture, and professionalism were all interrelated. Their public roles as professionals bolstered their demands for political rights, while their particular line of work, as makers of cultural symbols, helped shape popular opinion.[75] The suffrage movement, in turn, offered women recognition and respect as working professionals whose contributions were critical to winning political equality with men.

Even before the advent of the New Woman, suffrage art by women had its antecedents in the mid-nineteenth century, especially among women sculptors. Anne Whitney, for example, had abandoned her career as a poet in order to learn sculpture in the 1850s because she believed that art was a more effective vehicle to evangelize her dearest causes, abolitionism and woman's rights. Women artists later played an important part in the commemoration (and near beatification) of the founders of the women's movement. Though understudied by historians, visual culture played a vital role in the revitalization of the movement for woman's suffrage at the turn of the century.[76] Many important woman's rights activists granted commissions to women artists. Anne Whitney's busts of Lucy Stone and Harriet Beecher Stowe joined Adelaide Johnson's busts of Susan B. Anthony, Elizabeth Cady Stanton, Lucy Mott, and Caroline Winslow at the Woman's Building at the 1893 World's Columbian Exposition. Johnson's first version of *Susan B. Anthony* had been exhibited at the 1887 Woman Suffrage Convention in Wash-

ington, D.C.[77] Johnson later incorporated the busts of Anthony, Stanton, and Mott into her *Memorial to the Pioneers of the Women's Suffrage Movement* (1921, Figure 11), sculpted for the U.S. Capitol in celebration of the Nineteenth Amendment. In the *Memorial*, only the heads and torsos of the three women emerge from the seven-ton block of rough-hewn marble. Johnson's statue implied that despite the suffrage victory, women leaders had still only partially emerged as historical figures ready to be commemorated in marble.[78] Other sculptures of women leaders also touted their subjects as feminist heroines. Helen Farnsworth Mears's statue *Frances Willard* (1905), commissioned for the U.S. Capitol, portrayed Willard as an orator, leaning against her podium as she stared out at her audience.[79]

Suffrage artists, from sculptors to cartoonists, used their skills in a way

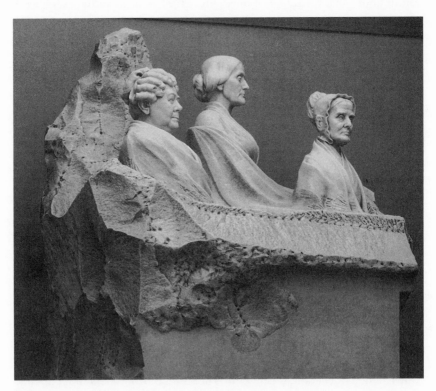

Figure 11. Adelaide Johnson, *Memorial to the Pioneers of the Woman Suffrage Movement* (1921). Courtesy U.S. Capitol Historical Society.

that was more directly political than any other group's brand of reform art. Blanche Ames Ames, for example, had considered herself a suffragist from a very young age. Irritated that she had been assigned the antisuffrage position in a history class debate at Smith College, she commented in her diary, "As long as I can remember I never could see a truly reasonible [sic] argument against woman's suffrage."[80] Ames divided her public life between art and feminist activism. She painted, developing a color theory based on optics (1912–1924), and beginning in 1903 producing exquisite illustrations of orchids for a series of books with her husband, Harvard botanist Oakes Ames. She simultaneously served as an officer of the Massachusetts Woman's Suffrage League, cofounding the Massachusetts Birth Control League in 1916. She united these two areas of her life most perfectly in a widely noted series of suffrage cartoons in 1915. As one writer noted, "Although Blanche believed in suffrage as a matter of right and justice her cartoons, published both locally and nationally, were also designed to counter anti[-suffrage] contentions by demonstrating that suffrage was compatible with traditional womanly values."[81]

The conversion of feminist artist into suffrage propagandist was not always so simple, though. In an anonymous autobiographical piece for the *Nation*, Lou Rogers described how she imagined, produced, and marketed her first political cartoon. Her narrative emphasized ideological fervor over art, averring an almost total lack of training, which would be incompatible with claims to professionalism. It also pointed up an important controversy within the movement: the question of whether political cartoons were too "unladylike" to serve their purpose.

In the place where I lived was a college-bred woman who bitterly hated the suffrage cause. Until I listened to her railings I really never knew there was such a thing. Now it did make an impression. I hunted up a street-corner speaker, got some literature and read it, and on the instant knew I belonged. There was no bitterness in my soul, just a recognition of the need to help men and women change their focus a bit. I still knew little about drawing, but I saw that there was not a cartoon on our side, though plenty of fierce ones on the other. I made a sketch in ink of a man standing in a most conceited attitude with both feet on the ballot box holding against his breast a diploma marked "Past master in egotism"; I drew huge donkey's ears on his head and under it I put the caption: "The ballot box is mine, because it's

mine." I went with this to suffrage headquarters. Dr. Anna Howard Shaw's experience with cartoons had been very unhappy. I am sure this unladylike picture filled her with horror. It was certainly not welcome, and I took it to the New York *Call*. The editor literally hugged me! Next day the thing came out on the front page—and a full page at that![82]

Nina Evans Allender described her gravitation toward suffrage cartooning in a similar fashion, stressing her decision to take on the work as an "unconscious" one. An article in the *Suffragist* explained, "When Alice Paul asked Mrs. Allender to draw a cartoon for THE SUFFRAGIST in 1914 she didn't know she could. Mrs. Allender said she painted, and preferred to paint. But unconsciously, as she had herself felt the new suffrage spirit, to oblige, she expressed this spirit in the series that suffragists in every state now know so well."[83] For Rogers and for Allender, feminism unleashed reserves of creativity of which they had been unaware.

Women artists identified themselves as professionals, as workers, and laid their claim to public life on that basis. Rather than making arguments about maternal responsibility, as other suffragists did, women painters, sculptors, and illustrators considered suffrage an issue of economic, as well as political, justice. In her memoir, artist Marietta Minnegerode Andrews described her staunch defense of suffrage on just those grounds when confronted by her conservative cousin. "'May,' she said, eyeing me very severely, 'I understand that you are an active Suffragette. What would your father think of that?' 'Well,' I said, 'my father must know that I did a man's work in providing for his large family after he was gone and perhaps he would approve of my having a man's opportunity and recognition.'"[84] This self-identification as professionals and pride as workers proved to be extremely important in the suffragist images women created. It formed a powerful connection between women artists and all types of women workers, like the working-class women whom Abastenia St. Leger Eberle referred to as simply "sisters."[85]

Given this strong professional identity, it was only natural that women marched as artists in various suffrage parades. In a 1911 parade of 3,000 women who were grouped by occupation, a whole section of women sculptors marched, led by Women's Political Union member Abastenia St. Leger Eberle; a section of artists' models also participated.[86] Women artists marched down Fifth Avenue again in 1913, Abastenia St. Leger Eberle, Janet Scudder, Edith Dimock Glackens among them, accompanied by several male supporters, including William Glackens, Edith's husband. Eberle

was one of six artists who recruited marchers from street corners in 1915 before New York's referendum on suffrage in November.[87] Perhaps she met art student Anita Pollitzer, who wrote to her friend Georgia O'Keeffe about participating in that parade. "As I am neither halt nor lame and have 'the courage of my convictions' I walk also.—I've decided to go with the Collegiate Group and then can wear cap and gown," Pollitzer reported.[88] The announced line of march and subsequent news reports of Boston's 1915 suffrage parade prominently featured women artists as a group. "Anne Whitney, Sculptress" was one of those accounted "Prominent in the Suffrage Parade." The brief list included another woman artist as well, Blanche Ames, though it only identified her as a "society woman."[89]

Women gained editorial positions that gave them a substantial amount of control over the themes and directions of the suffrage movement. The *Woman's Journal* already reported news of women artists regularly in the 1890s; assistant editor Florence M. Adkinson took an active interest in women's professional achievements as painters and sculptors. In 1912 Ida Proper became the first American art editor for a suffrage periodical (New York's *Woman Voter*). Soon afterward, the *Woman's Journal* established Blanche Ames, Mayme B. Harwood, and Frederikke Palmer as its own art editorial troika.

Women used their identity and work as professional artists to support the suffrage cause in other ingenious ways as well. Several women invoked suffrage in exhibits of their artwork. In one of the earliest examples of this, illustrator Rose O'Neill held a Kewpie doll "street exhibition" for suffrage at a very public site: the corner of Broadway and 42nd Street in New York City. Along with the androgynous Kewpie babies (who professed "We are for Suffrage. So is President Wilson"), O'Neill displayed a more serious poster of a mother and child, which carried the headline "She prepares the Child for the World. Help her to help prepare the World for the Child."[90] The press identified painter Ida Proper and sculptor Malvina Hoffman as "suffragists" from the time they first established a gallery together in Greenwich Village in 1912. Apparently well pleased with this representation, Proper and Hoffman publicized themselves as "suffragist artists" to promote their joint exhibition in 1915.[91] The fall exhibit at Macbeth Gallery that same year advertised a large-scale benefit for woman suffrage featuring 150 paintings, sculptures, drawings, and "plaster statuettes." Admission was free, and proceeds from sales went to the suffrage campaign. The suffragist periodical *Woman Voter* publicized the exhibit, which included its art editor Ida Proper

among the participants. A review in *Arts and Decoration* singled out seventeen women for commentary and noted the diversity of price and style among the works for sale. The headline, "Woman's Exhibit at Macbeth's," indicates the extent to which suffrage exhibitions and other women's exhibitions were regarded as interchangeable.[92] Meta Vaux Warrick Fuller donated a medallion to benefit the Equal Suffrage League in Framingham, Massachusetts, by its sale.[93] Profits from Mary Cassatt's first United States exhibit also went to suffrage; at the start of World War I, Cassatt instructed her friend, "the distinguished art collector Louisine Havemeyer," to "go home and work for the vote . . . If the world is to be saved, it will be the women who save it."[94] Such activities extended the tradition of women's separate exhibitions toward a more focused—and more explicitly political—purpose.

Inside and outside of targeted exhibits, women used their artistic skills and imagination to help create a new iconography in support of suffrage. Theresa Bernstein clearly saw her work as a professional painter as comprising her most successful suffrage activism. "On the day I was sketching the *Suffrage Meeting,* I met Rabbi Stephen Wise walking on Broadway," she recalled in her autobiography. "He was an imposing man who had organized a synagogue with meetings in Carnegie Hall. I had been sketching groups of people and spoke to him about the upcoming vote. He said, 'you know, Theresa, I think I will vote for the women.' I spoke to a few other people, but my main weight in this direction was through my work, which was exhibited and discussed."[95] Upon entering the field of political cartooning in the 1890s, American women such as Ida Sedgwick Proper, Nina Allender, Blanche Ames Ames, and Lou Rogers quickly began to devote their artistic talents to the cause of woman suffrage.[96] These women already belonged to feminist circles and networks of women professionals. For example, Proper, Rogers, and Mary Heaton Vorse (as well as decorative artist Mary Ware Dennett, *Arts and Decoration* art editor Ruth Pinchot Pickering, and art patron Mabel Dodge) belonged to the Heterodoxy Club, noted for the active careers and radical feminism of its members.[97]

Women artists as a group were singularly successful in transforming the imagery of the suffrage debate. On the most pragmatic level, this was possible because of suffragists' careful attention to media and publicity. Cartoons by a core group of eleven to fifteen women graced numerous periodicals, including the suffragist *Woman's Journal;* the more radical *Suffragist, Woman Voter,* and *Maryland Suffrage News;* national humor magazines such as *Judge,*

Puck, and *Life;* and the radical press, especially the *New York Call* and *The Masses.*[98] The suffragist press also publicized exhibitions and individual examples of "high" art. Photographs of sculpture such as Ella Buchanan's *The Suffragist Trying to Arouse Her Sisters* (in the September 1911 *Woman Voter*) and Gertrude Boyle's *Woman Freed* (in the *Suffragist* in 1920) made images of "high" art widely available. *The Woman Voter* even sold picture postcards and small copies of Buchanan's sculpture to benefit headquarters.[99]

Like suffrage pageants and parades, suffrage art drew on a wide range of images, one of which was bound to strike a chord in the casual viewer. Women artists' pantheon of heroines included followers as well as leaders, and reached back to historical and allegorical figures. Buchanan's composition for *The Suffragist Trying to Arouse Her Sisters* included five different allegorical figures: Vanity, clutching Prostitution; "somnolent and indifferent" Conventionality sitting on their skirts; and the Wage Earner, looking up to the central figure, a goddess-like Suffragist blowing the trumpet of freedom. The icon of the Great White Goddess had a long history within the woman's rights movement, reaching back to its abolitionist roots.[100] Women's use of allegory in general, and this symbol in particular, was not limited to "high" art; allegories appeared repeatedly in the most popular form of suffrage art, the suffrage cartoon. Mayme B. Harwood's *Woman's Journal* cartoon, "Up! For This Is the Day!" (1 May 1915), featured a winged goddess of victory, heralding the advent of "Freedom Truth Beauty Peace," as proclaimed in the scroll she unfurls. A frieze of liberated women (presumably suffragists) occupies the foreground: the domestic woman with her embroidery, the smocked woman artist with her palette, the college graduate in the center, the woman writer with pen and notepad, and the woman athlete with racquet. All of the female figures are blonde, fair copies of the magnificent goddess looming behind them.

Nell Brinkley gave the allegorical suffragist a decidedly nationalist edge in her syndicated cartoon "The Three Graces." "Any man who loves and reveres his mother and his country should idolize, if he worship at all, the three graces, Suffrage, Preparedness, and Americanism," the caption read.[101] The representations of these graces (including "Suffrage" in her feminine dress, straw hat, and sash) were all versions of the "Brinkley girl," a counterpart to the Gibson girl. The Brinkley girl, with her short, marcelled curls, her long lashes, her full Cupid lips, and her trim, youthful figure, prefigured film star Clara Bow. In depicting the suffragist as a beautiful, stylish, and feminine woman, Brinkley countered the image of suffragists as

unsexed, man-hating hags depicted in illustrations like Rodney Thomson's *Militants*.[102]

Indeed, women artists' most powerful contribution to the suffrage movement was the transformation of the suffragist into an analogue of the New Woman. In order to make this connection, one did not have to be as explicit as Lou Rogers (who clearly labeled the female figure wielding the hammer of "the vote" as "The New Woman" in a 1912 cartoon).[103] The more realistic female figures in Harwood's cartoon represented the fields into which the New Woman had advanced (the arts, sports, and the professions) while retaining her beauty and feminine character (as evidenced by the demure woman embroidering on the far left). In the iconography of the New Woman suffragist, a suffragist could be as young as Nina Allender's defiant girl armed with snowballs with which to pelt the Democratic Party and Judiciary Committee (*Suffragist*, 16 December 1915), or Alice Beach Winter's exploited, poverty-stricken factory waifs. But for the most part, women artists' icon of the suffragist was a young woman, not a girl. She was often clearly marked as a mother or a worker, but above all embodied bravery, strength, and freedom in the way that Charlotte Perkins Gilman had imagined the modern woman. The women in Nina Allender's *Supporting the President*, for example, look both feminine and modern, stylish and determined, as they clamor for train tickets to the capital "to demand Democracy at Home."[104]

The "New Suffragist" was thus both the artist herself and an idealized everywoman. Theresa Bernstein, for example, depicted the crowds at events in which she had participated in a series of paintings in 1914–1916, including *The Suffragette Parade* and *The Suffrage Meeting*. Similar subjects marked Ida Proper's painting *The End of the Suffrage Parade, Union Square*, and Nina Allender's cartoons *The Summer Campaign* (*Suffragist*, 6 June 1914) and *The Suffrage Protest in Lafayette Park* (*Suffragist*, 10 August 1918). In these examples, women artists repositioned the suffragist as one of many women, including themselves. If her attractive looks and crisp attire did not make this iconic suffragist entirely average, she still succeeded in looking more like "the woman of today" than her caricatured nemesis, the antisuffragist, did. Next to the suffragist, the antisuffragist looked dreadfully old-fashioned in her vapid preoccupation with the trappings of ladyhood; she did not display the characteristics of strong, earnest, determined womanhood. Numerous cartoons by Ida Proper, Blanche Ames, and others juxtaposed suffragist and "anti" to emphasize the superiority of the former.

Through suffrage art, women artists stretched the New Woman image to its limits, testing the icon's potential for inclusivity across class lines as well as its capacity to incorporate feminine professionalism. Suffragist artists recognized women's attainments in higher education and the professions, but were careful not to overemphasize them. For example, Jessie Banks's *Woman's Place Is in the Home: We're Going Home* tallied the number of women stenographers, bookkeepers, college presidents and professors, as well as waitresses, charwomen, and sewing machine workers.[105] The types of work that suffrage art emphasized—nursing, cleaning, cooking, teaching, and of course mothering—resisted the conflation of suffragist and middle-class woman.[106] Depictions of working-class women and girls (especially in anti–child-labor propaganda) were highly significant to the new iconography of the suffrage movement. These figures acted as the object and reason for woman suffrage. A few illustrations, such as *One Man—One Vote* by Cornelia Barns, went further, presenting ethnic, immigrant, and working-class women as potential voters who especially needed suffrage to improve their own lives. Images of nonwhite women were much more rare in suffrage art. The erasure of nonwhite women from the visual argument for suffrage was taken to its extreme in Nina Allender's *A Modern Eliza*. Allender's cartoon erases the racial content of the most famous scene in Harriet Beecher Stowe's *Uncle Tom's Cabin* by recasting Eliza as a white woman suffragist.[107] Yet it is important to note that women artists did not define the suffragist explicitly in terms of class or race, as many writers and other activists did. They identified the New Woman suffragist in primarily political and cultural terms, that is, as the converse of the antisuffragist, who was depicted as a vain, frivolous social butterfly.

The association of New Woman, suffragist, and professional woman artist was so persuasive that even antisuffrage women artists proved susceptible to empathy for the suffragist in her New Woman guise. Two women known to have produced antisuffrage cartoons, Laura Foster and Sarah Moore, also drew cartoons sympathetic to woman suffrage.[108] In *After the Meeting* (Figure 12), "anti" Cecilia Beaux depicted Dorothea Gilder at the close of a suffragist meeting. She is easily identifiable as a New Woman by her animation, youth, stylishness, and determination—attributes that were not lost on the painting's reviewers.[109] This beautiful and fashionable young woman seems far removed from the vicious caricatures of suffragists in the mainstream press. Rather, she exactly captures the image that suffragists like Carrie Chapman Catt proselytized: a woman whose femininity (and even

beauty and fashionableness) would not be compromised by her desire to vote.

Cecilia Beaux's appreciative portrait of a suffragist is all the more interesting because Beaux herself supposedly did not support the cause of woman suffrage.[110] Perhaps the work reflects the tensions between Beaux's conventional concept of proper womanhood and her own unconventional professional ambitions. If she in truth believed that woman was domestic by nature, that belief was not enough to keep Beaux herself in the home. She

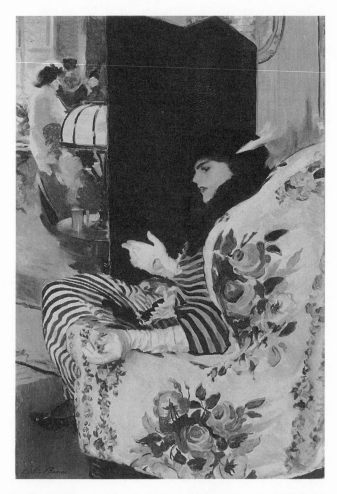

Figure 12. Cecilia Beaux, *After the Meeting* (1914). Courtesy Toledo Museum of Art; gift of Florence Scott Libbey.

could, like Margaret Head Bush-Brown, have believed that *most* women found their happiest destiny as wives and mothers while making allowances for exceptional women. Beaux equated her portrait painting with motherhood, but it was not really motherhood; she turned down proposals of marriage that could have converted her to actual domesticity, and she refused to believe that her artistic vocation (a higher vocation than marriage) "unsexed" her.[111] She lived the life of a New Woman in every sense, including a public, successful career—as did Bush-Brown, Anna Lea Merritt, and others. She participated actively in women's art clubs, such as the National Association of Women Painters and Sculptors, which others (including Anna Lea Merritt) feared would preserve gender distinctions in art at the expense of egalitarian professionalism.[112] And Beaux's oeuvre included other professional women sympathetically portrayed, such as Sarah Doyle, founder of Pembroke College and a trustee of the Rhode Island School of Design; and Beaux's friend Agnes Irwin, the first dean of Radcliffe College, whom Beaux painted in 1908 in cap and gown, emphasizing her attainments in higher education.[113]

In uniting the cause of equal rights with the icon of the New Woman, women artists were finally able to address the complex identity of the woman artist in both text and image. Alongside a photograph of Gertrude Boyle's romantic-realist sculpture *Woman Freed*, the *Suffragist* published her essay "Art and Woman's Freedom" in 1920. In that essay Boyle issued a passionate call for "woman-engendered art." She drew a direct relationship between woman's political emancipation and woman's creative freedom as an artist.

> How could woman, taught to compromise and placate, find self-expression, which is art? . . . Slowly and painfully woman has won her way toward a freedom in which art can live. Her years of subjugation will be a factor in woman's strength in art, for "the half of music is to have grieved." But with freedom has come an enriched experience, and will come a sincerity, which will not only make woman capable of art, but make art necessary to woman.

Boyle still saw a place for women artists as women within her egalitarian vision: "Woman lives more in her emotions than man. This of itself should tend to make her a greater artist, as art springs primarily from emotions, and her broadening sympathies and growing interest in all life will lead her away

from the great error into which artists have been prone to fall." Women artists had the advantage that "Art is not concerned in producing a masterpiece . . . Art is concerned with expressing life in all its phases, giving an outlet to thought, feeling, and emotion." There was also a place for women artists as artists; woman's fitness for art would enable her to make valuable public contributions.[114]

Given this millennial vision, it is hardly surprising that Boyle's sculpture expresses a singular faith in the power of womanhood. The figure in *Woman Freed* brings together the two great modes of expression in suffrage art: realism and idealism. It represents a winged woman, not a winged goddess; and, unlike Adelaide Johnson's suffrage leaders, this figure is not a mere bust. This woman has the power in her muscular body to lift herself out of the rough-hewn stone from which she is carved; indeed, she has already done so, and waits poised for the winds of the future to sweep her aloft. But Gertrude Boyle's vision for the woman artist would find its ultimate test in modernism. Just as women artists were achieving a secure balance between professional identity and gender ideology, the terms of the debate shifted radically. The professional status they had worked so diligently to consolidate would now have to battle against a revived discourse of genius and heroic masculinity. The very idea of what it meant to be an artist would change so profoundly that women artists found themselves vying for a place in the history of art as well as its present.

Making the Modern Woman Artist

Emily Sartain's retirement as director of the Philadelphia School of Design for Women in 1919 marked the passing of a generation. The fact that her niece, Harriet Sartain, succeeded her in the position was a testament to the degree of professional status that women artists had gained over the course of a century. Women painters, sculptors, and illustrators had established an unmistakable public presence and confidence as professionals by the early twentieth century. They had even penetrated that inner sanctum of American art, the National Academy of Design, in 1909 when Mary Cassatt became the first woman to be elected to full membership since Ann Hall in 1833. Seven other women would become Academy members and twenty-two would become associates between 1900 and 1930.[1] Women artists seemed to be reaping the benefits of America's sweeping cultural changes as the Roaring Twenties heaped scorn upon genteel Victorianism and the hopelessly old-fashioned True Woman who had become its emblem.[2] Now a different feminine icon appeared to embody what was newest about modern life: the emancipated modern woman, whose embrace of sexuality, enthusiastic participation in public amusements, and individualistic quest for free self-expression seemed finally to shed the most troublesome aspects of womanhood that women artists had tried to reconcile with their careers.

Women artists' professional achievements, however, elicited an increasingly shrill and defensive response. For many observers in the early twentieth century, women's successes seemed to feminize art, thus sounding the alarm for men to reassert the virile masculinity of the real modern artist.[3] At the extreme, painter Edward Simmons asserted that "no genius is or has been a woman." It was folly, he cried, for a woman to take up a serious career in art "in a vain attempt to rival men." His chastisements went far be-

yond those of any nineteenth-century critic when he charged that it wasted women's "lovely youth" to study and practice art even merely as a pleasant pastime.[4] Perhaps Simmons perceived the subversive potential of the lady dilettante. Women's "amateur" interest in art had gradually won them access to art education, facilitated their organizing women's art clubs, and laid the groundwork for their professionalization. Simmons, and the other artists and critics who preached variations of this message, were part of a wider masculine retrenchment at the turn of the century. Some historians interpret this cultural trend as a reaction to the appearance of the "liberated" New Woman.[5] That is, the New Woman necessitated a New Man, whose demeanor, physique, and attributes were renewedly, insistently masculine.

In the art world, this gender anxiety escalated within a particular context: the advent of modernism. Aesthetically, modernism embodied a reaction against the realist traditions of academic art. Modernist artists shared a preoccupation with experimentation and abstraction; they tended toward angular representations, flat natural forms, and a seemingly random use of color. Beyond these few general elements held in common, modernist art ranged far and wide.[6] Between 1900 and 1930 it encompassed a dazzling spectrum of movements and styles, including postimpressionism, cubism, vorticism, futurism, expressionism, dadaism, and surrealism. Modernist artists reveled in iconoclasm, individualism, and the contradictions of modern life. As painter Arthur Dove explained in a letter to photographer, Studio 291 owner, and modernist mentor Alfred Stieglitz, "The modern painting does not represent any definite objective, neither does 291 represent any definite movement in one direction, such as, Socialism, suffrage, etc. Perhaps it is these movements having but one direction that make life at present so stuffy and full of discontent."[7]

Whatever their particular aesthetic inclinations, all women artists—indeed, all artists—in the early twentieth century found themselves working within the powerful new *culture* of modernism.[8] This was the world that, as Willa Cather commented, "broke in two in 1922 or thereabouts."[9] In sharp contrast to the Victorian preference for segregation and hierarchy, modernist culture directly confronted the fragmentation of modern life and attempted to reintegrate "disparate elements of that experience into new and original 'wholes.'"[10] It valued integration and authenticity as well as self-referentiality and self-criticism. This ethos changed the basic function of the artist from a teacher to a hero, from an interpreter to an embodiment of human experience. Modernist culture held that the artist's point of view

should be readily apparent, revealing and celebrating the individual bias of one's perspective. Individualism superseded universalism as the driving force for artistic expression—that is, self-expression, art for art's sake. The supremacy of these ideas changed the basis on which both women and men formed their identities as artists.

Many women artists, including many of the most successful, sided with the traditionalists in decrying modernism as an aesthetic travesty. "Of the 'Cubists' and 'Radicals' I am sure they are following a false and baneful standard of hideousness and distortion. Would [that] they might learn that real art is 'truth and beauty,'" painter Almira Fenno-Gendrot wrote imperiously.[11] Cecilia Beaux described one modernist canvas as "nothing but a map with odd splashes of color stuck about."[12] She challenged the new narrative that labeled her generation as old-fashioned and unoriginal academicians. "Art has *always* been modern," she asserted at a 1907 lecture at Simmons College in Boston. "We should never separate the art of our time from the *past*. There is no fundamental reason for new standards. Art is what it has always been—a RESULT of humanity—not a gift of the Gods to one period—and withheld from another."[13] Other women made the same point through their art. Anna Elizabeth Klumpke, for example, specialized in portraits and genre subjects, most often depicting Brittany peasant women. Her large canvases directly referenced the old masters, particularly Vermeer, in palette, style, and composition. Klumpke's critically acclaimed figure paintings proved that there was room for women artists in the history and traditions of great Western art.

Yet the initial marginality of modernism as an avant-garde movement may have been exactly what attracted some women artists—especially the younger, less professionally established ones—and women quickly established a presence within the modernist movement. A younger generation of women artists, including cubist sculptor Alice Morgan Wright, postimpressionist painter Dorothea Dreier, fauvist painter Louise Herreshoff, and of course Georgia O'Keeffe, participated actively in the development of a modernist consciousness at galleries like Alfred Stieglitz's renowned Studio 291 in New York—to the extent that O'Keeffe, a regular exhibitor at 291, became an enduring representative figure of American modernism. Progressive women painters were instrumental in founding early modernist clubs in southern California.[14] And women were an intrinsic part of the 1913 Armory show, widely cited by art historians as the most important art exhibition in U.S. history, "the turning-point in American art," and the seminal

modernist moment. The Armory show toured three American cities (with slightly amended content at each show), generated sales of $45,000, and attracted about 300,000 viewers—fewer than world's fairs, but more than attended the National Academy's annual salons.[15] Women artists numbered roughly one out of every seven exhibitors in the show.[16]

Modernist aesthetics and philosophy offered several advantages to these women. They newly bridged the breach between fine art and handicraft that had so complicated professional women artists' association with women's culture. Modernism's condemnation of commercialism extended to the ranks of more conventional women artists as well, who remembered their commercial pasts with remorse. Cecilia Beaux adopted a confessional tone when revealing her own shameful, low-art past "in the ignoble art of over-glaze painting," when she sold portraits of children painted on china plaques. Some of these were ordered by mail; Beaux explained, "Mothers in the Far West sent with the photograph a bit of ribbon, the color of the boy's eyes, as well as a lock of the hair. In such cases, of course, I never saw the child. Without knowing why, I am glad to say that I greatly despised these productions, and would have been glad to hear that, though they would never 'wash off,' some of them had worn out their suspending wires and been dashed to pieces. This was the lowest depth I ever reached in commercial art, and, although it was a period when youth and romance were in their first attendance on me, I remember it with gloom and record it with shame."[17] Though elsewhere she defended "the best things of their kind, in what are unjustly called the 'lesser arts,'" Beaux recalled her drawing scientific illustrations of fossils as only a remote sort of preparation for her later career as a painter. "I did not connect the work I was to do with *Art*, the high mystery, nor did I consider myself in any way an artist or even that I was ever to become one."[18] Marietta Andrews agreed: "If you paint with the desire of pleasing the vulgar taste, of tickling the fancy of the ignorant, if your aim is to produce what will sell, I beg of you to put up your canvas and brushes and leave them forever. I really do . . . Art is too sacred to degrade in this way." Teach instead, Andrews advised, regretting that she had painted little portraits of Saint Peter for quick cash. William Merritt Chase had taught her that such "potboilers" were "death to art."[19]

Even painting, then, could be contaminated by vulgar commercialism, while authentic self-expression and technical experimentation might lead the artist back to "low" or domestic art. In this way, modernism could rationalize renewed associations between women's domestic and professional

work in art. Marguerite Zorach, first president of the modernist New York Society of Women Artists, became well known as a cubist and fauvist painter but decided to give up the brush after the birth of her second child. She began to make large, complex, brilliantly colored tapestries, which she exhibited in galleries and sold at high prices.[20] Zorach found needlework to be more compatible with motherhood than painting was, but she clearly regarded it as true art despite its domestic connections. "All the constructions and relations you find in painting are in the tapestries—just the technique and the materials are different," she explained later in life.[21] Like her paintings, the tapestries incorporated distorted modernist perspectives and abstract geometric forms. The muscular, visually distorted nude figure in her embroidery *For Bill and Lucy L'Engle* (1929) can hardly be mistaken for a well-bred lady's feminine accomplishment.

Modernism created significantly improved opportunities for African American women artists in particular. Enthusiasm for primitivism and African art in the early twentieth century inadvertently led to the first general appreciation of African American art by white as well as black viewers.[22] African Americans had gradually gained access to conventional art training and exhibition space beginning in the early twentieth century.[23] Sculptor May Howard Jackson, for example, exhibited her work at the Pennsylvania Academy of the Fine Arts (PAFA) in 1906, 1908, 1920, and 1928; Meta Vaux Warrick Fuller showed sculpture at the Corcoran Gallery (1915), the National Academy of Design (1916, 1928), and Veerhoff's Galleries in New York (1919). The PAFA awarded scholarships to African American women including Jackson, Fuller, and Laura Wheeler Waring, enabling these women to become professional artists.[24] Sometimes women's friendship and patronage managed to cross the color line, as had been the case with Edmonia Lewis, Harriet Hosmer, and Anne Whitney in the mid-nineteenth century. In 1922, sculptor Gertrude Vanderbilt Whitney helped finance study at L'École Nationale des Beaux Arts in Paris for Nancy Prophet after Prophet graduated from the Rhode Island School of Design. But racism persisted within the artists' "sisterhood." In one notorious example, Meta Fuller traveled to Paris to study art in 1899, arrived at the American Girls Club where many other women art students stayed, and found herself turned away because of her race. Sculptor Augusta Savage experienced similar treatment in 1923; her travel scholarship was revoked when two other women who held scholarships complained that they would not travel or room with a "colored girl."[25] Perhaps Savage felt some vindication in 1934

when the National Association of Women Painters and Sculptors elected her their first African American member.[26]

Given these experiences, it is little wonder that African American women artists looked for support outside of white women artists' established circles. African American communities provided them with financial and creative sustenance in many ways. Individuals such as painter Henry O. Tanner and writer W. E. B. Du Bois championed African American women artists with patronage and appreciative reviews of their work; for example, Du Bois described May Howard Jackson in terms that any modernist would treasure: "bitter and fierce with energy, cynical of praise, and, above all, at odds with life and people . . . She accomplished enough to make her fame firm in our minds."[27] Women artists contributed to the growth of higher education for African Americans, teaching art at such institutions as Howard University and Spelman College. Exhibits cosponsored by the Negro Society for Historic Research (founded by Arthur Schomburg) in the 1910s expanded opportunities for African American artists (including women) to show and sell their work. In 1926, the Harmon Foundation began awarding prizes to African Americans in the fine arts; Nancy Prophet was one of the first Harmon medalists. The foundation's first art exhibit in 1928 included sculpture by Prophet and Augusta Savage and paintings by Laura Wheeler Waring.[28]

The Harlem Renaissance proved a fertile movement for women painters and sculptors as well as writers, blues singers, and other women in the arts.[29] Like Langston Hughes, they believed in the cultural necessity to "paint and model the beauty of dark faces and create with new techniques the expressions of their own soul-world."[30] From the start of their careers many women, including May Howard Jackson, Laura Wheeler Waring, and Augusta Savage, dedicated themselves to African American subjects. Nancy Prophet claimed to be "distinctly unracial" in her life and art, and Meta Fuller expressed great initial reluctance in "limiting" herself to African American themes in her work. But by the 1910s, Fuller began to specialize in portraits and allegories (such as *Spirit of Emancipation*, 1913) that expressed her growing racial consciousness and race pride. Prophet produced sculptures, such as *Head of a Negro* and *Congolaise*, that referenced both modernist and African aesthetic traditions. Prophet's works, in wood or stone, did not aim to be either allegorical or realistic but rather expressive of her self. She described *Discontent*, a male head, as "the result of a long emotional experience, of restlessness, of gnawing hunger for the way to attainment."[31]

Like white women, African American women participated in the making of an American modernism that was (and is) often perceived as a masculine, masculinizing movement.[32] And like their white counterparts, African American women artists increasingly allied themselves professionally with men, embracing the newly dominant heterosociality of the twentieth century. The professional ethos seemed to make the boundaries of gender more permeable, but the color line remained difficult to cross; for the most part, women artists worked racially segregated from one another. Mabel Brooks arranged an exhibit for the Alpha Kappa Alpha Sorority in Atlanta comprising thirty-three paintings from the Metropolitan Museum of the Fine Arts in New York, to be shown at Atlanta University. This marked a rare moment of multicultural cooperation in the arts, but the alliance did not last long. In Brooks's own words, "This unusual exhibition for Atlanta brought the white and colored races together at various times for three weeks and from the interest which it created, a Fine Arts movement was started among the white Atlantans, who later tried to take the credit for our Metropolitan exhibition."[33]

In this sense, modernist culture succeeded where women's culture had failed: in making room for African American women in professional art. The ideal of feminine professionalism was too dependent on a white ideology of womanhood; racial homogeneity had undergirded women artists' shared female culture and facilitated their feelings of (white) sisterhood. Though both white and African American women artists turned to modernist discourse in the early twentieth century to establish their professional identities, they did so separately. The racial cooperation that painter Mabel Brooks had fleetingly witnessed in Atlanta would remain the exception rather than the rule. Most tellingly, African American women artists in this period embraced an identity organized around race rather than gender. Augusta Savage, for example, persuaded her friend to bring troubled youth to see her work "because they ought to know there are black artists"—not women artists.[34] This remained the pattern even when patrons selected men for special privilege, thus encouraging the relegation of women to secondary, service roles within racial lines.

For all women artists, though, the ideal of self-expression promised a heady mix of individualism, authenticity, and a simultaneous evasion of social and cultural fetters, including those based on gender. This was probably the most striking advantage that modernist culture offered to them. Art stu-

dent Anita Pollitzer expressed as much in her informed, passionate, personal avowal of modernism in a letter to Georgia O'Keeffe:

> I shook absolutely when I came to the serious part of your letter asking me what Art is—Do you think I know? Do you think I'd think anybody knew, even if they said they did? Do you think I'd *care what* anybody thought? Now if you ask me what we're trying to do thats a different thing—We're trying to live (& perhaps help other people to live) by saying or feeling— things or people—on canvas or paper—in lines, space and color. At least I'm doing that—Matisse perhaps cares chiefly for color—Picabia for shapes— Walkowitz for line—perhaps I'm wrong—but I should care only for those things in so far as they helped me express my feeling—To me that's the end always—To live on paper what we're living in our hearts & heads; & all the exquisite lines & good spaces & rippingly good colors are only a way of get- ting rid of the feelings & making them tangible—[35]

Versus art schools and associations that might not allow women access to what they needed to become artists, modernism granted the ultimate au- thority to one's own self and one's own feelings—a measure that, being en- tirely interior and individual, cannot be learned at an institution.

This ethos swept away a century of struggle by women for professional recognition and institutional inclusion, and it simultaneously made that struggle seem unnecessary. European training, life classes, studio space, membership in professional associations, all tumbled to a minor place of im- portance relative to individual self-expression. If they still mattered, it was only as a means to a larger end. This transformation was all the more potent because it seemed to be the culmination of women's struggle for equal sta- tus. In their bid for equality at the beginning of the twentieth century, women artists had increasingly chafed against the idea of women's culture and voiced their preference for eradicating "sex in art" entirely. They would produce work with universal meaning that betrayed no sign of the artist's gender. Any remaining links between womanhood and art made the most sense within a feminist context. Just as the suffrage movement organized women as women in order to demand a lack of sexual distinction in elec- toral politics, so did women artists use a gender-based collective identity to subvert and overturn gender-based exclusions.

The 1920s, however, saw a qualitative change in feminist discourse, one that resonated among women professionals. Victory for the suffrage move- ment meant the loss of a common cause that had even at times linked

women across race and class. It also removed the last major formal barrier to women's acceptance in the public sphere, thereby enabling women to adopt professionalism more openly than ever. Conversely, woman-centered strategies increasingly seemed to contradict professionalism.[36] As feminism turned from suffragist arguments based on the idea of women's "difference" (how their superior morality would clean up corrupt politics, for example) to calls for equality epitomized by the Equal Rights Amendment, the powerful gender-based alliance fractured.

Women artists likewise found their identity and allegiance challenged as "equality" overtook "difference" in postsuffrage feminism. Modernist culture offered them an ethos in which gender might still matter, but only as one aspect of themselves. That is, women artists need not embrace masculinity or androgyny; they could incorporate a redefined womanhood in their private lives, as part of the exploration and expression of the self that modernism valued. They could slough off, as no longer relevant, attributes such as purity and domesticity that had been essential to nineteenth-century women artists. For example, when Cecilia Beaux designed her summer place, Green Alley, specifically as a home for an active professional woman, she conceived of the house and studio as religious rather than domestic space. The architecture of her studio replicated the elements of a Gothic chapel in its high, narrow windows and pointed roof. She even referred to the house's terraced area as the "cloister."[37] Beaux ended her antidomestic memoir with a rhapsody on Green Alley and its beauties, its fitness for "work—and friendship—the two main divisions of its owner's interest." In several pages of description, she never mentions Green Alley's more private areas.[38] Perhaps "the first studio [she] ever entered," that of her cousin Catharine Drinker, provided the model; Beaux admired Drinker's studio for being "typical, traditional . . . not to be confused with any ordinary or domestic scene."[39] In her youth, Beaux's aunt had admonished her, "Only remember that you are first of all a *Christian*—then a *woman* and last of all an Artist."[40] It would seem that Beaux lived and conceptualized her life as first of all an artist, then a Christian (or, more precisely, a Catholic), and a woman only according to her own terms.

Gender boundaries in the early twentieth century seemed more permeable than they had been for Victorians, and gender identity increasingly became complex, unstable, performative. In the 1920s womanhood was visually redefined through bobbed hair, short skirts, and angular bodies—some aspects of which might seem to connote masculinity, but which contempo-

raries interpreted as representing youthfulness and female emancipation. Whatever its cultural meaning, fashion marked the avant-garde; it comes as no surprise that modernist painters Marguerite Zorach and Lucy L'Engle were the first to sport bobs in Provincetown, Massachusetts, a lively art colony. Florine Stettheimer also adopted the new styles, sporting a flapper look as early as 1917 and maintaining it into the 1930s, when she was over sixty years of age.[41]

Gender play and unconventionality were not limited to the bohemian life of an artist, but extended to their childhood. In autobiographies of the period, women artists remembered themselves as unattractive, even tomboyish, girls. Cecilia Beaux, for example, portrayed herself in the third person as a kind of gender changeling: "She was a slight, boyish witch, neither noisy nor talkative . . . She was a teasing, honest boy. How came she to have a nun's face?"[42] Illustrator Lou Rogers described her childhood as a "woods life" in which "it never seemed to occur to anybody that girls didn't do everything that boys did. Nobody ever followed us around or suggested fear to us . . . [and w]e met the test of endurance at every hand." After (perhaps unsurprisingly) failing her exams, Rogers set off on a "tramp adventure" with a schoolmate. "We pawned and sold our clothes, and I dipped candy in a chocolate factory, became an expert waitress, clerked in a hotel, and succeeded in organizing physical-culture classes which were big enough to support one but not two."[43]

To some extent, the adult woman artist could also ignore the prescriptions of conventional femininity: sloughing off "the necessities of a lady" in order to live in Europe cheaply, as painter Maria Thompson Daviess did; driving, smoking, ignoring housekeeping, and "prefer[ring] severely tailored clothes to fussy dresses" as sculptor Janet Scudder did.[44] Though Beaux's family did not know much about art, "They understood perfectly the spirit and necessities of an artist's life" and never asked her to make calls or run errands.[45] Daviess documented what she called her "storms" of cursing and even of physical violence. Some women challenged gender expectations more directly, experimenting with their names as a means of self-expression. Lee Krasner, born Lenore Krassner, called herself Leah and Lena while studying at Cooper Union's Women's Art School; she later settled on the androgynous "Lee" while typically signing her paintings with the even more ambiguous initials "L. K."—when she signed them at all.[46]

Manhood did not represent an oppositional nature, fundamentally different from that of woman, but rather an alternative model of freedom and

action to which modern women might aspire. "What would a man do?" Scudder asked herself when bored.[47] Perhaps that is in part why Anita Pollitzer's letters consistently addressed her classmate Georgia O'Keeffe as "Pat," or even "Patrick," as in, "Goodnight Patrick—You're a strong, healthy old fellow. It's good to drink with you."[48] Romaine Brooks shed her first name, Beatrice, in favor of an androgynous one; she also left off wearing women's clothing, which she considered one of the "many hateful prerogatives of my sex."[49] Her 1923 self-portrait celebrates this sartorial choice, appropriating the suit, shirt, gloves, and hat of a gentleman for her own. Brooks represents herself as destined to be an isolated outsider, evidenced by the ruined landscape in the background, though it remains unclear whether she is outcast for her rejection of rigid gender conventions or for her role as an artist. Such mannish garb also appears in almost all of her portraits of women with whom she shared salon life in Paris, such as that of Lady Una Troubridge, who is shown dressed in a tuxedo and peering through a monocle. The one exception is Brooks's portrait of her lover, Natalie Clifford Barney (*The Amazon*, 1920).

As meaningful and subversive as the external trappings of gender could become in the 1920s, the aspect of modern womanhood that incited the most controversy was that of public erotic display. The new fashions were as objectionable for their bareness as for their suggestions of social liberation. Indeed, eroticism and emancipation were conflated as women embraced the public celebration of sexuality, including the recognition of female desire, that marked modern America. "Love is no stranger to me," Lou Rogers admitted. "My love affairs began in childhood and have been going on ever since in varying kinds and with as many results. Love is good wherever it comes from. I am married now, and I find that good, too. Economic freedom is good, and I still have it."[50] Marietta Minnegerode Andrews remembered exploring her own budding sexuality by secretly donning a low-necked bodice, striking "poses similar to those in the old masters" and admiring herself in the mirror. She saw herself as "very passionate"—not as a "plaything" but in a focused, constructive way. "A woman's happiness and usefulness depend largely upon her sex life," she wrote; therefore, "these facts should be [made] clear while still impersonal, before the dawn even of curiosity."[51] Georgia O'Keeffe went so far as to explore her own sexuality through posing—sometimes nude—for Alfred Stieglitz's sensual photographic portraits. In some, she embodies an independent woman, an artist, while in others she plays the femme fatale.[52] Yet "liberated" female sexuality had its own

double edge; it functioned as a sign both of modernity and of its excesses. What women dared embrace—and admit—concerning their personal lives might still complicate their professional identities.

Thus even in modernist culture, sexuality could still pose problems for women's professionalism. Because life studies formed such a basic part of art education by this period, male autobiographers did not even consider it noteworthy. For a woman artist, however, the hard-won right to study from life still signified a potential crisis of sexuality. Many women artists' autobiographical narratives emphasized in some way their first instances of sketching the nude. Some expressed a defensive distaste for life studies or at least a discomfitting tension between what they did and should feel about the nude. For example, Maria Thompson Daviess described feeling "a Puritan shiver from my Mayflower ancestor" when she met Lizzette, "the first entirely nude adult figure I had ever beheld and the most beautiful I was ever to behold."[53] Marietta Minnegerode Andrews contended: "I did not like the nude. Grandma's modesty, I suppose, set me to thinking of all the things I ought not to have thought of, and I was glad my Aunt Ida could not see inside my head. The fig leaves made me uncomfortable."[54] In her initial embarrassment and surprise at facing a nude model in a coed life class, Lizzie Rose described the event with ironic distance: "A model came in and posed *nude* for us this morning, undressing calmly in the very middle of the floor and Lizzie with nothing but gents around."[55] Rose's agitation at feeling exposed (with "nothing but gents around") contrasted sharply with the model's calm. By the following month, Rose had learned to rationalize her feelings; "I hate to do men—especially naked ones with their millions of bothersome little muscles and ribs generally," she wrote.[56] The routine of art-student life in Paris generally overcame her scruples. "I am going to draw in charcoal again from the nude; I do love it," she confessed in her diary. She looked forward to the "sweet" nude model Marie and any other "very handsome" models.[57]

Other women artists consciously avoided writing about their emotional reactions to the nude. They strategically invoked professionalism as the context in which they viewed and depicted the nude. "Professional" artists were supposed to view the model as an inanimate object. Andrews accordingly desexualized the model in her memoir. "Our poor models! . . . I see their knotty joints, their hairy legs, their moles and blemishes and varicose veins. Their flabby breasts, protruding abdomens, loose flesh, corns and bunions. They had vaccination scars, they showed the unmistakable strains of child-

birth. They were always wonderful, and the hideous ones were just as wonderful as the beautiful ones, and far more interesting. Blood glowed through coarse skin as through fine, light played upon the scrawny old men of the Ribera type as upon the rosy nymphs of Bouguereau. It was I who found them, booked them, paid them and loved them. They were my children."[58]

Janet Scudder recounted a strange battle of wills between herself and a nude model, a notable episode because Scudder enlisted the aid of other women artists and won. Whenever Scudder's male teacher left the studio, the model (improbably named Lily White) "began her attack on me," Scudder recounted. The "attack" consisted of a sexual exhibition in which the model "jumped off the model throne, sprang from chair to chair, raced about wildly, and finally, pretending to be overcome with the heat, made Adonis [the male model] spray her with water from the syringe used to keep the clay moist." Scudder could only conclude that the model "resented any women students being in the studio and had made up her mind . . . to shock me into leaving." Yet Scudder, far from the bashful lady, was the kind of sculptor who felt perfectly comfortable even as "the only woman among a number of men who were working from nude models" in Lorado Taft's studio. She finally triumphed over the model by inviting White to her *women's* life class, where she asked the other students to applaud and praise lavishly whatever antics Lily White might perform. Failing to embarrass the ladies, White apparently felt embarrassed herself, and before the sketching session ended "threw on her clothes and hurried away without a word." In recognition of her guilt, White refused payment for the day of modeling. White's deviant, passionate, and unrespectable persona acted as a foil for Scudder's pure morals and unflappable temperament. Most crucially, it was Scudder's identity as an artist—objective and analytical—and her place in a community of women artists that enabled her to resist White's threats and exhibitions, her "seductions" of a sort.[59] The nude model's presence challenged the objectivity of the woman artist and risked the revelation of her sexuality. But by the same token, an ability to represent the nude successfully was proof of the artist's true professionalism.

By the 1910s, women artists had not only learned to manage the cultural pressures of the life class, but several had come to specialize in nude subjects. Kathleen McEnery exhibited two full-length and one half-length "decorative nudes" at the Armory show. Regarded by one newspaper as merely "light-hearted pictures," McEnery's paintings excited neither high praise nor damnation in an exhibition hall that included Marcel Duchamp's *Nude*

Descending a Staircase, the focal point for much of the media's ridicule of fu-turists and cubists. In all of the controversy surrounding the show's "lewd-ness," "immorality," and "degeneracy," no one pointed to McEnery's nudes as signs that feminine delicacy had atrophied.[60] Contemporary academician Lillian Genth won critical acclaim as a figure painter specializing in studies of nudes set in arcadian scenes, such as her *Adagio*. Romaine Brooks also por-trayed female nudes in this period, including *The White Azaleas* (1910) and *Weeping Venus* (1916–1918).[61] Though the figures of these works were in-variably female, the nude subject itself, "consistently carried out," had be-come an accepted feature of professional art, regardless of the sex of the art-ist. This marked a significant break with the past.

The final acceptance of the nude as a legitimate genre, even for women artists, occurred in the context of shifting formalist boundaries, so that all academic painting and sculpture appeared more conventional than modern-ist experiments, regardless of subject. The press ignored Abastenia St. Leger Eberle's sculpture *The White Slave*, like almost all works by women at the Ar-mory show, in favor of European exhibitors (including Marcel Duchamp, Henri Matisse, Pablo Picasso, and Wassily Kandinsky) and men such as sculptor Jo Davidson. Afterward, though, *The White Slave* circulated widely as the cover of the reformist magazine *The Survey* and, in that form, incited a barrage of controversy worthy of a cubist.[62] Readers flooded the periodical's offices with subscription cancellations and other letters protesting the im-morality of Eberle's image.[63] The subject was rooted in nineteenth-century reform traditions; indeed most of Eberle's work was informed by her com-mitment to the sort of "definite movements in one direction" that Arthur Dove defined as antimodernist. However, she used a modernist modeling style to depict the nude figure of the young "white slave" and the elongated auctioneer calling for bids on her. The modernism of the image—especially as reproduced for the general public, versus within avant-garde circles—inflamed dissent more than the fact that a woman artist had taken up the theme of prostitution and represented it through the female nude.

Most boldly of all, women artists began to produce a formerly unthink-able innovation of their own: the nude self-portrait. American examples appeared in the wake of similar works by European artists such as Paula Modersohn-Becker and Gwen John and American pictorialist photogra-phers such as Imogen Cunningham.[64] Florine Stettheimer's nude *Self-Por-trait*, painted around 1915–1916, was no private experiment. It hung in her studio where she and her sisters held their celebrated salons—though evi-

dently no one in their circle openly acknowledged it for what it was.[65] Stettheimer herself commented on this curious state of affairs in her painting *Soirée* (Figure 13), itself a complex portrait. The nude self-portrait is in prominent view at the back of the studio; in fact, though the back of a second canvas and the corner of a third are evident, the nude is the only painting fully reproduced as part of the scene. Stettheimer's own figure, sitting on the couch at the margins of the canvas, echoes it by cocking her head toward the viewer in manner similar to the nude portrait. None of the other guests at the party appears to notice Stettheimer or her audacious self-portrait, much less make the connection between the two.

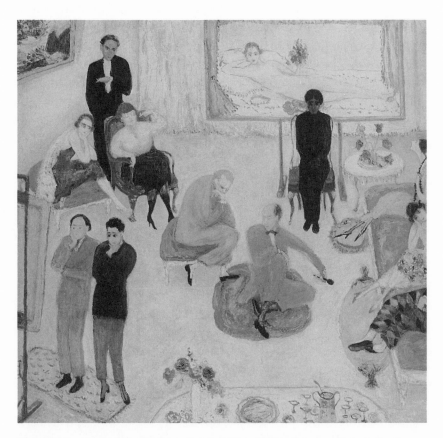

Figure 13. Florine Stettheimer, *Soirée* (1917–1919). Courtesy Yale Collection of American Literature, Beinecke Rare Book and Manuscript Library, Yale University.

Perhaps the nude self-portrait was so unthinkable that it was rendered invisible. It was in many ways an extension of earlier self-portraits by women in which they tested the boundaries of respectability and negotiated the tension between femininity and professionalism in their own identities. Yet it melded a greater variety of traditions: the ideal beauty of the female nude as an artistic subject; allegorical representations of art and painting as female figures, at least sometimes undraped; and the self-portrait as a declaration of professional identity. Stettheimer's self-portrait made explicit reference to Manet's *Olympia*, most obviously in the bouquet of flowers that the reclining nude holds. At the same time, the new form subverted artistic conventions from within, blurring the line between artist and model, asserting the nude artist/sitter's individuality, and rejecting the professional artist as a necessarily masculine figure. A masculine counterpart would have made no sense iconographically; indeed, the nude self-portrait was a form unique to women artists, untranslatable across the gender line. Furthermore, it would not have been possible before the twentieth century, in the context of wider cultural upheavals that redefined sexual repression as psychologically unhealthy. This innovation stands out among women's artistic production in that it alone prefigured the sexual and erotic themes that characterized feminist art in the 1960s and 1970s, in the midst of another sexual revolution.

Women artists in the early twentieth century thus celebrated sexuality and redefined womanhood to a degree formerly unthinkable, yet could at the same time insist that their sex was only one aspect of their identity among many that deserved expression. That is, even when gender was significant to the piece being produced, it was only one component of the artist's self. As Georgia O'Keeffe wrote to Michael Gold, editor of *New Masses*, in 1930, "I would hear men saying, 'She is pretty good for a woman; she paints like a man.' That upset me . . . I am trying with all my skill to do painting that is all of a woman, as well as all of me."[66] Unlike the more realist, even narrative, traditions that shaped nineteenth-century American art, modernist principles pushed artists away from the local and specific, toward the universal and abstract. Abstraction may have appealed to modernist women precisely as an escape from issues of sex and gender. "I, for one, didn't feel my art had to reflect my political point of view," Lee Krasner recalled about her work in the 1930s. "No, I was just going about my business and my business seemed to be in the direction of abstraction."[67] O'Keeffe too recognized that as a woman she faced special impediments. "I can't live where I want to—I can't go where I want to—I can't even say what I want to," she wrote

in conjunction with her first major exhibition in 1923. "[But] I found that I could say things with colors and shapes that I couldn't say in any other way—things that I had no words for."[68]

Believing that great art was truly universal, O'Keeffe, Anita Pollitzer, and other modernist women did not then consider themselves excluded by the maleness of the pantheon of Great Artists. "Picasso, Bach & Wagner are my Gods," Pollitzer declared.[69] But these gods were inspirations, not gatekeepers. "Keep at it," she advised O'Keeffe. "Cezanne & Van Gogh & Gaugin were all raving lunatics:—but they didn't mind a little thing like that."[70] Art-making itself could alternately invoke masculine and feminine processes, as Cecilia Beaux vividly described in her memoir. "The artist suffers agonies known only to women in the perils of childbirth, and, like this very large class, he [sic] suffers least when most powerfully aided by Nature . . . The struggle then is, the effort to bring forth the idea, and to give it a body acceptable. Sometimes in the artist's performance there is the almost savage joy of gladiatorial combat, the 'throwing of the beast'; but it is more often a birth . . . Indeed, an artist is a fruit-bearer." Elsewhere, Beaux compared painting to "war or hunting, adding the primitive zest of the chase to quite an opposite set of emotions."[71]

Yet for all the exciting potential for modernism to break down rigid categories of femininity and masculinity, gender difference persisted in shaping cultural practice; indeed, gender played a key role in the debate over the status and legitimacy of modern art. This is evident in the way painter and art collector Katherine Sophie Dreier conceptualized the modern artist. As the president of the Société Anonyme, Dreier was repeatedly called upon to speak about (and explain) modern art. In 1923, she turned her series of public lectures into a published volume, *Western Art and the New Era: An Introduction to Modern Art*. Dreier expressed a modernist philosophy of art throughout her book. In a typical passage, she challenged "Tolstoi's very simple definition of art, 'That the artist is a man who can paint and draw anything.' Those who are closely connected with art know only too well that there are many 'who can draw anything,' yet leave not a spark of art in that which have drawn." Art is more than training and verisimilitude, Dreier argued; art required a "spark" reminiscent of the divine fire of genius. In concert with this view of art, Dreier wrote a Whiggish history of art focused upon "those men who continued to be the pathfinders"—a category from which women artists were notably absent.[72]

For the most part, Dreier used anonymous women as foils against which

to define modernism. For example, Dreier described an occasion on which she spoke "to a group of artists" about modern art; note her choice of gender in the third-person pronouns:

> I quickly realized that what they really desired was to be amused, and to have a new topic for a dinner conversation. I therefore decided to put them to the test as to what they really knew about art, and asked them what their object was in painting . . . They answered quite naively, that they decided on a subject, and drew what they saw before them. "But" I asked—"suppose when you are through, it does not compose well?" "Oh," one said, "I then take a pair of scissors and trim down my picture until it forms a pleasant composition." In other words, she had not comprehended even the rudiments of art. For the first thing that an artist must know, whether he paints representative art, allegorical art, or abstract art, is how he will divide and fill the space which he has chosen to use for his work.[73]

Dreier repeated this pattern throughout her book. She reported that an "art teacher," at first unidentified as to gender, declared at a public meeting "that it was important to teach art in public schools, because it taught cleanliness and orderliness." Then Dreier unmasked this enemy of art as a woman, commenting that "she showed the confusion that existed not only in her mind, but more or less universally since we have robbed art of its proper place in life."[74] Another anecdote featured "a lady, who was a director of a Western museum" and who visited Studio 291. "She was greatly amused by one of the paintings, of which she asked the price. Finding that it was only thirty dollars, she said she would indulge in the pleasure of owning it. Mr. Stieglitz responded that he felt he ought not to sell the picture to anybody who regarded it merely from the standpoint of dollars and cents"—a point of view Dreier clearly shared.[75] In no instance in *Western Art and the New Era* does a man represent the dabbling amateur or the ignorant public.

The gendered implications of this equation are more complicated than they first appear. True, Dreier played modernism against the lady amateur stereotype in order to reveal it as a masculine and professional (or, rather, expert) project. In one passage, she even personified art, the object of the artist, as a female figure: "a free goddess with the right to exist for herself alone!" and censured those "who never give art her freedom or the right to express herself or cannot understand why art should want to be free." Both her language and the goddess metaphor evoke the recent campaign for woman suffrage—no coincidence, perhaps, since Dreier had been an advo-

cate for women's causes.[76] Dreier continued: "Why . . . should [art] not re-
main content to continue in the path she has always trod, which to them
is so pleasing—until the creative artist rises in rebellion and says:—'Why
should I give my life's blood just to please—let me create.'"[77] Here the "cre-
ative artist" seems to be the lady amateur liberated and transformed, finally
having tired of "the path she has always trod" and turned to real creativity
instead.

This narrative pattern associated womanhood with modernism as well as
antimodernism. Even in her lady-versus-modernist anecdotes, Dreier set up
a woman—herself—as the expert who could distinguish between ignorance
and true knowledge of art. In addition, though she cites no woman artist
from the past as significant in the history of art, a handful of women appear
as central figures in contemporary modernism. Dreier's review of modern
artists named her sister Dorothea Dreier and Baroness Werefkin and dis-
cussed her own portrait of Marcel Duchamp. Likewise, her art collection as
bequeathed to Yale University included works by sixteen European and five
American women (the Americans were Katherine and Dorothea Dreier,
Anne Goldthwaite, Ruby Warren Newby, and Marjorie Phillips).[78]

The place of women as artists in modernist culture was, however, less se-
cure than Dreier's account would suggest. As much as it nominally ascribed
to a sexless focus on genius and self-expression, the modern image of the
ideal artist drew strength from new concepts of masculinity in the early
twentieth century. The attributes of virility, criticism, self-expression, and
individualism all invoked seemingly masculine qualities, not metaphorical
associations with childbirth. Some male artists and critics made this con-
nection explicit. Feminist scholars trace the intense association of modern
art and manhood back to Renoir's infamous declaration "I paint with my
prick."[79] An accusation of effeminacy functioned as the most effective
weapon that traditionalists and modernists could wield against each other.
"It is quite true that women will indulge their savage instinct for color by
wearing coats of Empire green, Balkan blue, and Nellrose pink, with skirts of
brown and black and gray," the *New York Evening Sun* commented, "but they
do not go in for the Cubist coat. This is color run mad."[80] This commentary
feminized cubism by associating it with women's fashions. According to the
Sun, cubists were actually even *worse* than women, their taste in color too
"mad" even for a "savage instinct." Both sides of the debate over "extrem-
ist" art were in effect battling over exclusive rights to virility. At the same
time, in the face of general anxiety over gender roles, modernist culture

made art itself—whether aesthetically modernist or academic—seem more masculine.

The significance of gender in contemporary art discourse is readily apparent in reviews of the Armory show. Antimodernists associated women artists with the conventionally feminine stereotypes of the shopper and the amateur domestic artist and used these stereotypes to impugn modernist aesthetics. One such review described Marguerite Zorach's *Study* in terms that elided Zorach and her subject: "You see at once that the lady is feeling very, very bad. She is portraying her emotions after a day's shopping. The pale yellow eyes and the purple lips of her subject indicate that the digestive organs are not functioning properly. I would advise salicylate of quinine in small doses."[81] Which "lady" seems so obviously ill, the painter or her subject? Whose "emotions after a day's shopping" are being depicted? Who should take the salicylate of quinine? The review trivialized Zorach by associating her with ladies who shop. This type of woman, it seemed, should neither paint nor be painted.

Visual lampoons of modernism employed gender just as pointedly. A 1913 *Chicago Tribune* cartoon represented "The Original Cubist" as a quaint old woman making a crazy quilt. "I tuk the fust prize at the Fair last Fall," she declared proudly.[82] The illustration dismissed cubism by equating it with the handiwork of a domestic woman amateur. A far more elaborate parody appeared in 1914 at the Pennsylvania Academy of the Fine Arts's annual Students' Caricature exhibit: *Lady Ascending and Descending the Stairs,* by "Becilia Ceaux," a spoof of Duchamp's *Nude Descending a Staircase.* "The cubist idea of suggesting motion is here worked out in a new way," reported an exhibit attendee. "Instead of squares the artist has utilized two pieces of string one red and the other white, by which the figure of the lady moves up and down the stairs. The effect is very realistic."[83] It was no coincidence that the anonymous Pennsylvania Academy student chose the identity of a well-known *woman* artist to poke fun at the Armory show's modernism. (It is not clear whether Beaux's own staunch antimodernism was part of the joke.)[84]

Though the *Evening Sun* could not imagine them "go[ing] in for the Cubist coat," women too might exhibit masculine force and even virility in their work. Art critics praised women whose work displayed directness, simplicity, power, and a "masculine hand."[85] The *New York Evening Sun* wryly reported on evaluations of Nessa Cohen's sculpture, indicting gendered criticism of women's art more generally. "The critics say that her work is as good as a man's, which is a way critics have when they wish to pay a woman the greatest compliment that a critic's phrasing can devise."[86]

But masculine qualities did not always seem admirable when found in a woman's work. The "callous" effect in portraits by Cecilia Beaux earned the sharp disapproval of critic Charles Caffin, even as he praised portraitist John Singer Sargent for the very same: a "seldom sympathetic and often callously indifferent" manner toward his subjects. In Sargent, indifference connoted analytical objectivity; but it made a woman painter, like Beaux, unsympathetic and fundamentally unfeminine.[87] In fact, despite the insistent masculinity that characterized most modernist discourse, it was O'Keeffe's womanhood that attracted the professional admiration of the influential Alfred Stieglitz. "Finally a woman on paper," he announced upon first seeing O'Keeffe's work.[88] Likewise, reviewing O'Keeffe's paintings, critic Paul Rosenfeld declared, "Here speaks what women have dimly felt and uncertainly expressed," while Henry Tyrell announced that O'Keeffe's appearance in the art world marked a singular turning point when, "perhaps for the first time in art's history, the style is the woman."[89]

Trying to sidestep this charged atmosphere, O'Keeffe repeatedly denounced readings of her work as manifestations of female sexuality. Any sign of gender tarnished art, so that femininity connoted failure. "The thing seems to express in a way what I want it to but—it also seems rather effeminate," she complained of the painting on which she was working when she heard of Stieglitz's favorable criticism. "It is essentially a woman's feeling— satisfies me in a way—I don't know whether the fault is with the execution or with what I tried to say."[90] A nineteenth-century woman artist would have trumpeted the successful expression of a "woman's feeling," but O'Keeffe associated such a quality with a "fault." She felt unable to attribute the flaw to her method or her message; yet she believed in the possibility, indeed the necessity, of transcending sex in her work.

Like those women artists of the previous generation, who wished to eradicate "sex in art," modernist women considered their work to lie beyond the bounds of "women's art." Any explicit reference or trace of sex remaining in their art was justified as a facet of individual self-expression. Even within the discourse of modernism, however, art writers and critics persisted in seeing the woman artist's sex in her art. Thus, despite the modernist promise of considering them as individuals, women artists still had to contend with gender ideology.

The result was deeply problematic. Espousing modernist principles left women even less well equipped than their predecessors to articulate a response; they were fragmented by individualism, by continuing racism, and by the waning of organized feminism. Simple denial of sex in art, as in

O'Keeffe's strategy, proved ineffective; it required constant reiteration. There seemed to be only two options: either to claim a place for women artists among modern artists, thus associating women with the avant-garde, as Katherine Dreier did; or to carve out room for women artists in a unified art history, as Cecilia Beaux had proposed. In both cases, modernity had transformed the terms of discourse so definitively that the definition of what it meant to be an artist had changed. Older, more professionally established, and less avant-garde women artists like Beaux may not have embraced modernist aesthetics as Dreier did, but modernist culture had a profound effect on their identity as artists nevertheless. In the course of the nineteenth century, certain tropes of the artist's life came to define what it meant to *be* an artist, not simply work as one. Regardless of a woman artist's particular stance on modernism, she would have to reread her life and work against these new standards; that is, any claim to significance in art, whether among the avant-garde or in a continuing tradition of art, would need to take the new artist icon into account.

Faced with a new, modernist definition of the ideal artist, more conventional women took up the genre of autobiography in order to reexamine their lives and identities as artists. By 1930, a sizable body of women artists' autobiographies directly engaged the figure of the modern artist and implicitly tailored it for female use, abandoning the Victorian life-and-letters model that characterized the first published twentieth-century narratives of American women artists.[91] Within these memoirs, women adapted the new artist icon to fit their own lives and philosophies, including their views of womanhood. Nineteenth-century biographical and autobiographical narratives had constructed the artist as both masculine and individualist.[92] Women's narratives, by contrast, characterized the modern artist as mutable rather than masculine. Their memoirs revisited the historical problems of women's self-transformation into professional artists, including a consideration of the home, domesticity, and female relatives as potential resources, albeit ones that must eventually be left behind. By framing their lives and careers in such a manner, these women remained able to claim gendered identities as artists even as they turned from a woman-centered professionalism to a modernist, individualist ethos.

Unlike their male counterparts, women seemed reluctant to differentiate themselves from other children in their personal narratives. Marietta Minnegerode Andrews described herself as a misfit, a girl with an "unfortunate disposition" (something she says that artists and poets later called

"temperament"), but despite this mark of difference she claimed that her proclivity for art was not special. She had simply "always scribbled, as children do." Her family's move to Alexandria, Virginia, held little interest for her; the city's sights, "beloved of artists, had no charm for us," because neither she nor her siblings were yet artists.[93] Janet Scudder discounted the idea that "unless one were born with some mystic indications of genius, one must not think of being an artist." She insisted that "a slow laborious worker may develop into a great artist." At the same time, though, "Art is one of the mysteries of life," she wrote, "and no rules can be made about it."[94]

Perhaps because of the awkwardness with which they fit into conventional feminine or masculine roles, women seemed wary of invoking nature as the root of their identity as artists. Judging from the published autobiographies, only Almira Fenno-Gendrot and Cecilia Beaux, the "teasing, honest boy," alluded to the notion of natural genius. "Art in embryo must have been in my infant mind, for at four years of age I was actively engaged in trying to produce what I called, 'Pictures;' laboring with poppy and peony leaves, to put on paper my interpretations of roses and peonies, using the juice of pigweed, to make the necessary setting of green leaves," Fenno-Gendrot recalled.

> This gave me great satisfaction until I saw flowers and objects depicted by some one older than I, the fortunate possessor of a "paint box" and brushes. Then developed the grand passion of my youth—to be an artist—to paint; to have cakes of the beautiful colors all my very own, with the marvelous brushes. For to my child vision, the possession of paints and brushes was all I lacked to win success. A long life of sincere study and application has brought constant repetitions of my child vision—true art vision—constant strivings for perfection—never reaching the goal.[95]

Beaux wrote of the "discovery" of her "proficiency with a pencil" and her "natural *penchant* for textures," both of which presumably served her well in her career as a portraitist.[96] Her talent—and desire—outweighed her technical ability at an early age.[97] She categorized her keen, specific memories from this age as "supreme child-moments"; in one example of this, her "first realization of the light of morning" clearly marked her as an artist-to-be who would later come to "know that [that hour] was the hour, always destined for her to be the best, the productive, the creative hour."[98] Beaux's use of the third person in this section of the autobiography both lent authority

to her account and directly echoed the biographical models that had created the trope in the first place.

Yet even Beaux did not represent herself as a child who knew she would become a great painter. "How could I dream of being an artist? I never did," Beaux contended over and over in the memoir. "I had not the slightest idea of being an artist. The gulf between me and such an ambition was too great."[99] Pragmatism and economic necessity, not inborn genius, impelled Andrews toward an artistic profession: "I had no spark of what is called ambition. That has always remained outside my calculations. What I did most ardently desire was to be helpful and comforting to [Father]—to earn money—money—money. The revelations which study brought to me came later, gracious gifts of God to a sordid soul."[100] Mabel Brooks also wrote that for her art represented a pragmatic choice of career. It was not in childhood but after studying and obtaining favorable criticism that she felt "inspired . . . so much that I determined with all of my soul to become a painter."[101]

Gender thus played a barely visible role in modern women artists' definitions of art as in their accounts of their childhood. But when invoking transformative moments—usually their first experience *making* (as distinguished from selling) art—women artists revised the artist autobiography in a more radical way: they wrote female relatives into the narrative. By giving their mothers, grandmothers, and aunts crucial roles in the making of their identity as artists, women painters and sculptors thus constructed a feminine version of the virile artist who had natural genius. They claimed both their talent and their desire for art as part of a woman-centered, domestic continuity—a *cultural* part of their girlhood as much as it was supposed a *natural* part of boyhood for male artists. Eliza Allen Starr remembered playing with "bright gifts" of thread that fell from the table at which her mother and young lady friends embroidered:

> I picked up each one and proceeded to make flowers on paper with the snips picked into lint, and made to resemble roses, pansies, buttercups, anything I fancied. Once I got very much excited and burst out crying because I could not make a bunch stay on the stem. My mother took out her pencil, I had never used one, and outlined some flowers on a paper which I filled in with pale pink and soft purple crewel lint. After this she sometimes drew a flower for me, until I drew them for myself.[102]

In this story, Starr's mother owns the stuff (colored thread and pencils) from which art is made and chooses to share these items with her daughter in or-

der to teach her—almost to initiate her into their use. The act of creating art could replicate motherhood when the artist herself taught and inspired future generations of artists. Beaux's students at the Pennsylvania Academy of the Fine Arts included Violet Oakley and Caroline Peart. Anna Klumpke believed that the "revelation of [her] artistic vocation" came to her while she copied Rosa Bonheur's *Plowing in Nivernais.* "That picture became to me a talisman. In those early years, how I had longed to meet the artist herself. I realized, however, that she, in her quiet retreat, and engaged in important work, could hardly wish to be disturbed by students' votaries, however ardent their admiration."[103]

The bonds of sisterhood were just as significant as the influential lessons of female role models. Marietta Minnegerode Andrews remembered a moment of despair as she held her dead baby sister in her arms. "I wanted to know and see, I wanted to do good," she wrote. "I wanted beauty desperately, that morning, to be praised and kissed, to fulfill myself, to create something strong and splendid," a wish that eventually became realized through her painting.[104] Malvina Hoffman identified her first sculpture as a figure fashioned on a skeleton of hairpins and spools; it portrayed the sister Hoffman was grieving. Such stories echoed Anna Lea Merritt's from 1879, in which she described that her impetus to draw came from her longing for her departed sister, Florence. Merritt poignantly recalled holding her prettiest drawing "against the windowpane, calling Florrie to look at it."[105] In a similar account, Mabel Brooks considered her first piece of real art to be the altar hanging she painted in memory of her mother.[106] Each of these narratives directly relates art to the expression of grief. In this way they incorporate modern ideals of art as individualist self-expression. At the same time, though, they assert the special nature and importance of women's relationships to both their lives and their work.

Sisterhood also served as a vital metaphor for this generation of artists as they remembered the camaraderie of studio life. Anna Klumpke wrote that several of her American classmates approached her "to teach them the mysteries of mixing color, a detail not taught at Julian's." They proposed to share all of the studio expenses and to work together. "And so for many weeks the eager little group of young students fared on together," Klumpke recalled. "There was light and laughter, as well as arduous work, and the ineffable rose-glow of youth and anticipation pervading the very atmosphere."[107] The sororal atmosphere of the studio even extended beyond artists at times to include their female models. "The girls sing and joke a great deal, and I can

understand so little, but the model *roars*," Lizzie Rose noted in her diary on 15 October 1907.[108]

Unlike memories of maternal figures, though, the descriptions of women artists' sisterhood elided questions of gender; once the issue of professionalism came into question it became risky to invoke domestic scenes and feminine nature. Most women subtly but studiously avoided praising their sisters-in-arms in gendered terms even while portraying these relationships at their rosiest. For example, Almira Fenno-Gendrot remembered her first efforts at William Hunt's class, when "compassionate class-mates soon gave me helpful hints, loaned me plumb-line and T square, which I had not previously used," until Fenno-Gendrot felt "pushed along by the magnetism of eager companionship."[109] The specificity of gender would have seemed a violation of the androgynous professional ethos; artists like Fenno-Gendrot, who had described themselves as children or "boys," not girls, unsurprisingly grew up to study alongside "class-mates" and "companions," not women. Upon taking their artistic talents out of the domestic sphere of home and into the professional sphere of the studio, women artists tended to drop references to domesticity and femininity.

In addition, the notion of a professional sisterhood did not always mark women artists' relationships with one another, even in the memories of a romantic like Klumpke. Along with the "light and laughter," Klumpke recalled episodes of fierce competitiveness and self-aggrandizement within the studio. Her classmate, Marie Bashkirtseff, taunted Klumpke for her ambition: "'Klumpke, have you finished? Perhaps you expect to get the medal?' 'Why not?' I replied. 'Like you, I am working towards that aim.' 'If you get it,' she returned, 'I shall pay the refreshments. But do not worry—this time I shall receive the medal.'" Klumpke won one of the two medals; Bashkirtseff did not. "According to custom the two recipients of the honors were offered a collation of cakes and punch by their classmates, but Marie Bashkirtseff did not appear among them."[110] Marietta Minnegerode Andrews recounted an example of vicious competitiveness among women artists. She and thirteen classmates decided to occupy a new studio together in Philadelphia. Andrews began to move into the studio, but after a lunch break found that her sister artists had made room for themselves by tossing Andrews's things out onto the sidewalk, "the plaster Venuses without a rag to cover them, creating something of a sensation among the newsboys and loafers." As in Klumpke's case, the teller of the tale emerged victorious. Andrews immediately went to draw an advance on her salary, paid the rent on the room her-

self, and thus leased it in her name only. "Returning to the midst of the portrait-painting sisterhood, I said very quietly, 'Ladies, I think after all it will be more satisfactory for us not to begin this partnership in one studio—so you may look for a room elsewhere.'"[111] Competition and individualism thus distinguished women's professional culture from the intimate female bonds found in private, domestic, home life.

Still, the potent combination of professionalism, modernism, and individualism did not spell the end of these artists' self-identification as women; nor did the problem of gender identity evaporate as an issue that women artists had to negotiate in their lives and work. The autobiographies had their visual counterparts not only in the rise of the nude self-portrait but also in modernist portraits, such as Anne Goldthwaite's portrayal of Katherine Dreier (1915–1916). Compared to Dreier's stern demeanor in her own 1911 self-portrait, Goldthwaite has Dreier facing forward more directly, thus seeming more engaged with the viewer. She displays an amused expression rather than a piercing gaze; a slight smile plays on her lips in place of the earlier self-portrait's firm-set mouth. Even the choice of dress in the two paintings is instructive: in the self-portrait Dreier wears a ruffled collar with a somber dark jacket, while Goldthwaite presents her in a lighter colored, floral-patterned robe that leaves more of her throat and bosom exposed. To her friend, it would seem, Dreier is more affable and even more feminine than in Dreier's own self-image of four years before. Like the memoirs, then, portraits such as Goldthwaite's pointed to a female professionalism that could survive within modernism.

A touchstone for women artists' hard-won collective identity survived the modernist transformation as well: women's art clubs endured as professionalizing institutions. Eminent women painters and sculptors, including Cecilia Beaux and Janet Scudder, continued to contribute work to exhibitions of the National Association of Women Painters and Sculptors; younger artists, such as Theresa Bernstein, Harriet Frishmuth, and Alice Morgan Wright, participated as well. The NAWPS estimated its membership at 800 members in 1930. Other professional women artists' societies included the New York Society of Women Artists and the Art Workers Club for Women (also in New York), Woman's Art Clubs of Cincinnati and Cleveland, the Detroit Society of Women Painters and Sculptors, and the San Francisco Society of Women Artists. The Pen and Brush Club brought women artists together with other women professionals. Art departments graced women's clubs, especially in the Midwest but also across the United States, from Min-

neapolis to El Paso to Lynchburg, Virginia. And women held prominent po-sitions as officers in most art clubs, even monopolizing some boards, such as those of the Birmingham Art Club in Alabama, the Wisconsin Society of Applied Arts, and the La Jolla (California) Art Association.[112]

Modernism divided professional women artists for the first time over stylistic and philosophical differences. No longer was the argument simply one of the relative status of fine arts versus the decorative arts. Dissent erupted within the National Association of Women Painters and Sculptors between art conservatives and art radicals, traditionalists and the avant-garde. In 1925, a group of women with modernist sensibilities, including longstanding members Anne Goldthwaite and Ethel Paddock, broke away from the NAWPS to establish their own organization, the New York Society of Women Artists (NYSWA).[113] The new association cited three aims: "to supply the need of an outlet for the more unacademic painters, to act as a unified body in the arranging of shows of their work, and to present to the public their modern expressions."[114] The original twenty-six members of the NYSWA had clearly felt marginalized even within an association of professional women artists. The rupture indicates how powerful modernism was as both a polarizing force and as a point of reference for women's professional identity in the period. It is also a testament to how many women artists there were; women had achieved some kind of critical mass within the profession that enabled them to separate into camps *within* the boundaries of gender. Despite the aesthetic division that the split reflected, however, the two organizations shared the assumptions that women artists had a distinct identity and that their experiences and opportunities differed from men's. After all, the NYSWA organized itself as a professional art association specifically for women, just like its parent, the NAWPS. In fact, the NYSWA criticized the NAWPS for being dominated by society women and thus insufficiently professional in its focus.[115] Several women maintained ties to both organizations.

Women's associations, even professional ones, did not appeal to every woman artist. Even those artists whom others identified with feminine subjects and genres might reject a group identity based on gender. Marie Danforth Page, who specialized in portraits of children and mothers, declined an invitation to join the Woman's Professional Club of Boston. "Although I should enjoy meeting women belonging to other professions I have always maintained that women should not encourage a separate point of view toward their professional work," Page wrote.[116] The rising generation

increasingly rejected a collective identity as women. Isabel Bishop, for example, decided early on in her career that she would study, live, and work "on her own"—that is, in a heterosocial environment. She did not rely on woman-centered associations for support.[117] The demands of individualism imposed by modernist culture affected both avant-garde artists like Bishop and their more conventional peers like Page.

Women art critics defended individualism even more vociferously than women artists did, and at the expense of gender solidarity. Helen Appleton Read made some allowance for gender, "since every work of art must carry with it the flavour of personality, and since personality carries with it inevitably the quality of sex. The feminine view-point and reaction to life are an essential ingredient in woman's expression in the fine arts. Femininity does not, however, mean the traditional feminine subjects, such as flowers, babies, and delicate colour schemes. The feminine character has many facets." Read expressed pleasant surprise that "even so traditional and conservative a group as the Women Painters and Sculptors forges ahead in quality," but looked forward to a time when "women will eventually produce creative work which does not need the modifying, feminine prefix—women's work."[118] Rather less generously, *New York Evening Post* art critic Margaret Breuning dismissed the possibility of any continued sexism in art institutions in her review of the NYSWA's fourth annual exhibition. "Where are the organizations of artists that these ladies, now exhibiting, wish to join and cannot because of their sex? . . . Why should young women who pride themselves on being modern revert to the doubtful protection of outworn procedure and band themselves together in this clinging vine sort of attitude?" In Breuning's estimation, a modern woman would naturally reject the feminine professionalism to which "ladies" clung. On this point Read concurred: "Why have a women's organization at all? The time has passed when women need to band themselves together in order to break down the prejudice against the possibility of feminine accomplishment in art."[119]

In the end, however, both the National Association of Women Painters and Sculptors and the New York Society of Women Artists, as well as dozens of other women's art clubs across the nation, survived despite the attacks of critics—including women art critics—who thought that the very idea of a women's art club was outdated and misguided. Earlier women artists' clubs, like Philadelphia's Plastic Club and the Woman's Art Club of Cincinnati, continued to thrive while new ones formed. In 1925, the NAWPS opened a clubhouse in New York City, containing apartments, a kitchen and restau-

rant, and the first gallery in the United States to devote itself to artwork by women.[120] The same year, professional women artists on the other coast founded an association of their own: the San Francisco Society of Women Artists. Even the powerful cultural forces of modernism, heterosociality, the sexual revolution, and feminism's postsuffrage hush could not undo the pattern of women's associations. Long after romanticized notions of sisterhood and women's culture had faded into the sepia-toned past, affinities along the lines of both gender and professionalism remained relevant to most women artists.

Women's art clubs, like women's verbal and visual self-portraits, did begin to reveal fractures between womanhood and professionalism. Most women's art clubs joined one of two national networks, allying themselves either with the General Federation of Women's Clubs (as the Cincinnati Women's Art Club did) or with the American Federation of the Arts (whose founding members in 1909 included the Plastic Club and the National Association of Women Painters and Sculptors).[121] This very choice forced each club to decide on *either* womanhood (the General Federation of Women's Clubs) *or* art (the American Federation of the Arts) as its primary affiliation. Professional and amateur women took a final, decisive step apart; the professionals integrated themselves more fully into a heterosocial art community, leaving behind the women's culture that had enabled them as a group to become artists in the first place. Yet many women artists continued to affiliate themselves as female professionals. Membership in the 1920s remained stable in some associations, like the Plastic Club, and grew dramatically in others, like the NAWPS; the higher levels seem to have continued through subsequent decades.[122] Female professionalism thus built on specific traditions that women had developed over a century of work in art. Such identification did not preclude other concurrent ones; it had never prevented women from also seeking to join peer networks with men. In essence, it recognized women artists' specialized position and reflected their belief that the greatest hope lay in collective action.

In practice, modernism did not prove to be especially beneficial for women artists. It opened up new areas for self-expression, most notably female sexuality. It revitalized connections to "primitive" African and pre-Columbian forms as well as to folk, decorative, and domestic art in ways that validated African American and women's cultural traditions. Its emphasis on form, abstraction, and experimentation rather than narrative or realism seemed to offer an escape from cultural constraints, a way for women artists to repre-

sent an internal reality where "sex in art" mattered only so far as sex was a single element of an individual.

Rather than being able to acknowledge her sex as one part of her self, however, the woman artist found herself still categorized by, equated with, in fact reduced to her gender alone. The potential that women saw in modernism ran against the grain, their perceptions were not influential but prescient, recapitulating a creative quest for flexibility within a language that was not as hospitable as it appeared.[123] Modernist culture devalued art training and group identity—exactly the aspects of professionalization that women had fought to obtain—in favor of self-expression and individualism. Women artists adapted by bolstering the strategies they had developed over past generations, trying to find a middle ground between womanhood and professionalism. They invented new, more specific, one might say more fragmented identities, like that of the *modernist* woman artist in the New York Society of Women Artists. They did not, as a group, abandon their identity as women but rather continued to seek a place for it within the new context even as their presence exerted its own pressure for further cultural change—including, in particular, the redefinition of gender difference.

The following decades witnessed the same formula: a superficial inclusivity tempered by practices that reflected gender difference and social inequity. The New Deal offered expanded opportunities for women to make art; in the comparative context of discrimination against women's wage work during the Depression, the Federal Art Project (FAP) and other government-funded art programs seem remarkably inclusive. Women found difficulty in meeting FAP eligibility guidelines, however, and there was a particular gender imbalance in the number of prestigious and repeat commissions granted by the Treasury Section of Fine Arts.[124] Certain movements, like surrealism and abstract expressionism, seemed particularly hostile to women's participation. The largely male avant-garde had the most to gain from alienating women, thereby legitimating its art as virile creativity. But women infiltrated every artistic movement. Some adapted to male standards, accepting the role of disciple rather than innovator, privileging public ("universal") subjects over private ("female") themes and paying the price of isolation after sacrificing any hope of gender solidarity. As Joan Mitchell put it, "It's still a small world for women and they're cutthroat with each other."[125] The majority of women artists continued to work within more conventional art traditions, where they could capitalize on the gains women had made, including access to academic training.

The explosion of feminist art—and women artists' feminist groups—in the

1960s thus signified a coming to fruition rather than a rupture with the past. It marked a moment when women artists' deeply rooted identity as female professionals took on a political, activist, and explicitly feminist meaning that had been only latent and potential (but nevertheless present) since the early nineteenth century. Without a necessarily conscious awareness of their predecessors, associations like Women Artists in Revolution, Redstocking Artists, the Ad Hoc Women Artists' Group, and Women in the Arts made demands with which women artists generations earlier would have agreed: greater representation for women in exhibitions, and later the founding of institutions of women's own, like the National Museum of Women in the Arts. In many examples—the most widely known being Judy Chicago's *The Dinner Party* (begun in 1974)—feminist artists have also worked to recover women artists in history. In establishing a dialogue between past and present, these artists and historians have at last infused the problem of "sex in art" with the most vital sense: memory. In response to Georgia O'Keeffe's grumbling "Write about women. Or write about artists. I don't see how they're connected," many individuals have exposed that connection, and recognized it as vital.[126] Although women artists did not control the terms on which they were judged, they became active participants in the creation of an empowering identity and carved out a place for themselves as professionals. It was they who made the term "woman artist" a choice rather than an edict, an identity that one might either reject or celebrate, retire or reappropriate for a different age.

NOTES

BIBLIOGRAPHY

INDEX

Notes

Introduction

1. Mary Cassatt to Bertha Palmer, 11 October 1892, letter quoted in Frederick Arnold Sweet, *Miss Mary Cassatt: Impressionist from Pennsylvania* (Norman: University of Oklahoma Press, 1966), p. 131.
2. Georgia O'Keeffe in *New Masses* (1930), quoted in Barbara Buhler Lynes, *O'Keeffe, Stieglitz, and the Critics, 1916–1929* (Chicago: University of Chicago Press, 1989), pp. 157–158. O'Keeffe's later insistence on the autonomy of being an artist was more a by-product of her faith in modernism than a sign of her gender politics; though she consistently refused to label herself a woman artist, at the same time she was a suffragist and member of the Woman's Party.
3. Neil Harris, *The Artist in American Society: The Formative Years, 1790–1860* (New York: George Braziller, 1966), p. 7.
4. Georgia O'Keeffe in *New Masses* (1930), quoted in Lynes, *O'Keeffe, Stieglitz, and the Critics*, pp. 157–158.
5. Edward Simmons, "The Fine Arts Related to the People," *International Studio* 63 (November 1917): ix–xii; Augustus Saint-Gaudens, *Reminiscences of Augustus Saint-Gaudens*, vol. 2 (New York: Century, 1917), p. 4.
6. For some notable examples, see Isabelle Anscombe, *A Woman's Touch: Women in Design from 1860 to the Present Day* (New York: Viking Penguin, 1984); Shulamith

Behr, *Women Expressionists* (New York: Rizzoli, 1988); Robin Bolton-Smith, *Lilly Martin Spencer, 1822–1902: The Joys of Sentiment* (Washington, D.C.: Smithsonian Institution Press, 1973); Arna A. Bontemps, ed., *Forever Free: Art by African American Women, 1862–1980* (Alexandria, Va.: Stephenson, 1981); Frances Borzello, *Seeing Ourselves: Women's Self-Portraits* (New York: Harry N. Abrams, 1998); Mary Alice Heekin Burke, *Elizabeth Nourse, 1859–1938: A Salon Career* (Washington, D.C.: National Museum of Women in the Arts, 1983); Lillian Miller, ed., *The Peale Family: Creation of a Legacy, 1770–1870* (New York: Abbeville Press, 1996); and Eleanor Tufts, *American Women Artists, 1830–1930* (Washington, D.C.: International Exhibitions Foundation for the National Museum of Women in the Arts, 1987).

7. See Whitney Chadwick, *Women, Art, and Society* (London: Thames and Hudson, 1990); Germaine Greer, *The Obstacle Race: The Fortunes of Women Painters and Their Work* (New York: Farrar, Straus, Giroux, 1979); C. Jane Gover, *The Positive Image: Women Photographers in Turn of the Century America* (Albany: State University of New York Press, 1988); Pamela Garrish Nunn, *Victorian Women Artists* (London: The Women's Press, 1987); Charlotte Streifer Rubinstein, *American Women Artists* (Boston: G. K. Hall, 1982) and *American Women Sculptors* (Boston: G. K. Hall, 1990); Wendy Slatkin, *Women Artists in History* (Englewood Cliffs, N.J.: Prentice Hall, 1985); Eleanor Tufts, *Our Hidden Heritage: Five Centuries of Women Artists* (New York: Paddington Press, 1974); and Charlotte Yeldham, *Women Artists in Nineteenth-Century France and England*, 2 vols. (New York: Garland Publishers, 1984).

8. Linda Nochlin, *Women, Art, and Power and Other Essays* (New York: Harper & Row, 1988), p. 147; Lynda Nead, *The Female Nude: Art, Obscenity, and Sexuality* (London: Routledge, 1992). Other contributors to the social history of art include Elizabeth Johns, *American Genre Painting: The Politics of Everyday Life* (New Haven: Yale University Press, 1993); Diana Korzenik, *Drawn to Art: A Nineteenth Century American Dream* (Hanover, N.H.: University Press of New England, 1985); Angela Miller, *The Empire of the Eye: Landscape Representation and American Cultural Politics, 1825–1875* (Ithaca: Cornell University Press, 1993); Lillian Miller, *Patrons and Patriotism: Encouragement of the Fine Arts in America, 1790–1860* (Chicago: University of Chicago Press, 1966); and H. Wayne Morgan, *New Muses: Art in American Culture, 1865–1920* (Norman: University of Oklahoma Press, 1978).

9. Martha Banta, *Imaging American Women: Idea and Ideals in Cultural History* (New York: Columbia University Press, 1987); Rosemary Betteron, ed., *Looking On: Images of Femininity in the Visual Arts and Media* (New York: Pandora Books, 1987); Joy Kasson, *Marble Queens and Captives: Women in Nineteenth-Century American Sculpture* (New Haven: Yale University Press, 1990); Bailey Van Hook, *Angels of Art: Women and Art in American Society, 1876–1914* (University Park: Pennsylvania State University Press, 1966); and Carol Wald, *Myth America: Picturing Women, 1865–1945* (New York: Pantheon, 1975) all focus on representations of femininity, albeit primarily by men. David Lubin, *Picturing a Nation: Art*

and Social Change in Nineteenth-Century America (New Haven: Yale University Press, 1994) and Ellen Wiley Todd, *The New Woman Revised: Painting and Gender Politics on Fourteenth Street* (Berkeley: University of California Press, 1993) both analyze the effects of gender ideology on artists and art. Numerous studies of British and French women artists also take gender ideology into account as a formative influence. See Susan P. Casteras and Linda H. Peterson, eds., *A Struggle for Fame: Victorian Women Artists and Authors* (New Haven: Yale Center for British Art, 1994); Deborah Cherry, *Painting Women: Victorian Women Artists* (London: Routledge, 1993); Gladys Engel and Kurt Lang, *Etched in Memory: The Building and Survival of Artistic Reputation* (Chapel Hill: University of North Carolina Press, 1990); Tamar Garb, *Sisters of the Brush: Women's Artistic Culture in Late Nineteenth-Century Paris* (New Haven: Yale University Press, 1994); and Lisa Tickner, *The Spectacle of Women: Imagery of the Suffrage Campaign, 1907–14* (Chicago: University of Chicago Press, 1988).

10. See, for example, British painter Emily Mary Osborn's brilliant *Nameless and Friendless* (1857), analyzed in Cherry, *Painting Women*, pp. 78–86.

11. A rich body of feminist literary scholarship takes this view—for example, Sandra M. Gilbert and Susan Gubar, *The Madwoman in the Attic: The Woman Writer and the Nineteenth-Century Literary Imagination* (New Haven: Yale University Press, 1979); and the essays in Suzanne W. Jones, ed., *Writing the Woman Artist: Essays on Poetics, Politics, and Portraiture* (Philadelphia: University of Pennsylvania Press, 1991).

12. Elizabeth Stuart Phelps, *The Story of Avis*, Carol Farley Kessler, ed. (New Brunswick, N.J.: Rutgers University Press, 1995), pp. 71, 73.

13. Lisa Tickner, "Men's Work? Masculinity and Modernism," in Norman Bryson, Michael Ann Holly, and Keith Moxey, eds., *Visual Culture: Images and Interpretation* (Hanover, N.H.: University Press of New England, 1994), p. 47.

14. Many New York male and female visual artists in other fields practiced photography and used photographs as part of their work, but this study does not include women photographers because the history of professionalization was very different in that field. Photography was not widely considered to be an "art" in the United States until the late nineteenth century, when art schools began to include it in their curricula. This was long after women painters, sculptors, and illustrators had claimed their place as art professionals. See Gover, *Positive Image;* Jeanne Moutoussamy-Ashe, *Viewfinders: Black Women Photographers* (New York: Dodd, Mead & Co., 1986); and Naomi Rosenblum, *A History of Women Photographers* (New York: Abbeville Press, 1994).

15. See Harris, *Artist in American Society.* Burton J. Bledstein, *The Culture of Professionalism: The Middle-Class and the Development of Higher Education in America* (New York: W. W. Norton and Co., 1978), studies the connections among professionalism, class formation, and educational institutions. Another influential work on the subject is Robert Wiebe, *The Search for Order, 1877–1920* (New York: Hill and Wang, 1967).

16. Barbara Melosh, *"The Physician's Hand": Work Culture and Conflict in American*

Nursing (Philadelphia: Temple University Press, 1982), p. 3. Joan Jacobs Brumberg and Nancy Tomes, "Women in the Professions: A Research Agenda for American Historians," *Reviews in American History* 10 (June 1982): 275–296, provides an excellent overview of early work. Histories of gender and professionalization published since that time have tended to concentrate on individual professions. See Susan Coultrap-McQuin, *Doing Literary Business: American Women Writers in the Nineteenth Century* (Chapel Hill: University of North Carolina Press, 1990); Virginia Drachman, *Sisters in Law: Women Lawyers in Modern American History* (Cambridge, Mass.: Harvard University Press, 1998) and *Hospital with a Heart: Women Doctors and the Paradox of Separatism at the New England Hospital, 1862–1969* (Ithaca: Cornell University Press, 1984); Lori Ginzburg, *Women and the Work of Benevolence: Morality, Politics, and Class in the Nineteenth-Century United States* (New Haven: Yale University Press, 1990); Regina Kunzel, *Fallen Women, Problem Girls: Unmarried Mothers and the Professionalization of Social Work, 1890–1945* (New Haven: Yale University Press, 1993); Gloria Moldow, *Women Doctors in Gilded Age Washington: Race, Gender, and Professionalization* (Urbana: University of Illinois Press, 1987); Robyn Muncy, *Creating a Female Dominion in American Reform, 1890–1935* (New York: Oxford University Press, 1991); Bonnie Smith, *The Gender of History* (Cambridge, Mass.: Harvard University Press, 1998); Laurel Thatcher Ulrich, *A Midwife's Tale: The Life of Martha Ballard, Based on Her Diary, 1785–1812* (New York: Alfred A. Knopf, 1990). Among the very few wider comparisons or syntheses is Penina Migdal Glazer and Miriam Slater, *Unequal Colleagues: The Entrance of Women into the Professions, 1890–1940* (New Brunswick, N.J.: Rutgers University Press, 1987), which includes chapters on college teaching, medicine, science, and social work. For an even broader comparison, Alice Kessler-Harris incorporates professions—though not in the visual arts—in her excellent survey of women and wage work, *Out to Work: A History of Wage Earning Women in the United States* (New York: Oxford University Press, 1982).

17. James Jackson Jarves, "Progress of American Sculpture in Europe," *Art Journal* 33 (1871), quoted in Jean Gordon, "Early American Women Artists," *American Quarterly* 30, no. 1 (Spring 1978): 67. Penina Migdal Glazer and Miriam Slater identify four strategies—subordination, separatism, superperformance, and innovation—that characterized women's careers. Glazer and Slater, *Unequal Colleagues*, p. 211. Subordination and separatism are both intimately connected with nineteenth-century gender ideology, albeit in different ways. On the pattern of utilizing gender conventions to legitimate women's work in medicine and science, see Ellen S. More, *Restoring the Balance: Women Physicians and the Profession of Medicine, 1850–1995* (Cambridge, Mass.: Harvard University Press, 1999); Patricia Phillips, *The Scientific Lady: A Social History of Women's Scientific Interests, 1520–1918* (New York: St. Martin's Press, 1990); and Margaret W. Rossiter, *Women Scientists in America: Struggles and Strategies to 1940* (Baltimore: The Johns Hopkins University Press, 1982).

18. Muncy, *Creating a Female Dominion*, pp. 164–165; Joyce Antler, *The Educated*

Woman and Professionalization: The Struggle for a New Feminine Identity, 1890–1920 (New York: Garland Publishers, 1987), p. 15.

19. June Sochen, *The New Woman: Feminism in Greenwich Village, 1910–1920* (New York: Quadrangle Books, 1972) represents the older view, in which tired feminists ceded the field to "young and frivolous women" in the 1920s. Estelle B. Freedman first questioned the "flapper theory" of the decline of feminism in "The New Woman: Changing Views of Women in the 1920s," *Journal of American History* 61 (1974): 372–393. More recently, Nancy Cott wrote, "What historians have seen as the demise of feminism in the 1920s was, more accurately, the end of the suffrage movement and the early struggle of modern feminism." Women's political activism continued to express itself through voluntary organizations, however, rather than through newly won voting rights. Cott, *The Grounding of Modern Feminism* (New Haven: Yale University Press, 1987), p. 10.

20. More, *Restoring the Balance*, p. 55.

1. Peculiarly Fitted to Art

1. The other artistic relatives were Mary Jane Simes, daughter of Anna's eldest sister (a non-artist), Jane; Raphaelle's son, James Peale Jr., and grandson, Washington Peale; Rembrandt's daughter, Rosalba Carriera Peale; Rubens's daughter, Mary Jane Peale; and Sophonisba's son, Coleman Sellers. Charles Willson Peale named the children from his first marriage after famous painters, but the daughters, Angelica Kauffmann Peale and Sophonisba Anguissola Peale, did not become artists like the sons Raphaelle, Titian, Rembrandt, and Rubens. The artistic ties uniting both men and women in this family are eloquently expressed in *The Lamplight Portrait* (1822) by Charles Willson Peale. The oil painting depicts Charles's painter brother James looking at a miniature of Charles's granddaughter, Rosalba. The miniature in *The Lamplight Portrait* is a copy of a real miniature portrait of Rosalba that was painted by James's daughter Anna. Both *The Lamplight Portrait* and the miniature of Rosalba are now at the Detroit Institute of Arts.

2. For an excellent detailed study of portraiture in colonial America, see Wayne Craven, *Colonial American Portraiture: The Economic, Religious, Social, Cultural, Philosophical, Scientific, and Aesthetic Foundations* (Cambridge, England: Cambridge University Press, 1986). Neil Harris traces the role of portraiture, among other genres, in the professionalization of American art through the mid-nineteenth century in his classic work *The Artist in American Society: The Formative Years, 1790–1860* (New York: George Braziller, 1966).

3. Anne Sue Hirshorn, "Anna Claypoole, Margaretta, and Sarah Miriam Peale: Models of Accomplishment and Fortune," in Lillian Miller, ed., *The Peale Family: Creation of a Legacy, 1770–1870* (New York: Abbeville Press, 1996), p. 229.

4. Jean Gordon, "Early American Women Artists and the Social Context in Which They Worked," *American Quarterly* 30, no. 1 (Spring 1978): 54–69. See also Germaine Greer, *The Obstacle Race: The Fortunes of Women Painters and Their*

Work (New York: Farrar Straus Giroux, 1979), p. 319; and Lynda Nead, *The Female Nude: Art, Obscenity, and Sexuality* (London: Routledge, 1992).

5. See Mabel Munson Swan, *The Boston Athenaeum Gallery, 1827–1873* (Boston: The Boston Athenaeum, 1940) for a complete list of exhibitors.

6. Jane Stuart, "Anecdotes of Gilbert Stuart," *Scribner's Monthly,* July 1877, p. 379.

7. Anna Claypoole Peale's *Self-Portrait* on canvas is in the private collection of Arthur Whallon, Centerville, Indiana.

8. See Richard Bushman, *The Refinement of America: Persons, Houses, Cities* (New York: Vintage Books, 1992), esp. Chapter 3, "Bodies and Minds," for conventions of dress and posture and the role of portraits in genteel American culture before 1850.

9. Sarah Miriam Peale's 1818 self-portrait is in the private collection of Charles Coleman Sellers. James Peale later used the same pose in his portrait of Sarah. Charles H. Elam, *The Peale Family: Three Generations of American Artists* (Detroit: Detroit Institute of Arts and Wayne State University Press, 1967), p. 135.

10. Hirshorn, "Anna Claypoole, Margaretta, and Sarah Miriam Peale," p. 237. Richard Bushman links white fabric to gentility: "The genteel . . . were required to wear clean, fine linen at throat and wrists. Every male and female portrait shows fine white fabric at these points, and usually lace at the sleeve ends . . . The genteel image required fine white fabric where skin met suit or dress, revealing that the immaculate body was covered by a film of white cloth." Bushman, *Refinement of America,* p. 71. The wedding ring helps date this painting as well. Anna Peale temporarily abandoned her art career when she married Dr. William Staughton in 1829, but she was widowed just three months later and returned to painting as her livelihood until 1841, when she married General William Duncan.

11. This tendency marks the majority of the 1,300 portraits of distinguished artists in the National Academy of Design's collection. "The Victorian artist presented himself as a gentleman with a respectable, but unnamed, profession. Neither did he cast himself in the role of genius. He was a man of property and taste who happened to paint, but did not feel it important to show his brushes in his portrait any more than a surgeon would have held his scalpel or a merchant a fistful of coins," Michael Quick explains in his Introduction to *Artists by Themselves: Artists' Portraits from the National Academy of Design* (New York: National Academy of Design, 1983), p. 17.

12. See Frances Borzello, *Seeing Ourselves: Women's Self-Portraits* (New York: Harry N. Abrams, 1998) for an excellent discussion of women's self-portraiture in Europe and America from the sixteenth century to the present.

13. "Hiram Powers," *The Illustrated Magazine of Art* 3 (1855): 207, 208; B.B.T., "Sketch of a Self-Made Sculptor," *Knickerbocker* 4 (April 1835): 271–276.

14. Neil Harris analyzes this process in detail in *The Artist in American Society.*

15. Burton Bledstein first argued that a "culture of professionalism" emerging in the nineteenth century enabled the middle class to define itself; see Bledstein, *The Culture of Professionalism: The Middle Class and the Development of Higher Educa-*

tion in America (New York: Oxford University Press, 1976). Paul Johnson, *A Shopkeeper's Millennium: Society and Revivals in Rochester, New York, 1815–1837* (New York: Hill & Wang, 1978) relates middle-class formation to religious revivalism and patterns of social control; Mary P. Ryan, *Cradle of the Middle Class: The Family in Oneida County, New York, 1790–1865* (Cambridge, England: Cambridge University Press, 1981) stressed the importance of family and gender in shaping both class and religion. Other significant, influential scholarship on the formation of the American middle class in this period includes: Karen Halttunen, *Confidence Men & Painted Women: A Study of the Middle Class in America, 1830–1870* (New Haven: Yale University Press, 1982); John S. Gilkeson, Jr., *Middle-Class Providence, 1820–1940* (Princeton, N.J.: Princeton University Press, 1986); Stuart Blumin, *The Emergence of the Middle Class: Social Experience in the American City, 1760–1900* (Cambridge, England: Cambridge University Press, 1989); and, for a later period, Joan Rubin Shelley, *The Making of Middlebrow Culture* (Chapel Hill: University of North Carolina Press, 1992).

16. George Hillard, *Six Months in Italy* (Boston: Ticknor Reed & Fields, 1854), pp. 138–139.
17. Ralph Waldo Emerson, "Thoughts on Art," *The Dial* 1, no. 3 (January 1841): 367–378.
18. Justin Winsor, "The Perfect Artist," *The Crayon* 3 (September 1856): 278.
19. Susanna Paine, *Roses and Thorns, or Recollections of an Artist: A Tale of Truth for the Grave and the Gay* (1854), p. 104.
20. Paine, *Roses and Thorns*, p. 104. When she could look less shabby, she did: "I was enabled, by my constant receipt of money, to dress as I chose,—and for once, in my life, indulged my tastes, however expensive; so that I was richly and fashionably attired; I could not desire more attention than I received" (ibid., p. 72).
21. According to sociologist James Harwood Bernett, divorce first became a theme of American novels in the late 1850s. Bernett, "Divorce and the American Divorce Novel, 1858–1937: A Study in Literary Reflections of Social Influences" (Ph.D. diss., University of Pennsylvania, 1939).
22. Paine, p. 53. Nina Baym defines the basic narrative of woman's fiction as that of "a young woman who has lost the emotional and financial support of her legal guardians—indeed who is often subject to their abuse and neglect—but who nevertheless goes on to win her way in the world . . . Her 'own way' is nothing like a success story of today, since it seldom involves more than domestic comfort, a social network, and a companionable husband; what makes her success is her overcoming of obstacles through a hard-won, much tested 'self-dependence.'" As a genre, it is undeniably, proudly middle-class. Baym, *Woman's Fiction: A Guide to Novels by and about Women in America, 1820–70*, 2nd ed. (Urbana: University of Illinois Press, 1993), pp. ix, xxi–xxii. On domestic novels and women writers, see also Nancy Armstrong, *Desire and Domestic Fiction: A Political History of the Novel* (New York: Oxford University Press, 1987); Cathy Davidson, *Revolution and the Word: The Rise of the Novel in America* (New

York: Oxford University Press, 1986); Mary Kelley, *Private Woman, Public Stage: Literary Domesticity in Nineteenth-Century America* (New York: Oxford University Press, 1984); and Jane Tompkins, *Sensational Designs: The Cultural Work of American Fiction* (New York: Oxford University Press, 1985).

23. Paine, *Roses and Thorns,* pp. 60–61.

24. Ibid., p. 165.

25. Anne Whitney to Adeline Manning, 26 January 1862; Anne Whitney Papers, WCA.

26. Paine, *Roses and Thorns,* preface (n.p.).

27. Ibid., p. 74.

28. Ibid., p. 81.

29. Mary Ryan, *The Empire of the Mother: American Writing about Domesticity, 1830–1860* (New York: Haworth Press, 1982), p. 15; Blumin, *Emergence of the Middle Class,* pp. 187, 191; Ryan, *Cradle of the Middle Class.*

30. A Mother, *Thoughts on Domestic Education* (Boston: Carter & Hendee, 1829), pp. 24–25.

31. *Godey's Lady's Book* 30 (February 1845), p. 60, engraving p. 61.

32. Mrs. Mary Arthur, "The Young Artist," *Godey's Lady's Book* 41 (November 1850): 281.

33. See, for example, the series "Lithography" and "The Ornamental Artist," *The Lady's Book* 1 (1831), pp. 93, 149, 177, 288.

34. A. H. L. Phelps, *The Fireside Friend or Female Student* (1840); cited in Mirra Bank, *Anonymous Was a Woman* (New York: St. Martin's Griffin, 1995), p. 40.

35. Catherine Beecher, *A Treatise on Domestic Economy* (New York: Harper, 1841), p. 62.

36. Christie Anne Farnham, *The Education of the Southern Belle: Higher Education and Student Socialization in the Antebellum South* (New York: New York University Press, 1994), pp. 40–41, 86–87; Betty I. Madden, *Art, Crafts, and Architecture in Early Illinois* (Chicago: University of Illinois Press, 1974), p. 109.

37. Nancy Cott also identifies drawing as a typical part of the curriculum at all-female schools in New England. Cott, *The Bonds of Womanhood: "Woman's Sphere" in New England, 1780–1835* (New Haven: Yale University Press, 1977), p. 115. Linda Kerber traces the roots of this educational revolution back to the ideology of republican motherhood in *Women of the Republic: Intellect and Ideology in Revolutionary America* (Chapel Hill: University of North Carolina Press, 1980) and her 1976 essay, "Daughters of Columbia: Educating Women for the Republic, 1787–1805," reprinted in Kerber, *Toward an Intellectual History of Women* (Chapel Hill: University of North Carolina Press, 1997). For an excellent general narrative of the history of women's education in the United States, see Barbara Miller Solomon, *In the Company of Educated Women: A History of Women and Higher Education in America* (New Haven: Yale University Press, 1985).

38. "Placing a Daughter at School," *Godey's Lady's Book* 46, no. 5 (May 1853), p. 457; Thomas Woody, *A History of Women's Education in the United States,* vol. 1 (New York: Science Press, 1929), p. 415.

39. Charlotte Streifer Rubinstein, *American Women Artists* (Boston: G. K. Hall, 1982), p. 31.

40. Christine Jones Huber, *The Pennsylvania Academy and Its Women* (Philadelphia: Pennsylvania Academy of the Fine Arts, 1979), p. 9.

41. Mary McCord to Anna Dulles, Savannah, Georgia, September 1845, Cheves Family Correspondence, folder 12-95-1, South Carolina Historical Society, Charleston. Special thanks to Sarah J. Purcell for taking time from her own dissertation research in Charleston in order to find this letter and other wonderful material on women artists on my behalf.

42. Caroline Ticknor, *May Alcott: A Memoir* (Boston: Little, Brown, and Co., 1927), p. 44.

43. Lida Rose McCabe, "Mme. Bouguereau, Pathfinder," *New York Times Book Review and Magazine,* 19 February 1922, p. 16.

44. Madeleine Fidell-Beaufort, "Elizabeth Jane Gardner Bouguereau: A Parisian Artist from New Hampshire," *Archives of American Art Journal* 24, no. 2 (1984): 2–3.

45. Paine claimed that she had received no formal instruction in art prior to this, but her boast is difficult to reconcile with her other avowal of attending "the best academy in Rhode Island, where I remained until I was so far advanced in my studies, as to be able to teach any of the common branches of education," which would most certainly have included drawing. Paine, *Roses and Thorns,* pp. 24, 55–58.

46. Claire Richter Sherman traces the early successes of women as "interpreters of the visual arts" (i.e., art critics and writers on art subjects) to traditions of female art amateurism. Sherman, ed., *Women as Interpreters of the Visual Arts, 1820–1979* (Westport, Conn.: Greenwood Press, 1981), p. 17.

47. For more detailed narratives of the development of art education in the United States see Arthur Efland, *A History of Art Education: Intellectual and Social Currents in Teaching the Visual Arts* (New York: Teachers College Press, 1990); Foster Wygant, *Art in American Schools in the Nineteenth Century* (Cincinnati: Interwood Press, 1983); Diana Korzenik, *Drawn to Art: A Nineteenth Century American Dream* (Hanover, N.H.: University Press of New England, 1985); Charles C. Perkins, *Art Education in America, Read before the American Social Science Association at the Lowell Institute, Boston, February 22, 1870* (Cambridge, Mass.: American Social Science Association, 1870).

48. Contemporary European women artists usually received art training that was appreciably inferior to men's in various ways. While American women artists might travel to Europe to supplement their training or to study with a particular specialist or at a particular salon, European women artists had no recourse to the informal studio system. Women did not attend the most prestigious schools. The École des Beaux Arts did not admit women at all until 1897. The Royal Academy in London declared women enrollable in 1860 but did not permit them to study from the nude until 1900. See Marcia Hyland Green, "Women Art Students in America: An Historical Study of Academic Art In-

struction during the Nineteenth Century" (Ph.D. diss., American University, 1990), p. 38. At salons where women students were admitted, they were typically charged higher prices than men for equivalent study. While American women could plan for this and shorten the length of their supplementary study abroad if necessary, European women were often unable to afford the average amount of art training that their male counterparts possessed. See Charlotte Yeldham, *Women Artists in Nineteenth-Century France and England* (New York: Garland Publishing, 1984).

49. Earlier the National Academy of Design had admitted women students, but excluded them from 1831 to 1846. Rubinstein, *American Women Artists*, p. 441, n. 3.

50. Green, "Women Art Students," p. 39; Daniel P. Huntington reported Asher B. Durand's remarks in the "President's Annual Report" 13 (May 1846), Minute Books of the National Academy of Design, quoted in Lois Marie Fink, "Academic Departures: 1825–1869," in Lois Marie Fink and Joshua C. Taylor, eds., *Academy: The Academic Tradition in American Art* (Washington, D.C.: Smithsonian Institution Press, 1975), p. 33.

51. Margaret Rives King, *Memoirs of the Life of Mrs. Sarah Peter*, vol. 1 (Cincinnati: Robert Clarke & Co., 1889), p. 69.

52. *Proceedings of the Franklin Institute of the State of Pennsylvania for the Promotion of the Mechanic Arts, Relative to the Establishment of a School of Design for Women* (Philadelphia, 1850), p. 3, Moore College of Art and Design records, AAA, Reel 3654.

53. Frederika Bremer, 15 July 1851, quoted in Theodore C. Knauff, *An Experiment in Training for the Useful and the Beautiful: A History* (Philadelphia: Philadelphia School of Design for Women, 1922), p. 13, Moore College of Art and Design records, AAA, Reel 3654.

54. *Proceedings of the Franklin Institute*, p. 1.

55. John F. Frazer, chairman, to the Board of Managers of the Franklin Institute, Philadelphia, 15 May 1850; Moore College of Art and Design records, AAA, Reel 3654.

56. Knauff, *Experiment in Training*, p. 53.

57. Martin Family Papers and Campus Martius Museum records, AAA, Roll 132.

58. Frances Dana Gage, "Mrs. L. M. Spencer, the Artist," excerpt from a St. Louis newspaper, ca. 1850. Typescript, Martin Family Papers, AAA, Roll 132.

59. Martin Family Papers, AAA, Roll 132.

60. "Morton," "The Arts in the West," *Marietta [Ohio] Intelligencer*, 12 September 1839. Cited in Robin Bolton-Smith and William H. Truettner, *Lilly Martin Spencer, 1822–1902: The Joys of Sentiment* (Washington, D.C.: Smithsonian Institution Press, 1973), which also notes that the stream of visitors continued after the Spencers moved from the home, until the new tenants grew tired of the publicity and painted over the sketches in the 1860s. Edward D. Mansfield, *Cincinnati Chronicle* (August 1841); "From the *Cincinnati Chronicle*: Letters from the Editor, no. 3," *Marietta Intelligencer*, 26 August 1841.

61. Lilly Martin Spencer may have taken lessons from painter John Inisco Wil-

liams, but for the most part educated herself; perhaps her portrait commissions functioned as life studies classes of a sort.

62. McConkey to Durand, 14 June 1847, A. B. Durand Papers, New York Public Library; quoted in Bolton-Smith and Truettner, *Lilly Martin Spencer*, p. 27. By describing Spencer's status as an artist as "inexplicable," McConkey thus reveals his normative criteria for an artist: trained, financially secure, unencumbered, refined, and implicitly masculine.

63. Hiram Powers, Robert Duncanson, and Thomas Buchanan Read, three other Cincinnati artists, gladly accepted Nicholas Longworth's aid in obtaining training and commissions. Robert C. Vitz, *The Queen and the Arts: Cultural Life in Nineteenth-Century Cincinnati* (Kent, Ohio: Kent State University Press, 1989), pp. 22–23.

64. Lilly Martin Spencer to Angelique Martin, 10 September 1856, Martin Family Papers, AAA, Roll 132.

65. Lilly Martin Spencer to her parents, 29 December 1859, Martin Family Papers, AAA, Roll 132.

66. See William Dunlap, *History of the Rise and Progress of the Arts of Design in the United States* (New York: George P. Scott and Co., Printers, 1834), vol. 2, pp. 204–207 (Sharples); vol. 3, pp. 196–197 (Leslie), pp. 254–255 (Stuart), and pp. 160–162 (Hall).

67. Unlike the historical sketches, "the sketches of living American women who are pursuing art are chiefly prepared from materials furnished by their friends." Elizabeth Ellet, *Women Artists in All Ages and Countries* (London: R. Bentley, 1859), p. 286. No other book on American women artists appeared until after the turn of the twentieth century, with Clara Erskine Clement Waters's *Women in the Fine Arts: From the Seventh Century B.C. to the Twentieth Century A.D.* (Boston: Houghton Mifflin, 1904) quickly followed by Walter Shaw Sparrow's *Women Painters of the World* (New York: Frederick A. Stokes Co., 1905). No book-length biographies of individual women artists appeared until the twentieth century, and no great number of these until the 1970s.

68. See also Elizabeth Ellet, *Domestic History of the American Revolution* (New York: Baker and Scribner, 1850), where Ellet used research that could not be included in the three volumes of *The Women of the American Revolution* (New York: Baker and Scribner, 1848–50). On the expansion of educational opportunities for women, and especially its relation to the concept of woman's sphere, see Cott, *Bonds of Womanhood*. Ellet herself was the product of this educational revolution; she studied history and foreign languages, among other subjects, at Susanna Marriott's school for girls in Aurora, New York.

69. Giorgio Vasari, *Le Vite de' più eccellenti architetti, pittori, et scultori italiani . . .* (The Lives of the Most Eminent Italian Architects, Painters, and Sculptors), first published in 1550; Jean Baptiste Descamps, *La Vie des peintres flamands, allemands, et hollandais* (The Lives of Flemish, German, and Dutch Painters), 4 vols., 1753–1764. Ellet's research on American artists was her own original work.

70. Ellet, *Women Artists*, p. 22.

71. Ibid., p. vi.
72. Ibid., p. 333.
73. Ryan, *Empire of the Mother,* p. 12. Historians have not achieved consensus in pinpointing the exact moment in which domesticity acquired an ideological meaning.
74. Domesticity is one of the most richly explored and vigorously debated subjects in women's history. Nancy Cott, Mary Beth Norton, Kathryn Kish Sklar, Carroll Smith-Rosenberg, and Barbara Welter pioneered the subject in the 1970s. See Cott, *Bonds of Womanhood;* Mary Beth Norton, *Liberty's Daughters: The Revolutionary Experience of American Women, 1750–1800* (Boston: Little, Brown, and Co., 1980); Kathryn Kish Sklar, *Catharine Beecher: A Study in American Domesticity* (New Haven: Yale University Press, 1973); Carroll Smith-Rosenberg, "The Female World of Love and Ritual," *Signs* 1, no. 1 (1975): 1–29; and Barbara Welter, "The Cult of True Womanhood," *American Quarterly* 18 (1966): 151–174. Later historians began to connect ideas about domesticity to women's entrance into the public sphere through social, cultural, and political work. See, for example, Barbara Leslie Epstein, *The Politics of Domesticity: Women, Evangelism, and Temperance in Nineteenth-Century America* (Middletown, Conn.: Wesleyan University Press, 1981); Lori Ginzburg, *Women and the Work of Benevolence: Morality, Politics, and Class in the Nineteenth-Century United States* (New Haven: Yale University Press, 1990); Mary Kelley, *Private Woman, Public Stage: Literary Domesticity in Nineteenth-Century America* (New York: Oxford University Press, 1984); Peggy Pascoe, *Relations of Rescue: The Search for Female Moral Authority in the American West, 1874–1939* (New York: Oxford University Press, 1990). Phyllis Palmer's *Domesticity and Dirt: Housewives and Domestic Servants in the United States, 1920–45* (Philadelphia: Temple University Press, 1989) and Glenna Matthews's *"Just a Housewife": The Rise and Fall of Domesticity in America* (New York: Oxford University Press, 1987) examine domesticity as a cultural ideal that shaped women's domestic labor. Another group of historians has studied the way in which women social reformers at the turn of the twentieth century justified their work as "social housekeeping" and "domestic politics." See Paula Baker, "The Domestication of Politics: Women and American Political Society, 1780–1920," *American Historical Review* 89 (June 1984): 640–647.
75. With a similar sense of propriety, the young Herminie Borchard Dassel "devoted herself to the art of painting as a profession, hoping to derive from it a support for herself and family. She would attend to her household duties in the morning, and then, with port-folio in hand, wander off over the dusty or muddy road to the city, and again return to the flowers and cabbages, and the making of cheese and butter." Thus, her work as an artist did not disrupt her domestic duties. Like Peale, she exemplified selflessness; she decided to emigrate from Prussia to the United States to avoid "becoming a burden to her friends." Ellet, *Women Artists,* pp. 312, 313.
76. Ibid., pp. 329, 333, 296, 301.

77. Ibid., p. 304.

78. Ibid., p. 319. The French animal painter Rosa Bonheur was a widely celebrated figure among American audiences, forgiven for her short hair and masculine attire because of her immense talent—and probably because of her foreignness as well.

79. Ibid., pp. 304, 298.

80. Ibid., p. 338.

81. Ibid., p. 305.

82. Ibid., p. 307.

83. Ibid., p. 309.

84. Ibid., p. 311.

85. *Charleston [S.C.] Courier,* 23 September 1843.

86. Unsigned, "Woman's Position in Art," *The Crayon* 8, no. 2 (February 1860): 26.

87. *The Crayon*'s fanciful language intriguingly evoked an alter ego for the woman artist: the *un*veiled, brightly lit odalisque, the epitome of the nude subject.

88. William Dunlap, "Patience Wright," *The Crayon* 21, no. 11 (12 September 1855): 163.

89. *The Crayon* 2 (December 1855): 394.

90. *The Crayon* 3 (February 1856): 60.

91. Virginia Penny, *The Employments of Women: A Cyclopaedia of Woman's Work* (Boston: Walker, Wise, 1863). Frances B. Cogan discusses Penny's work at length in *All-American Girl: The Ideal of Real Womanhood in Mid-Nineteenth-Century America* (Athens: University of Georgia Press, 1989).

92. See Sarah Burns, *Inventing the Modern Artist: Art and Culture in Gilded Age America* (New Haven: Yale University Press, 1997).

2. Domesticating Professional Art

1. On networks among male artists and their role in the marginalization of women artists, see Kathleen D. McCarthy, *Women's Culture: American Philanthropy and Art, 1830–1930* (Chicago: University of Chicago Press, 1991), pp. 8–34. McCarthy documents the extent to which women were excluded from these powerful networks of male artists and patrons; she does not note that women artists formed their own parallel networks. Scholarship thus far has only hinted at the existence of identifiable networks among women artists, because most studies have focused on the lives of "great" artists; yet much work also remains to be done on the wider male subculture (the other "separate sphere") that undergirded men's artistic networks. Griselda Pollock, "Modernity and the Spaces of Femininity," in *Vision and Difference: Femininity, Feminism, and Histories of Art* (London: Routledge, 1988), approaches the masculinity of the art world from a different vantage point; she investigates the tension between the modern, masculine *flâneur* and Mary Cassatt and Berthe Morisot's use of space in their paintings in Second Empire Paris.

2. Sarah Ellen Blackwell, 17 August, 6 September, and 8 September 1850, in

1847–1855 Diary, Blackwell Family Papers, Schlesinger Library, Radcliffe Institute for Advanced Study, Cambridge, Massachusetts.

3. McCarthy, *Women's Culture*, p. 13. McCarthy identifies the Century Association, founded in 1847, as "a descendant of the Sketch Club," a less formal but equally eclectic and distinguished association founded in 1829.

4. Recently scholars have begun to trace a critical, gendered analysis of the relationship between artists and models in the nineteenth century. See April Masten, "Model into Artist: The Changing Face of Art Historical Biography," *Women's Studies* 21 (1992): 17–41; Griselda Pollock, "Woman as Sign: Psychoanalytic Readings," and Griselda Pollock and Deborah Cherry, "Woman as Sign in Pre-Raphaelite Literature: The Representation of Elizabeth Siddall," in Pollock, *Vision and Difference*.

5. Sara Foose Parrott argues that Cushman offered these women a model for having a successful career without sacrificing domestic life. Parrott, "Networking in Italy: Charlotte Cushman and 'The White Marmorean Flock,'" *Women's Studies* 14 (1988): 305–388; Joseph Leach, *Bright Particular Star: The Life and Times of Charlotte Cushman* (New Haven: Yale University Press, 1970); and *Charlotte Cushman: Her Letters and Memories of Her Life* by Cushman's companion, sculptor Emma Stebbins (Boston: Houghton Osgood & Co., 1878).

6. Much of the same scholarship that analyzes domesticity also explores the creation of "women's culture"; see Carroll Smith-Rosenberg, "The Female World of Love and Ritual" and other essays in *Disorderly Conduct: Visions of Gender in Victorian America* (New York: Knopf, 1985); Nancy Cott, *The Bonds of Womanhood: "Woman's Sphere" in New England, 1780–1835* (New Haven: Yale University Press, 1977). For further examination of the place of women's culture within the middle class, see Mary Ryan, *Cradle of the Middle Class: The Family in Oneida County, New York, 1790–1865* (Cambridge, Mass.: Harvard University Press, 1981); Ryan, "The Power of Women's Networks: A Case Study of Female Moral Reform in Antebellum America," *Feminist Studies* 5 (Spring 1979): 66–87; Nancy Hewitt, *Women's Activism and Social Change: Rochester, New York, 1822–1871* (Ithaca, N.Y.: Cornell University Press, 1984). For relationships among women in the working class in this period, see Christine Stansell, *City of Women: Sex and Class in New York, 1789–1860* (Chicago: University of Illinois Press, 1982).

7. Mary Williams to Mary Ann Bell, 20 February 1853, box 1, folder 2, Mary Elizabeth Williams Papers, Peabody Essex Institute, Salem, Mass.

8. Mary Williams to Mary Ann Bell, 18 April 1857, box 1, folder 2, Williams Papers, Peabody Essex Institute. Bell did not accompany Williams to Europe, probably because of reasons related to her marriage the following year.

9. Charlotte Streifer Rubinstein, *American Women Artists from Early Indian Times to the Present* (New York: Avon, 1982), p. 110.

10. Anne Whitney to Adeline Manning, 6 March 1866, Anne Whitney Papers, WCA.

11. Frederic Sharf, "Fidelia Bridges: Painter of Birds and Flowers," *Essex Institute Historical Collections* 104, no. 3 (July 1968): 221–222.

12. Adeline Manning to Anne Whitney, 20 November 1865, Anne Whitney Papers, WCA.

13. Emma Stebbins to Anne Whitney, 22 June 1873, Anne Whitney Papers, WCA.

14. In contemporary England, Harriet Grote founded the Society of Female Artists in 1857. English women painters, especially Barbara Leigh Smith Bodichon, were particularly prominent in the first campaign toward a Married Women's Property Bill. See Paula Gillett, *Worlds of Art: Painters in Victorian Society* (New Brunswick, N.J.: Rutgers University Press, 1990), p. 134.

15. H. Barbara Weinberg describes the experiences of American artists in France in *The Lure of Paris: Nineteenth-Century American Painters and Their French Teachers* (New York: Abbeville Press, 1991). Male artists who went to Europe at crucial points in their careers include painters Thomas Cole, Miner K. Kellogg, Benjamin Champney, George Inness, and Albert Bierstadt; sculptors Horatio Greenough, Hiram Powers, Shobal Clevenger, Thomas Crawford, William Wetmore Story, Henry Kirke Brown, Randolph Rogers, Joseph Mozier, and William Henry Rinehart all had studios in Italy. Perhaps one of the most widely traveled, painter John Frederick Kensett (1816–1872) lived in Paris, Dusseldorf, and Rome in the 1840s, in the company of other artists at each location. For detailed individual examples of artists' lives and work in Europe, see Keith L. Bryant Jr., *William Merritt Chase: A Genteel Bohemian* (Columbia: University of Missouri Press, 1991); and Michael Quick, *An American Painter Abroad: Frank Duveneck's European Years* (Cincinnati: Cincinnati Art Museum, 1987). Anna Mary Howitt provides the perspective of a European woman artist in *An Art Student in Munich*, 2 vols. (Boston: Ticknor Reed & Fields, 1854).

16. Mary Williams to Mary Ann Bell, 22 December 1855, box 1, folder 2, Williams Papers, Peabody Essex Institute.

17. Recently, art historians have encouraged a new understanding and appreciation for the influence of Italy on early and mid-nineteenth-century American art. See essays in the exhibition catalog by Theodore E. Stebbins Jr., *The Lure of Italy: American Artists and the Italian Experience, 1760–1914* (Boston: Museum of Fine Arts, 1992), especially Stebbins's "American Painters and the Lure of Italy" (pp. 29–65) and William H. Gerdts, "Celebrities of the Grand Tour: The American Sculptor in Florence and Rome" (pp. 66–93); William L. Vance, *America's Rome*, 2 vols. (New Haven: Yale University Press, 1989); Irma B. Jaffe, ed., *The Italian Presence in American Art, 1760–1860* (New York: Fordham University Press, and Rome: Istituto della Enciclopedia Italiana, 1989); Regina Soria, *Dictionary of Nineteenth-Century American Artists in Italy, 1760–1914* (East Brunswick, N.J.: Associated University Presses, 1982); University of Kansas Museum of Art, *The Arcadian Landscape: Nineteenth-Century American Painters in Italy* (Lawrence: University of Kansas Museum of Art, 1972); John W. Coffey, *Twilight of Arcadia: American Landscape Painters in Rome, 1830–1880* (Brunswick, Maine: Bowdoin College, 1987); Paul R. Baker, *The Fortunate Pilgrims: Americans in Italy, 1800–1860* (Cambridge, Mass.: Harvard University Press, 1964); Van Wyck Brooks, *The Dream of Arcadia: American Writers and Artists in Italy, 1760–1915*

(New York: Dutton, 1958); Samuel Osgood, "American Artists in Italy," *Harpers Monthly* (1870); Katherine C. Walker, "American Studios in Rome and Florence," *Harpers Monthly* 33 (June 1866): 102–103. Quote is from Stebbins, *The Lure of Italy*, p. 21.

18. Anne Whitney to Adeline Manning, 11 September 1860, Anne Whitney Papers, WCA.

19. Adeline Manning to Anne Whitney, 1 April 1860, Anne Whitney Papers, WCA.

20. Anne Whitney to Adeline Manning, April 1860, Anne Whitney Papers, WCA.

21. Anne Whitney to Adeline Manning, 24 or 28 February 1866, Anne Whitney Papers, WCA.

22. See, for example, Anne Whitney to her family, 15 March 1867 and 21 March 1867, Anne Whitney Papers, WCA.

23. Henry Tuckerman, "American Artists," *Hours at Home* 3, no. 6 (October 1866): 517.

24. Harriet Hosmer, "The Doleful Ditty of the Roman Caffe Greco," in Cornelia Carr, ed., *Harriet Hosmer: Letters and Memories* (London: John Lane/The Bodley Head, 1913), pp. 194–197.

25. Histories of wage-earning women have charted the expansion of opportunities for women to live independently, with increasing urbanization and female employment throughout the century. For a study of the later nineteenth century, see Joanne J. Meyerowitz, *Women Adrift: Independent Wage Earners in Chicago, 1880–1930* (Chicago: University of Chicago Press, 1988).

26. Even Whitney's artist friends regarded this as a "gift," not an entitlement. See Eliza C. Bridges to Rebecca Northey (Buffum), 30 January 1859, Northey Family Papers, Peabody Essex Institute, Salem, Mass.

27. "Du Pré, Julia Clarkson," in Mrs. Russell Sage, *Emma Willard and Her Pupils, or Fifty Years of Troy Seminary, 1822–1872* (New York: Mrs. Russell Sage, 1898).

28. Susan Coultrap-McQuin, *Doing Literary Business: American Women Writers in the Nineteenth Century* (Chapel Hill: University of North Carolina Press, 1990), pp. 35–37.

29. Sharf, "Fidelia Bridges," pp. 218–219. Bridges may also have taken care of the children of painter William Trost Richards while she studied art with Richards in the summer of 1860; Sharf, p. 222.

30. Mary Williams, 6 March 1852, Diary, box 1, folder 1, Williams Papers, Peabody Essex Institute.

31. Charlotte Streifer Rubinstein, *American Women Artists* (Boston: G. K. Hall, 1982), pp. 71, 56; James McGovern, ed., *The Life and Letters of Eliza Allen Starr* (Chicago: Lakeside Press, 1905), p. 32.

32. A writer in *The Crayon* stated, "There are a great many ladies in this community whose situations would be vastly improved by making themselves good teachers of drawing. It is an art easily attained. The profession is very pleasant, and uncommonly remunerative. An offer was made through us lately, of 500 dol-

lars a year, and all expenses paid, in a young ladies' seminary. How many poor girls are suffering even for the necessaries of life, who might, with a tenth part of the time they have wasted on some piano, become well fitted for such a position. Great efforts have been made in England, and other parts of Europe to educate teachers of drawing. The result, so far, has been satisfactory: in the long run, it must tell very sensibly upon the people. When a good knowledge of elementary drawing shall become a part of every common school education, the true millennium of Art will be inaugurated." *The Crayon*, February 1856, p. 60.

33. Sarah Ellen Blackwell, 24 May 1851, in 1847–1855 Diary, Blackwell Family Papers, Schlesinger Library.
34. Sarah Ellen Blackwell, 16 September 1850, in 1847–1855 Diary, Blackwell Family Papers, Schlesinger Library.
35. Sarah Ellen Blackwell, 1 October 1850, in 1847–1855 Diary, Blackwell Family Papers, Schlesinger Library.
36. Sarah Ellen Blackwell, January 1852, 1847–1855 Diary, Blackwell Family Papers, Schlesinger Library.
37. On romantic friendships, lesbianism, and relationships between women see Carroll Smith-Rosenberg, "The Female World of Love and Ritual: Relations between Women in Nineteenth-Century America," in Nancy F. Cott and Elizabeth H. Pleck, eds., *A Heritage of Her Own* (New York: Simon and Schuster/ Touchstone, 1979), pp. 311–342; Lillian Faderman, *Surpassing the Love of Men: Romantic Friendship and Love between Women from the Renaissance to the Present* (New York: William Morrow and Co., 1981); John D'Emilio and Estelle B. Freeman, *Intimate Matters: A History of Sexuality in America* (New York: Harper & Row, 1988).
38. Harriet Hosmer, "The Process of Sculpture," *Atlantic Monthly* 14, no. 86 (December 1864): 734–737. In 1863, Hosmer sued two English periodicals, *The Queen* and *The London Art-Journal*, for libel; she dropped the suit when the journals published retractions. Hosmer's *Atlantic Monthly* article was reprinted and distributed during the U.S. tour of the sculpture in question, *Zenobia in Chains*. In addition, she won the support of art critic Anna Jameson and wrote her own letter to the *Art-Journal;* but it took the endorsements of two men, her mentor John Gibson and William Wetmore Story, to quiet the last whispers.
39. Harriet Hosmer to Wayman Crow, [1871], Harriet Goodhue Hosmer Collection, Schlesinger Library.
40. Unsigned editorial, "Rosa Bonheur," *The Crayon*, March 1861: 174–175.
41. Cornelia Carr, ed., *Harriet Hosmer: Letters and Memories* (New York: Moffat, Yard, and Co., 1912), p. 35.
42. Anna Lea Merritt, *Henry Merritt: Art Criticism and Romance* (London: C. Kegan Paul & Co., 1879). Interestingly, she also quotes her husband as declaring, "I must never think of marrying" (p. 41).
43. Along similar lines, Greenwood wrote, "True feminine genius is ever timid,

doubtful and clingingly dependent; a perpetual childhood." Quoted in David E. Shi, *Facing Facts: Realism in American Thought and Culture, 1850 to 1920* (New York: Oxford University Press, 1995), p. 18.

44. Dolly Sherwood, *Harriet Hosmer: American Sculptor, 1830–1908* (Columbia: University of Missouri Press, 1991), p. 118.

45. Elizabeth Barrett Browning to Mary Russell Mitford, 10 May [1854], in Meredith B. Raymond and Mary Rose Sullivan, eds., *The Letters of Elizabeth Barrett Browning to Mary Russell Mitford, 1836–1854*, vol. 3 (Winfield, Kansas: Armstrong Browning Library of Baylor University, the Browning Institute, Wedgestone Press, and Wellesley College, 1983), p. 409.

46. H. G. Hosmer, letter in *The Crayon*, September 1860.

47. Harriet Hosmer to Wayman Crow, 9 December 1857, 14 January [1859], 9 December 1857, and 12 June 1853, Harriet Goodhue Hosmer Collection, Schlesinger Library. See also Harriet Hosmer to Harriet Carr, quoted in Cornelia Crow Carr, ed., *Harriet Hosmer: Letters and Memories* (London, 1913), pp. 54–55; Harriet Hosmer to Cornelia Crow Carr, [1856], Harriet Goodhue Hosmer Collection, Schlesinger Library.

48. Another example: "I have been speculating upon the probable consequences to Art of an extension of this war through hostilities with England, and I about conclude that it will be best for me to dig a pit, and dig it deep, on Meetinus hill, near the shanty, and bury the boy [*Lotus Eater*] and the girls [*Godiva* and *Africa*] till the storm blows over." Anne Whitney to Adeline Manning, early August 1863 and April 1860; Anne Whitney to Sarah Whitney, 14 June 1859, Anne Whitney Papers, WCA.

49. Tara Leigh Tappert, "Choices—The Life and Career of Cecilia Beaux: A Professional Biography" (Ph.D. diss., George Washington University, 1990), p. 392.

50. Laura Curtis Bullard, "Edmonia Lewis," *The Revolution*, 20 April 1871, p. 20.

51. Lydia Maria Child to Sarah Shaw, 3 November 1864; to Harriet Sewall, 10 July 1868; in Milton Meltzer and Patricia G. Holland, eds., *Lydia Maria Child: Selected Letters, 1817–1880* (Amherst: University of Massachusetts Press, 1982), pp. 446, 480.

52. Lydia Maria Child to Harriet Sewall, 10 July 1868; in Meltzer and Holland, *Lydia Maria Child: Selected Letters*, p. 481.

53. As late as 1893, African American audiences at the Columbian Exposition were viciously lampooned for their interest in high culture. However, all of these communities had vibrant traditions of creative "folk art," including quilts and embroidery, which scholars have only just begun to consider.

54. See Elizabeth Johns, *American Genre Painting: The Politics of Everyday Life* (New Haven: Yale University Press, 1991).

55. Lilly Martin Spencer papers, Roll 132, AAA.

56. Lilly Martin Spencer to her parents, 11 July 1847, Roll 132, AAA. I have chosen not to correct Spencer's orthographic mistakes because they reveal her lack of formal education at the same time that the words attest to her sophisticated ideas and beliefs.

57. Johns, *American Genre Painting*, p. 161. Organized by merchants, not artists, the Art-Union was a primarily commercial venture and encouraged the production of paintings with American themes, which the organization believed would sell best. Robin Bolton-Smith and William Truettner, *Lilly Martin Spencer, 1822–1902: The Joys of Sentiment* (Washington, D.C.: Smithsonian Institution Press, 1973), p. 26.

58. Quoted in Johns, *American Genre Painting*, pp. 161–162.

59. This argument is convincingly set forth in David Lubin, *Picturing a Nation: Art and Social Change in Nineteenth-Century America* (New Haven: Yale University Press, 1994), pp. 158–203.

60. Johns, *American Genre Painting*, pp. 166–175.

61. Spencer also resembles the maternal figures in *Don't Wake Them* (1849), *Kiss Me and You'll Kiss the 'Lasses* (1856), *Choose Between* (ca. 1857), and the original painting of *This Little Pig Went to Market* (1857; the later etching no longer resembles her).

62. *The Crayon*, May 1856, p. 146.

63. Bryan Jay Wolf, *Romantic Re-Vision: Culture and Consciousness in Nineteenth-Century American Painting and Literature* (Chicago: University of Chicago Press, 1982).

64. The relationship between the Hudson River school and luminism has been hotly debated among art historians. Some, such as James Thomas Flexner, consider luminists a subcategory, or second generation, of Hudson River school artists; others, for example Barbara Novak, see luminism as an alternative tradition to that of the Hudson River school. I favor Bryan Jay Wolf's interpretation of the luminists as direct descendants of the Hudson River school, in that they shared a similar faith in "the symbolic potential of the landscape, that goes back to Cole, Quidor, and Allston. At the same time that the luminist painter is breaking out of the conventions of the picturesque inherited from the eighteenth century, he is reaffirming by redefining the underlying sublime possibilities of the American wilderness." There are important differences between the two groups, however; these differences lie in the contrast between "prewar Jacksonian energies" and a mid-nineteenth-century unease with "the rise of industrial capitalism, a loss of individual power within society, and a growing depersonalization of the work process" reminiscent of Thoreau's *Walden;* Wolf finds luminism rich in "its own subversive poetry of light and space." Wolf, *Romantic Re-Vision*, pp. 245–246. I would add that increasingly heated sectional politics, and the Civil War itself, also mark a point of fracture between the expansive canvases of the Hudson River school artists and the much smaller-scale scenes favored by the luminists. The grand unifying landscape became a more contained and motionless, contemplative scene.

65. See Barbara Novak, *American Painting of the Nineteenth Century: Realism, Idealism, and the American Experience* (New York: Praeger Publishers, 1969), especially pp. 61–79 on Thomas Cole.

66. William Cullen Bryant, "To Cole, the Painter, Departing for Europe" (1829),

cited in John W. McCoubrey, ed., *American Art, 1700–1960: Sources and Documents* (Englewood Cliffs, N.J.: Prentice-Hall, 1965), p. 96. For an artist's own explanation of the meaning and importance of landscape in American painting, see Thomas Cole, "Essay on American Scenery," *American Monthly Magazine*, n.s. 1 (January 1836): 1–12, reprinted in McCoubrey, *American Art*, pp. 98–110. Several excellent studies have explored the relationship between landscape painting and the development of American ideologies and national identity: Albert Boime, *The Magisterial Gaze: Manifest Destiny and American Landscape Painting, c. 1830–1865* (Washington, D.C.: Smithsonian Institution Press, 1991); Angela L. Miller, *The Empire of the Eye: Landscape Representation and American Cultural Politics, 1825–1875* (Ithaca: Cornell University Press, 1993); Barbara Novak, *Nature and Culture: American Landscape and Painting, 1825–1875*, rev. ed. (New York: Oxford University Press, 1990).

67. Charlotte Streifer Rubinstein, *American Women Artists from Early Indian Times to the Present* (New York: G. K. Hall, 1982), p. 63.

68. William Cullen Bryant, *Funeral Oration on the Death of Thomas Cole before the National Academy of Design, May 4, 1848*, cited in McCoubrey, *American Art*, pp. 96–97. Louis Legrand Noble, *The Life and Works of Thomas Cole*, ed. Elliot S. Vessell (Cambridge, Mass.: Belknap Press of Harvard University Press, 1964); Noble, *The Course of Empire, Voyage of Life, and Other Pictures of Thomas Cole* (New York: Cornish, Lamport, 1853).

69. Ita G. Berknow, "Evalina Mount," *American Art Review*, April 1997: 86–93. It was not until after the Civil War that several Western women artists took up landscape as their principal genre. Helen Tanner Brodt (1838–1908) began painting in California in the late 1860s; Mary Elizabeth Michael Achey (1832–1886) opened her Colorado studio in 1868; Helen Henderson Chain (1849–1892) established the first art school in Denver (1877); Annie Cornelia Shaw (1852–1887) studied with Henry C. Ford until 1872. See Rubinstein, *American Women Artists*, pp. 63–64; Erika Doss, "'I *Must* Paint': Women Artists of the Rocky Mountain Region," in Patricia Trenton, ed., *Independent Spirits: Women Painters of the American West, 1890–1945* (Berkeley: University of California Press, 1995), p. 213.

70. As Angela L. Miller noted, "Critics, writers, and artists wrote about the properties of light and air in both nature and art in specifically feminine terms." Miller, *Empire of the Eye*, p. 256. She interprets the advent of luminism as the domestication of the sublime: "Atmospheric imagery reaffirmed feminine values in the context of masculine assumptions . . . space rather than mass . . . Atmospheric effects not only domesticated the sublime; they also threatened to displace it as a carrier of masculine will and to substitute a very different order of knowledge and causality symbolized by silent feminine influence rather than noisy manifestations of power." Ibid., pp. 287, 259. Though Miller does not directly engage the question, the regendering of the represented landscape in this model would seem to have taken place independently of the gendering (or biological sex) of the representers.

71. Albert Boime compares what he calls "the magisterial gaze" of landscape to the gaze and function of the surveyor; landscape painter and surveyor share a "tension between fixing one's own boundary as a sign of possession of the land and the urge to transcend boundaries." Boime, *Magisterial Gaze*, p. 137. See also William H. Truettner and Alan Wallach, eds., *Thomas Cole: Landscape into History* (New Haven: Yale University Press; Washington, D.C.: National Museum of American Art, Smithsonian Institution, 1994).

72. Miller, *Empire of the Eye*, p. 16.

73. Helena E. Wright, *With Pen and Graver: Women Graphic Artists before 1900* (Washington, D.C.: National Museum of American History, Smithsonian Institution, 1995), pp. 3–8.

74. Few critics or historians to this day have traversed this boundary between "high" and "low" art in the nineteenth century. To begin with, the history of mass-produced visual art in the United States has not received an equivalent amount of study as has the history of "fine art." As Neil Harris writes, "Artistically suspect, commercially tainted, technically cumbersome, and intellectually isolated, the development of modern visual reproduction methods has failed to engage general historical interest." Harris, *Cultural Excursions: Marketing Appetites and Cultural Tastes in Modern America* (Chicago: University of Chicago Press, 1990), p. 309. Furthermore, in order to transcend the hierarchies of (and within) fine art, industrial art, applied art, popular art, etc., one must understand how, why, and when those hierarchies were constructed, rather than accepting them as natural rankings that perceptive viewers or audiences would instinctually make. Lawrence Levine has traced the process of cultural bifurcation, or the "sacralization of culture," in the mid-nineteenth century in his incisive *Highbrow / Lowbrow: The Emergence of Cultural Hierarchy in America* (Cambridge, Mass.: Harvard University Press, 1988). Levine suggests several types of connections between "high" and "low": "Our comparative understanding might well be furthered . . . by adding to the almost exclusively aesthetic criteria of the present hierarchy, thematic criteria (the message of various forms of expressive culture), functional criteria (how various forms of expressive culture 'work'), and quantitative criteria (to what extent various forms of expressive culture are diffused throughout the society)." Ibid., p. 8.

75. Elizabeth Johns has identified depictions of courtship as a "theme of male self-definition" among genre painters, while "motifs of females in the home" such as the ones Lilly Martin Spencer chose "undergirded female self-definition." Johns, *American Genre Painting*, p. 163. This interpretation helps explain why Currier and Ives's most sentimental pictures of beauties and courting couples were the work of men, but the lack of domestic scenes of any type in the work of Fanny Bond Palmer suggests that women might also define themselves outside the context of home.

76. Angela L. Miller describes the middle landscape as "a rural Arcadia gently shaped by the hand of the farmer and aesthetically balanced between the extremes of wilderness and city. The middle landscape implied stability in a pe-

riod of rapid change; its modulated topography was the expression of a yearning for uncomplicated social relations. But not only did the middle landscape function as an idealized image of a harmonious nature; it also served the cultural dream of a structured transformation of the social order that was Whig in spirit . . . The various elements of landscape—its spatial constructions, its passage from near to far and light to shade, its combination of various artistic modes from picturesque to beautiful and sublime—embodied a form of *concordia discors,* or harmony of opposing elements, which was the aesthetic correlative of social dynamics in a healthy republic . . . Conflicts between freedom and order, change and continuity, growth and stability, could be rehearsed through spatial scenarios." Miller, *Empire of the Eye,* pp. 13–14.

77. Rubinstein, *American Women Artists,* p. 69.
78. Palmer also celebrated progress in depictions of trains, such as *The Lightning Express Trains* (1863), and steamships, including a pair of prints that drew her into new thematic material: war. War marked the endpoint of progress and threatened to destroy Arcadia, as the contrast between *The Mississippi in Time of Peace* and *The Mississippi in Time of War* (both 1865) makes clear.
79. Smillie's painting was also engraved and distributed by the American Art-Union in 1851. Miller, *Empire of the Eye,* p. 272.
80. Rubinstein, *American Women Artists,* p. 69.
81. Harry T. Peters, *Currier and Ives: Printmakers to the American People* (Garden City, N.Y.: Doubleday & Co., 1942), p. 21.
82. Woman's rights advocate Laura Curtis Bullard saw this physical aspect in a positive, empowering light in her biographical study of Edmonia Lewis, published in *The Revolution* of 20 April 1871. But strength and physicality were often attributed to African American women—usually as proof of their masculinity and racial inferiority, in opposition to white women's delicacy.
83. H. M., "Lady Artists in Europe," *Art Journal* 5 (1866), quoted in Whitney Chadwick, *Women, Art, and Society* (London: Thames and Hudson, 1990), p. 199.
84. Child to Harriet Sewall, 10 July 1868, in Meltzer and Holland, *Lydia Maria Child: Selected Letters,* p. 481.
85. See Joy Kasson, *Marble Queens and Captives: Women in Nineteenth-Century American Sculpture* (New Haven: Yale University Press, 1990).
86. Whitney's is probably the first example of a male nude modeled by an American woman artist. Rubinstein, *American Women Sculptors,* p. 47.
87. *The Sublime and the Beautiful: Images of Women in American Sculpture, 1840–1930* (Boston: The Museum of Fine Arts, 1979).
88. Unidentified person to Reverend Robert Collyer, quoted in Carr, *Harriet Hosmer: Letters and Memories,* pp. 221–222.
89. Oenone was "perhaps in the same awkward predicament that you would be if Lucien should desert you for me, for instance," Hosmer wrote to her childhood friend Cornelia Crow Carr, June 1856, Harriet Goodhue Hosmer Collection, Schlesinger Library.

90. Nathaniel Hawthorne, Preface, *A Marble Faun* (1860). Hawthorne had previously used Zenobia as the name of the main female protagonist in his novel *The Blithedale Romance* (1852).

91. *Chicago Evening Journal,* 14 June 1856.

92. Kasson, *Marble Queens and Captives,* pp. 155–161. For an incisive analysis of *Zenobia* and Hosmer's other work, see Kasson's entire chapter "The Problematics of Female Power: Zenobia," ibid., pp. 141–165.

3. Figures and Fig Leaves

1. Sexuality had always been linked to cultural prescriptions and definitions of gender. A "good" woman's control of her sexuality, maintenance of her innocence, cultivation of her purity, and conformity to the rules of sexual propriety indicated her control over all other aspects of her womanhood, respectability, and femininity. Conversely, a "bad" woman was one who exhibited uncontrolled sexuality, and her sexual misconduct suggested her involvement in other unrespectable activities. Any type of gender transgression risked association with sexual transgression. Accusations of sexual misconduct were a convenient, specific way to attack a woman's unwomanliness. This tactic was commonly used to discredit female public speakers, from free-love advocates to abolitionists. On women's sexuality and the cult of true womanhood, see especially Nancy Cott, "Passionlessness: An Interpretation of Victorian Sexual Ideology, 1790–1850," *Signs* 4 (1978): 219–236; and Carl Degler, "What Ought to Be and What Was: Women's Sexuality in the Nineteenth Century," *American Historical Review* 79 (1974): 1467–1490. On the equation of sexual transgression and gender transgression, see Victoria Bynum, *Unruly Women: The Politics of Social and Sexual Control in the Old South* (Chapel Hill: University of North Carolina Press, 1992), and the rich historiography on prostitution in the nineteenth-century United States, including Timothy Gilfoyle, *City of Eros: New York City, Prostitution, and the Commercialization of Sex, 1790–1920* (New York: W. W. Norton & Co., 1992). Gilfoyle argues that a new, permissive sexual culture existed in the mid-nineteenth-century United States, but was accessible only to men. Karen Lystra finds that passionlessness was not the ideal of most American couples; both romantic love and a sense of duty worked to reconcile purity and sex. Lystra, *Searching the Heart: Women, Men, and Romantic Love in Nineteenth-Century America* (New York: Oxford University Press, 1989).

2. Lynda Nead discusses how this "sexual myth" both genders and sexualizes the life class; Nead, *The Female Nude: Art, Obscenity, and Sexuality* (London: Routledge, 1992), pp. 46–55. Frances Borzello investigates how in nineteenth-century Britain the professional artist's model became equated with the female nude. Borzello, *The Artist's Model* (London: Junction Books, 1982).

3. This law was strengthened to include books in 1857; see David Loth, *The Erotic in Literature* (New York: Dorset Press, 1961). Also see William H. Gerdts, *The*

Great American Nude: A History in Art (New York: Praeger 1974); John D'Emilio and Estelle Freedman, *Intimate Matters: A History of Sexuality in America* (New York: Harper & Row, 1988), pp. 157–158.

4. Joy Kasson's "Narratives of the Female Body: The Greek Slave," Chapter 3 of her *Marble Queens and Captives: Women in Nineteenth-Century Sculpture* (New Haven: Yale University Press, 1990), pp. 46–72, provides greater detail on how this sculpture fit into the discourse on female sexuality and its importance in the nineteenth century's cultural construction of gender.

5. Katharine C. Walker, "American Studios in Rome and Florence," *Harper's Monthly Magazine*, June 1866: 102.

6. "Visits to the Studios of Rome," *Art-Journal* 10 (1871): 164; "Exhibition of the Society of Female Artists," ibid., 91.

7. Charles Timothy Brooks, "In Loving Memory of Margaret F. Foley, Native of U.S.A., who entered into rest at Meran, Tyrol, December 7, 1877," n.p., n.d. [ca. 1878].

8. Robinson cited in Eleanor Tufts, "Margaret Foley's Metamorphosis: A Merrimack 'Female Operative' in Neo-Classical Rome," *Arts Magazine*, January 1982: 93.

9. Katharine C. Walker, "American Studios in Rome and Florence," *Harper's Monthly Magazine*, June 1866: 102–103; "Miss Foley in Rome," *Boston Evening Transcript*, 30 May 1865; *Mary Howitt: An Autobiography*, ed. Margaret Howitt, vol. 2 (Boston: Houghton Mifflin, 1889), pp. 221–222. Cited in Tufts, "Margaret Foley's Metamorphosis," pp. 88–95, which is the fullest biographical treatment of Foley to date. Also see "Visits to the Studios of Rome," *Art Journal* 10 (1871): 164.

10. On the contrast between women industrial workers and the ideal image of the "lady" pursuing leisure activities see Gerda Lerner, "The Lady and the Mill Girl: Changes in the Status of Women in the Age of Jackson," in Nancy Cott and Elizabeth H. Pleck, eds., *A Heritage of Her Own* (New York: Touchstone, 1979), pp. 182–196.

11. Lucy Larcom, *A New England Girlhood, Outlined from Memory* (1889; reprint, New York: Corinth Books, 1961), pp. 157–158, 255.

12. See the *Independent* (a New York weekly), 25 June 1863 and 23 November 1864, mentioned in Shirley Marchalonis, *The Worlds of Lucy Larcom, 1824–1893* (Athens: University of Georgia Press, 1989), p. 151.

13. See Thomas Dublin, *Women at Work: The Transformation of Work and Community in Lowell, Massachusetts, 1826–1860* (New York: Columbia University Press, 1979).

14. Mary Wheeler to Mary Noble, 3 February 1878; quoted in Blanche E. Wheeler Williams, *Mary C. Wheeler—Leader in Art and Education* (Boston: Marshall Jones Co., 1934), p. 146.

15. Mary Wheeler to Mary Noble, 27 July 1878; quoted in ibid., p. 157.

16. May Alcott Nieriker, *Studying Art Abroad, and How to Do It Cheaply* (Boston: Roberts Brothers, 1879).

17. Cecilia Beaux, *Background with Figures* (Boston: Houghton Mifflin Co., 1930), p. 257.

18. Griselda Pollock, "Modernity and the Spaces of Femininity," in Norma Broude and Mary D. Garrard, eds., *The Expanding Discourse: Feminism and Art History* (New York: IconEditions, 1992).

19. Nancy Mowll Mathews, *Mary Cassatt: A Life* (New York: Villard Books, 1994), p. 78.

20. Ibid., p. 128.

21. Beaux, *Background with Figures*, p. 177.

22. Mathews, *Mary Cassatt: A Life*, pp. 34–36.

23. Emily Edson Briggs, in *Philadelphia Times*, 25 April 1881.

24. Hawthorne, entries dated 28 January and 6 February 1858, in his Pocket Diary; Thomas Woodson, ed., *The French and Italian Notebooks/Nathaniel Hawthorne* (Columbus: Ohio State University Press, 1980), pp. 580, 581.

25. Ibid., p. 78.

26. Nathaniel Hawthorne to William D. Ticknor, 14 April 1858; in Thomas Woodson, James A. Rubino, L. Neal Smith, and Norman Holmes Pearson, eds., *The Letters of Nathaniel Hawthorne, 1857–1864* (Columbus: Ohio State University Press, 1987), pp. 140–141.

27. Entry dated 17 October 1858, in Woodson, *French and Italian Notebooks*, p. 615.

28. Letter of John Rogers Jr., 14 December 1858, quoted in Charlotte Streifer Rubinstein, *American Women Sculptors* (Boston: G. K. Hall, 1990), p. 59. See also H. Wayne Craven, *Sculpture in America* (New York: Thomas Crowell, 1968); John L. Idol Jr. and Sterling Eisiminger, "Hawthorne Sits for a Bust," *Essex Institute Historical Collections* 114 (1987): 207–212.

29. Rogers quoted in Rubinstein, *American Women Sculptors*, p. 59.

30. Nathaniel Hawthorne to Louisa and Elizabeth Lander, Rome, 13 November 1858, in Woodson et al., *Letters*, pp. 158–159.

31. The experience with Lander was only one of many sexual conflicts that blasted the Hawthorne family that season. Literary scholar T. Walter Herbert analyzes a nexus "of sexual conflicts that drove Sophia toward hysterical rigidity and overwhelmed Nathaniel with confusion and self-disgust." In addition to the events surrounding Lander's disgrace, their daughter Una contracted Roman fever while out sketching in the evening, and the doctor attending her attempted to seduce Una's governess. Herbert suggests that Louisa Lander may have functioned as a role model for Una—making Lander's moral decline seem all the more threatening to the Hawthornes. Herbert, *Dearest Beloved: The Hawthornes and the Making of the Middle-Class Family* (Berkeley: University of California Press, 1993), especially Chapter 13, which includes a detailed account of the Lander-Hawthorne episode. Herbert also casts serious doubt on the veracity of the tale that some mysterious interloper changed (and ruined) Hawthorne's bust while Lander was in America; he suggests the story was an invention to mask the family's embarrassment at the sensuality of the portrait bust that Lander sculpted.

32. After her marriage, Sophia Peabody Hawthorne continued to produce art as an amateur. She created and copied art while in Rome, for example "delay[ing] at the Arch of Constantine to sketch a bas-relief of the moon rising over the Tiber." Sophia Peabody Hawthorne, *Notes in England and Italy* (New York: G. P. Putnam's Sons, 1875), p. 13.

33. Virginia Dare (b. 1587) was a historical figure, the first child born to English parents in the Americas; she disappeared along with all of the other white colonists on Roanoke Island. Lander bequeathed the statue to the state of North Carolina; it is now located in the Elizabethan Gardens on Roanoke Island.

34. James Jackson Jarves, *The Art Idea: Sculpture, Painting, and Architecture in America* (Boston: Houghton Mifflin, 1864), p. 269.

35. "The National Statue," *Virginia Dare* exhibition catalog (Boston: Studio Building, [1863]).

36. "A Salem Artiste in Rome," *Salem Register,* 1858; quoted in Rubinstein, *American Women Sculptors,* p. 62.

37. Swisshelm cited in George Langley Hall, *Vinnie Ream: The Story of the Girl Who Sculptured Lincoln* (New York: Rinehart and Winston, 1963), p. 45.

38. *Washington Evening Star,* 7 January 1871.

39. The full account of the unveiling of Ream's *Abraham Lincoln* was published in the *Washington Evening Star,* 26 January 1871.

40. On the late nineteenth century as a turning point in the history of sexuality in Euro-American cultures, see D'Emilio and Freedman, *Intimate Matters;* John C. Fout and Maura Shaw Tantillo, eds., *American Sexual Politics: Sex, Gender, and Race since the Civil War* (Chicago: University of Chicago Press, 1990); and Carolyn J. Dean, *Sexuality and Modern Western Culture* (New York: Twayne Publishers, 1996). Dean describes this process as the "unraveling" of "the Victorian construction of womanhood" (p. xviii). Also see Lawrence Birken, *Consuming Desire: Sexual Science and the Emergence of a Culture of Abundance, 1871–1914* (Ithaca: Cornell University Press, 1988); Michael Mason, *The Making of Victorian Sexuality* (Oxford: Oxford University Press, 1994); Jane Randall and Susan Mendus, eds., *Sexuality and Subordination: Interdisciplinary Studies of Gender in the Nineteenth Century* (New York: Routledge, 1989); Carol Smart, ed., *Regulating Womanhood: Historical Essays on Marriage, Motherhood, and Sexuality* (New York: Routledge, 1992); Jeffrey Weeks, *Sexuality* (London: Routledge, 1989).

41. Samuel Wetmore to Vinnie Ream, 27 February 1873; quoted in Richard Hoxie, *Vinnie Ream* (privately printed, 1908), p. 33.

42. Virginia L. Farragut to Vinnie Ream, 22 February 1873; quoted in ibid., p. 31.

43. Emily Edson Briggs, *Philadelphia Times,* 25 April 1881.

44. Emma Stebbins, leaflet, frame 958 of Scrapbook, Emma Stebbins Papers, Roll 2082, AAA. The verse Stebbins cited was John 5:2–4, "We can be sure that we love God's children when we love God and do what he has commanded. The love of God consists in this: that we keep his commandments—and his commandments are not burdensome. Everyone begotten of God conquers the world, and the power that has conquered the world is this faith of ours." Apparently, the specific images of God's commandments as allegories of health,

temperance, peace, and purity resulted from Stebbins's own imagination, not the verse.

45. Thomas Crawford to Louisa Crawford, 5 July 1854, Thomas Crawford Papers, Roll D181:783, AAA.

46. William Trost Richards to Anne Whitney, 15 February 1860, Anne Whitney Papers, WCA.

47. Caroline Healy Dall to Anne Whitney, 7 October 1861; AW to CHD, 15 October 1861. Anne Whitney Papers, WCA.

48. Beaux, *Background with Figures,* p. 163.

49. Mathews, *Mary Cassatt: A Life,* pp. 120, 124.

50. Prostitutes did comprise an important segment of the Victorian theater audience, though they were often confined to seats in the gallery. See Claudia D. Johnson, "That Guilty Third Tier: Prostitution in Nineteenth-Century American Theaters," in Daniel Walker Howe, ed., *Victorian America* (Philadelphia: University of Pennsylvania Press, 1976), pp. 111–120. However, especially after the Astor Place Riot in 1846, theater managers increasingly demanded decorum and passivity in their audiences as they attempted to attract a more gentrified clientele, including more women. See Lawrence Levine, *Highbrow/ Lowbrow: The Emergence of Cultural Hierarchy in America* (Cambridge, Mass.: Harvard University Press, 1988).

51. Robert L. Herbert, *Impressionism: Art, Leisure, and Parisian Society* (New Haven: Yale University Press, 1988), p. 99, and Chapter 4, "Theater, Opera, and Dance," passim.

52. Cassatt's biographer Mathews implies that Cassatt's sense of betrayal by the aloof, inconstant Degas had something to do with her abandonment of the theater subject; Mathews, *Mary Cassatt: A Life,* p. 149.

53. Griselda Pollock, *Mary Cassatt* (New York: Harper & Row, 1980), p. 10.

54. Ibid.

55. Lynda Nead, *The Female Nude: Art, Obscenity, and Sexuality* (London: Routledge, 1992), p. 46. Nead's Part One, "Theorizing the Female Nude," analyzes how the female nude came to represent the ultimate transformation of matter into art by the artist and thus the epitome among subjects of high art as well as a genre unto its own.

56. "History of the Pennsylvania Academy of the Fine Arts," PAFA Papers, Roll P50:511, AAA.

57. Eliza Haldeman to her father; quoted in Marcia Hyland Green, "Women Art Students in America" (Ph.D. diss., American University, 1990), p. 80.

58. Kirsten Swinth, "Painting Professionals: Women Artists and the Development of the Professional Ideal in American Art, 1870–1920" (Ph.D. diss., Yale University, 1995), p. 66. Swinth interprets the change as part of a more widespread campaign by students of both sexes to make the Pennsylvania Academy's curriculum more professionally oriented. In other art schools as well, "women helped establish professional standards as the norm," including both themselves and men within the professional ideal; women students "resisted reduction of their aims to their sex." Ibid., pp. 70, 68. The history of women's

participation in the restructuring of American art academies is an important and understudied topic. I am emphasizing something different, however: the extent to which women recognized and even exploited the limitations placed on their art studies and work *because* of their sex. Women's acceptance of, and even preference for, separate ladies' life classes marks a significant compromise between the ideology of professionalism and the ideology of gender, and points to their self-identification as women *and* artists even as they began to imagine a genderless professional ideal.

59. Susan Macdowell, Petition to Fairman Rogers, 2 November 1877, PAFA Papers, Reel 4337:381–382, AAA.

60. Beaux, *Background with Figures,* p. 87. Uncle Will relented only when Beaux's female schoolmate organized a class and arranged for the renowned William Sartain to come from New York fortnightly and offer criticism. Beaux's uncle did not approve of the even more famous Thomas Eakins, and thus prevented Beaux, his ward, from studying with Eakins; and he never allowed Beaux to study at the academy on a full-time basis. Beaux's study of china painting at the National Academy of Design, however, won his full acceptance. Tara Leigh Tappert, "Choices—The Life and Career of Cecilia Beaux: A Professional Biography" (Ph.D. diss., George Washington University, 1990), pp. 89–98.

61. Green, "Women Art Students," pp. 138, 81; National Academy of Design Papers, Minute Books, 8 November 1825 to 8 May 1893, Council Minutes dated 24 November 1873, roll 798, AAA, quoted in Green, "Women Art Students," p. 138.

62. H. Barbara Weinberg, "Class Struggles: American Women Artists in Paris, 1865–1900," in *Artistic Exchanges: Akten des XXVIII Internationalen Kongresses für Kunstgeschichte* (Berlin, 1992), p. 264. In 1877, women students at the Art Students' League protested the disparities between the men's and the women's life classes, but it is not known whether the complaint led to permission for nude men to model for the women's class. Green, "Women Art Students," pp. 171–175.

63. Nead, *The Female Nude,* p. 47.

64. In the European salon system, the typical instructor was laconic, detached, and frequently absent from the classroom, coming to give criticism about once per week. Some women preferred this approach. "It was all between the fascinating object and myself," Cecilia Beaux wrote of her experience as an art student in Paris. "Not even the Master would come between. He would say little." Beaux, *Background with Figures,* p. 124.

65. For a detailed analysis of *Roma* see Lisa B. Reitz, "The Political Voice of the Artist: Anne Whitney's *Roma* and *Harriet Martineau,*" *American Art* 8, no. 2 (Spring 1994): 44–65. Reitz argues that sources, including Hellenistic iconography, offered Whitney models and precedents for the naturalistic representation of Rome as an aged beggar woman.

66. For a theoretical approach to this topic, see April F. Masten, "Model into Artist: The Changing Face of Art Historical Biography," *Women's Studies* 21 (1992): 17–41. Even in the case of portraiture, the sitter was supposed to be incidental to

the creation of a great work of art. As one woman painter wrote, "the broad opportunity which portraiture offers lies in the fact that, when personality is lacking, treatment, on its own account, design, color, much that is independent of character, is ready and waiting to be used. Titian at his best, whether he merges himself—unconsciously, of course—in a fascinating personality, and cuts out . . . all else, as encumbrance, or finds his pleasure and satisfies his taste in sensuous, external qualities, is always Titian." Beaux, *Background with Figures*, p. 165.

67. William C. Brownell, "The Art Schools of Philadelphia," *Scribner's Monthly* 18, no. 5 (September 1879): 737–750. Susan Macdowell would later marry her life class instructor, Thomas Eakins. Alice Barber, later the wife of fellow student Charles Hallowell Stephens, was offered the post of teaching life drawing at the Pennsylvania Academy in 1899, but turned it down because of overwork and exhaustion; in 1902 she accepted the post of life-drawing instructor at the Philadelphia School of Design for Women, run by Emily Sartain. Charlotte Streifer Rubinstein, *American Women Artists* (Boston: G. K. Hall, 1982), p. 146.

68. R. S. to James L. Claghorn, 11 April 1882, quoted in "History of the Pennsylvania Academy of Fine Arts," Pennsylvania Academy of Fine Arts Papers, Reel P50, Frame 607, AAA.

69. Green, "Women Art Students," p. 93.

70. Louise Lippincott, "Thomas Eakins and the Academy," in *In This Academy: The Pennsylvania Academy of the Fine Arts* (Philadelphia: Pennsylvania Academy of the Fine Arts, 1976), p. 177; Green, "Women Art Students," pp. 96–100.

71. Thomas Eakins to Mr. E. Mitchell, 27 October 1888, Eakins to Horace Bradley, 10 February 1889, and Mrs. M. W. Tyndale, in "Secretary's Scrapbook," Art Students' League Papers, NY59–25:375–378, 435–436, 437–438, AAA; quoted in Green, "Women Art Students," pp. 178–180.

72. Lippincott, "Thomas Eakins and the Academy."

73. Nieriker, *Studying Art Abroad*, pp. 48–49. Also see William W. Stowe, *Going Abroad: European Travel in Nineteeth-Century American Culture* (Princeton, N.J.: Princeton University Press, 1994).

74. Weinberg, "Class Struggles," p. 265; Lida Rose McCabe, "Mme. Bouguereau, Pathfinder," in *New York Times Book Review and Magazine*, 19 February 1922, p. 16.

75. Weinberg, "Class Struggles," p. 266.

76. May Alcott to her family, October 1876; quoted in Caroline Ticknor, *May Alcott: A Memoir* (Boston: Little, Brown and Co., 1927), p. 140.

77. Anna Elizabeth Klumpke, *Memoirs of an Artist*, ed. Lilian Whiting (Boston: Wright & Potter Printing Co., 1940), p. 19.

78. Anna Lea Merritt, *Love Locked Out: The Memoirs of Anna Lea Merritt with a Checklist of Her Works*, ed. Galina Gorokhoff (Boston: Museum of Fine Arts, 1981), p. 132.

79. Mary Wheeler to Mary Noble, 27 July 1878; quoted in Williams, *Mary C. Wheeler*, p. 157.

80. Mary Wheeler to Mary Noble, 14 January 1879; quoted in ibid., p. 165.

81. On the gaze, see Laura Mulvey, *Visual and Other Pleasures* (London: Macmillan, 1989); Eunice Lipton, "Women, Pleasure, and Painting," *Genders* (Spring 1990): 69–86; Edward Snow, "Theorizing the Male Gaze: Some Problems," *Representations* 25 (Winter 1989): 30–41.

82. May Alcott to her family, October 1876, quoted in Ticknor, *May Alcott,* p. 141.

83. Beaux, *Background with Figures,* p. 146.

84. On Kinsella, see ibid., p. 178.

85. Alcott to family, early January 1877; quoted in Ticknor, *May Alcott,* p. 164.

86. D'Emilio and Freedman, *Intimate Matters,* pp. 104–106.

87. See Claudia Tate, *Domestic Allegories of Political Desire: The Black Heroine's Text at the Turn of the Century* (New York: Oxford University Press, 1992); Martha Hodes, "Wartime Dialogues on Illicit Sex: White Women and Black Men," in Catherine Clinton and Nina Silber, eds., *Divided Houses* (New York: Oxford University Press, 1992); and Hodes, "The Sexualization of Reconstruction Politics: White Women and Black Men in the South after the Civil War," in Fout and Tantillo, eds., *American Sexual Politics;* Bynum, *Unruly Women;* D'Emilio and Freedman, *Intimate Matters.*

88. Mary Livermore, *Our Famous Women* (Hartford, Conn.: A. D. Worthington, 1884), p. 677.

89. Mary Livermore, *Perry Magazine* 5–6 (February 1903): 241.

90. Anne Whitney to Adeline Manning, 31 May 1863, Anne Whitney Papers, WCA.

91. James Daffrone, "British Artists: Their Style and Character," *Art-Journal* 3 (1864): 172.

92. Quoted in Elizabeth Payne, "Anne Whitney," typescript, WCA, p. 528.

93. See George Frederickson, *The Black Image in the White Mind: The Debate on Afro-American Character and Destiny, 1817–1914* (Middletown, Conn.: Wesleyan University Press, 1972), especially Chapter 4, "Uncle Tom and the Anglo-Saxons: Romantic Racialism in the North," pp. 97–129.

94. "Octoroon" referred to a person who was one-eighth black in racial heritage, thus classified as black and kept in slavery. In American literature and art, the usual narrative of the "tragic octoroon" involves an octoroon woman who is promised freedom by her white father, but the father dies unexpectedly, leaving no will, and the octoroon is sold on the auction block. The racist implication of the story is that slavery was a much more tragic fate for a woman seven-eighths white than for a pure-blooded black woman.

95. Thomas Wentworth Higginson to Anne Whitney, 27 November 1864, Anne Whitney Papers, WCA.

96. Caroline Dall, *Boatswain's Whistle,* 18 November 1864; *New Path* review, undated; quoted in Payne, "Anne Whitney," p. 525.

97. Anne Whitney to Adeline Manning, 28 February 1866 and 6 March 1866, Anne Whitney Papers, WCA.

98. Quoted in Payne, "Anne Whitney," p. 568.

99. Anne Whitney to Adeline Manning, 2 May 1866, Anne Whitney Papers, WCA.

100. After the Civil War, the theme of slavery seems to have become more widely palatable to (Northern) American audiences. While portraits of free blacks were painted throughout the eighteenth and nineteenth centuries, it was not until the 1870s that artists began producing scenes of daily life among enslaved African Americans. A handful of artists "made use of unobtrusive abolitionist symbolism that could be fully understood only by the initiated, as in Eastman Johnson's *Negro Life at the South* of 1859 and Thomas Waterman Wood's *A Southern Cornfield, Nashville, Tennessee* of 1861. The fact that black life became a legitimate subject in painting did not mean that racism in art had been erased, however; black suffrage activist Ednah Dow Cheney, certainly one of the "initiated," complained in 1867 that Johnson painted a feudal, flattering view of "the beauty of the Patriarchal relation" in his images of blacks and slave life. Hugh Honour, *The Image of the Black in Western Art* (New York: Morrow, 1976), p. 20; Ednah Dow Cheney, "Jean François Millet: A Sketch," *The Radical: A Monthly Magazine, Devoted to Religion* 2 (1867): 671–672.

101. For a discussion of the incident and Lewis's legal defense, see Geoffrey Blodget, "John Mercer Langston and the Case of Edmonia Lewis, Oberlin, 1862," *Journal of Negro History* 53: 3 (July 1968): 202–213.

102. The figure might portray Lewis herself; Laura Curtis Bullard described Lewis's hair as "more of the Indian type, black, straight, and abundant," in *The Revolution*, 20 April 1871. For analysis of the supplicant slave image, see Jean Fagan Yellin, *Women and Sisters: The Antislavery Feminists in American Culture* (New Haven: Yale University Press, 1989).

4. Sculpting Butter

1. Some scholars have concluded that professional identity replaced gender identity among women artists. For example, Kirsten Swinth contends that women art students were able to use the malleable and ostensibly objective ideology of professionalism to gain substantial power in shaping art schools. She concludes that women artists pursued a more gender-neutral professional model than other women professionals (e.g., in medicine) did. Swinth, "'Thousands upon Thousands of Girl Art Students: Gender and the Professionalization of American Art Schools," paper presented at the annual meeting of the Organization of American Historians, Washington, D.C., 1 April 1995, pp. 1, 10. This view overlooks the extent to which women artists internalized or pragmatically accepted the strictures of gender ideology and attempted to integrate conventions of womanhood with professional requirements, for instance in the separate Ladies' Life Class. I find abundant evidence of a female professionalism among women artists even after they abandoned the model of domestic art.

2. Estelle Freedman, "Separatism as Strategy: Female Institution Building and American Feminism, 1870–1930," *Feminist Studies* 5, Fall 1979: 512–529. Lori D. Ginzberg, in *Women and the Work of Benevolence: Morality, Politics, and Class in the Nineteenth-Century United States* (New Haven: Yale University Press, 1990),

traces the ideological transformation of a "benevolent femininity" into an efficient, notably genderless, model of charity and relief work; Ginzberg interprets this transition as part of the formation of women's middle-class identity. While Ginzberg locates the shift in ideals from moral femininity to genderless efficiency beginning in the 1850s, other historians have found that the ideological conflation of femininity and morality bolstered women's participation in reform campaigns and associations, from temperance to antiprostitution to prison reform, into the early twentieth century. For example, see Anne Firor Scott, *Natural Allies: Women's Associations in American History* (Urbana: University of Illinois Press, 1991); Peggy Pascoe, *Relations of Rescue: The Search for Female Moral Authority in the American West, 1874–1939* (New York: Oxford University Press, 1990); and Estelle B. Freedman, *Maternal Justice: Miriam Van Waters and the Female Reform Tradition* (Chicago: University of Chicago Press, 1996). On the connections between postbellum women's clubs and feminism, see Karen J. Blair, *The Clubwoman as Feminist: True Womanhood Redefined, 1868–1914* (New York: Holmes and Meier, 1980); and Nancy F. Cott, *The Grounding of Modern Feminism* (New Haven: Yale University Press, 1987). Karen J. Blair studies women's art clubs (many of which offered art instruction) in "Women's Societies for the Visual Arts: The Struggle to Be Seen," Chapter 4 in *The Torchbearers: Women and Their Amateur Arts Associations in America, 1890–1930* (Bloomington: Indiana University Press, 1994).

3. Mariana Van Rensselaer was the art critic for *Century Magazine*. Hallowell to Bertha Palmer, quoted in Jeanne Madeline Weimann, *The Fair Women: The Story of the Woman's Building, World's Columbian Exposition, Chicago 1893* (Chicago: Academy Chicago, 1981), p. 280.

4. *Boston Herald*, 5 February 1888, quoted in Martha J. Hoppin, "Women Artists in Boston, 1870–1900: The Pupils of William Morris Hunt," *American Art Journal* 13 (Winter 1981): 33.

5. E. H. B., "Some Women Artists of Massachusetts," unidentified newspaper clipping, Richard Morris Hunt Archive, American Institute of Architects, Washington, D.C.; quoted in Hoppin, "Women Artists in Boston," p. 46.

6. Burton J. Bledstein links the "culture of professionalism" to middle-class status and control, the creation of formal discipline-specific societies, the trend toward specialization, and the requirement of specific credentials (which were increasingly tied to higher education). "Americans distinguished between female professional services and male," but Bledstein does not investigate the implications of that distinction. Bledstein, *The Culture of Professionalism: The Middle Class and the Development of Higher Education in America* (New York: W. W. Norton, 1976), p. 120. In *Modernism, Mass Culture, and Professionalism* (Cambridge, England: Cambridge University Press, 1993), Thomas Strychacz analyzes the way in which the discourse of professionalism worked dialectically with mass culture to shape modernist literature; this is a useful model for considering the case of visual artists, whose professionalization is rarely considered. Also see Samuel Haber, *The Quest for Authority and Honor in the American*

Professions, 1750–1900 (Chicago: University of Chicago Press, 1991). Many excellent studies have traced the history of women's professionalization in specific fields in the Progressive era, such as medicine, social work, and law. Several scholars have sought to identify more general patterns as well. Joyce Antler contends that women professionals in the Progressive era sought to redefine traditional gender roles in order to become more "human, rather than purely female, beings." Antler, *The Educated Woman and Professionalization: The Struggle for a New Feminine Identity, 1890–1920* (New York: Garland Publishers, 1987), p. 9. Penina Migdal Glazer and Miriam Slater examine case studies in college teaching, medicine, research science, and psychiatric social work to show that women's professionalization did not merely run parallel to men's but constituted markedly different narrative. Women developed various distinct strategies in order to overcome prejudices and obstacles, but they did not succeed in effecting structural changes. Glazer and Slater, *Unequal Colleagues: The Entrance of Women into the Professions, 1890–1940* (New Brunswick, N.J.: Rutgers University Press, 1987).

7. Historian Lisa Tickner has found that in Great Britain as well, "the woman artist was a popular character in New Woman fiction, where the heroine's 'happy ending' usually required the abandonment of her career for marriage and motherhood." Tickner, *The Spectacle of Women: Imagery of the Suffrage Campaign, 1907–1914* (Chicago: University of Chicago Press, 1988), p. 278.

8. Mary Hallock Foote to Helena de Kay Gilder, 4 April 1886, quoted in Lee Ann Johnson, *Mary Hallock Foote* (Boston: Twayne Publishers, 1980), p. 64.

9. Charlotte Perkins Gilman, *The Living of Charlotte Perkins Gilman* (New York: D. Appleton Century Co., 1935), p. 91. As a young woman, Charlotte Perkins Gilman earned money through commercial art, designing local advertisements and cards, painting, and teaching drawing. She exhibited with the Providence Art Club in 1883. See Denise D. Knight, ed., *The Diaries of Charlotte Perkins Gilman* (Charlottesville: University Press of Virginia, 1994); Mary Armfield Hill, ed., *Endure: The Diaries of Charles Walter Stetson* (Philadelphia: Temple University Press, 1985).

10. Kirsten Swinth writes, "Of the women in the sample from Clara Waters' 1904 biographical dictionary, slightly over half married. At least two-thirds of those who married did continue to paint, but the level and intensity of their work varied quite widely." Swinth, "Painting Professionals: Women Artists and the Development of a Professional Ideal in American Art, 1870–1920" (Ph.D. diss., Yale University, 1995), p. 196.

11. May Alcott Nieriker to Alcott family, April 1878; quoted in Caroline Ticknor, *May Alcott: A Memoir* (Boston: Little, Brown and Co., 1927), p. 267.

12. May Alcott Nieriker to Alcott family, post-April 1878; quoted in ibid., pp. 277–278.

13. May Alcott Nieriker to Alcotts, autumn 1878; quoted in ibid., p. 281.

14. Patricia Trenton, "Islands on the Land," in Trenton, ed., *Independent Spirits: Women Painters of the American West* (Berkeley: Autry Museum of Western Heri-

tage in association with University of California Press, 1995); "Partners in Illusion: William and Alberta McClosky," *American Art Review* 6, no. 5 (October–November 1994): 166, 176.

15. Nevertheless, the stress of revisiting a traditional role as domestic wife and mother may have affected Lilian's physical health. Swinth, "Painting Professionals," p. 195. Their daughter Nancy Hale wrote a memoir of her mother, *The Life in the Studio* (Boston: Little, Brown and Co., 1969). Also see Erica Eve Hirshler, "Lilian Westcott Hale (1880–1963): A Woman Painter of the Boston School" (Ph.D. diss., Boston University, 1992).

16. Susan Macdowell Eakins, diary, 16 February 1899, quoted in Kathleen A. Foster and Cheryl Leibold, eds., *Writing about Eakins: The Manuscripts in Charles Bregler's Thomas Eakins Collection* (Philadelphia: University of Pennsylvania Press, 1989), p. 265.

17. See "Chronology of the Life of Susan Macdowell Eakins," in Foster and Leibold, *Writing about Eakins*, pp. 309–311. The debate over whether Susan Macdowell Eakins "reli[n]quish[ed] her artistic career" dominates discussions of her life and art. Susan P. Casteras weighs in vehemently on the side that Susan "was not a martyr who sacrificed her art," contending "that she had the time and freedom to paint" facilitated by the presence of an Irish maid in the household until 1893, and that the Eakinses' relationship "was marked by peaceful co-existence as artists and as husband and wife." Susan P. Casteras and Seymour Aldeman, *Susan Macdowell Eakins* (Philadelphia: Pennsylvania Academy of the Fine Arts, 1973), p. 24.

18. The date of this painting remains in dispute. Feminist art historians Whitney Chadwick and Charlotte Streifer Rubinstein both date the painting to 1889. However, various Eakins exhibition catalogs identify it as a product of 1920, four years after Thomas's death. Cheryl Leibold cites an 1889 photograph, probably taken by Susan, of Thomas in a similar pose to the one in the painting; since both she and her husband often used photographs as references, perhaps Susan started the painting in 1889 but did not finish it until 1920. See Chadwick, *Women, Art, and Society* (London: Thames and Hudson, 1990), plate 115; Rubinstein, *American Women Artists*, figure 4-31; Foster and Leibold, *Writing about Eakins*, figure 46 (p. 301); Casteras and Aldeman, *Susan Macdowell Eakins;* and *Thomas Eakins, Susan Macdowell Eakins, Elizabeth Macdowell Kenton: An Exhibition of Paintings, Photographs, and Artifacts*, exhibition catalog (Roanoke, Va.: North Cross School, 1977).

19. By contrast, Thomas's paintings of Susan never cast her in the role of artist. *The Artist's Wife and His Setter Dog* (alternately titled *Lady with a Setter Dog*) depicts a melancholy, emaciated, leisured, passive, even neurasthenic woman—a figure consistent with his usual manner of depicting women. Her upturned palm rests in an awkward, submissive position on a book that she is not reading. Her costume (rather than ordinary dress) clearly marks her as a studio model; this is a painting, not a portrait, and Susan as model is interchangeable with other models. She looks out at the viewer, but her expression is pathetic and she in-

clines her head to the side, soliciting approval or comfort. At the same time, though, the painting makes an intriguing reference to Susan's portrait of her father in a similar pose, with a dog at his feet in the family parlor. John Wilmerding suggests that "By reiterating it, Eakins seems to suggest that, having taken a wife, he will adopt her art too." Wilmerding, *Thomas Eakins* (Washington, D.C.: Smithsonian Institution Press, 1993), p. 106. Whether homage to Susan's artistic skill or an example of artistic coverture, the painting constructs her art career as something past, irrelevant to her present. Susan has become someone else's subject instead of the painter of her own.

20. Swinth, "Painting Professionals," p. 197.

21. Eliza Haldeman to Mary Haldeman, 15 May 1867, Pennsylvania Academy of the Fine Arts; quoted in Nancy Mowll Mathews, *Mary Cassatt: A Life* (New York: Villard Books, 1994), p. 34.

22. Anna Elizabeth Klumpke, *Memoirs of an Artist,* ed. Lilian Whiting (Boston: Wright & Potter Printing Co., 1940), p. 52.

23. Enid Yandell, Jean Loughborough, and Laura Hayes, *Three Girls in a Flat* (Chicago: Knight, Leonard & Co., 1892).

24. Carroll Smith-Rosenberg cited the correspondence between Foote and Gilder in her article "The Female World of Love and Ritual: Relations between Women in Nineteenth-Century America," *Signs* 1, no. 1 (1975): 1–29. Givers of the "Presents to the Unknown" are listed in the Gilders' diary, 11 December 1875, Roll 285, Frame 526, AAA.

25. Article X, section 4 in *Constitution and By-Laws of the Boston Art Club* (Boston: Boston Art Club, 1883). Even when invited women (preferably members' "immediate family") finally gained their own "Ladies' Department" within the clubhouse around 1912, they had to use a separate entrance, and their admittance to any other club areas was strictly forbidden.

26. Rubinstein, *American Women Artists,* p. 141.

27. *Constitution of the Providence Art Club; Also a List of Officers and Members* (Providence: Rhode Island Printing Co., 1880). Of 171 total membership, there were 73 women members (43.6 percent). The involvement of an African American artist, Edward Bannister, in the formation of the Providence Art Club was also a singular departure from the way in which other contemporary art organizations defined the professional artist.

28. George Leland Miner, *Angell's Lane: The History of a Little Street in Providence* (Providence, R.I.: Akerman-Standard Press, 1948), p. 146.

29. Per the 1885 spring exhibition catalog, 27 percent of the works exhibited were by women, and 25 percent of exhibiting artists were women.

30. See Article X in the 1880 Providence Art Club Constitution.

31. *Providence Art Club Manual* (Providence: Providence Art Club, 1890), p. 6.

32. Ibid.

33. For example, the Society of Female Artists formed in 1856–1857 in London; its exhibitions often included work by both professionals and amateurs, and won criticism from art critics and feminists alike. Later Englishwomen's artist groups

included the Manchester Society of Women Painters (est. 1879) and the Glasgow Society of Lady Artists (f. 1882). Deborah Cherry, *Painting Women: Victorian Women Artists* (London: Routledge, 1993), pp. 67–71. France's ambitious Union des Femmes Peintres et Sculpteurs organized annual "Salons des femmes" (women's exhibitions) beginning in January 1882; it also held regular meetings and banquets, published a journal, founded a museum and an archive, nurtured its younger members, and campaigned for art reform. In the 1880s, the Union heatedly debated whether to establish a jury to select exhibitors. In the eyes of some members, a jury would violate the Union's basically nonhierarchical organization. Other members believed that only a juried show could assure the seriousness and high quality necessary to refute "women's art" as a term of derision. The same controversy—gender solidarity versus quality—faced organizations of American women artists. Tamar Garb, *Sisters of the Brush: Women's Artistic Culture in Late Nineteenth-Century Paris* (New Haven: Yale University Press, 1994), especially pp. 3–18; Julie Graham, "American Women Artists' Groups," *Woman's Art Journal* 1 (Spring–Summer 1980): 7–12.

34. "The Women's Art Association," *Philadelphia Evening Star*, 19 November 1866.
35. LAA general letter, 12 April 1882, and LAA publicity flyer to Senate and Assembly of the State of New York, n.d., LAA records, Reel 3592, Frames 92 and 109, AAA.
36. "Women's National Art Association," *Philadelphia Press*, 22 November 1866; "Women's National Art Association," *New York Times*, 12 November 1866, p. 4; Kathleen D. McCarthy, *Women's Culture: American Philanthropy and Art, 1830–1930* (Chicago: University of Chicago Press, 1991), p. 101.
37. *Ladies' Art Association Constitution and By-Laws* (New York: American Church Press Co., 1871). The rules of membership were probably amended sometime after 1877, per an LAA flyer stating that "Professional Artists, Amateurs, and others interested in Art Industry shall be eligible as members." Attendance at regular meetings was still limited to women members, however; and the designations of "active," "associate," "annual," "Council of Reference," and "honorary" members may have preserved the original intent of levels of membership. LAA Records, Reel 3592, Frame 96, AAA; List of Members, LAA Records, Reel 3592, Frames 97–99, AAA. Men served on an Advisory Committee since the LAA's inception, and later qualified as honorary and annual members as well.
38. "Announcement of Ladies' Art Association Exhibit at the Galleries of Messrs. Leavitt, February 24, 25, 26, 27, 28 [1877]," LAA Records, Reel 3592, Frame 108, AAA; Alice Donlevy, E. C. Field, and S. R. Hartley, "Facts Concerning the Ladies' Art Association; For the Promotion of the Interests of Women Artists," 15 April 1887, clipping in LAA Records, Reel 3592, Frame 88, AAA.
39. LAA Records, Reel 3592, Frames 88–89, AAA.
40. Masthead, *Ladies' Home Journal*, December 1886. The February 1887 issue also depicted a woman oil painting on the heading for "Brush Studies"; instructions on the technique were given in the article.

41. On the bifurcation of culture in the late ninteenth century, see Lawrence W. Levine, *Highbrow/Lowbrow: The Emergence of Cultural Hierarchy in America* (Cambridge, Mass.: Harvard University Press, 1988), especially pp. 146–158 on the development and influence of art museums and the sacralization of fine art. These were the very trends that the Arts and Crafts movement organized itself to counter. Also see Neil Harris, *The Artist in American Society* (New York: George Braziller, 1966), *Humbug: The Art of P. T. Barnum* (Chicago: University of Chicago Press, 1973), and *Cultural Excursions: Marketing Appetites and Cultural Tastes in Modern America* (Chicago: University of Chicago Press, 1990); and H. Wayne Morgan, *New Muses: Art in American Culture, 1865–1920* (Norman: University of Oklahoma Press, 1978). Kathleen D. McCarthy raises important questions about the relationship between women and the sacralization of culture. McCarthy, *Women's Culture.*

42. Among the paintings whose subjects could be easily deduced from their titles, there were 91 nature/flower subjects; 61 landscapes; 16 genre, interior, or urban subjects; 10 figure paintings or sketches; 10 animal subjects; 9 still lifes; and 6 portraits; 55 additional works were of unidentified subject. *First Annual Exhibition of the Lady Artists of San Francisco,* catalog, December 1885, California Historical Society, San Francisco. It is not evident whether the women artists of the SFAA or the association as a whole generated the idea to sponsor a segregated exhibit of the "lady artists." Some San Francisco newspapers accorded the exhibit front-page space (though reporters seemed more interested in the artists' gowns and "toilet" than in their work). See *Daily Alta,* 16 December 1885, *San Francisco Chronicle,* 20 December 1885, *San Francisco Examiner,* 16 December 1885, and "The Ladies' Art Exhibition," *Argonaut* 17 (19 December 1885), all cited in Susan Landauer, "Searching for Selfhood: Women Artists of Northern California," in Trenton, *Independent Spirits,* p. 11.

43. Other San Francisco art clubs were apparently less hospitable to women; an all-male monopoly at the Bohemian Club annual art exhibition was not broken until 1898, when Alice Chittenden and Maren Froelich's work was selected for exhibition. Raymond L. Wilson, "Introductory Essay," in *A Woman's Vision: California Painting into the Twentieth Century* (San Francisco: Maxwell Galleries, 1983), p. 7. Also see "Ladies Day at the Bohemian Club Winter Picture Show," *San Francisco Chronicle,* 14 October 1898, Alice Chittenden Papers, Roll 919, AAA.

44. Wilson, "Introductory Essay," p. 6.

45. Landauer, "Searching for Selfhood," p. 11. The Sketch Club changed its name in 1925 to the San Francisco Society of Women Artists.

46. Erika Doss, "'I *Must* Paint': Women Artists of the Rocky Mountain Region," in Trenton, *Independent Spirits,* p. 213.

47. ". . . We have drawn, daubed, and dabbled together, / For ten years of struggle and stress; / We have all hung together, if not on the line; / We have weathered the prate of the press; / We've known genius to burn with but little return / And our chefs d'ouvre [*sic*] to end in a mess. // We've been skied by the

hanging committees / Rejected by juries galore; / We have offered our wares to the charity fairs / Who have thanked us and asked us for more; / We have offered the same where the publishers came / And politely referred to the door . . ." Handwritten manuscript signed "Caroline A. Lord, Woman's Art Club of Cincinnati; December 13, 1902, on occasion of 10th anniversary of club," Box 1, Woman's Art Club Archives, Cincinnati Historical Society, Cincinnati, Ohio.

48. The Plastic Club, still located on 247 South Camac Street in Philadelphia, is the oldest American women's art club in continuous existence. Plastic Club papers, Reels 2536–2537, AAA; Helen Goodman, "The Plastic Club," *Arts Magazine* 59 (March 1985): 100–103.

49. Second Annual Report 1898, 1899, 1900, and Third Annual Report 1899, 1900, 1901, Plastic Club archives, quoted in Ann Barton Brown, *Alice Barber Stephens: A Pioneer Woman Illustrator* (Chadds Ford, Pa.: Brandywine River Museum, 1984), p. 25.

50. *The Pen and Brush: History, Constitution, By-Laws, Rules* [pamphlet] (n.d.), Roll NPBC1, Frames 2–4, AAA; Minnie S. Muchmore, "Original Meeting of the Pen and Brush," 1894, Roll NPBC1, Frames 385–393, AAA.

51. Over the past twenty years or so, the 1893 World's Columbian Exposition has become something of a cottage industry among historians of American culture. See David Burg, *Chicago's White City of 1893* (Lexington: University Press of Kentucky, 1976); Reid Badger, *The Great American Fair: the World's Columbian Exposition and American Culture* (Chicago: N. Hall, 1979); Robert Rydell, *All the World's a Fair: Visions of Empire at American International Expositions, 1876–1914* (Chicago: University of Chicago Press, 1984), which is also an excellent source on the Centennial Exhibition; Neil Harris, "All the World a Melting Pot? Japan at America's Fairs, 1876–1904" and "Great American Fairs and American Cities: The Role of Chicago's Columbian Exposition," in *Cultural Excursions: Marketing Appetites and Cultural Tastes in Modern America* (Chicago: University of Chicago Press, 1990); Carolyn Kinder Carr and George Burney, eds., *Revisiting the White City: American Art at the 1893 World's Fair* (Washington, D.C.: National Museum of American Art/National Portrait Gallery, 1993); Neil Harris, Wim de Wit, James Gilbert, and Robert W. Rydell, *Grand Illusions: Chicago's World's Fair of 1893* (Chicago: Chicago Historical Society, 1993); John E. Findling, *Chicago's Great World's Fairs* (Manchester, England: Manchester University Press, 1994); and Julie K. Brown, *Contesting Images: Photography and the World's Columbian Exposition* (Tucson: University of Arizona Press, 1994). Studies of the Women's Building in particular include Mary Frances Cordato, "Representing the Expansion of Woman's Sphere: Women's Work and Culture at the World's Fairs of 1876, 1893, and 1904" (Ph.D. diss., New York University, 1989); Frances K. Pohl, "Historical Reality or Utopian Ideal? The Woman's Building at the World's Columbian Expo, Chicago 1893," *International Journal of Women's Studies* 5, no. 4 (1982): 289–311; and Weimann, *The Fair Women*. The Centennial Exhibition has not inspired as much scholarly attention, but Rydell and Pohl each analyze the 1876 fair in their works, cited above.

52. *First Annual Report of the Women's Centennial Executive Committee* (Philadelphia: J. B. Lippincott & Co., 1874), p. 2; quoted in Judith Paine, "The Women's Pavilion of 1876," *Feminist Art Journal* 4, no. 4 (Winter 1975–1976): 11.

53. Contributing art schools included the Woman's Art School of Cooper Union, the Lowell School of Design at the Massachusetts Institute of Technology, the Pittsburgh School of Design, and the Cincinnati School of Design. McCarthy, *Women's Culture*, pp. 101–102, 109.

54. H. C., "The Great Exhibition: What Women Have Done for It," *New York Times*, 4 June 1876, p. 1.

55. Ibid.

56. "A Lady's Experience," *Philadelphia Press*, 11 May 1876.

57. *Centennial and Journal of the Exposition* (Philadelphia) 4, no. 4 (July 1876): 5. In the anecdote recounted in this issue, women cannot even be trusted to look at art and interpret it correctly. "Annie," a "girl of the period," misidentifies the statue to an "old gentleman" companion as depicting Christopher Columbus; "a modest-looking little lady" attempts to correct Annie's mistake but is silenced by the younger woman's brashness. Neither woman makes a very effective art critic—one cannot decipher what she sees and the other cannot convey her reading convincingly.

58. "The Great Exhibition: What Women Have Done for It," *New York Times*, 4 June 1876, p. 1.

59. Edward Strahan, *The Masterpieces of the Centennial International Exhibition*, vol. 1 (Philadelphia: Gebbie & Barrie, 1876), p. 55.

60. Philip Quilibet, "Art at the World's Fair," *Galaxy* 21 (February 1876): 272.

61. William J. Clark made clear that this should not be considered a lovely or tasteful example of sculpture: "This was not a beautiful work but it was a very original and very striking one . . . The effects of death are represented with such skill as to be absolutely repellent. Apart from all questions of taste, however, the striking qualities of the work are undeniable, and it could only have been produced by a sculptor of very genuine endowments." William J. Clark, Jr., *Great American Sculptures* (Philadelphia: Gebbie & Barrie, 1878), pp. 141–142. As a symbol of Africa, *Death of Cleopatra* was consistent with Lewis's oeuvre, dominated by Native American and African American themes as refracted through Euro-American culture (e.g., Longfellow's *Song of Hiawatha*) rather than Lewis's own experience. The other artwork by an African American at the Centennial Exhibition was Edward Bannister's *Under the Oaks*. Rydell, *All the World's a Fair*, p. 29.

62. Samuel J. Burr, *Memorial of the International Exhibition* (Hartford, Conn.: L. Stebbins, 1877), p. 591, quoted in Anne L. Macdonald, *Feminine Ingenuity: How Women Inventors Changed America* (New York: Ballantine Books, 1992), p. 92.

63. J. S. Ingram, *The Centennial Exposition, Described and Illustrated* (Philadelphia: Hubbard Brothers, 1876), p. 706.

64. Joan M. Jensen, "Butter-Making and Economic Development in Mid-Atlantic

America, 1750–1850," in *Promise to the Land: Essays on Rural Women* (Albuquerque: University of New Mexico Press, 1991), p. 185. Also see "Cloth, Butter, and Boarders: Women's Household Production for the Market," in Jensen, *Loosening the Bonds: Mid-Atlantic Farm Women, 1750–1850* (New Haven: Yale University Press, 1986).

65. Macdonald, *Feminine Ingenuity*, p. 91.

66. Burr, *Memorial*, p. 615; "The Woman's Pavilion," in "Centennial Notes 21," *Friends' Intelligencer*, 21 October 1876, p. 557; James D. McCabe, *Illustrated History of the Centennial Exhibition* (Philadelphia: National Publishing Co., 1876), p. 219; Macdonald, *Feminine Ingenuity*, pp. 90, 92; Dale P. Kirkman, "Caroline Shawk Brooks: Sculptress in Butter," *Phillips County Historical Quarterly*, March 1967: 9. This was a common trope in describing women artists; Brooks's representation as a "native Western genius" connects her to other nineteenth-century women artists, including Ohio painter Lilly Martin Spencer and Wisconsin sculptor Vinnie Ream Hoxie.

67. *Biographical and Historical Memoirs of Eastern Arkansas* (Chicago: Goodspeed Publishing Co., 1890), p. 753.

68. *Iolanthe* continues to be ridiculed by art critics and historians as the epitome of women's art gone awry. This attitude often overlooks the fact that similar pieces, unassociated with women artists, appeared at other world's fairs—for example, the Stollwerck Company's statue of Germany for the 1893 Columbian Exposition was made out of chocolate. If *Iolanthe* is indeed "bad art," it is neither the medium nor the sex of its artist that makes it so.

69. Cordato, "Representing the Expansion of Woman's Sphere," p. 232.

70. Quoted in Weimann, *The Fair Women*, p. 279.

71. Quoted in ibid.

72. "Mrs. Potter Palmer's Brilliant Address," in Benjamin C. Truman, ed., *History of the World's Fair* (Philadelphia: Mammoth Publishing Co., 1893), p. 177.

73. Katherine M. Cohen, "Life of Artists," in Mary Kavanaugh Oldham Eagle, ed., *The Congress of Women, Held in the Woman's Building* (Chicago: W. B. Conkey Co., 1894), pp. 428–431. This volume contains the full text of 190 speeches given at the Woman's Building at the Columbian Exposition. Mary E. Cherry Norris (whose profession was "Shakespearean studies and vocal culture") also strove for a gender-neutral definition of the artist: "that man or that woman who looks upon talent as God-given, and who therefore strives to advance art regardless of self." Mary E. Cherry Norris, "An Appeal of Art to Lovers of Art," in ibid., p. 674.

74. Alice Barber Stephens, "The Art of Illustrating," *Woman's Progress* 2, no. 2 (November 1893): 53.

75. Anne Whitney to Adeline Manning, 17–18 March 1866, Anne Whitney Papers, WCA.

76. C. Emily Frost to Mrs. [Amey Dorrance] Starkweather, 9 April 1892, in Letters to Bertha Honore Palmer / Board of Lady Managers, box 2, folder 3, Columbian Exposition collection, Chicago Historical Society.

77. Mary Crease Sears corroborated to Mrs. Starkweather, 13 April 1892, in ibid.

78. Board of Lady Managers papers, Chicago Historical Society; quoted in Weimann, *The Fair Women*, p. 269. Western women followed this directive, largely limiting their contributions to collections of Western plants and minerals, though Vinnie Ream offered *America* and *Miriam*, along with *The West*, "as an Arkansas exhibit." Eagle, *The Congress of Women*, p. 603.

79. On the racist imperialist ideology inherent in the fair, see Robert W. Rydell, "The Chicago World's Columbian Exposition of 1893: 'And Was Jerusalem Builded Here?'" Chapter 2 in *All the World's a Fair*. For an analysis of the fair's gendered subtext, see Gail Bederman, *Manliness and Civilization: A Cultural History of Gender and Race in the United States, 1880–1917* (Chicago: University of Chicago Press, 1995), pp. 31–41.

80. Truman, *History of the World's Fair*, p. 189.

81. Bederman, *Manliness and Civilization*, p. 38.

82. Feminists had often expressed the same logic, for example, agitating against tight lacing by comparing it to the "obviously" barbaric practice of foot binding in China.

83. Candace Wheeler, "A Dream City," *Harper's Magazine*, May 1893, p. 838; quoted in John Hutton, "Picking Fruit: Mary Cassatt's *Modern Woman* and the Woman's Building of 1893," *Feminist Studies* 20, no. 2 (Summer 1994): 318–348. Curtis M. Hinsley, "The World as Marketplace: Commodification of the Exotic at the World's Columbian Exposition, Chicago, 1893," in Ivan Karp and Steven D. Levine, eds., *Exhibiting Cultures: The Poetics and Politics of Museum Display* (Washington, D.C.: Smithsonian Institution Press, 1990), pp. 344–365.

84. Quoted in Weimann, *The Fair Women*, p. 281.

85. Ibid., pp. 165–166.

86. Quoted in Hutton, "Picking Fruit," p. 329.

87. As John Hutton noted, "Each critic found in the mural whatever he or she detested. Nevertheless, they help to delineate Cassatt's transgressions—the ways in which her work broke through the boundaries of accepted imagery for women in the latter nineteenth century." Ibid., p. 319.

88. Quoted in ibid., p. 334.

89. My concept of a "white gaze" corresponds to the "male gaze" theorized by various scholars of cinema, art history, and cultural studies, beginning with Laura Mulvey, "Visual Pleasure and Narrative Cinema," *Screen* 16, no. 3 (Autumn 1975): 6–18.

90. It is interesting, though, that a Jewish woman, Katherine Cohen, became part of the establishment, and apparently highlighted rather than hid her Jewishness. Cohen, who had spoken at the Woman's Building at the World's Columbian Exposition on the life of artists, exhibited sculpture on Jewish themes at the Plastic Club in Philadelphia in the period 1899–1900.

91. Sandra D'Emilio and Sharyn Udall have found that during the revival of Spanish and Native American crafts in the early twentieth-century West, Latinas actively produced and marketed fiber arts and pottery, but "rarer were Hispanic

women's efforts in painting, or in making *santos,* the carved and painted reli-
gious images highly sought by collectors. Although many *santeras* (women
who carve and paint) and other Hispanic women painters have emerged since
1945, they were rare before this time." D'Emilio and Udall, "Inner Voices, Out-
ward Forms: Women Painters in New Mexico," in Trenton, *Independent Spirits,*
p. 160.

92. Patricia Trenton has researched another early twentieth-century African
American woman artist from California: Lula Josephine Adams (d. 1952), a
"genteel" painter of flowers and domestic objects who "work[ed] in obscurity"
and about whom little is known. The *Negro Year Book* first listed Adams as "a
promising artist" in 1918. See Trenton, "Islands on the Land," in *Independent
Spirits,* pp. 64, 66, p. 279n72.

93. Susette LaFlesche Tibbles's biographer imagined her drawing in secret while at-
tending the mission school at the Omaha Reservation—a pastime that eventu-
ally earned her teacher's praise because of the skill of the drawings, all Indian
subjects. Dorothy Clark Wilson, *Bright Eyes: The Story of Susette La Flesche, an
Omaha Indian* (New York: McGraw-Hill Book Co., 1974), pp. 106–107.
"LaFlesche Tibbles, Susette," in Gretchen M. Bataille, ed., *Native Amerian
Women: A Biographical Dictionary* (New York: Garland Publishing, 1993),
pp. 150–152, makes no mention of Tibbles's painting, emphasizing instead her
writing and speaking on behalf of Indian reform. In her biography of Susette
LaFlesche Tibbles, Dorothy Clarke Wilson finds Tibbles's art career incidental to
her life and reform work. Wilson, *Bright Eyes,* especially pp. 106–108 and 362–
363. Ann Diffendal, "The LaFlesche Sisters: Susette, Rosalie, Marguerite, Lucy,
Susan," in *Perspectives: Women in Nebraska History,* June 1984. Susette LaFlesche
Tibbles's papers are included among the LaFlesche family papers, Nebraska
State Historical Society, Lincoln.

94. On Native American education see David Wallace Adams, *Education for Extinc-
tion: American Indians and the Boarding School Experience, 1875–1928* (Lawrence:
University Press of Kansas, 1995); Donal F. Lindsey, *Indians at Hampton Institute,
1877–1923* (Urbana: University of Illinois Press, 1995); K. Tsianina Lomawaima,
They Called It Prairie Light: The Story of Chilocco Indian School (Lincoln: University
of Nebraska Press, 1994); Michael C. Coleman, *American Indian Children at
School, 1850–1930* (Jackson: University Press of Mississippi, 1993). Hampton, for
instance, instituted instruction in pottery, basketmaking, and woodcarving in
1883; lacemaking was taught in conjunction with sewing.

95. Angel DeCora, "An Autobiography," *The Red Man* 3 (March 1911): 279–285.
For biographical information on DeCora, see Sarah McAnulty, "Angel DeCora:
American Indian Artist and Educator," *Nebraska History* 57 (1976): 143–199.

96. Narcissa Chisholm Owen, *Memoirs* (1907; reprint, Siloam Springs, Ark.: Siloam
Springs Museum, 1980), pp. 94–95. On Owen, also see Joni L. Kinsey, "Culti-
vating the Grasslands: Women Painters in the Great Plains," in Trenton, *Inde-
pendent Spirits,* p. 265.

97. There were Woman's Buildings at the 1895 Atlanta Cotton States and Interna-

tional Exposition, the 1901 Pan-American Exposition, the 1904 Louisiana Purchase Exposition, and the 1907 Jamestown Tercentennial of Norfolk, Virginia; but none approached the grand vision of the Woman's Building at the Columbian Exposition. In 1898 Omaha, the women's board of the Trans-Mississippi and International Exposition decided to construct a Boys and Girls Building in lieu of a Woman's Building; the few women's exhibits were scattered throughout the fairgrounds. Subsequent contributions to fairs tended to grow smaller and focus on commemorations or hospitality. Later women's boards narrowed their efforts—for example, on a mere monument in the California Building at the Panama Pacific International Exposition in 1915 and a women's display in the Hall of Social Sciences at the Century of Progress exhibition in 1933. Weimann, *The Fair Women*, pp. 587–588.

98. *A Woman's Vision*, pp. 7–8.

99. Blair, "The Torchbearers," pp. 78–81. Major art museums and art schools in New York, Washington, Philadelphia, and Chicago supplied most of the AFA's leadership. Women artists were a minority on the board of directors, but women edited the AFA's two journals: Florence Levy edited the *Annual* and Leila Mechlin edited the *Magazine of Art*. Nina de Angeli Walls, "'The Trained Artistic Brain': Women Professionals in the Design Arts, 1880–1930," paper presented at the annual meeting of the Organization of American Historians, 1 April 1995, p. 12. See AFA Papers, Smithsonian Institution.

5. Portrait of the Artist as a New Woman

1. Theresa Bernstein Meyerowitz, *The Journal* (New York: Cornwall Books, 1991), p. 42. Bernstein was active in various women's art clubs; she was a charter member of the New York Society for Women Artists. Patricia M. Burnham, "Theresa Bernstein," *Woman's Art Journal* 9 (Fall 1988–Winter 1989): 24.

2. Lisa Tickner, "Men's Work? Masculinity and Modernism," in Norman Bryson, Michael Ann Holly, and Keith Moxey, eds., *Visual Culture: Images and Interpretation* (Hanover, N.H.: University Press of New England, 1994), pp. 47–48.

3. Nancy Cott, *The Grounding of Modern Feminism* (New Haven: Yale University Press, 1987), p. 7.

4. Ellen Wiley Todd, *The New Woman Revised: Painting and Gender Politics on Fourteenth Street* (Berkeley: University of California Press, 1993). June Sochen, *The New Woman: Feminism in Greenwich Village, 1910–1920* (New York: Quadrangle Books, 1972) pioneered the historical analysis of the New Woman as a social type connected to individual women's avowal of feminism and progressive ideologies. More recently, Martha Banta catalogued the extraordinary malleability of the New Woman image in *Imaging American Women: Idea and Ideals in Cultural History* (New York: Columbia University Press, 1987). Patricia Marks, *Bicycles, Bangs, and Bloomers: The New Woman in the Popular Press* (Lexington: University Press of Kentucky, 1990) draws its conclusions from a close analysis of four periodicals, two American (*Life* and *Chic*) and two British (*Punch* and the London

Truth); Marks neglects to consider the roles of any women artists in creating images of the New Woman.

5. Tara Leigh Tappert and Ellen Wiley Todd are the only scholars to have explicitly identified the real life of an American woman artist (Cecilia Beaux and Margaret Foster Richardson, respectively) with the New Woman ideal. Tappert, "Choices—The Life and Career of Cecilia Beaux: A Professional Biography" (Ph.D. diss., George Washington University, 1990), especially pp. 420, 444. The connection between women artists and the New Woman was more apparent to contemporaries. In an article entitled the "Twelve Greatest Women," *The New York Times*, for example, noted Beaux's devotion "to the ideals of the new womanhood"; 25 June 1922, section 7, p. xx. For a contemporary narrative description of the Gibson girl, see Caroline Ticknor, "The Steel-Engraving Lady and the Gibson Girl," *Atlantic Monthly*, July 1901, pp. 105–108.

6. On the immigrant, working-class "New Woman," see Elizabeth Ewen, "City Lights: Immigrant Women and the Rise of Movies," in Elizabeth Ewen and Stuart Ewen, *Channels of Desire: Mass Images and the Shaping of American Consciousness* (Minneapolis: University of Minnesota Press, 1992). The July 1923 issue of the *Messenger* magazine dedicated itself to the "New Negro Woman"; cited in Ernest Allen Jr., "The New Negro: Explorations in Identity and Social Consciousness, 1910–1922," in Adele Heller and Lois Rudnick, eds., *1915: The Cultural Moment* (New Brunswick, N.J.: Rutgers University Press, 1991), pp. 48–68.

7. Editors, "No Sex in Art," *Woman's Journal*, 28 March 1896; Lida Rose McCabe, "Some Painters Who Happen to Be Women," *Art World* 3 (March 1918): 488–493. Other influential women art critics who advocated the genderless ideal included Giles Edgarton (Mary Fanton Roberts), who wrote for the *Craftsman*, and Mariana G. van Rensselaer, art critic for *Century Magazine*.

8. Frank Weitenkampf, "Our Women in Art," *The New York Independent* (1892), quoted in Julie Graham, "American Women Artists' Groups," *Women's Art Journal* 1 (Spring–Summer 1980): 8.

9. Tara Leigh Tappert, Beaux's biographer, finds that Beaux's art teachers "convinced her that she was more talented than many of the women with whom she studied, favorably describing her talents and work in masculine terminology." Tappert, "Choices—The Life and Career of Cecilia Beaux," pp. 7, 238, citing Leila Mechlin, "The Art of Cecilia Beaux," *International Studio*, July 1910: iii.

10. Vinnie Ream Hoxie, "The Field of Sculpture for Women," an address before the International Council of Women, Toronto, 30 June 1909, quoted in Charlotte Streifer Rubinstein, *American Women Sculptors* (Boston: G. K. Hall, 1990), pp. 74–75.

11. Cecilia Beaux, address given at Barnard College, 1915, Cecilia Beaux Papers, AAA; also see Cecilia Beaux, "Why Does the Girl Art Student Fail?" *Harper's Bazaar*, May 1913, p. 249.

12. Anna Lea Merritt, "A Letter to Artists: Especially Women Artists," *Lippincott's Monthly Magazine* 65, no. 387 (March 1900): 463–469.

13. Ibid.

14. Anna Lea Merritt, "Art as a Profession for Women," speech to the Women's Art Congress and the Cambridge Discussion Society, 1900, cited in Chester Austin, "The Art of Anna Lea Merritt," *Windsor Magazine* 38, no. 227 (November 1913): 618.

15. Margaret Lesley Bush-Brown, "The Relations of Women to the Artistic Professions" (1901 lecture, handwritten manuscript), Box 5, Bush-Brown Family Papers, Sophia Smith Collection, Smith College, Northampton, Massachusetts (hereafter cited as Sophia Smith Collection).

16. Margaret Lesley Bush-Brown, "Short Account of the Professional Life of Margaret Lesley Bush-Brown, Written by Herself in 1914," Biographical Material, Box 5, Bush-Brown Family Papers, Sophia Smith Collection. The autobiography was apparently written for a *Washington Times* sketch that appeared on 7 June 1914.

17. "A Little Journey to the Home of Alice Barber Stephens," *Southern Woman's Magazine* (n.d.), p. 9. Alice Barber Stephens Papers, Reel 4152, Frame 353, AAA.

18. Bush-Brown, "The Relations of Women to the Artistic Professions," Sophia Smith Collection.

19. Bush-Brown, "Short Account of the Professional Life of Margaret Lesley Bush-Brown," Sophia Smith Collection.

20. Bush-Brown, "The Relations of Women to the Artistic Professions," Sophia Smith Collection.

21. Bush-Brown, "Short Account of the Professional Life of Margaret Lesley Bush-Brown," Sophia Smith Collection.

22. 1894 Diary, Box 5, Bush-Brown Family Papers, Sophia Smith Collection.

23. Bush-Brown, "Short Account of the Professional Life of Margaret Lesley Bush-Brown," Sophia Smith Collection.

24. Bush-Brown, "The Relations of Women to the Artistic Professions," Sophia Smith Collection. June Sochen describes contemporary Greenwich Village feminists as advocates of expanding women's roles beyond the traditional in order "to include many roles traditionally reserved to men. This did not mean the abandonment of women's maternal and domestic roles; rather, women with ability and interest would be allowed to pursue goals beyond the home." Sochen, *The New Woman,* p. 6.

25. For example, the *Providence Journal* favorably assessed the work of Jane Nye Hammond in 1900, but added, "It is seldom that the art of the sculptor is chosen as a profession by a woman. It is perhaps the most difficult of the arts and least likely, one would suppose, to attract a delicate woman, but when her choice does lead her in this direction it presupposes a degree of talent which is likely to make its possessor heard sooner or later." *Providence Journal,* 9 December 1900, p. 18. This comment simultaneously praises Hammond as an exceptional individual and casts doubt on whether other "delicate" women could do similarly well.

26. Jessie Hamilton to Agnes Hamilton, 29 November 1907, Hamilton Family Pa-

pers, Roll 9, Folder 200, Schlesinger Library, Radcliffe Institute for Advanced
Study, Cambridge, Massachusetts (hereafter Hamilton Family Papers).

27. Ellen Wiley Todd, in *The New Woman Revised*, pp. 15–16, describes the painting
eloquently: "*A Motion Picture*, Margaret Foster Richardson's unprecedented self-
portrait, captures the sense of unfettered possibility inscribed in the new
woman by her most optimistic and progressive advocates . . . It is as if Richard-
son has provided a visual image for Charlotte Perkins Gilman's description of a
feminist—a woman freed from the trappings of Victorian femininity and the
ideology of women's sphere."

28. These early catalogs also implicitly established a multicultural history of
women artists; exhibition announcements in 1899 featured a medieval woman
artist and a Japanese woman artist in a kimono (for an exhibition of "Japanese
kakemonos," thirty-eight paintings from the fifteenth to the nineteenth centu-
ries, of which only one was identified as the work of a "lady"). See Plastic Club
Papers, Reel 2536, Frames 236 and 253, AAA.

29. See the covers for the Plastic Club's Exhibition of Applied Art (9–28 December
1901), Reel 2536, Frame 331, AAA; the 1902 Spring Exhibition Catalog, 1909
Annual Color Exhibition, 1909 Annual Exhibition of Illustration, 1910 Annual
Exhibition of Color Work, and 1911 Annual Exhibition of Illustration, Reel
2536, Frames 386, 467, 490, 507, AAA; and the 1912–15 Color Exhibitions,
1913–14 Exhibitions of Illustration, and 1916 Exhibition of the Work of
Women Sculptors, Plastic Club Papers, Reel 2536, AAA.

30. Bailey Van Hook analyzes the many meanings and manifestations of idealized
female figures in American art in this period; see Van Hook, *Angels of Art:
Women and Art in American Society, 1876–1914* (University Park: Pennsylvania
State University Press, 1996).

31. Susan Landauer, "Searching for Selfhood: Women Artists of Northern Califor-
nia," in Patricia Trenton, ed., *Independent Spirits: Women Painters of the American
West, 1890–1945* (Berkeley: University of California Press, 1995), p. 19.
Landauer describes California painters Evelyn Almond Withrow, E. Charlton
Fortune, Mary DeNeale Morgan, and others enjoying unmarried, bohemian,
New Woman lifestyles.

32. Henri Murger popularized the term in his novel, *Scènes de la vie de bohème*
(1845), first translated into English in 1887 as *The Bohemians of the Latin Quarter*.
Albert Parry traces "the widespread social phenomenon" of bohemianism to its
creation by early nineteenth-century French romantics; bohemian communi-
ties throughout Europe and the United States developed from the original Pari-
sian model. Bohemianism in the United States may be traced to Edgar Allan
Poe, Ada Clare, Walt Whitman, and Pfaff's saloon in early nineteenth-century
New York City. Parry, *Garrets and Pretenders: A History of Bohemianism in America*
(New York: Covici Friede Publishers, 1933). The most incisive study of bohe-
mianism in Paris is Jerrold E. Seigel, *Bohemian Paris: Culture, Politics, and the
Boundaries of Bourgeois Life, 1830–1930* (New York: Viking, 1986). Bohemianism
played a vital role in the professionalization and creative development of male

artists in the United States; see, for example, Keith L. Bryant, *William Merritt Chase: A Genteel Bohemian* (Columbus: University of Missouri Press, 1994). The most widely studied bohemian community in the United States in this period is Greenwich Village, New York City; others include Taos, New Mexico (including the salon of Mabel Dodge Luhan), San Francisco (home of the all-male Bohemian Club), Chicago, Boston, and Philadelphia. Other American cities, from Cincinnati to San Antonio to Richmond to Buffalo, published literary magazines titled *Bohemian* (or some variation thereof). Parry, *Garrets and Pretenders,* p. 97.

33. Norah Hamilton to Jessie Hamilton, 4 April 1893, Hamilton Family Papers M24, Folder 697, Reel 32.

34. Michael Wilson argues that women are essential to bohemianism, by acting out "conventional, highly sexualized" roles that preserve gender hierarchy, but individual women never qualify as bohemians. Wilson, "'Sans les femmes, qu'est-ce qui nous resterait': Gender and Transgression in Bohemian Montmartre," in Julia Epstein and Kristina Straub, eds., *Body Guards: The Cultural Practice of Gender Ambiguity* (New York: Routledge, 1991), pp. 195–222. Wilson documents and incisively analyzes the way in which bohemian men's discourse excluded the woman artist from their ranks. However, he does not evaluate whether Montmartre women regarded themselves as bohemian, regardless of this discourse. His approach thus risks reifying masculine discourse as normative discourse when the actual practice and dynamics of bohemian identity were more complex.

35. Parry comments that "American girls wanted to be Trilbies without undressing; they wanted to be Bohemians and yet remain virgins." Parry, *Garrets and Pretenders,* pp. 105–106. *Harper's Monthly* published *Trilby* in serial form from January to August 1894. See L. Edward Purcell, "Trilby and Trilby-Mania: The Beginning of the Bestseller System," *Journal of Popular Culture* 11 (Summer 1977): 62–76.

36. Anna Alice Chapin, *Greenwich Village* (New York: Dodd, Mead, & Co., 1925), p. 277. For romanticized descriptions of several women's studios see the *Providence Journal,* 9 December 1900, p. 18.

37. Emilie Ruck de Schell, "Is Feminine Bohemianism a Failure?" *The Arena* 20, no. 104 (July 1898): 68–75. At the same time, de Schell recognized the benefits of bohemianism for cautious women, who would become better wives and wiser mothers as a result of their worldly experience.

38. Marietta Minnegerode Andrews, *Memoirs of a Poor Relation: Being the Story of a Post-War Southern Girl and Her Battle with Destiny* (New York: E. P. Dutton, 1927), pp. 403–404.

39. Plastic Club Papers, Roll 2536, Frame 892, AAA.

40. "'Rabbit' Gambols at Plastic Club's Frolic," unidentified clipping, 1912, in Scrapbook, Plastic Club Papers, Roll 2537, Frame 199, AAA.

41. "Plastic Club Gives Alice in Wonderland," clipping, *North American,* 19 January 1907, scrapbook, Plastic Club Papers, Roll 2537, Frame 139, AAA.

42. 1903–1910 Scrapbook, Plastic Club Papers, Roll 2537, Frame 162, AAA.

43. Recent studies of British women artists have also challenged a static model of public versus private spheres and asserted that women were indeed users of public spaces. See Deborah Cherry, *Painting Women: Victorian Women Artists* (London: Routledge, 1993); and Lynne Walker, "Vistas of Pleasure: Women Consumers of Urban Space in the West End of London, 1850–1900," in Clarissa Campbell Orr, ed., *Women in the Victorian Art World* (Manchester, England: Manchester University Press, 1995), pp. 70–85.

44. Rebecca Zurier and Robert W. Snyder, "Picturing the City," in Rebecca Zurier, Robert W. Snyder, and Virginia M. Mecklenburg, eds., *Metropolitan Lives: The Ashcan Artists and Their New York* (Washington, D.C.: National Museum of American Art with W. W. Norton & Co., 1995), pp. 188–189. Griselda Pollock has analyzed the impressionist painters' Paris in much the same terms; Pollock, "Modernity and the Spaces of Femininity," *Vision and Difference: Femininity, Feminism, and the Histories of Art* (London: Routledge, 1988).

45. The group that came to be known as The Eight (Arthur B. Davies, William Glackens, Robert Henri, Ernest Lawson, George Luks, Maurice Prendergast, Everett Shinn, John Sloan) held their landmark exhibition on 3 February 1908 at Macbeth Galleries in New York. Five were staunch realists with a keen interest in depicting everyday scenes of urban life. For studies of the Ashcan school, see Bernard B. Perlman, *The Immortal Eight: American Painting from Eakins to the Armory Show, 1870–1913* (Westport, Conn.: North Light Publishers, 1979) and Elizabeth Milroy, *Painters of a New Century: The Eight and American Art* (Milwaukee, Wisc.: Milwaukee Art Museum, 1991).

46. See Charlotte Streifer Rubinstein, "Women of the Ash Can School," in *American Women Artists* (Boston: G. K. Hall, 1982), pp. 165–172. The Ashcan men had a propensity for marrying women artists. Emma Bellows, Edith Glackens, and Linda Henri gave up painting when they wed, but Florence Scovel Shinn, May Wilson Preston, and Marjorie Organ Henri did not. Among the other Ashcan women, Bessie Marsh and Amy Londoner had studied with Robert Henri. Marsh and Londoner, together with Cornelia Barns, Abastenia St. Leger Eberle, Theresa Bernstein, and Elizabeth Sparkhawk-Jones, "contributed street images to an exhibition that attracted some press attention in 1906, but little is known of their work after that time." Robert W. Snyder and Rebecca Zurier, "Picturing the City," in *Metropolitan Lives*, p. 218, n.59.

47. Meyerowitz, *The Journal*, p. 40.

48. Barns and Winter were members of the Socialist party. Barns went on to illustrate *The Woman Voter* and *The Suffragist*, among other periodicals, and became art editor for *Birth Control Review* in 1921. Winter worked for more mainstream magazines, such as *Century* and *Scribner's*, and also earned money painting the portraits of the elite. Little is known about Grieg. See Margaret C. Jones, *Heretics and Hellraisers: Women Contributors to the Masses, 1911–1917* (Austin: University of Texas Press, 1993); Rebecca Zurier, *Art for the Masses: A Radical Magazine and Its Graphics, 1911–1917* (Philadelphia: Temple University Press, 1988).

49. Rubinstein, *American Women Sculptors*, pp. 217–220; "Woman's Exhibit at Macbeth's," *Arts and Decoration*, November 1915: 62. See Leslie Katz, *The Sculpture of Ethel Myers* (New York: Robert Schoelkopf Gallery, 1963).

50. Helen Goodman, "Women Illustrators of the Golden Age of American Illustration," *Woman's Art Journal* 8, no. 1 (Spring–Summer 1987): 14. A related revival in etching first swelled in the 1880s, then lay dormant until the 1910s to peak in the 1920s and 1930s. On the cultural anxieties surrounding the growth of illustration in the print revolution, see Neil Harris, "Pictorial Perils: The Rise of American Illustration," *Cultural Excursions: Marketing Appetites and Cultural Tastes in Modern America* (Chicago: University of Chicago Press, 1990), pp. 337–348. In addition to the factors Harris describes, the subtle connection between pictorialism and femininity and the attendant sense of both of these as consumables also contributed to anxiety over commercial images. On the distinctions between fine and commercial art, see Michelle Bogart, *Artists, Advertising, and the Borders of Art* (Chicago: University of Chicago Press, 1996). Bogart identifies the perceived feminization of illustration as one of the central problems for illustrators seeking higher professional status. The founding of schools of illustration in the 1890s and professional societies like the Society of Illustrators helped to reformulate illustration "as a male and professional endeavor" by the turn of the century. Ibid., pp. 30–33.

51. On the first generation of historians of women, see Nancy Cott, ed., *A Woman Making History: Mary Ritter Beard through Her Letters* (New Haven: Yale University Press, 1991).

52. Emily Maria Scott, "Women as Oil Painters," in *What Women Can Earn* (New York: The Tribune Association, 1898), p. 220.

53. Lilian Westcott to her mother, Harriet Westcott, n.d. [ca. 1897–1898], Box 51c, Folder 1388, Hale Papers, Sophia Smith Collection; quoted in Erica Eve Hirschler, "Lilian Westcott Hale: A Woman Painter of the Boston School" (Ph.D. diss., Boston University, 1992), pp. 39–40.

54. Alice Kellogg (Tyler) to Mabel Kellogg, 21 November 1888, Alice Kellogg Tyler papers, Roll 4183, Frame 14, AAA.

55. Hull House in Chicago provided the classic case study for the conversion of female networks of friendship into avenues for women's explicitly political involvement. Historians of women regard the settlement house as the archetypal crucible in which women's general social reformist activities were gradually and inexorably politicized as settlement workers found themselves pitted against political machines and the graft system in their efforts to improve the living conditions of the urban poor. Kathryn Kish Sklar, "Hull House in the 1890s: A Community of Women Reformers," *Signs* 10 (Summer 1985): 657–677.

56. The rich body of scholarship on American women and reform overwhelmingly identifies the Progressive era as the historical moment in which women's reform activities took on a self-consciously public and political tenor. This sea change is evident not only in the birth of the settlement movement, but also in

strategic shifts within women's rights, labor, temperance, antiprostitution, and other reform movements. See Karen Blair, *The Clubwoman as Feminist: True Womanhood Redefined, 1868–1914* (New York: Holmes and Meier Publishers, 1980); Ruth Bordin, *Women and Temperance: The Quest for Power and Liberty, 1873–1900* (Philadelphia: Temple University Press, 1981); Nancy Cott, *The Grounding of Modern Feminism* (New Haven: Yale University Press, 1987); Peggy Pascoe, *Relations of Rescue: The Search for Female Moral Authority in the American West, 1874–1939* (New York: Oxford University Press, 1990); Ruth Rosen, *The Lost Sisterhood: Prostitution in America, 1900–1918* (Baltimore: Johns Hopkins University Press, 1982).

57. Both Sarah Whitman and Alice Kellogg cited *Robert Elsmere* in their correspondence. Sarah Wyman Whitman, *Letters of Sarah Wyman Whitman* (Cambridge, Mass.: Riverside Press, 1907), p. 32; Alice Kellogg Tyler papers, AAA. Besides energetically working for Nationalism (a movement inspired by Edward Bellamy), Anne Whitney and Adeline Manning supported schools for freedmen and for the blind.

58. Barbara Sicherman, *Alice Hamilton: A Life in Letters* (Cambridge, Mass.: Harvard University Press, 1984), p. 12. Sicherman compares Norah Hamilton's style and subject matter to reform-minded contemporary German artist Käthe Kollwitz. Hamilton illustrated *Exploring the Dangerous Trades* (Boston: Little, Brown, 1943), the autobiography of her sister, Alice, another active reformer who helped create the field of industrial medicine.

59. Ellen Gates Starr to her cousin Mary Allen, 15 September 1889, Starr Papers, Box 1, Folder 3, Sophia Smith Collection; cited in Mary Ann Stankiewicz, "Art at Hull House, 1889–1901: Jane Addams and Ellen Gates Starr," *Woman's Art Journal,* Spring–Summer 1989: 35. Jane Addams, "The Art-Work Done by Hull-House, Chicago," *Forum,* July 1895: 614–617.

60. See Ruth Crocker, *Social Work and Social Order: The Settlement Movement in Two Industrial Cities* (Urbana: University of Illinois Press, 1992); Ralph Luker, *The Social Gospel in Black and White: American Racial Reform, 1885–1912* (Chapel Hill: University of North Carolina Press, 1991).

61. Stankiewicz, "Art at Hull House," p. 37.

62. Eileen Boris, *Art and Labor: Ruskin, Morris, and the Craftsman Ideal in America* (Philadelphia: Temple University Press, 1986), pp. 32–33, 100. Robert Judson Clark, ed., *The Arts and Crafts Movement in America, 1876–1916* (Princeton, N.J.: Princeton University Pres, 1972), provides an excellent overview of the movement. For more detailed studies of Arts and Crafts communities on the West and East coasts, see Kenneth R. Trapp, ed., *The Arts and Crafts Movement in California: Living the Good Life* (Oakland, Calif.: Oakland Museum; New York: Abbeville Press, 1993); and Cory L. Ludwig, *The Arts and Crafts Movement in New York State, 1890s–1920s* (Hamilton, N.Y.: Gallery Association of New York State, 1983).

63. On the roles of amateur women artists in such clubs, see Karen Blair, *The Torchbearers: Women and Their Amateur Arts Associations in America, 1890–1930* (Bloomington: Indiana University Press, 1994); Kathleen D. McCarthy,

Women's Culture: American Philanthropy and Art, 1830–1930 (Chicago: University of Chicago Press, 1991); Mary R. Spain, *The Society of Arts and Crafts, 1897–1924* (Boston: Society of Arts and Crafts, 1924); Papers of the Society of Arts and Crafts, AAA. Mary Ware Dennett wrote various articles expounding her philosophy of art, including "Aesthetics and Ethics," *Handicraft* 1 (May 1902): 29–47; and "The Arts and Crafts: An Outlook," *Handicraft* 2 (April 1903): 3–27.

64. Calista Halsey, "Wood-Carving for Women," *Art Amateur* 6 (June 1897): 17; Candace Wheeler, *The Development of Embroidery in America* (New York: Harper, 1921), pp. 107–121, quoted in Boris, *Art and Labor*, pp. 100–101.

65. As historian Eileen Boris notes, "Even within a single craft, gender often determined the division of labor, so that women designed but men hammered metal; men shaped but women decorated pottery." The same division of art along sexual lines occurred within the Arts and Crafts movement in England. Boris, *Art and Labor*, p. 99.

66. Suzanne Ormond and Mary E. Irvine, *Louisiana's Art Nouveau: The Crafts of the Newcomb Style* (Gretna, La.: Pelican Publishing Co., 1976), p. 80.

67. Leslie H. Fishel, Jr., "Fannie Barrier Williams," *Notable American Women* (Cambridge, Mass.: Harvard University Press, 1971). Elisabeth Lasch-Quinn analyzes the African American settlement experience in *Black Neighbors: Race and the Limits of Reform in the American Settlement House Movement, 1890–1945* (Chapel Hill: University of North Carolina Press, 1993). The role of art in the African American club movement has not yet been fully explored. Anne Firor Scott describes local black women's clubs as "interested in self-education and particularly in art and music," in Scott, *Natural Allies: Women's Associations in American History* (Urbana: University of Illinois Press, 1991), p. 127. Dorothy Salem notes that the National Association of Colored Women established a department of organizational work in art by 1904. Salem, *To Better Our World: Black Women in Organized Reform, 1890–1920* (Brooklyn, N.Y.: Carlson Publishers, 1990), p. 37. But a separate article by Scott does not describe art as a typical part of African American women's association work. Scott, "Most Invisible of All: Black Women's Voluntary Associations," *Journal of Southern History* 56, no. 1 (February 1990): 3–22. Neither these scholars nor historian Paula Giddings indicates any resonance of the Arts and Crafts movement in the African American community; in African American settlements like Atlanta's Neighborhood Union, "the arts . . . comprised industrial work in dressmaking, embroidery, millinery, cooking, and nursing." Salem, *To Better Our World*, p. 99; Elizabeth Lindsay Davis, *Lifting as They Climb* (Washington, D.C.: National Association of Colored Women, 1933); Paula Giddings, *When and Where I Enter: The Impact of Black Women on Race and Sex in America* (New York: Morrow, 1984).

68. Narcissa Chisholm Owen, *Memoirs* (1907; reprinted Siloam Springs, Ark.: Siloam Springs Museum, 1980); see Chapter 4 for a more detailed discussion of Owen. For a more mainstream contemporary view, see Constance Goddard Du Bois, "The Indian Woman as a Craftsman," *Craftsman* 6 (July 1904): 391–393.

69. Abastenia St. Leger Eberle to R. G. McIntyre, n.d., Macbeth Gallery records,

AAA; also see R. G. McIntyre, "The Broad Vision of Abastenia Eberle," *Arts and Decoration,* August 1913: 334–337.

70. Eberle quoted in McIntyre, "Broad Vision," p. 336. Eberle's profession as an artist sometimes overrode the sensitivities of an ideal settlement worker. A poor Italian woman collecting coal refused to accept Eberle's offer of a dollar to model in her studio. But Eberle used her anyway, modeling her from memory to produce her sculpture *Old Woman Picking Up Coal.* Louise Noun, "Introduction," *Abastenia St. Leger Eberle* (Des Moines, Iowa: Des Moines Art Center, 1980), p. 5.

71. Eberle quoted in Christina Merriman, "New Bottles for New Wine: The Work of Abastenia St. Leger Eberle," *Survey,* 3 May 1913: 196. Merriman may have been a pseudonym for Eberle's sister, Louise, a journalist who also wrote for *Outlook* and *Scribner's.*

72. Meyerowitz, *The Journal,* p. 45.

73. The Ashcan women artists in particular were noted as suffragists; Rubinstein, *American Women Artists,* p. 165. But it is problematic (to say the least) to equate suffrage with feminism. The social and political conservatism (even antifeminism) of American women artists has been the subject of passionate debate among scholars; see Kathleen Pyne, *Art and the Higher Life: Painting and Evolutionary Thought in Late Nineteenth-Century America* (Austin: University of Texas Press, 1996); Bernice Kramer Leader, "Antifeminism in the Paintings of the Boston School," *Arts* 56, no. 5 (January 1982): 112–119; Bailey Van Hook, *Angels of Art: Women and Art in American Society, 1876–1914* (University Park: Pennsylvania State University Press, 1996).

74. Alice Sheppard elaborates on these connections in her article "The Relation of Suffrage Art to Culture," in Ronald Dotterer and Susan Bowers, eds., *Politics, Gender, and the Arts* (Selinsgrove, Pa.: Susquehanna University Press, 1992), pp. 32–51. On visual culture and women artists in the British suffrage movement, see Lisa Tickner, *The Spectacle of Women: Imagery of the Suffrage Campaign, 1907–1914* (Chicago: University of Chicago Press, 1988). Tickner writes, "Suffragists were interested in the woman artist because she was a type of the skilled and independent woman, with attributes of autonomy, creativity, and professional competence, which were still unconventional by contemporary criteria. But she was also of interest because the question of women's *cultural* creativity was constantly raised by their opponents as a reason for denying them the vote . . . There were several ways of dealing with this. One was to borrow the high-flown rhetoric of masculine genius, and use it to hail the corresponding identities of the avant-garde artist and the modern suffragette . . . Another was to play down art altogether, or at least, men's practice of it as the guarantee of their social and sexual pre-eminence." Ibid., p. 14.

75. Ruth St. Denis, for example, performed a National Women's Suffrage Association benefit. Suzanne Shelton, *Ruth St. Denis: A Biography of the Divine Dancer* (Austin: University of Texas Press, 1981), p. 122. Another modern dancer, Joan Sawyer, went on a suffrage tour of the United States via automobile and in

Boston held a much-publicized Suffrage Dance Festival, with proceeds to bene-fit the movement, in March 1915. Albert Auster has studied in detail how "ac-tresses both wittingly and unwittingly used the stage and the celebrity that some of them derived from it to raise women's consciousness in the struggle for women's rights and women's emancipation in the period from 1890 to 1920." Auster, *Actresses and Suffragists: Women in the American Theater, 1890–1920* (New York: Praeger, 1984), p. 6. On the divide between politics and culture see "Politics and Culture in Women's History: A Symposium," *Feminist Studies* 6 (Spring 1980): 26–64.

76. Sara Hunter Graham describes various processes at work in this "suffrage re-naissance," including the development of the "society plan" to attract elite women to the movement, the creation of a suffrage tradition including the writing of women's political history, and the invention of Susan B. Anthony as the first of many "suffrage saints." Graham, *Woman Suffrage and the New Democ-racy* (New Haven: Yale University Press, 1996). Margaret Finnegan considers visual elements from advertisements to National American Woman Suffrage Association merchandise in *Selling Suffrage: Consumer Culture and Votes for Women* (New York: Columbia University Press, 1999).

77. Charlotte Streifer Rubinstein writes that Johnson, "who believed in the occult, claimed that while she was in Italy having the bust put into marble, it shat-tered and then regrouped itself. On another occasion she woke from a dream and saw a message on the wall telling her to complete it at once." Rubinstein, *American Women Sculptors,* pp. 137–138.

78. Johnson made this sentiment explicit elsewhere, declaring that the coarse marble symbolized the unfinished nature of the women's movement. The Na-tional Woman's Party presented this sculpture to the nation in a gala ceremony on 15 February 1921. Congress accepted it with the greatest reluctance, how-ever, and quickly removed it to the basement of the Capitol.

79. Rubinstein, *American Women Sculptors,* pp. 130–133; Susan Porter Green, *Helen Farnsworth Mears* (Oshkosh, Wisc.: Paine Art Center and Arboretum, and Cas-tle-Pierce Press, 1972).

80. 11 May 1899, 1897–1900 Diary, Box 4A, Blanche Ames Ames papers, Sophia Smith Collection.

81. James J. Kennealy, *Blanche Ames and Woman Suffrage,* pamphlet (Borderland State Park, Mass.: Friends of Borderland, 1992), pp. 26–27. Also see the exhibi-tion catalog *Blanche Ames, Artist and Activist (1878–1969),* Brockton Art Museum/ Fuller Memorial, Mass., 27 February to 9 May 1982.

82. [Lou Rogers], "Lightning Speed through Life," *Nation* 124 (13 April 1927): 396; "Lou Rogers—Cartoonist," *Woman's Journal* 44 (2 August 1913): 243.

83. *Suffragist* 6 (2 March 1918): 6.

84. Marietta Minnegerode Andrews, *Memoirs of a Poor Relation: Being the Story of a Post-War Southern Girl and Her Battle with Destiny* (New York: E. P. Dutton, 1927), p. 195.

85. Noun, *Abastenia St. Leger Eberle,* p. 11.

86. *Good Housekeeping*, August 1911; *Harper's Weekly*, 20 May 1911, p. 8; *New York Times*, 6 May 1911, p. 5. New York suffragists had adopted the parade strategy in 1910, two years after British suffragettes invented it; other cities, including Boston and Philadelphia, followed suit.

87. *New York Herald*, 13 October 1915.

88. Anita Pollitzer to Georgia O'Keeffe, October 1915, in Clive Giboire, ed., *Lovingly, Georgia: The Complete Correspondence of Georgia O'Keeffe and Anita Pollitzer* (New York: Simon and Schuster / Touchstone, 1990), p. 62. Pollitzer was a very active suffragist, from distributing "suffrage literature and lemonade" to inspire "private conversions" in Charleston, South Carolina, to the public speaking and organizational work that eventually overtook her art; she succeeded Alice Paul as the legislative secretary of the National Woman's Party. Pollitzer to O'Keeffe, September 1915, in ibid., p. 20.

89. Clippings in "Woman Suffrage Campaign: Cartoons and Clippings, 1913–1915," scrapbook collected by Oakes Ames and Blanche Ames Ames, Woman's Rights Collection (M-133), Schlesinger Library, Radcliffe Institute for Advanced Study, Cambridge, Massachusetts.

90. See Ames scrapbook, Schlesinger Library. Shelley Armitage's biography of O'Neill, *Kewpies and Beyond: The World of Rose O'Neill* (Jackson: University Press of Mississippi, 1994), does not compare O'Neill to contemporary women artists and pays scant attention to O'Neill as a feminist, but reports that "a strident interview for the *New York Post* in 1914 indicates her strong feelings about a woman's right to her body, the necessity of woman's influence in social, political, and aesthetic spheres, and the meaning of careers for women." Ibid., p. 47. Also see Miriam Formanek-Brunell, ed., *The Story of Rose O'Neill: An Autobiography* (Columbus: University of Missouri Press, 1997).

91. Zenobia Ness and Louise Orwig, *Iowa Artists of the First Hundred Years* (Des Moines, Iowa: Wallace-Homestead, 1939); "Artists for Suffrage," *Woman Voter* 6, no. 10 (October 1915), p. 10; Alice Sheppard, *Cartooning for Suffrage* (Albuquerque: University of New Mexico Press, 1994), p. 107.

92. "Artists for Suffrage," p. 10; "Woman Suffrage Exhibition at Macbeth's," *Arts and Decoration*, November 1915: 37.

93. Judith N. Kerr, "Meta Vaux Warrick Fuller," in Darlene Clark Hine, ed., *Black Women in America: An Historical Encyclopedia* (Brooklyn, N.Y.: Carlson Publishing, 1993), p. 472.

94. Cassatt quoted in Dorothy and Carol J. Schneider, *American Women in the Progressive Era, 1900–1920: Change, Challenge, and the Struggle for Women's Rights* (New York: Doubleday, 1993), pp. 169, 177; Frances Weitzenhoffer, *The Havemeyers: Impressionism Comes to America* (New York: Harry N. Abrams, 1986), p. 220n.

95. Meyerowitz, *The Journal*, p. 45.

96. Historically, cartooning had been a male province within art: "The role of a political cartoonist was judged masculine because it wielded power and served as a privileged vantage point from which to expose and ridicule social structures

and political leaders . . . The cartoon form was created and consolidated around male sensibilities; it affirmed feminine glamour and denigrated independent women." Sheppard, *Cartooning for Suffrage*, pp. 25, 29. Sheppard identifies the major suffrage artists as Nina Evans Allender, Blanche Ames Ames, Cornelia Barns, Edwina Dumm, Rose O'Neill, Fredrikke Schjöth Palmer, May Wilson Preston, Ida Sedgwick Proper, Lou Rogers, Mary Ellen Sigsbee, and Alice Beach Winter. In addition to these, Marjorie Organ cartooned for the *New York Journal* both before and after her marriage to Ashcan painter Robert Henri. All of these women were "white, Protestant, and middle-class in values"; only Palmer was foreign-born. Ibid., pp. 96, 104. Sheppard argues further that the New Woman functioned as an important professional model for these women cartoonists.

97. Judith Schwarz, *Radical Feminists of Heterodoxy: Greenwich Village, 1912–1940*, rev. ed. (Norwich, Vt.: New Victoria Publishers, 1986).

98. Lucy Stone and Henry Blackwell founded the *Woman's Journal* in 1870; *Suffragist*, founded in 1913, became the National Woman's Party newspaper and changed its name to *Equal Rights* in 1923.

99. "The Suffragist Arousing Her Sisters," *Woman Voter* 2, no. 8 (September 1911): 25; "Art and Woman's Freedom," *Suffragist* 8 (1920): 62.

100. Jean Fagan Yellin traces the iconographic history of the liberating goddess and supplicant slave dyad in *Women and Sisters: The Antislavery Feminists in American Culture* (New Haven: Yale University Press, 1989), pp. 3–26.

101. Nell Brinkley, "The Three Graces," International News Service, 1916, Sophia Smith Collection.

102. Rodney Thomson, "Militants," *Life*, 27 March 1913.

103. Lou Rogers, "She Will Spike War's Gun," *Judge*, 14 September 1912, Periodicals Division, Library of Congress.

104. Nina E. Allender, "Supporting the President," *Suffragist*, 3 August 1918.

105. Jessie Banks, "Woman's Place Is in the Home," *Woman Voter*, October 1915, Periodicals Division, Library of Congress.

106. See the suffrage cartoons reproduced in Sheppard, *Cartooning for Suffrage*, pp. 188–193, for examples of these themes.

107. Nina Allender, "A Modern Eliza," *Suffragist*, 4 May 1918.

108. On antisuffragism more generally see Jane Jerome Camhi, *Women against Women: American Anti-Suffragism, 1880–1920* (Brooklyn, N.Y.: Carlson Publishers, 1994); Thomas J. Jablonsky, *The Home, Heaven, and Mother Party: Female Anti-Suffragists in the United States, 1868–1920* (Brooklyn, N.Y.: Carlson Publishers, 1994); Manuela Thurner, "'Better Citizens without the Ballot': American Anti-Suffrage Women and Their Rationale during the Progressive Era," in Marjorie Spruill Wheeler, ed., *One Woman, One Vote* (Troutdale, Ore.: NewSage Press, 1995).

109. *Art and Progress* 6, no. 1 (November 1914).

110. In 1910, a reporter asked Beaux whether she was a suffragist. Beaux laughed; when pressed, she declared, "No, I am not, most emphatically." "Is a woman's

place in the home?" the interviewer then coached. "Miss Beaux smiled. Then, more seriously, [said], 'Yes, I am a very firm believer in all that kind of thing.'" See "Cecilia Beaux, Artist, Her Home, Work, and Ideals," *Boston Sunday Herald,* 23 September 1910, p. 7 (magazine section).

111. Ibid. As late as 1911, John Wilkie's courtship of Beaux "seems to have frightened her." Tappert, "Choices—The Life and Career of Cecilia Beaux," p. 409.

112. The Association's tenth annual exhibition (1899) featured the work of Beaux, Rosa Bonheur, and Mary Cassatt, the most distinguished women artists of the day, and marked these women's continued involvement and support of the club. Beaux served on the club's juries and also helped to fund the construction of their headquarters. Tappert, "Choices—The Life and Career of Cecilia Beaux," p. 418; Graham, *Woman Suffrage,* p. 10.

113. According to Tappert, "Well over half of all the portraits in Beaux's oeuvre—both commissioned and non-commissioned—are paintings of women," and "Most of the professional women whose portraits Beaux painted were educators, nurses and reformers who had never married." She contends that "Beaux identified with their choice of a career instead of marriage and supported their sense of mission regarding their work." Tappert, "Choices—The Life and Career of Cecilia Beaux," pp. 325, 345.

114. Gertrude Boyle, "Art and Woman's Freedom," *Suffragist* 8 (1920): 62.

6. Making the Modern Woman Artist

1. Julie Graham, "American Women Artists' Groups, 1867–1930," *Woman's Art Journal* 1, no. 1 (Spring–Summer 1980): 8.

2. Many social and cultural historians have pointed to the decade of the 1920s as a decade of intense change in American life. Stanley Coben, for example, describes the decade as a profound cultural and intellectual revolt against Victorian traditions and values. Stanley Coben, *Rebellion against Victorianism: The Impetus for Cultural Change in 1920s America* (New York: Oxford University Press, 1991).

3. Lisa Tickner, "Men's Work? Masculinity and Modernism," in Norman Bryson, Michael Ann Holly, and Keith Moxey, eds., *Visual Culture: Images and Interpretation* (Hanover, N.H.: University Press of New England, 1994), p. 48. Deborah Cherry and Griselda Pollock also argue that the insistent masculinity of the modernist canon effectively excluded women from the avant-garde. Cherry, *Painting Women: Victorian Women Artists* (London: Routledge, 1993), pp. 73–77; Griselda Pollock, *Vision and Difference: Femininity, Feminism, and the Histories of Art* (London: Routledge, 1988). This is consistent with Nancy Cott's findings regarding women's professional work in medicine and academia: "Perhaps it was where women had gained the *most* headway and made the most substantial numerical impact that professional backlash against feminization was most visible." Nancy Cott, *The Grounding of Modern Feminism* (New Haven: Yale University Press, 1987), p. 223.

4. Edward Simmons, "The Fine Arts Related to the People," *International Studio* 63 (November 1917): ix–xiii. Also see Simmons's autobiography, *From Seven to Seventy: Memoirs of a Painter and Yankee* (New York: Harper and Brothers, 1922), especially p. 227 regarding women patrons.

5. John Higham, "The Reorientation of American Culture in the 1890s," in John Weiss, ed., *The Origins of Modern Consciousness* (Detroit: Wayne State University Press, 1965) and Gail Bederman, *Manliness and Civilization: A Cultural History of Gender and Race in the United States, 1880–1917* (Chicago: University of Chicago Press, 1995) offer particularly insightful analyses of gender at the turn of the twentieth century.

6. "Modernism" is a complex, contested, even enigmatic term. Heated debate, rather than consensus, marks efforts to define modernism and its history. As Bridget Elliott and Jo-Ann Wallace explain, "There is no innate or unproblematic modernism whose history can simply be uncovered." Elliott and Wallace, *Women Artists and Writers: Modernist (Im)positionings* (London: Routledge, 1994), p. 2. Different scholars use "modernism" alternately to denote an aesthetic, a sensibility, a philosophy, a time period, an ideology, or an epistomology. Mid- and even early nineteeth-century art may qualify as "modernist" in its sympathies and intent. Bryan Jay Wolf, for example, examined "the peculiar modernity of American Romantic painting: its sense of loss and dispossession, its conservative fear of the artist's visionary powers, and its recurrent self-consciousness and self-referentiality." Wolf, *Romantic Re-Vision: Culture and Consciousness in Nineteenth-Century American Painting and Literature* (Chicago: University of Chicago Press, 1982), p. xiv.

7. Arthur Dove to Alfred Stieglitz, 19 October 1914, cited in Ann Lee Morgan, ed., *Dear Stieglitz, Dear Dove* (Newark: University of Delaware Press, 1988), p. 41.

8. By the 1920s, the culture of modernism had become the dominant culture of twentieth-century America. Daniel Joseph Singal, *Modernist Culture in America* (Belmont, Calif.: Wadsworth Publishing Co., 1991), p. 2.

9. Quoted in Warren I. Susman, *Culture as History: The Transformation of American Society in the Twentieth Century* (New York: Pantheon Books, 1984), p. 105.

10. Singal, *Modernist Culture,* p. 8.

11. Almira B. Fenno-Gendrot, *Artists I Have Known* (Boston: Warren Press, 1923), p. 43.

12. When Gertrude Stein then prompted Beaux to express her impressions of the picture, Beaux described it as "a sort of translation of an idea." Stein replied, "This is realism, a still life group." Tara Leigh Tappert, "Choices—The Life and Career of Cecilia Beaux: A Professional Biography" (Ph.D. diss., George Washington University, 1990), p. 441.

13. Beaux lecture, 30 April 1907, in Cecilia Beaux Papers, AAA.

14. Ilene Susan Fort, "The Adventuresome, the Eccentrics, and the Dreamers: Women Modernists of Southern California," in Patricia Trenton, ed., *Independent Spirits: Women Painters of the American West, 1890–1945* (Berkeley: Autry Mu-

seum of Western Heritage in association with University of California Press, 1995), p. 75. Another recent study that considers women central to modernism is Anne Middleton Wagner, *Three Artists (Three Women): Modernism and the Art of Hesse, Krasner, and O'Keeffe* (Berkeley: University of California Press, 1996).

15. Meyer Schapiro, *Modern Art: Nineteenth and Twentieth Centuries, Selected Papers* (New York: George Braziller, 1982), pp. 135, 139. Milton W. Brown succinctly summarizes the organization of the Armory show and its impact on American art in "The Armory Show and Its Aftermath," in Adele Heller and Lois Rudnick eds., *1915, The Cultural Moment: The New Politics, the New Woman, the New Psychology, the New Art, and the New Theatre in America* (New Brunswick, N.J.: Rutgers University Press, 1991), pp. 164–184.

16. Milton Brown lists all the exhibitors in *The Story of the Armory Show,* 2nd ed. (New York: Abbeville Press, 1988); unfortunately, he could trace the whereabouts of only a small fraction—16 of the 105 named and cataloged artworks by women (or 15 percent of the works by women, making up 1.5 percent of the works in the Armory show). It is difficult to calculate a percentage for women's participation in the exhibit because although the exhibition catalog listed 1,100 works, it was incomplete. Walter Pach estimates that some 1,600 objects actually were on display. Considering the catalog alone, women (American and European) contributed 105 works out of 1,100, or 9.5 percent of the works shown. The Armory show also marked an important moment in the history of women's art patronage. In his narrative of the exhibition's history, organizer Walt Kuhn singled out Gertrude Vanderbilt Whitney and Clara Potter Davidge for their support of younger artists by letting these artists show their work for free at the two women's Madison Avenue gallery. It was this small group of artists that formed the core of the Association of American Painters and Sculptors, which in turn organized the Armory show. As for the show itself, women contributed a total of $3,900 (versus $5,750 total from the men). Arthur B. Davies gave the most ($4,050), but Dorothy Whitney Slaight and Gertrude Vanderbilt Whitney donated the next largest amounts ($1,000 each). Eliminating these top three contributors, women gave more than men, with seventeen individual women contributing a total of $1,900 and five men contributing a total of $1,700. In addition to her financial contributions, Mabel Dodge Luhan wrote articles that publicized the show. Walt Kuhn, *The Story of the Armory Show* (New York: Walt Kuhn, 1938; reproduced by University Microfilms International, 1980), p. 5; Brown, *The Story of the Armory Show,* p. 333. On Luhan's role, see Mabel Dodge Luhan, *European Experiences* (New York: Harcourt Brace & Co., 1935).

17. Cecilia Beaux, *Background with Figures* (Boston: Houghton Mifflin, 1930), p. 85.

18. Ibid., pp. 163, 83.

19. Marietta Minnegerode Andrews, *Memoirs of a Poor Relation: Being the Story of a Post-War Southern Girl and Her Battle with Destiny* (New York: E. P. Dutton, 1927), p. 396.

20. Charlotte Streifer Rubinstein, *American Women Artists* (Boston: G. K. Hall, 1982), p. 174.

21. Zorach quoted in Joan Bazarin, "'Pure Color' Search Led to New Art Form," *Tucson Daily Citizen*, 26 February 1964, p. 19; Marguerite Zorach, *Marguerite Zorach: The Early Years, 1908–1920* (Washington, D.C.: Smithsonian Institution Press, 1973), p. 50.

22. Various African American intellectuals, such as Alain Locke and painter Romare Bearden, traced an affinity between African and African American art; however, there was no consensus within the African American community on the potential usefulness of primitivism for the peoples that the movement exoticized. "The Euro-American tradition looks to the primitive to discover the 'other,' the African American artist goes to the primitive to discover the 'self,'" writes Eloise E. Johnson in *Rediscovering the Harlem Renaissance: The Politics of Exclusion* (New York: Garland Publishing, 1997), p. 96.

23. Houston A. Baker Jr. notes that art proved less rigidly exclusionary of African Americans than politics, education, and the more profitable professions. Baker, *Modernism and the Harlem Renaissance* (Chicago: University of Chicago Press, 1987), p. 11. Important exhibition catalogs of African American art include *Against the Odds: African-American Artists and the Harmon Foundation* (Newark, N.J.: Newark Museum, 1989); City University of New York, *The Evolution of Afro-American Artists, 1800–1950* (New York: City College, 1967); David Driskell, *Two Centuries of Black American Art* (New York: Knopf, 1976), on an exhibition at the Los Angeles County Museum of Art; Regina Perry, *Free within Ourselves: African-American Artists in the Collection of the National Museum of American Art* (Washington, D.C.: Pomegranate Artbooks, 1992). Among bibliographical works, see Theresa Cederholm, *Afro-American Artists: A Bio-Bibliographical Directory* (Boston: Trustees of the Museum of Fine Arts, 1973); Lenwood Davis and Janet L. Sims, *Black Artists in the United States* (Westport, Conn.: Greenwood Press, 1980); Chester M. Hedgepeth, Jr., *Twentieth-Century African American Writers and Artists* (Chicago: American Library Association, 1991).

24. Arna A. Bontemps presents the fullest view of African American women artists in Bontemps, ed., *Forever Free: Art by African American Women, 1862–1980* (Alexandria, Va.: Stephenson, 1981); also see individual entries in Darlene Clark Hine, ed., *Black Women in America: An Historical Encyclopedia* (Brooklyn, N.Y.: Carlson Publishing, 1993).

25. Deirdre Bibby, "Savage, Augusta," in Hine, *Black Women in America*, p. 1012.

26. Romare Bearden and Harry Henderson, *Six Black Masters of American Art* (Garden City, N.Y.: Zenith Books and Doubleday, 1972), p. 173. On Savage's later influence as a teacher, see the exhibition catalog *Augusta Savage and the Art Schools of Harlem* (New York: Schomburg Center for Research in Black Culture, 1988).

27. For example, W. E. B. DuBois, "Postscript: May Howard Jackson," *Crisis*, October 1931, quoted in Leslie King-Hammond, "Jackson, May Hammond," in Hine, *Black Women in America*, p. 625.

28. The foundation later organized traveling art exhibits as well. David Levering Lewis, *When Harlem Was in Vogue* (New York: Oxford University Press, 1979), p. 262.

29. The vast majority of scholarship thus far on women of the Harlem Renaissance has focused on women writers; see, for example, Gloria T. Hull, *Color, Sex, and Poetry: Three Women Writers of the Harlem Renaissance* (Bloomington: Indiana University Press, 1987); Lorraine Roses and Ruth Randolph, *The Harlem Renaissance and Beyond: Literary Biographies of One Hundred Black Women Writers, 1900–1945* (Boston: G. K. Hall, 1990); Cheryl A. Wall, *Women of the Harlem Renaissance* (Bloomington: Indiana University Press, 1995). On the art of the Harlem Renaissance, also see Alain LeRoy Locke, *The Negro in Art: A Pictorial Record of the Negro Artist and of the Negro Theme in Art* (Washington, D.C.: Association in Negro Folk Education, 1940); Richard J. Powell, *Black Art and Culture in the Twentieth Century* (New York: Thames and Hudson, 1997). The classic work on the movement overall is Nathan Irvin Huggins, *Harlem Renaissance* (New York: Oxford University Press, 1971). Several other recent works, also primarily literary studies, have begun to explore the complicated relationship between modernism and race; see Baker, *Modernism and the Harlem Renaissance;* and Michael North, *The Dialect of Modernism: Race, Language, and Twentieth-Century Literature* (New York: Oxford University Press, 1994).

30. Langston Hughes, "The Negro Artist and the Racial Mountain," *The Nation* (June 1926): 692–694.

31. Prophet quoted in Charlotte Streifer Rubinstein, *American Women Sculptors* (Boston: G. K. Hall, 1990), p. 245. Prophet is the subject of Countee Cullen, "Elizabeth Prophet: Sculptress," *Opportunity,* July 1930: 205; for a concurring interpretation of Prophet's themes, see Bontemps, *Forever Free,* pp. 26–27; this view is in direct opposition to that of Gloria V. Warren, who writes, "Her subjects were always Black . . . [and a] strong African influence is characteristic of the heads she sculpted." Warren, "Elizabeth Nancy Prophet," in Hine, *Black Women in America.* Few of Prophet's sculptures have survived to the present day, so it is difficult to comment on them now.

32. Michael North sees two different modernisms emerging in early twentieth-century United States: one Anglo-Saxon (typically labeled the only "modernism") and one, equally modernist but distinctly African American, that flowered in the Harlem Renaissance. North, *Dialect of Modernism,* p. 11. Cheryl Wall notes that in actuality "the Harlem Renaissance was not a male phenomenon"; women like Marita Bonner were significant to the movement and "want[ed] to claim a racial *and* a gendered identity." Wall, *Women of the Harlem Renaissance,* pp. 9, 7.

33. Mabel Brooks, "The Autobiography of an Artist," *Crisis,* February 1932: 48.

34. "Augusta Savage," in Romare Bearden and Harry Henderson, *A History of African-American Artists from 1792 to the Present* (New York: Pantheon Books, 1993), p. 173.

35. Anita Pollitzer to Georgia O'Keeffe, October 1915, in Clive Giboire, ed., *Lov-*

ingly, Georgia: The Complete Correspondence of Georgia O'Keeffe and Anita Pollitzer (New York: Simon & Schuseter, 1990), pp. 63–64.

36. See "Professionalism and Feminism" in Cott, *The Grounding of Modern Feminism*, pp. 213–240.

37. "Cecilia Beaux, Artist, Her Home, Work and Ideals," *Boston Sunday Herald*, 23 September 1910, Magazine Section, p. 7. Perhaps influenced by her conversion to Catholicism, Beaux often used religious and metaphysical language when discussing her philosophy of art; besides calling art "the High Mystery" she theorized that "Nature's Trinity" was "the Sun or Light, the Object, and its Shadow. Out of the union of these three emerged Form. Form made Flesh and dwelling among us, intimate and divine at the same time." Beaux, *Background with Figures*, p. 128.

38. Ibid., pp. 341–344.

39. Ibid., p. 58.

40. Eliza Leavitt to Cecilia Beaux, 1 April 1888, Cecilia Beaux Papers, AAA.

41. Barbara J. Bloemink, *The Life and Art of Florine Stettheimer* (New Haven: Yale University Press, 1995), p. 113.

42. Beaux, *Background with Figures*, p. 54.

43. [Lou Rogers], "Lightning Speed through Life," *Nation* 124 (13 April 1927): 395–397.

44. Maria Thompson Daviess, *Seven Times Seven, an Autobiography* (New York: Dodd, Mead, 1924), p. 155; Janet Scudder, *Modeling My Life* (New York: Harcourt Brace & Co., 1925), p. 22.

45. Beaux, *Background with Figures*, pp. 203–204.

46. Anne Middleton Wagner analyzes Lee Krasner's names, art, and gender identity in depth in Chapter 3 of *Three Artists (Three Women): Modernism and the Art of Hesse, Krasner, and O'Keeffe* (Berkeley: University of California Press, 1996).

47. Scudder, *Modeling My Life*, pp. 166–167.

48. Pollitzer to O'Keeffe, 8 January 1916, in Giboire, *Lovingly, Georgia*, p. 120.

49. Meryle Secrest, *Between Me and Life: A Biography of Romaine Brooks* (Garden City, N.Y.: Doubleday and Co., 1974), p. 180.

50. [Rogers], "Lightning Speed through Life," pp. 395–397.

51. Andrews, *Memoirs of a Poor Relation*, pp. 301, 219, 283–284.

52. Barbara Butler Lynes, "Georgia O'Keeffe and Feminism: A Problem of Position," in Norma Broude and Mary D. Garrard, eds., *The Expanding Discourse* (New York: Harper Collins, 1992), p. 438.

53. Daviess, *Seven Times Seven*, p. 133.

54. Andrews, *Memoirs of a Poor Relation*, p. 276.

55. Elizabeth A. Rose, *Lizzie's Own Journal: La Vie Heureuse*, ed. Robert Rose Carson (New York: Vantage Press, 1983), p. 10 (9 October 1907).

56. Ibid., p. 107 (11 November 1907).

57. Ibid., pp. 24 (7 January 1907), 144 (17 February 1908), and 132 (6 January 1908).

58. Andrews, *Memoirs of a Poor Relation*, p. 411.

59. A woman artist's relationship to a nude male model was even more problematic, and thus remained largely invisible in the women's autobiographies. Within this group, only Scudder mentions male nudes; and the only male nude she describes is a little boy—not the "Adonis" of the Lily White story. Scudder, *Modeling My Life*, pp. 27, 53, 87, 91.

60. *New York Evening Post*, 22 February 1913; clipping in Armory show scrapbooks, Walt Kuhn Papers, Roll D71, Frame 106, AAA. See the end of scrapbook vol. 2 for clippings pertaining to the censure of the show as "lewd" and "immoral" as it closed in Chicago.

61. Art critic Lida Rose McCabe commended Genth for making the nude a respectable subject for women artists. "Woman as an art producer has ceased to be curio, enigma or trifle. Upon intrinsic merit her achievement now stands or falls." McCabe, "Some Painters Who Happen to Be Women," *Art World* 3, no. 6 (March 1918): 488–493. On Brooks, see Adelyn D. Breeskin, *Romaine Brooks: Thief of Souls* (Washington, D.C.: Smithsonian Institution Press, 1971).

62. *Survey*, 3 May 1913.

63. Louise Noun, *Abastenia St. Leger Eberle, Sculptor (1878–1942)* (Des Moines, Iowa: Des Moines Art Center, 1980), p. 9.

64. Frances Borzello describes several examples from "the sudden rash of female self-portraits in the nude" from the beginning of the twentieth century. Borzello, *Seeing Ourselves: Women's Self-Portraits* (New York: Harry N. Abrams, 1998).

65. Bloemink, *Florine Stettheimer*, p. 66.

66. Georgia O'Keeffe apparently agreed with Alfred Stieglitz that her painting was about "thoughts and feelings distinctive to a woman" but not that it expressed sexuality in particular. Barbara Buhler Lynes, *O'Keeffe, Stieglitz, and the Critics, 1916–1929* (Chicago: University of Chicago Press, 1989), pp. 157–158.

67. Barbara Rose, *Lee Krasner: A Retrospective* (Houston: Museum of Fine Arts; New York: Museum of Modern Art, 1983), p. 37.

68. Quoted in Anna C. Chave, "O'Keeffe and the Masculine Gaze," *Art in America*, January 1990: 15.

69. Pollitzer to O'Keeffe, 27 December 1915, in Giboire, *Lovingly, Georgia*, p. 111.

70. Pollitzer to O'Keeffe, December 1915, in ibid., p. 104.

71. Beaux, *Background with Figures*, pp. 301, 91. Tappert writes that Beaux "justified her own career by equating her portrait work to motherhood and particularly to the raising of boys." Tappert, *Choices*, p. 392.

72. Katherine Dreier, *Western Art and the New Era: An Introduction to Modern Art* (New York: Brentano's, 1923), p. 25.

73. Ibid., pp. 66–67.

74. Ibid., pp. 100, 102.

75. Ibid., p. 123.

76. Robert L. Herbert, Eleanor S. Apter, and Elise K. Kenney, eds., *The Société Anonyme and the Dreier Bequest at Yale University: A Catalogue Raisonné* (New Haven: Yale University Press, 1994), p. 3.

77. Dreier, *Western Art and the New Era*, p. 94.

78. See Herbert, Apter, and Kenney, *The Société Anonyme and the Dreier Bequest.*

79. Quoted in Whitney Chadwick, *Women, Art, and Society* (London: Thames and Hudson, 1990), p. 266. In the central myth of modernity, it is masculinity that represents the active, heroic qualities of the age, while the feminine emphasizes its passivity and subjectivity. Rita Felski, *The Gender of Modernity* (Cambridge, Mass.: Harvard University Press, 1995), identifies these two avenues as the vying interpretations of the "gender of modernity," which continue to mark scholarship on modernity and modernism.

80. *New York Evening Sun*, 7 March 1913, clipping in Scrapbook vol. 2, Walt Kuhn Papers, Roll D37, AAA.

81. Aloysius P. Levy, "The International Exhibition of Modern Art," *New York American*, 22 February 1913. Regrettably, Zorach's Armory show painting is now lost, so it is impossible to assess Levy's description against the work he was reviewing; *Marguerite Zorach: The Early Years*, p. 36. See the Walter Kuhn Papers, AAA, for collected reviews of the Armory show.

82. *Chicago Tribune*, 20 March 1913, clipping in Scrapbook vol. 2, Walt Kuhn Papers, AAA.

83. "A Feature of the Academy Caricature Show," March 1914, newspaper clipping, Cecilia Beaux Papers, Roll 429, Frame 250, AAA.

84. The other famous lampoon of Duchamp's painting, *The Rude Descending a Staircase (Rush Hour at the Subway)*, appeared in the New York *Evening Sun*, 20 March 1913.

85. Chadwick, *Women, Art, and Society*, p. 265.

86. *New York Evening Sun*, 10 February 1913; clipping in Scrapbook vol. 1, Walt Kuhn Papers, Roll D73, AAA.

87. Charles H. Caffin, "The Picture Exhibition at the Pan-American Exposition," *International Studio* 14 (Spring 1901): xxviii; Charles H. Caffin, "Exhibition of the Pennsylvania Academy," *International Studio* 19 (March 1903): cxvi; Charles H. Caffin, "John Singer Sargent, the Greatest Contemporary Portrait Painter," *World's Work* 7 (November 1903): 4100, 4116, cited in Sarah Burns, *Inventing the Modern Artist: Art and Culture in Gilded Age America* (New Haven: Yale University Press, 1996), pp. 172–177. Burns contrasts Caffin's critical reception of work by Beaux and work by Sargent; she argues that while male artists succeeded in "colonizing" and co-opting feminine spaces and attributes, women who appropriated masculinity risked being seen as "unnatural, unsexed, repellent, barren, and offensive." Ibid., p. 169. The general assumption is that masculinity is "the norm for artistic or creative achivement, however 'feminine' that male might be . . . Males can *transcend* their sexuality; females are *limited* by theirs—or, if not, must themselves have *male* sexual energy," which is deviant by definition. Christine Battersby, *Gender and Genius: Towards a Feminist Aesthetics* (Bloomington: Indiana University Press, 1989), p. 18.

88. Pollitzer to O'Keeffe, 1 January 1916, in Giboire, *Lovingly, Georgia*, p. 115.

89. Quoted in Chave, "O'Keeffe and the Masculine Gaze," p. 118.

90. O'Keeffe to Pollitzer, 4 January 1916, in Giboire, *Lovingly, Georgia,* p. 117.

91. Though American women artists had always explored their personal identity through self-portraiture, no book-length individual biographies on a par with those of men appeared until the twentieth century, and no great number of these until the 1970s. Only one woman artist's autobiography was published between Susanna Paine's 1854 memoir *Roses and Thorns* and *The Life and Letters of Eliza Allen Starr* in 1905: expatriate painter Anna Lea Merritt's 1879 memoir of her husband, which folded her own life narrative into his. See James McGovern, ed., *The Life and Letters of Eliza Allen Starr* (Chicago: Lakeside Press, 1905), which includes a short autobiography written by Starr; and Cornelia Crow Carr, ed., *Harriet Hosmer: Letters and Memories* (London: John Lane/The Bodley Head, 1913). In addition to these, one may consider Anna Elizabeth Klumpke's French-language biography of her companion, French painter Rosa Bonheur, *Rosa Bonheur, Sa Vie, Son Oeuvre* (Paris: E. Flammarion, 1908).

92. The earliest American painters, still largely within the artisanal tradition, had no need of this narrative in order to assert their status as great artists (see Chapter 1). It should also be noted that many biographies of male American artists were written by their children (including daughters and granddaughters), students (including women students), and wives. In fulfilling their appropriately feminine roles as keepers of the flame, these women inserted themselves into the artist narrative, albeit in an oblique way; the best example of this is Anna Lea Merritt, *Henry Merritt: Romance and Art Criticism* (London: C. K. Paul & Co., 1879).

93. Andrews, *Memoirs of a Poor Relation,* pp. 176, 210, 250.

94. Scudder, *Modeling My Life,* p. 291.

95. Almira B. Fenno-Gendrot, *Artists I Have Known* (Boston: Warren Press 1923), p. 7.

96. Beaux, *Background with Figures,* pp. 35, 42.

97. Ibid., p. 60.

98. Ibid., p. 15.

99. Ibid., pp. 39, 56.

100. Andrews, *Memoirs of a Poor Relation,* p. 274.

101. Mabel Brooks, "The Autobiography of an Artist," *Crisis,* February 1932: 48.

102. McGovern, *Life and Letters of Eliza Allen Starr,* p. 27.

103. Anna Elizabeth Klumpke, *Memoirs of an Artist,* ed. Lilian Whiting (Boston: Wright & Potter Printing Co., 1940), p. 28.

104. Andrews, *Memoirs of a Poor Relation,* p. 257.

105. Galina Gorokhoff, ed., *Love Locked Out: The Memoirs of Anna Lea Merritt with a Checklist of Her Works* (Boston: Museum of Fine Arts, 1982), p. 4.

106. Brooks, "Autobiography of an Artist," p. 48.

107. Klumpke, *Memoirs of an Artist,* p. 18.

108. Rose, *Lizzie's Own Journal,* p. 95.

109. Fenno-Gendrot, *Artists I Have Known,* pp. 13–14.

110. Klumpke, *Memoirs of an Artist*, p. 17. Bashkirtseff was famous less for her art than for her diaries of Parisian art life, published after the promising Russian-born artist's death at age twenty-five from tuberculosis. The volume was translated into English by Mathilde Blind and republished as *The Journals of Marie Bashkirtseff* (London: Virago, 1985) with an introduction by Roszika Parker and Griselda Pollock.

111. Andrews, *Memoirs of a Poor Relation*, p. 353.

112. *American Art Annual* (New York: Macmillan, 1913), passim.

113. Ronald G. Pisano, "The National Association of Women Artists," in *One Hundred Years: A Centennial Celebration of the National Association of Women Artists* (Roslyn Harbor, N.Y.: Nassau County Museum of Fine Art, 1988), p. 14. The New York Society of Women Artists held its first exhibit in 1926. Regrettably, the organization did not leave behind any archival collections. Amy J. Wolf, *New York Society of Women Artists, 1925* (New York: ACA Galleries Exhibition Catalogue, 1987), p. 16.

114. Wolf, *New York Society of Women Artists*, p. 7.

115. Ibid., p. 7.

116. Marie Danforth Page to Marie Dewing Faelten, n.d. (post–World War I), Marie Danforth Page Papers, Roll 4071, Frame 33, AAA. Intriguingly, Faelten, who had invited Page to join the Women's Professional Club, had herself been an antisuffragist. John William Leonard, ed., *Woman's Who's Who of America, 1914–15* (New York: Commonwealth Co., 1915), s.v. "Faelten, Marie Dewing."

117. Ellen Wiley Todd, *The New Woman Revised: Painting and Gender Politics on Fourteenth Street* (Berkeley: University of California Press, 1993), p. 61.

118. Helen Appleton Read, "The Feminine View-Point in Contemporary Art," *Vogue* 71 (15 June 1928): 76–77, 96; Helen Appleton Read quoted in *Art Digest* 3 (1 February 1929): 16.

119. Margaret Breuning writing for the *New York Evening Post* and Helen Appleton Read in the *Brooklyn Eagle;* both quoted in "Women Art Critics Attack Organization of Modernist Women," *Art Digest* 3 (1 March 1929): 9.

120. Due to growing debt, the NAWPS sold the building five years later.

121. Cott, *The Grounding of Modern Feminism*, pp. 85–100; Karen J. Blair, *The Torchbearers: Women and Their Amateur Arts Associations in America, 1890–1930* (Bloomington: Indiana University Press, 1994), pp. 76–85.

122. See issues of the *American Art Annual* for membership figures for individual clubs.

123. Marlene Park and Gerald E. Markowitz, *New Deal for Art* (Hamilton, N.Y.: Gallery Association of New York State, 1977) find fairness and inclusiveness in women's rates of participation in New Deal public art initiatives; these rates roughly equaled the percentage of women who were professional artists (versus those who were primarily art teachers). Likewise, Karal Ann Marling and Helen A. Harrison argue that New Deal art programs were havens of egalitarianism compared with general contemporary discrimination against women's wage work. Marling and Harrison, eds., *Seven American Women: The Depression*

Decade (Poughkeepsie, N.Y.: AIR Gallery, 1976). More recent scholarship, however—including Kimn Carlton-Smith, "A New Deal for Women: Women Artists and the Federal Art Project, 1935–1939" (Ph.D. diss., Rutgers University, 1990); Barbara Melosh, *Engendering Culture: Manhood and Womanhood in New Deal Public Art and Theater* (Washington, D.C.: Smithsonian Institution Press, 1991); and Helen Langa, "Egalitarian Vision, Gendered Experience: Women Printmakers and the WPA/FAP Graphic Arts Project," in Broude and Garrard, *The Expanding Discourse*—points out the unequal practices and gendered assumptions that persisted within those general outlines.

124. Wagner, *Three Artists,* p. 289.

125. Quoted in Norma Broude and Mary D. Garrard, "Introduction: Feminism and Art in the Twentieth Century," in *The Power of Feminist Art* (New York: H. N. Abrams, 1994), p. 16.

126. O'Keeffe quoted in the *Washington Post,* 9 November 1977, section C, p. 3.

Bibliography

Manuscript Sources

Archives of American Art, Smithsonian Institution, Washington, D.C.

Cecilia Beaux Papers
Elizabeth Gardner Bouguereau Papers
Century Magazine Letters (originals in Manuscript Division, New York Public Library)
Gabrielle de Veaux Clements Papers
Albert Duveen Collection of Artists' Letters and Ephemera
Elizabeth Shippen Green Elliott Papers (some originals in Free Library of Philadelphia)
Lillian Genth Papers
Richard Watson and Helena de Kay Gilder Papers
Hale Family Papers
Harriet Goodhue Hosmer Letters
Walter Kuhn Papers
Ladies' Art Association Records (originals at the Friends Historical Library, Swarthmore College, Swarthmore, Penn.)
Marian V. Loud Papers
Macbeth Gallery Records
Martin Family Papers and Campus Martius Museum records regarding Lilly Martin Spencer (originals at the Ohio Historical Society, Columbus, Ohio)
Leila Mechlin Papers
Anna Lea Merritt Papers
Moore College of Art Collection (some originals in the Franklin Institute, Philadelphia, Penn., and the Moore College of Art and Design, Philadelphia, Penn.)
Marie Danforth Page Papers
Pen and Brush Club Papers (originals at the Pen and Brush, New York, New York)
Pennsylvania Academy of the Fine Arts Records (originals at the Pennsylvania Academy of the Fine Arts)
Plastic Club Records (originals at the Plastic Club, Philadelphia, Penn.)

Jesse Wilcox Smith Papers (originals at the Pennsylvania Academy of the Fine Arts)
Spencer Family Papers
Alice Barber Stephens Papers
Alice Kellogg Tyler Papers

California Historical Society, San Francisco, California

Helen Hyde Papers
Mary Curtis Richardson Papers

Chicago Historical Society, Chicago, Illinois

Artists' Files
Chicago Columbian Exposition Papers

Cincinnati Historical Society, Cincinnati, Ohio

Cincinnati Women's Art Club Papers
Elizabeth Nourse Papers

Peabody Essex Institute, Salem, Massachusetts

Hawthorne-Manning Collection
Northey Family Papers
Mary Elizabeth Williams Papers

Providence Art Club, Providence, Rhode Island

Providence Art Club Papers

Schlesinger Library, Radcliffe Institute for Advanced Study, Cambridge, Massachusetts

Blanche (Ames) Ames Papers
Artists' Suffrage League Collection
Blackwell Family Papers
Hale Family Papers
Hamilton Family Papers
Harriet Goodhue Hosmer Collection
Woman's Rights Collection Papers

Sophia Smith Collection, Smith College, Northampton, Massachusetts

Blanche (Ames) Ames Papers
Bush-Brown Family Papers
Nancy Cox-McCormack Cushman Papers
Ellen Day Hale Papers
Alice Morgan Wright Papers

Wellesley College Archives, Wellesley, Massachusetts

Anne Whitney Papers

Published Primary Sources

Andrews, Marietta Minnegerode. *Memoirs of a Poor Relation: Being the Story of a Post-War Southern Girl and Her Battle with Destiny.* New York: E. P. Dutton, 1927.
———. *My Studio Window: Sketches of the Pageant of Washington Life.* New York: E. P. Dutton, 1928.
"Art Work for Women," I, II, and III. *Art Journal* (1872): 65–66, 102–103, 129–131.
Aylward, Emily Meredyth. "The American Girls' Art Club in Paris." *Scribner's Magazine* 16 (November 1894): 598–605.
Beaux, Cecilia. *Background with Figures.* Boston: Houghton Mifflin Co., 1930.
———. "Professional Art Schools." *Art and Progress* 7 (November 1915): 3–8.
———. "What Should the College A.B. Course Offer to the Future Artist?" *American Magazine of Art*, October 1916: 479–484.
———. "Why the Girl Art Student Fails." *Harper's Bazaar*, May 1913: 221, 249.
Belloc, Marie Adelaide. "Lady Artists in Paris." *Murray's Magazine* 8, no. 45 (September 1890): 371–384.
Benjamin, S. G. W. *Art in America: A Critical and Historical Sketch.* New York: Harper & Bros., 1880.
———. *Our American Artists.* Boston: D. Lothrop & Co., 1879.
Bodichon, Barbara Leigh Smith. *An American Diary.* Ed. Joseph W. Reed Jr. London: Routledge & Kegan Paul, 1972.
Brownell, William C. "The Art Schools of Philadelphia." *Scribner's Monthly* 18, no. 5 (September 1879): 737–750.
Bullard, Laura C. "Edmonia Lewis." *The Revolution* 7, no. 6 (20 April 1871): 20.
Carl, Katherine A. *With the Empress Dowager of China: Illustrated by the Author and with Photographs.* Tientsin, China: Société Française de Librairie, 1926.
Carr, Cornelia Crow, ed. *Harriet Hosmer: Letters and Memories.* London: John Lane/The Bodley Head, 1913.
Child, Lydia Maria. "Harriet E. [*sic*] Hosmer. A Biographical Sketch." *The Ladies' Repository: A Monthly Periodical* 21 (January 1861): 1–7.
———. "Harriet Hosmer." *Littell's Living Age* 58, no. 720 (13 March 1858): 697–698.

Clark, William J. *Great American Sculptures.* Philadelphia: Gebbie & Barrie Publishers, 1878.

Cooke, Abigail Whipple. "Providence Art Club." *New England Magazine,* January 1910: 492–496.

Daviess, Maria Thompson. *Seven Times Seven: An Autobiography.* New York: Dodd, Mead, 1924.

De Forest, Katherine. "Art Student Life in Paris." *Harper's Bazaar* 33 (July 7, 1900): 628–632.

Dewing, Maria Oakey. "Abbott Thayer—a Portrait and an Appreciation." *International Studio* 74 (August 1921): p. vii.

Ellet, Elizabeth Fries Lummis. *Women Artists in All Ages and Countries.* London: R. Bentley, 1859.

"An Employment for Young Ladies." *Godey's Lady's Book and Magazine* 80, no. 477 (March 1870): 287.

Fenno-Gendrot, Almira B. *Artists I Have Known.* Boston: Warren Press, 1923.

Finck, Henry T. "Only a Girl." *Independent* 53 (May 9, 1901): 1061–64.

French, Mary. *Memories of a Sculptor's Wife.* Boston: Houghton Mifflin Co., 1928.

Gilder, Rosamond, ed. *Letters of Richard Watson Gilder.* New York: Houghton Mifflin, 1916.

Hale, Lilian Westcott. *The Life in the Studio.* Boston: Little, Brown & Co., 1969.

Hawthorne, Hildegarde. "A Garden of the Heart—Green Alley, the Home of Miss Cecilia Beaux." *Century Magazine* 80 (August 1910): 581–587.

Hoffman, Malvina. *Heads and Tales.* New York: Charles Scribner's Sons, 1936.

Holland, Clive. "Lady Art Student's Life in Paris." *International Studio* 12 (January 1904): 225–233.

Hosmer, Harriet. "The Process of Sculpture." *Atlantic Monthly* 14, no. 86 (December 1864): 734–737.

Howitt, Anna Mary. *An Art Student in Munich.* Boston: Ticknor Reed & Fields, 1854.

Jarves, James Jackson. *The Art Idea: Sculpture, Painting, and Architecture in America.* Boston: Houghton Mifflin, 1864.

———. *Art Thoughts: The Experiences and Observances of an American Amateur in Europe.* New York: Hurd and Houghton, 1869.

Klumpke, Anna Elizabeth. *Memoirs of an Artist.* Ed. Lilian Whiting. Boston: Wright & Potter Printing Co., 1940.

Knauff, Theodore C. *An Experiment in Training for the Useful and the Beautiful.* Philadelphia: Philadelphia School of Design for Women, 1922.

Livermore, Mary A. *What Shall We Do with Our Daughters?* Boston: Lee and Shepard, 1883.

McIlvaine, Charles. "The Pennsylvania Academy of the Fine Arts." *Quarterly Illustrator* 2, no. 5 (January–March 1894): 10–17.

McLaughlin, M. Louise. *China Painting: A Practical Manual for the Use of Amateurs in the Decoration of Hard Porcelain.* Cincinnati, Ohio: Stewart & Kidd Co., 1877.

Merritt, Anna Lea. *Love Locked Out: The Memoirs of Anna Lea Merritt with a Checklist of Her Works.* Ed. Galina Gorokhoff. Boston: Museum of Fine Arts, 1981.

Nieriker, May Alcott. *Studying Art Abroad, and How to Do It Cheaply.* Boston: Roberts Brothers, 1879.

Nunn, Pamela Garrish, ed. *Canvassing: Recollections by Six Victorian Women Artists.* London: Camden Press, 1986.

O'Keeffe, Georgia. *Georgia O'Keeffe.* New York: Viking, 1976.

Paine, Susanna. *Roses and Thorns, or Recollections of an Artist: A Tale of Truth for the Grave and the Gay.* Providence, R.I.: B. T. Albro, Printer, 1854.

Providence Art Club. *Constitution of the Providence Art Club; also, a List of Officers and Members.* Providence: Rhode Island Printing Co., 1880.

Rose, Elizabeth A. *Lizzie's Own Journal: La Vie Heureuse.* Ed. Robert Rose Carson. New York: Vantage Press, 1983.

Rowland, Geraldine. "The Study of Art in Paris." *Harper's Bazaar* 36l, no. 9 (September 1902): 756–761.

Sage, Mrs. Russell [M. Olivia]. "Opportunities and Responsibilities of Leisured Women." *North American Review* 181 (November 1905): 712–722.

Sandhurst, Philip T. *The Great Centennial Exhibition.* Philadelphia: P. W. Ziegler & Co., 1876.

Scudder, Janet. *Modeling My Life.* New York: Harcourt, Brace, & Co., 1925.

Sparrow, Walter Shaw. *Women Painters of the World.* New York: Frederick A. Stokes Co., 1905.

Stuart, Jane. "Anecdotes of Gilbert Stuart by His Daughter." *Scribner's Monthly Magazine,* July 1877: 377.

Sutherland, J. "An Art Student's Year in Paris." *Art Amateur,* January 1895: 52.

Talbot, Eleanor W. *My Lady's Casket of Jewels and Flowers for the Adorning.* Boston: Lee & Shepard, 1885.

Ticknor, Caroline, ed. *Classic Concord, as Portrayed by Emerson, Hawthorne, Thoreau, and the Alcotts.* Boston: Houghton Mifflin Co., 1926.

Tuckerman, Henry. "American Artists." *Hours at Home* 3, no. 6 (October 1866): 517.

Ward, Elizabeth Stuart Phelps. *The Story of Avis.* Boston: James R. Osgood and Co., 1877.

Waters, Clara Erskine Clement. *Charlotte Cushman.* Boston: J. R. Osgood, 1882.

———. *Women in the Fine Arts: From the Seventh Century B.C. to the Twentieth Century A.D.* Boston: Houghton Mifflin, 1904.

Willard, Frances E., and Mary A. Livermore. *A Woman of the Century.* Buffalo, N.Y.: Moulton, 1893.

Index

abolitionism, 101, 103, 105–106, 162
Académie des Beaux Arts, 96
Académie Julien, 96–97, 98
Adams, Henry, 1
Addams, Jane, 163, 166
Ad Hoc Women Artists' Group, 210
African Americans, depictions of, 53–54, 71, 100–101, 101–107, 243n100. *See also* racial stereotypes
African American women artists, 140, 183–185, 208
Alcott, Louisa May, 114
Alcott, May: marriage to Ernest Nieriker, 114–115; study of art in Boston, 25; study of art in Paris, 96, 97–98, 99, 100–101; *Studying Art Abroad,* 75
Alexander, Francesca, 47
Allen, Marion Boyd: *Portrait of Anna Vaughan Hyatt,* 153
Allender, Nina Evans, 170, 172, 174, 175
Allston, Washington, 31
amateurism, 14, 63, 125, 129, 144, 180; and education, 24–25; as stereotype of women artists, 3, 4, 26, 196
American Art-Union, 55–56
American Federation of the Arts, 143, 208, 255n99
Ames, Blanche Ames, 169, 171, 172, 174
Ames, Oakes, 169
Andrews, Marietta Minnegerode, 157–158, 170, 182, 189, 190–191, 200, 203, 204–205
Ann Eliza Club, 119
Armory Show, 181–182, 191–192, 198
art, as suitable career for women, 3, 8, 13, 22–29, 32–39

art clubs, 17, 26, 42, 109, 118–125, 186, 205–206; women's, 10–11, 28–29, 120–125, 144, 145, 164, 205, 207–208
art criticism, 71–72; and gender, 129, 147–148, 199, 207
Arthur, Mary: "The Young Artist," 22–23
Art Institute of Chicago, 31, 138
Arts and Crafts movement, 163–165
art schools. *See* education
Art Students League, 31, 118; life classes at, 91–92, 96
Art Workers Club, 205
Ashburton, Louisa Lady, 51
Ashcan artists, 159–160, 162, 163
Asian Americans, representations of, 138
Asian American women artists, 139–140
Association for Mutual Improvement (Cincinnati), 26
"Aurora Leigh," 33
autobiography, 18–22, 200–205

Banks, Jessie, 175
Barber, Alice. *See* Stephens, Alice Barber
Barney, Alice Pike: self-portraits, 112
Barney, Natalie Clifford, 189
Barns, Cornelia, 160, 175, 260n46
Bartol, Elizabeth Howard, 102, 111
Bashkirtseff, Marie, 98, 204
Beaux, Cecilia: admiration for Rubens, 87; *After the Meeting,* 175–176; career of, 6, 52, 111, 159; childhood of, 188, 201–202; on commercial art, 182; friendship with Angel DeCora, 140; on gender in art, 148, 149, 153, 195, 200; and models, 99–100; on modernism, 181, 199; NAWPS contributions, 205; portraits by,